$ 59. 95

Gen Willer

THE HISTORY
OF AMERICAN ART
EDUCATION

THE HISTORY OF AMERICAN ART EDUCATION

Learning About Art in American Schools

PETER SMITH

Contributions to the Study of Education, Number 67

GREENWOOD PRESS
Westport, Connecticut • London

Library of Congress Cataloging-in-Publication Data

Smith, Peter J.
 The history of American art education : learning about art in
American schools / Peter Smith.
 p. cm.—(Contributions to the study of education, ISSN
0196–707X ; no. 67)
 Includes bibliographical references and index.
 ISBN 0–313–29870–X (alk. paper)
 1. Art—Study and teaching—United States—History. I. Title.
II. Series.
N105.S6 1996
707′.073—dc20 95–20555

British Library Cataloguing in Publication Data is available.

Library of Congress Catalog Card Number: 95–20555
ISBN: 0–313–29870–X
ISSN: 0196–707X

First published in 1996

Greenwood Press, 88 Post Road West, Westport, CT 06881
An imprint of Greenwood Publishing Group, Inc.

Printed in the United States of America

The paper used in this book complies with the
Permanent Paper Standard issued by the National
Information Standards Organization (Z39.48–1984).

10 9 8 7 6 5 4 3 2 1

Copyright Acknowledgements

The author wishes to thank the National Art Education Association, Thomas Hatfield, Executive Director, and Stacie Lequar, Managing Editor of NAEA publications, for allowing me to use materials which originally were incorporated in journal articles or chapters of books published by NAEA. These materials have for the most part undergone extensive adaptation, revision, and additions, but the following were the sources for the adaptations:

"A Troublesome Comedy: The Cause of Walter Smith's Dismissal." In P. Amburgy, D. Soucy, M. Stankiewicz, B. Wilson & M. Wilson (Eds.), *The History of Art Education: Proceedings from the Second Penn State Conference*. Reston, VA: NAEA, 1992.

"Working with Art Education History: Natalie Robinson Cole as a 'Living Document.' " *Art Education 44* (4) (1991): 6–15.

"An Art Educator for All Seasons: The Many Roles of Eugenia Eckford Rhoads." *Studies in Art Education 31* (3) (1990): 174–183.

"Lowenfeld in Viennese Perspective: Formative Influences for the American Art Educator." *Studies in Art Education 30* (2) (1989): 104–114.

"The Hampton Years: Lowenfield's Forgotten Legacy." *Art Education 41* (6) (1988): 38–43.

"The Role of Gender in the History of Art Education." *Studies in Art Education 29* (1988): 232–240.

"Lowenfeld Teaching Art: A European Theory and American Experience at Hampton Institute." *Studies in Art Education 29* (1) (1987): 30–36.

"Franz Cizek: Problems of Interpretation." In H. Hoffa & B. Wilson (Eds.), *The History of Art Education: Proceedings of the Penn State Seminar*. Reston, VA: NAEA, 1987.

"The Ecology of Picture Study." *Art Education 39* (5) (1986): 48–54.

"Franz Cizek: The Patriarch." *Art Education 38* (2) (1985): 28–31.

"Natalie Cole: The American Cizek?" *Art Education 37* (1) (1984): 36–39.

"Lowenfeld in a Germanic Perspective." *Art Education 35* (6) (1982): 25–27.

"Germanic Foundations: A Look at What We Are Standing On." *Studies in Art Education 23* (1982): 23–30.

To Mary Louise Lanoue Smith:
Ten thousand words would
not suffice to
thank you for
all
you mean to me.

Contents

Acknowledgments

Anyone who thinks any book, excepting perhaps poems or novels, is the work of one person is completely deluded. The name appearing as author on the title page is a deeply indebted co-worker with many, many others whose names will not receive the glory, but may escape the infamy, associated with the materials within the book covers.

My wife, Mary Lou Smith has made my whole career possible and with foresight and patience steered me away from many pitfalls. She should receive much credit and no blame for this book. To our friend James D. Pusch, now at Youngstown State University, but a friend since I worked with him in public school, I want to give thanks for reading patiently some of the early versions of this book.

To the past editors of *Art Education* and *Studies in Art Education*, including Ron MacGregor, Gilbert Clark, Kenneth Marantz, Hilda Present Lewis, Georgia Collins, Jerome Hausman, and Karen Hamblen, I want to give thanks for much very good advice on how to be an understandable writer as well as a diligent researcher.

I would be most ungrateful if I did not especially thank Marcella VanSickle of Purdue University for her bottomless patience and good humor in preparing the manuscript for me and amazing capacity to read my handwriting when no one else could. And thanks to Paul Terrazas of the University of New Mexico for his kind efforts in getting the manuscript ready for publication.

THE HISTORY
OF AMERICAN ART
EDUCATION

Introduction

Art and education are two of the most noble achievements of humankind. They both have led individuals to sublime heights of achievement and revealed the infinite potential of homo sapiens. Our initial helplessness and prolonged childhood have made us very teachable; our subtle intelligence, hungry for meaning in every form and color we happen upon or can manage to make with our marvelously nimble hands, has brought about the production of imagery ranging from sweetly suggestive to overwhelmingly forceful.

Artists such as Apelles (Gombrich, 1976) or Pygmalion have passed into mythology, even in a society which gave rise to Plato's anti-art theorizing, and in which those who worked with their hands were regarded as socially inferior. Indeed, the Greeks saw visual art as embodiments of religious, social, political, and civic values.

We cannot claim that art holds that status in American society. Alas, an American artist may feel like an exile, an Apelles or Pygmalion shoved from the central concerns of her or his society into the dissenting edges. That being so, art in schools, pushed into the margins of the curriculum, the last subject to find a home in the schools and the first to be cast out in times of adversity, is the often unacknowledged offspring of both the artist and the educator, an orphan whose parents will not acknowledge the existence of their offspring. Unfortunately, this orphanhood tells us a great deal about the makeup of the American mind, of the culture of a nation that claims pride in diversity, yet ignores or belittles the types of intelligence and activities that claim experiences are of value for their aesthetic impact, or which disparages the pursuit of achievements and aesthetic expressions that are intrinsically rewarding, rather than as instrumental means to utilitarian ends.

Yet the orphanhood of art in schools cannot be blamed entirely on American schools whose values are not primarily intellectual or aesthetic--however damaging these values may be. At least since the end of the nineteenth century,

the values of the art world have frequently been anti-educational, or impossible to translate into an educational theory that the public at large could either understand or accept. There has also been, again since the nineteenth century, a strong tweak-the-nose-of-the-middle-class strand in Eurocentric art. Despite this, art has found some place in American schools, if perhaps, a little like that of David Copperfield in Mr. Murdstone's untender clutches. Its history is torturous and troubled but also, colorful and character-filled. It has brought together--like the larger American nation--a world of influences, although like the nation it has heeded some, ignored others, and misunderstood several. In some ways, if small in scale, the story of visual art in the American schools is a study of America in all its depths and shallows.

WRITING ART EDUCATION HISTORY

The old approach to writing American educational history has been to shape the report so that all things seem to be moving in an upward trajectory towards some far, far better day. The quaint past was shrouded by the historian in a miasma of superstition. Public schools, advocated by noble and forward-looking heroes (and, rarely acknowledged, heroines), were the stairway to an enlightened future that would be among the metaphorical stars. Progress, these writers believed, was evident--it was predestined.

Thus, Frederick Logan wrote an art education history titled *The Growth of Art in American Schools* (1955). The title has a message, although a close reading of the book reveals that Logan had many doubts about predicting a necessarily rosy future for art education. While he knew that learning about art was not just a matter of school study, the hope of the future seemed to be in schools. Logan's book implied increasing sophistication in art programs in the schools and suggested a future that had to be good and less troublesome than the past.

This history, in contrast, is not teleological. Nor is it strongly optimistic. While I reject nihilism, vis-à-vis the history of education in visual arts, I feel that there has been a tragic element in American art education. I do not intend a complete explication of the word "tragic," but here I will use it only in the sense of high hopes and lofty ideals ruined because of a refusal to examine fully the world in which art education must exist.

In the following pages I will explain that learning about visual art has been too frequently marginal in American education, but despite what many art educators might wish to claim, not all the reasons for this can be pushed off on to the shoulders of forces outside art education. Once we have blamed puritanism, crass materialism, adverse economics, and so forth, we have far from exhausted the reasons for the strangely uneasy place of art education in American schools. We (art teachers and educators) must look to ourselves, just as much as to others, to find the reasons for the weak place of art in American schools and society.

For the most part, education in visual art has not only been marginal in schools, but also tenuously related to the world of art. As I have said it has been a stereotypical orphan child of education, and it has also been an orphan of art. This orphan status can be partly blamed on the modern art world's adherence to a philosophy of art, formalism, that undercut any hope of convincing the general public that art had a really vital part in modern society. So, there has been, in Arthur Efland's term, a school art style (1976b) that arose in part because pedagogues could not find in the art world a broad and demonstrable purpose for art, a purpose that the general populace could understand and accept.

The alternative to the school art style (typically the production of decorative objects) and to trying to convince the public that art is important has been to attempt the argument that art work is useful. Doing art activities may improve the self-image, vent emotions, serve as a way to gain recognition for the non-academically oriented, improve visual acuity, educate the right brain, and so on. It is this using of art, coupled with what I referred to before, usually taking the form of "holiday art" (paper pumpkins and valentines at the very crudest level), that gave rise to the school art style. It was the failure to confront the art world's unblinking acceptance of formalism that caused art education to become alienated from the extra-school world and from the art world.

THE USES OF ART EDUCATION HISTORY

Having just sketched one of my principal arguments, the weakening effect of formalist art theory, I want to address the reasons for writing a history of visual art education in American culture. After all, what use is a history? Why did I want to put myself to a big and bothersome task of constructing a history of visual art education, and why do I want to subject readers to hours of labor? Can a study of what has been done do any good in relation to an admittedly dark, or at least troublesome, present situation? The answer is not as obvious as I might wish. No historical writer should shrug such a question off as if it were merely the talk of philistines.

In 1989 Elliot Eisner presented an address (later published in the 1992 *The History of Art Education: Proceedings from the Second Penn State Conference*) in which he questioned how history research contributed to the field of art education. The presentation was titled "The Efflorescence of the History of Art Education: Advance into the Past or Retreat from the Present?" With such a title, it may not be surprising that Eisner's view of art education historical research was not overly warm. "Efflorescence" has an aura of luxuriant bacterial growth, of fungi on a very dead and rotten creature, the implication being that historical writers are like maggots on the decaying and useless corpse of days long dead. Eisner explained:

Although I have a deep admiration for high quality scholarship and while I believe it is important for those in any field to understand its roots, I do experience a slight

nagging feeling when I think more broadly about the efflorescence ... that attention to historical matters in American art education may reflect ... a retreat from the problems which plague it at present. (1992, p. 38)

Paraphrasing a 1969 article by Joseph Schwab, Eisner insisted that education was a matter of pressing needs, of finding practical solutions. Eisner went on to refer to those who "[D]escended into the past to study the history of the field and through such maneuvers ... avoided the more complicated but essential task of dealing with what should be taught in school" (p.39).

While Eisner admitted the possibility of historical research being of some use, he wanted it to help, "[T]he rest of us better understand how to deal with the problems we face and the challenges we must overcome if art education is to have the kind of significance that all of us ... believe it deserves. From my reading of the literature, few published historical pieces have made this connection" (p. 40).

Eisner set up one criterion for what constitutes worthwhile research in educational matters--note I say "education," not art education or art education historical research--and that is, no research is worthwhile unless its aim is the correction of current practical problems. These problems addressed must be defined at the outset of research.

TYPES OF RESEARCH

I want to pursue the question implied by Eisner's apparent belief that all educational research must lead to suggestions for cures for today's lacks, that what is presently believed to be ineffectual needs to be corrected through discoveries made through research focused on whatever specific problems are currently identified. I contend that the notion that educational research always must, in some ethically imperative sense, tell us what to do now is flawed. Therefore, historical research, even if it is connected to an educational enterprise, need not be lacking in respectability, or even potential utility if its use is not immediately apparent. For my argument I will use the reflections of Philip Jackson (1990) in "The Functions of Educational Research." Jackson, in turn, used two categories of research he had found in *Research for Tomorrow's Schools* by Lee J. Cronbach and Patrick Suppes (1969). Jackson's analysis of these authors' statements provides an unusually clear and succinct explication and is, therefore, in some ways more useful for my explanatory purposes than the longer and more complex Cronbach and Suppes book chapter.

Cronbach and Suppes, Jackson explained, labeled research as "decision-oriented" and "conclusion-oriented." The first category had a direct bearing on educational practice. It was usually commissioned by some institution or political entity, and its results were to be immediately used in practice. The second, or "conclusion-oriented studies, on the other hand, originate with the investigator ... the research *need not* be tied to some practical outcome, though

the latter possibility is by no means prohibited" (Jackson, 1990, pp. 3–4, emphasis in original). Eisner's criterion embraces "decision-oriented" and ignores "conclusion-oriented" research.

Jackson, however, saw a profound utility in conclusion-oriented investigations and points out, "we often derive unexpected benefits from research that was not *designed* to have practical outcomes" (Jackson, 1990, p. 4, emphasis in original). Jackson then goes on to make a very important claim for "conclusion-oriented research":

Cronbach and Suppes argue that conclusion-oriented research is chiefly of value because of what it does to something they call the "prevailing view." This term, they explain, refers to "a widely held belief system [that] underlies the normal practice of every institution"...As applied to education, it "embraces the ends to be sought, the procedures that may be used, the costs it is reasonable to incur, and the degree of success that may be expected..." This prevailing view, Cronbach and Suppes conclude, is a synthesis or compromise shaped by human nature, political institutions, and the writings of learned men. (Jackson, 1990, pp. 4–5)

Jackson draws our attention to the similarity of this to Thomas Kuhn's (1962) writings about paradigms. Conclusion-oriented studies, Jackson notes, are often carried out for the enlightenment of the researcher and a small number of others interested in the same problem. We can translate this into meaning persons interested in art education history. Jackson then goes on to quote Cronbach and Suppes on the crucial value of such apparently not directly practical research:

As [researchers] discuss their results with colleagues, a restlessness emerges. Findings from different studies seem to conflict. Phenomena are noticed that cannot well be summarized in the available language. Similarities are observed among findings on what we previously considered to be distinct topics. As investigators puzzle over these irregularities, they find themselves assembling what they know in a new way. Some of the concepts so created will influence thought throughout the educational world. Some especially stimulating or clarifying concepts will influence even the views of the public. (Cronbach & Suppes, 1969, pp 127-128)

From the art educator's standpoint, the standards of judgment for assessing conclusion-oriented research listed by Cronbach and Suppes are striking and significant. Cronbach and Suppes "call for well-crafted studies, ones that are rigorous in method, thorough in outlook and cumulative in their programmatic linkages ... giving preference to researchers who have demonstrated an enduring commitment to a problem or set of problems" (quoted in Jackson, 1990, p. 5). Jackson points out that this is much the sort of criterion we use in judging the life work of artists.

Jackson's view of research then is that the well-crafted study is worthy, quite aside from its immediately perceivable relationship to educational practice. There

exists the possibility that the conclusion-oriented study will, in fact, be one step in the direction of changing practice through possible change in the educational paradigm. Accumulated related studies may bring about an unease, a perception that there is a lack of fit between the ordinary everyday view of the world and the evidence gathered. This unease will be the lever shifting the whole educational community's viewpoint, and thus a need for change in practice will become evident. Of course, the direction that this accumulation of evidence is taking may be very unclear, sometimes until the evidence has reached a considerable mass, sometimes until a single individual has a sudden insight as to how the evidence could be interpreted in a new way.

First, however, the new way of seeing the world must be *developed*. The bits or pieces of evidence in themselves may not seem to be building into a grand conceptual image. Thus, Mary Ann Stankiewicz's 1984 study of the work of the developer of finger painting, Ruth Faison Shaw, might seem to smack of the antiquarian, but Stankiewicz's use of stylistic analysis to judge the validity of Shaw's self-expression rhetoric points to an area of teaching evaluation that has not been thoroughly explored. What Stankiewicz showed through her study of Shaw's work--that Shaw's talk about untainted self-expression was betrayed by her influence on her students' style--might be the foundation for a kindergarten through graduate school analysis of teaching. Or perhaps it might lead to something I cannot at this time imagine if the same stylistic analysis process was used in relation to the students' work with various art teachers. In any case, Stankiewicz's study might be one small first step in research findings that, after others had pursued other steps, could change the field of art teaching. Or it could remain for many years an isolated example of research about a curious figure (Shaw) of doubtful importance in education in art. We cannot know, either prior to the investigation or before other evidence related to it is accumulated.

In Jackson's terms, historical research in visual art education would be valuable if it were rigorous and carefully wrought, without regard to immediate applicability to action. While the community of art teachers should not expect art education history studies (or any other art education research) to always be immediately "useful," they should be alert to how accumulated historical research might affect the way art teaching and learning is conceptualized as it is practiced at the present. In saying this, of course, I am calling for a new attitude for most art teachers, an alertness to the need for and implications of research in education.

Also using Kuhn's terms, Efland (1989) has pointed out one way his own major study of art education history might bring about a change of view and, perhaps, a change in action. Efland said that as each new art education paradigm gained ascendancy, its adherents have historically rejected the earlier paradigm and all its attributes with harsh abruptness. Efland pointed out the wastefulness of discarding what was good in rejected paradigms for art education. I would add that even if common practice has become a matter of unthinking repetition, the initial establishment of the practice probably was the work of intelligent persons or, at least, was developed by people who saw particular actions as practical and

desirable within the limitations of their times. Total rejection suggests unthinking hubris, a belief that we, the inhabitants of the present, are omniscient.

This rejectionist attitude is, of course, antihistorical. It must make the claim that the new alone embodies all that is good and wise, or at least that the past was the present writ quaintly small (Bailyn, 1960), and is thus somehow too juvenile for consideration in our present age of wisdom.

THE MORE IMMEDIATE USES OF THE PAST

While Efland (1992) saw criticism as one of the uses for our past, John Swift (1991) in "The Use of Art and Design Education Archives in Critical Studies" made a more explicit case for the utility of art education history. Teachers, some working, Swift tells us, in modern inner city schools and searching for effective models for teaching to replace current ineffective ones, studied the archival evidence on the teaching methods of Marion Richardson, a well-known British art teacher of the first half of the twentieth century. They found that the methodology used by that educator worked very well even sixty years after Richardson developed it. Aside from this, Swift informed us that "They were brought face-to-face with their usual practices, and by meeting them, consciously had to reconsider their beliefs and teaching styles. They became more critically aware of some of their unspoken beliefs and practices, and of the limitations of some of the orthodoxies that currently exist in art education" (Swift, 1991, p. 170). In other words, a careful examination of history provides us with a means of examining, critically and analytically, our own day.

I do not, however, want to subscribe wholeheartedly to the old saw that those who do not know history are condemned to repeat it. I am more inclined to see history in the terms of Heraclitus, a stream that flows without identical reoccurrence. Every time we put our foot into the river of art education, art education is different from what it was in the past. However, because of the present's confusing novelty, the past does give us a framework from which we can judge. Through the practice of examining that which can be seen in history with some detachment, we can study by comparison (and contrast) what is being done now. Thus, in my opinion, Eisner missed the point when he complained, "I can't help but think that one of the attractive features of history is its malleability compared to the seemingly intractable problems of practice in art education. Old books on the shelf in a library are findable, they don't talk back, they are not subject to the vicissitudes of politics and economics; in short, they are materials you can work on and bring, at least, to partial closure" (Eisner, 1992, p. 39).

I see nothing wrong with the idea of using study of what has been done, that which one can examine until decision or closure of judgment can be tentatively reached, as a point from which to analyze and evaluate the present. The end of a particular historical study is only the beginning of its use.

I have tried to look at historical research in two ways: First, and I believe this to be most important, I attempted to establish the point that research, educational or art educational, need not be immediately useful. In the terms of Cronbach and Suppes, conclusion-based research *might* be the most important research in the long run, and I linked this type of research to art education historical inquiry. Second, I discussed the more direct use of historical research as an instrument for critical examination of the theories and practices of education in visual art of the present time.

My opinion is that, despite Joseph Schwab, conclusion-oriented research-- that is, research not too closely tied to what is at the moment perceived to be a particular problem--can be the most far- reaching research. As the traveler from a far-off land may see things no native can perceive, the historical researcher can look at our landscape of today with newly opened eyes and with spectacles ground fine by scholarly study of that other place, the past, and see the present as never before.

Finally, I hope that the pages that follow will prove to be stimulating and that for some they will be a foundation for viewing education in visual art in a different light. Perhaps that change will lead to new ways of acting, of doing.

WHY THIS ART EDUCATION HISTORY?

Why write another art education history? Frederick Logan's *The Growth of Art in American Schools* treated the subject up to 1955. Arthur Efland's *A History of Art Education: Intellectual and Social Currents in Teaching the Visual Arts* covered many aspects neglected by Logan and brought the history up to 1990. In 1985 and 1989 two Pennsylvania State University conferences on the history of art education resulted in published proceedings and a third conference occurred in 1995.

Logan's book remains quite readable, rather informal and deliberately not heavy or too scholarly in tone. It includes more context than some present-day critics of art education historians would have us believe,[1] yet there is no denying that depth of examination of any issue is not one of the book's strengths. It attempts to tell the whole story of art in the schools of the United States, essentially by citing isolated and conventionally selected bits of the school educational scene. In some ways its date of publication proved to be a misfortune. If it had been written at the end of the 1960s, for example, Logan might have been better able to document the apparent end of the long self-expression era and the rise of new directions that would eventually lead to discipline-centered art education. In the light of revisionist historians, Logan might have looked on American schooling with a less tranquil attitude. However, any historian has the misfortune of having to write as the river of events flows unceasingly past.

Efland's book is a monumental work. It will probably remain a challenge for writers about education in visual art for many years to come. Its importance is a

given, but its very existence requires response, because it has weaknesses, even wrong-headedness, that require consideration, fuller discussion and, perhaps, correction.

Although Efland's text is primarily a history of American art education--and most vital when it concentrates on American materials--almost forty pages are spent on epochs of European history for which Efland seems to have no historical expertise beyond that of a well-educated layman. Unfortunately, even in periods of American art education history closer to our times, a reliance on secondary sources sometimes led Efland into historical shallows. A minor example of this is his assumption that Viktor Lowenfeld initially was employed at Hampton Institute for some sort of psychological job. The Hampton University Archives hold materials that would have contradicted this supposed fact, derived from a dissertation that Efland seems not to have subjected to critical examination. Finally, and while I hope not to disparage too much a work I admire, Efland's book is surprisingly muted about eras he knew very well, including the aesthetic education movement. For example, his own experience at Ohio State University during the Barkan era would seem to be a source for insights about this time, but Efland says rather little about it. In this book an eyewitness account of that era helps to give a richer picture of what happened narratively and theoretically during that important moment (see Chapter 11). Efland's book would have been greatly enriched by a more memoir-like approach, for Efland is a man of great intelligence, of analytical power far beyond the usual in American art education, and he has been close to some of the most influential figures in the shaping of American visual art education. If ever there was an American art educator who should write an autobiography as witness to his times, it is Efland.

Foster Wygant's *Art in American Schools of the Nineteenth Century* (1983) is an invaluable, but very specialized work. Its greatest asset is a rich gathering of visual examples drawn from books and other sources published during the nineteenth century. Its text is cautiously balanced, but Wygant seems to me to avoid any attempt at analysis in depth, or in analysis of the context of materials shown. That may not be a vice. For students of American culture his work provides a source for examination that goes beyond the few precious objects held in museums. By its nature, museum art is a collection of unusual objects winnowed from the abundant ordinary "stuff" produced in any particular era. Wygant provides the background ephemera that fill out an image of the setting which produced the museum-worthy objects.

The various later anthologies, including the first two Penn State Conferences' proceedings, contain papers so widely varying in content and quality as to forestall any attempt at overall evaluation. They have individual value, but almost all the disparate pieces suffer from the compression and lack of carefully worked-out explanation typical of conference presentations. The first two volumes are composed of isolated chapters in which no attempt has been made to ask various authors to develop themes that hang together to make a

whole of comprehensible form. What both volumes do, inadvertently, is to present a picture of the idiosyncratic and scattered nature of historical research about how Americans have learned about art through the schools.

This book, unlike the anthologies, attempts to examine some of the currents, figures, and moments in American art education in a consistent critical light. I have tried to investigate things that were done in art education and people who were leaders in one way or another within the environments of their own times and places. I have made a strong effort to look at primary sources and, when the era studied allowed, I used oral history methods to try to get the sound of the time. I attempt to answer the question, of what this event, person, or movement tells us about learning about visual art in America.

Because my work has been written within this era called the postmodern, it is probably inevitable that an ironic element seeps into many things I say about what I have found in my research. The ironic has been said to be the pervasive quality or tone of the post modern era. However, I do not want to convey any notion that what I describe or analyze is something to be looked down upon. In fact, for example, when I discuss Picture Study, I am distressed by those who have written about history in such a way as to communicate a condescending disparagement of a past that does not happen to match the fashions of our time.

Yet, how can one look upon art educators' chronic desire to put our field into education's first place and not be reminded of Sisyphus and his boulder? Sometimes the struggles expended do seem misdirected or absurd, especially since we can see the puny ends the efforts came to. Yet, to turn from Sisyphus to Don Quixote, futile but idealistic effort has its own kind of beauty, absurd and sublimely tragic all at once.

I make the claim that this book has an important role to play in the literature of art education history because it presents both familiar and unfamiliar materials in a consistent interpretive light. The materials are subjected to close examination, and primary materials are used to an extent not common enough in art education histories. And the interpretation, as I have implied before, relies more on art education's relationship to art in American society than has usually been attempted.

This history is a study of one aspect of American culture. It tries to explain why Americans' attempts to learn about visual art in public schools is as it is through explication of the forces and historical occurrences in American society that shaped how art *could* be taught and understood. I hope that persons beyond the art education community will also find the book to be a valuable explanation of what art teachers have attempted, how American culture has shaped or thwarted their ideas, and, through the role of art in the educational setting, how the visual arts have been regarded in American culture.

NOTE

1. An example of this was the presentation by Efland at the 1993 National Art Education Association Conference in Chicago entitled "Lacking Context."

1

The Beginnings of Education in the Visual Arts in America

A history of American art education must begin by narrowing down what is to be discussed, but what might go into a definition of art education is not a simple matter, the field as it now exists in the schools having grown from various and scattered roots. What it is now has little resemblance to practices at the time of Horace Mann, or even the early work of Henry Turner Bailey, the long time editor of *School Arts*. It was a peculiar approach of early twentieth-century education historians to trace the origins of the public schools to Colonial, Revolutionary, and Federal era institutions and educational efforts that had no real relationship to later forms of public schooling (Bailyn, 1960). Art education writers have sometimes followed suit and have neglected to note education in the visual arts has always existed in the Americas, even in pre- and post-Columbian times when no schools existed. Education about visual art did and does exist outside schools. It was not created at the same time as public schools, yet writers have discussed art being "introduced" in the schools and gone on to explain the "growth" of art in American schools as if education in the visual arts and schooling were in a necessarily symbiotic relationship. They rarely refer to the art education found in American extra-school society. Since art is a universal human behavior, to say that visual art education existed in seventeenth- and eighteenth-century America--to say nothing about indigenous American cultures--is to merely restate a truism.

Despite my contention that there is little to be learned about Americans' attempts to gain knowledge about the visual arts in the seventeenth-, eighteenth- and very early nineteenth-century schools, some consideration of the days before Walter Smith "introduced" school art (the 1870s) must be undertaken because the later forms art education assumed are thus shown to be choices made by humans, not the inescapable results of imagined faceless zeitgeist, or products of inevitable economic forces, even though all choices are affected by a mental climate, a pervasive attitude in certain periods or societies. At the

same time, readers should be aware that school art programs before Smith bore little or no resemblance to the art education for the masses which, however metamorphosized, has been the American art teacher's ideal since Smith's time.

THE PURITAN EXCUSE

It is conventionally asserted that art found an unfruitful soil in America because of the Puritan heritage. That is far too easy an explanation. The first problem with this notion is, of course, that it ignores the non-European arts in America. The Native Americans produced work we now generally place within the category of art, and the skills manifested by these objects proclaim that they were produced by persons who had undergone careful training. In other words, they had experienced an art education. The Iroquois mask or Kwakiutl totem pole possessed as potent meaning for the original Americans as did a portrait of King James I in full regalia for the seventeenth-century English newly arrived in the Americas. Indeed, the Native American forms may have embodied far less conflicted values for their societies then the those of the increasingly divided values of the new Euroamericans. An object, made by human beings intending the object to embody symbolic or affective meaning, is one definition of a work of art. To make such an object requires education and skills, whether the object is a fetish or a royal portrait. The maker requires art education, and the beholder, to grasp its meaning, requires art education.

In invoking the Puritan heritage, I have begun on conventional grounds. Yet the northeastern area of the United States is not necessarily the beginning of Americans' education in the visual arts. In American art education histories the Hispanic heritage of the United States has been mostly ignored, unless the author chose to write about influences seen during the time of the great twentieth-century Mexican muralists. Efland (1990) and Logan (1955) wrote almost as if the Hispanic and Native Americans had never existed and as though African Americans had never contributed to art in North America. What was the art education of, for example, the peoples who created San Xavier del Bac? I cannot recall an answer to this question anywhere in the literature of American visual art education. We have surprisingly recently become aware that African Americans made diverse contributions to the visual heritage of the United States, whether in fine art, folk art, or in crafts. There has been a slightly more evident awareness that the Native Americans made distinctive art. The comparative value of that art in relation to the European heritage, however, was a different story.

Despite the ignorance of the Catholic tradition of the American Southwest, in that area there was a heritage rich in pictorial imagery which had started in times at least as far back as the Anglo-Saxon incursion we associate with the Puritans. Analyzing the Catholic tradition as opposed to the Anglo Saxon heritage, John Dillenberger (1989) has pointed out that the Puritans (as well as many other Protestants) placed primary emphasis on the word. Appeals to the

visual and tactile senses distracted from the word. Catholic tradition, in contrast, utilized the color and beauty of an elegantly mysterious liturgy and an appeal to the senses through visual art. One was to lead to an insistence on learning to read, the other to a love of colorful images and the visual appeal of elaborate buildings.

Of the Puritans, a passage from James Flexner's *First Flowers of Our Wilderness: American Painting, the Colonial Period* (1969) gives information correcting the stereotypical image many of us retain from our hectograph-ridden elementary school days:

The Puritans brought with them from England a tradition of design that had been an integral part of their folk culture for numberless generations. That pigment was applied to walls and furniture, that shapes were sometimes worked in textiles rather than on canvas, does not change the fact that the seventeenth-century settler was familiar with the application of color to achieve decorative effect. Another medieval necessity required representation in its baldest form. When many people could not read and shop-windows were non-existent, inns and stores were identified by signs with pictures on them. Each business street became a picture gallery open to all, and there are documents to show that the colonial connoisseurs rushed to see a new masterpiece of sign-painting more avidly than we rush to the art shops of New York's Fifty-Seventh Street. (p. 8)

Flexner's account does not fully explain that this rush to view representations shows the hunger for images on the part of a people deprived of the rich pictorial heritage of Europe. And, in England and on the European continent there remained a great repository of religious visual expression, despite Oliver Cromwell and other Protestant iconoclasts. The American Puritans were deprived of the deepest and most resonant themes for imagery because of geographical distance as well as their own somewhat anti-image religious tenets. Except, of course, they did create those macabre and powerful headstone carvings we can see reproduced in *Graven Images* (Ludwig, 1966).

The absence of paradigms of what visual art might be, that is the architecture, sculpture, and paintings remaining in Europe, deprived young white eastern Americans of the incentives to develop the learnings and skills necessary to produce great art. As Gombrich (1961) has so convincingly argued, students of art learn far more from art than from representing directly the chaos of nature.

In making these last few statements, I realize I have fallen into the elitist trap of labeling only architecture, painting, and sculpture "art." My tendency to do so is in turn a reflection of my socialization in a male-dominated society since, while women from the earliest colonial period on produced objects of finest needlework and quilts in abstract designs now acknowledged to be worthy of the reverent attention hitherto lavished on twentieth-century nonobjective paintings, women were excluded from fine arts education. The number of women who overcame the barriers they encountered to become "fine artists" remained minute right up and into the twentieth-century.

For both men and women art education as apprenticeships in craft were the rule in colonial European-derived America and continued in that same culture in the years stretching from revolutionary days into the beginning of industrialization in the nineteenth century. Education in visual art--usually drawing lessons--in schools was sporadic and rarely lasted more than a few months at any one time. While these early attempts at school art education have undoubted interest, that interest is essentially antiquarian.

Yet Puritanism as an excuse for the weak place visual arts hold in American culture is a constant theme in writing about visual art education. However, I think it is instructive to read how Flexner explained the Puritan attitude towards visual art:

Puritanism was not exclusively a religious movement; it was part of the long battle of the middle classes against the aristocracy,...An expression of the British mercantile class, Puritanism was a way station on the road to democracy. It reflected the preconceptions of the group from which it stemmed, altered in some particulars by reaction against the preconceptions of the group against which its believers were fighting. It did not attack the handicrafts practiced by its own constituents, but rather the elegant arts of the courts....Efforts were made to keep down luxury, but luxury was thought of not in middle class but in aristocratic terms. (1969, p. 21)

The schools that had been set up under the influence of the Puritans through the Old Deluder Satan Act of 1647 were more akin in purpose to twentieth-century parochial schools than to our present-day public schools. The Puritans did not intend to educate a whole public as citizens of a secular state, but meant to save Puritan souls for the more important life to come after death. Soul saving was done through right knowledge of Scripture and, therefore, good reading skills were the necessary means towards that end. Of course art, fine or applied, had no role in such a limited educational scheme, but neither did study of secular poetry or driving techniques. The Puritans would have been puzzled by our insistence on art in schools, not because they were against all art, but because art or craft was something learned at home in the extended family that included children, apprentices, and servants (Bailyn, 1960).

Dillenberger (1989) has made the observation that, while the Puritans may have expressed notions that have been interpreted as iconoclastic, the Church of England from Tudor times on was not a great patron of painters and sculptors either. Symbol, not expressive representation, was what the Church of England preferred. I would speculate that the British monarch, as head of the Established Church, wished to monopolize affective imagery as far as possible, allowing no rivalry by the Church. Thus, Elizabeth used the imagery of the Virgin Queen, seizing upon the people's devotion to the Queen of Heaven and turning emotional appeal to her own secular ends. Religious imagery had previously rested on the powerful foundations of religious myth. Its appropriation by the monarch led to an inevitable trivialization. It is difficult to associate profound imagery with any British monarch after Elizabeth. It may be more accurate to

claim that painting and sculpture found a sterile soil in British society than to blame Puritanism.

Unlike Holland, England did not develop middle-class art patrons on any considerable scale. That is a far more interesting problem than Puritanism as anti-art. Thus, lack of stimulus for artists in American society is as easily traced to general British as to specifically Puritan prejudices.

FROM THE REVOLUTIONARY PERIOD TO 1850

Art can be used for many purposes. It can be used in ritual to supplement or embody the spiritual concerns of a people. In Catholic and Native American cultures it was used for just such ends. It can inform the people of the qualities exemplified by (or supposed to be the ordained heritage of) the ruling class. Louis XIV was the master of using art in this way. Or it can be a decoration, a nice touch of color over the living room couch. When George Washington purchased a landscape done in England in the manner of Poussin (Flexner, 1969), he was looking for the decorative touch. It is highly unlikely he sought some profoundly stirring image. To be merely decorative is hardly to command deepest emotions or intellectual respect.[1]

In the eighteenth century, as the idea of the United States became formulated, the Rococo style that flooded Europe was delightful in its way, but as Kenneth Clark (1969) said, it seemed as if the soul of Europe was dormant, if not dead. It was a style often without substance, a perpetual childish party celebration rather than an exaltation of the world thoughtfully or in any sense deeply lived. Was it any wonder that art could be dismissed as a frill, or that it could be associated with shallow decorativeness? An eighteenth-century American traveler to Europe would see a contemporary confectionery art, not the soul commanding work of the previous Renaissance or Gothic eras. Perhaps only in Catholic monuments would these (mostly) Protestants see overwhelming powerful imagery, and that left from previous eras. Or the same American travelers might encounter the visual embodiments of the monarchal claims their nation rejected in 1776. In one case art seemed, to the American tourist, idolatry, in the other case, celebration of tyranny.

The neoclassical art that followed the Rococo at least had the virtue of trying to deal with serious if narrow themes. Neoclassicism could be associated with the birth of democracy in ancient Greece and republican Rome and was, therefore, suited to American social and political notions. In architecture, designers, such as Thomas Jefferson and Benjamin Latrobe, used its forms effectively. When neoclassical notions were applied to painting or sculpture, however, the resulting images were seen to be uncomfortably imported, imposed upon a land that had no obvious physical link to the lands of antiquity and myth. Nothing looked quite as absurd as America's authentic but very human heroes disguised as Greek demigods, as in Horatio Greenough's statue of Wash-

ington. And, of course, America had no aristocratic class educated in the mythological-metaphorical language European artists had developed for just such a class.

It took romanticism, although it may have been brought from Europe, and the development of a messianic strain in American thought to become intermixed before some began to see in the American landscape a message of God manifested. He was, or so a growing number of Americans thought, directing the destiny of America and willing it to be His chosen land. The visual realization of this belief was the rise of the Hudson River School of landscapists, the first truly significant American art movement. Curiously, and perhaps not coincidentally, the inception of the first "school art," the industrial drawing movement (immediately after the Civil War), was contemporaneous with the collapse of the prestige and fortunes of the Hudson River painters (Howat, 1983). The schoolmen's vision and the artists' vision seemed from the start not to be in synchrony.

Maxine Greene (1965) in *The Public School and the Private Vision* described the strange and in many ways tragic dichotomy between the visions of life of the early nineteenth-century common school advocates and America's first great literary artists. The one group held a view of human nature as perfectible and capable of being consciously molded through well-planned education. The writers, however, saw humans as possessing a far less knowable, essentially dark and uncontrollable nature.

The school advocates tended to appeal to the middle class desire for control and stability. The working poor or "lower classes," after the disillusioning crash of 1837, were not warm supporters of the schools.

The literary artists were frequently not supporters of schools either, although later writers like Ellwood Patterson Cubberley (1919) told us that only the ignorant adherents to superstition opposed the common school. Contradicting this opinion, Greene quotes from a journal of Ralph Waldo Emerson these damning words: "We are shut in schools...for ten or fifteen years, and come out at last with a bellyful of words and do not know a thing" (1965, p. 27). The Hudson River School artists, like Emerson, saw in untamed nature a spiritual message, and that message was not to be found in ill-lit classrooms, where assorted bits of information were crammed into students' heads.

As the nineteenth century got under way, American public schools of a type we could recognize as predecessors of twentieth- century schools developed. They were for a long time mostly rural and reflected a pan-Protestant Anglo-Saxon value system (Hansot & Tyack, 1982). They were also segregated racially. From the standpoint of present day art educators they were bleak, unconcerned with the aesthetic, widely scattered in the thinly settled countryside where most Americans lived and, with school terms based on the seasonal needs for child labor rather than awareness of the developmental needs of children, school people had little time to attempt anything but reading and elementary mathematics. They could afford little else not only because of time limits and

poverty, but also because teachers were part time and often not much better educated than their students (see Chapter 5). And, of course, what was then categorized as art still remained a matter of specialized training beyond the scope of public education. I will have more to say in regard to this notion when I discuss theories of art in Chapter 2.

Art has usually been regarded as an urban phenomenon, or at least fine arts have been. However, it is true that art forms have arisen among non-urban peoples of every nation. In Australia aborigines did their extraordinarily interesting rock and bark paintings, the Native Americans built San Xavier del Bac (with Spanish-influenced tutelage by clergymen) in the Sonoran Desert, and the Pueblo Indians created a great pottery tradition in their small communities. Art forms were utilitarian and, besides the examples just named, have included quilts, painted and carved furniture, wrought-iron devices, and so forth. Elaborate institutions for display of "fine art" did not exist, nor were there wealthy individuals who could acquire objects that had no instrumental function that could be readily understood by the uneducated. For an artist-as-specialist to take his or her place in society, urban centers must exist, and these centers must be where what is called surplus income can be found.

For the most part, American students for much of the nineteenth century were not in such centers of population and wealth. This condition, just as much as puritanism, played a major role in the arts not being found in American schools, but, to repeat myself, various applied arts were being taught at home. Bailyn (1960) has observed that from their very earliest days American schools had to provide the education *not* provided by the family.

Flexner (1969) tells us that art instruction was offered even in the pre-revolutionary era by private instructors in the little cities of the time, some giving classes exclusively for males. Americans in the nineteenth century eventually became urbanized to some degree, and surplus wealth was accumulated. Both came about because of industrialization.

Despite the two favorable conditions, urban life and surplus wealth, industrialization was not a fertile setting for the development of art. As James Anderson (1992) has explained, work in preindustrial days was based on the model of the craftsman. Wherever one looked, at home or in the barn or in the blacksmith's shop and so on, the general mode of work was that of the person educated in many skills and personally responsible for a finished result. The worker learned to do something from start to finish. His or her education was for mastery of meaningful tasks to accomplish comprehensible goals. Such work resembles in many ways the artist's task even as it is generally imagined today. Industrial work, by contrast, was fragmented and consisted in repeating bits of the process of making. These atomistic bits were not intrinsically interesting, sometimes even hard to perceive as a meaningful part of a whole. Work became mechanical, without any enlivening quality, devoid of that completeness of experience John Dewey (1934) described as an important property of aesthetic experience. In Dewey's terms, work became anesthetic. Work became separate

from, divorced from, the rest of experience. Work became the opposite of a well-lived life.

A fracturing of life took place, one that was to prove injurious to the development of artists as the role of the artist had come to be known in Western culture. Artists had come to be expected, and usually still are in the fine arts, to bring a degree of total personal commitment to their work. The fragmented industrial experience was a contradiction to this ideal.

Before I continue with my examination of facets of American education in the visual arts, I want to reflect on the limitations of the traditional attitude towards art I have so far expressed. As do many of my mid-twentieth-century generation and Euroamerican background, I find myself constantly slipping into the assumption that art is Fine Art and that its only important history is Eurocentric. For example, in my reference to the attitude of the fine artist and his or her needs, the Native American might point out that the emotional commitment ("temperament," if you wish to use a stereotypical descriptor) of an artist is not a characteristic solely restricted to a European or Euroamerican postromantic artist. Ruth Bunzel (1929) in *The Pueblo Potter* has described the sleepless nights and depressions of the Native American potter searching for her perfect motif, and her pride in originality, in terms very similar to those used to describe the travail of a Wassily Kandinsky or a Mark Rothko. Indeed, long before Bunzel's reportage, Aztec craftsmen claimed their art to be on the highest spiritual plain, giving them access to commerce with the gods (VonHagen, 1958). With this expression of my uneasiness about my biases and having warned the reader about the omissions of most historical accounts of education in the visual arts in America, I hope the reader will read on, but critically and watching for my confessed weaknesses.

EDUCATION IN THE VISUAL ARTS IN THE URBANIZING YEARS OF THE LATE NINETEENTH CENTURY

The final years of the nineteenth century have been studied and analyzed with minute care in art education histories. Abundant documentation exists, allowing for multiple studies and various interpretations of the records. As each generation of historical researcher moves from attention to one aspect of life to another, the archives, the contents of attics and dusty publications can be reexamined and reexplained, framing the same materials in different ways to draw attention to hitherto overlooked features. It should be realized, however, that those archives, attics, and publications tell only part of a larger story. Elizabeth Hansot and David Tyack (1988) have described how "interesting have been those decisions embedded in [schools'] practice about which people have mostly been silent" (p. 33). Hansot and Tyack were specifically concerned about gender and how American education became coeducational without much documented discussion, but their study implies issues beyond those related to sex alone. That is, things

were done and traditions of practice established with little or no theoretical explanation, sometimes not even rationalizations formulated for existing conditions.

Americans came to identify themselves as a nation of white persons of European origin. While this was hardly just or a complete description of reality, the dominant culture formed this definition and had the power--perhaps the blindness--to try to make it true in practice. The African Americans, the Native Americans, and the Hispanic Americans were in the territory of the United States, but the voices of their cultures were not listened to by those of power or influence. What the dominant culture regarded as worth heeding came from Northern Europe, or from white Americans of Northern European derivation.

I am particularly concerned with the peculiar influence that Germanic sources have had on American art education, with how surprisingly often Americans looked to German-speaking individuals and practices originated in Germany as authoritative sources or models for imitation. This will be a theme I will revert to frequently, but I do not want the reader to imagine I wish to deny other formative sources. There is certainly no denying that England often provided many of the foundational concepts for American education in general and, therefore, for art education. England was the mother country for most white citizens of the United States in the early nineteenth-century, although after 1848 Germans certainly constituted a strong and easily identifiable minority, one very much interested in education. Significantly for art in American public life, neither England nor Germany had a visual arts community as socially and culturally prestigious within its own society as did, for example, nineteenth-century France.

Aside from the sporadic attempts at persuading individual communities to sponsor art education in public schools, the first major attempt at statewide persuasion by a recognized education leader was Horace Mann's publication of Peter Schmid's system of drawing instruction in 1844 and 1845 (Saunders, 1961).

Like the founders of the English schools of design, Mann was impressed by the Prussian pedagogical drawing system (MacDonald, 1970). Peter Schmid, the deviser of the dominant Prussian system, had received some, if rather dubious, academic training as an artist, but found the roles of artist and teacher incompatible in his own career as an advocate of pedagogical drawing methods (Ashwin, 1981). He developed a system of drawing for nonartists to teach students not planning to be artists. The exact relationship of Schmid's system to training designers in Prussia is not clear. What is clear is that the system was chillingly logical, divorced from any of the warm, sensuous emotionalism of romantic art being produced at the same time by mainstream German artists. It was also the product of a Protestant culture in which art had lost all association with an esthetically formed liturgy and deeply moving, spiritually based imagery. Yet the various Germanic pedagogical drawing systems were attempts to bring a spark of physical activity into the hard-seated, grindingly

immobile life of schooling, whether in Germany or America. Mann saw the Schmid system as potentially creating a new emotional climate, one that had some regard for the need for activity on the part of the students in the schools, and Mann advocated its use partly because he wanted school to be less harsh and more considerate of the needs of the growing child and youth.

The rigidly mechanical, lockstep Schmid system seems an unlikely vehicle for opening up a channel of warmth between pupils and teacher. This oddness requires the historian to exercise her or his imagination to the fullest, yet avoiding the trap of explaining it all away as caused by changes in the meaning of words over time. One only has to turn to *The Scarlet Letter* by Nathaniel Hawthorne, Mann's brother-in-law, to see that emotion and the language used to describe it are not changed out of all recognition. Read, for example, the confrontation in the forest between Hester Prynne and the guilty minister, Arthur Dimmesdale. It evokes all the fire and tumult of a Giuseppi Verdi operatic scene and belongs very much to the romantic emotionalist arts of the Western world of the 1800s, which are still accessible to our understandings. Incidentally, Hawthorne made it very clear that he believed the Puritans were greatly appreciative of fine work, including the exquisite artistry Hester commanded in her needlework. Hawthorne did not believe Puritanism was necessarily anti-art.

Although Mann wanted drawing introduced in public schools, there is some question as to Mann's valuing of art in society. His remarks in his European travels (quoted in Saunders, 1970) show that he favored the word over the image as an ethical-moral imperative. His attitude toward art may be revealed in his choice of Schmid's school training system, rather than a system of art instruction that would lead to the development of artistic talent and enthusiasm for art making. Perhaps the best explanation of this would be that Mann felt that the schools needed to move away from the head-cramming and anti-affective learning of his youth, but his own anti-aesthetic education unfitted him as an adult for developing a theoretical system for attaining the aesthetic education he intuitively hoped for. In other words, Mann longed for an alternative but did not have the background necessary to comprehend what that alternative needed to be.

The drawing instruction methods of Schmid and the later Walter Smith were two related German-influenced strands in nineteenth century American art education. Another German-influenced strand was the Froebelian Kindergarten movement. Elizabeth Peabody, Mann's sister-in-law, was one of the American leaders in that movement in the United States (Saunders, 1961).

Friedrich Froebel and kindergarten are so widely associated with the notion of the laissez-faire teacher who allowed the child to unfold creatively (Weber, 1960) that it is illuminating to look at Froebel's *The Education of Man* (1826) and the Froebel gifts illustrated in Robert Saunder's dissertation (1961). The structured elements in Froebel's work made him seem more akin to Schmid than to the later art education theorists, Franz Cizek or Viktor Lowenfeld, both of whom were thought to be influenced by Froebel (Efland, 1976a). "Natural unfolding," or a variant of the phrase, appeared in the rhetoric of many American art

educators in the first half of the twentieth century; but natural unfolding in the United States might have meant something quite different from natural unfolding in a Germanic culture. While language changes more slowly than some wish to claim, cultures do differ, and languages deeply reflect those differences in culture (Smith, 1982b).

Efland (1985) drew attention to a less widely known aspect of Froebel's theories, his notion of opposites. Froebel believed that opposites make up the world but have an essential unity. That is, a thorough understanding of opposites shows us that they fit together to form a whole. Gombrich (1963) mentioned the Germanic art historians' tendency to bring forward bipolar schemes, or characteristics in art that seem to be in opposition yet are both helpful descriptors for aspects of art. This construction of schemes structured in contrasting pairs seems characteristic of Germanic thought in the most diverse fields (one need only think of Hegel's thesis and antithesis), and it is certainly evident in art education literature in Lowenfeld's haptic and visual theory (Lowenfeld, 1939). The haptic and visual approaches in art, Lowenfeld claimed, were characteristics of the psychology of individuals and of whole eras in art. The haptic person or art was inward looking and emotionalist. The visual individual or period of art was concerned only with outward appearance and strove for realism (to varying degrees, of course). In Chapter 10 I will go into more detail about this aspect of Lowenfeld's thinking.

Although German education did not respond to Froebel's more anti-authoritarian side until the twentieth century (Hearnden, 1976), Froebel's ideas not only entered the United States through the kindergarten movement, but also by way of the Oswego Normal School Movement. This movement brought the ideas of Johann Heinrich Pestalozzi, Froebel's intellectual mentor, to the United States through the work of Herman Krüsi (Stark, 1985; Krüsi, 1872). Krüsi, as a faculty member of the normal school in Oswego, New York, became a major contributor to the Oswego Movement. Describing the work of the American founder of the Movement, Edward Sheldon, Stark wrote: "By the time of his death in 1897, Sheldon has [sic] successfully incorporated the philosophies of Prussian normal schools, Pestalozzi (object drawing), Herbart (moral character and lesson planning), Froebel (kindergarten)...into the Oswego Normal School Training curriculum" (1985, p. 40).

The overwhelming prestige of Germanic education systems was described in autobiographical remarks of Jane Betsey Welling, an American art educator who received her public school education before the First World War: "I grew up in an educational setting [in New York State] where German science, German rational thought, and German thoroughness were patterns for conduct." Welling continued "If I had not been interested in art, I would never have known that German art was different from German science, and that it was mystical, often even sentimental, always charged with romantic feeling, and never 'rational' in the cold and purely scientific sense" (1939b, p. 310).

In some ways the Schmid system of drawing instruction had been a German

attempt to cast art in a mold consistent with a German science model that Welling described. However, in Germany counterforces existed to provide an alternative view of art and of the possibilities of aesthetic experience for any intelligent viewer. Eventually, as I will later discuss, a reaction to the long reign of pedagogical drawing systems erupted, based in part on German romanticism and its enthusiasm for emotion, the natural, and the primitive.

THE SMITH ERA: THE LAST THIRTY YEARS OF THE NINETEENTH CENTURY

The Industrial Drawing Movement and the time Walter Smith worked in the United States have been amply discussed (as I will demonstrate in the next chapter), partly because a great deal of archival material has survived. Here I want to point out that Bolin (1986) has made clever use of archival materials about the Drawing Act (1870) to note that the desires of wealthy and influential industrialists wanting to force on the schools training of designers for their own industries were resisted from the beginning and some modifications (though slight) were effected. Modifications did enter into the drafting of the act; yet the final result was a more or less British model based on a German system.

Stuart MacDonald (1970) claimed the British had chosen the German system for the education of designers despite ample evidence that the French system of design education (which followed the methods used in training artists) produced superior designers and better sales of their designed products. In 1893, according to Clive Ashwin (1981), even Germans recognized the financial success France had long maintained through attention to fine art. This was twenty-two years after the Englishman, Smith, brought his more or less British-German program to the United States. Since both the British and the American advocates of so-called industrial drawing in the schools wanted to have a pool of good designers for industry, and thus increase profits for that industry, this seemingly self-defeating adoption of a relatively ineffective system seems strange indeed. The British choice appears to have been made in part to reinforce a caste system, since the authorities apparently disliked the superior social status given artists in French society (MacDonald, 1970). Although the English schools of design were later taken over by Henry Cole, an astute political realist and a progressive figure in architecture (MacDonald, 1970), the Germanic basis of design education was not replaced by the more successful French system. While the comparative degree of success of the French system or failure of the British systems needs more thorough attention than can be given in this book (which concentrates on the twentieth-century American scene), French textile design seems to have retained a higher status and financial success throughout the nineteenth-century and into the twentieth, thus making the Smith system a still more puzzling choice.

Nevertheless, Walter Smith, educated in the British system and experienced

as a teacher in that system, brought this German-derived method to the United States. Diana Korzenik (1987) has sketched the energetic, if not always straightforward, efforts of Smith to establish drawing instruction in Massachusetts schools. What Smith did not tell his Boston industrialist sponsors was that the South Kensington method he practiced had not succeeded in producing the sought-after superior textile designers identified as its original goal. Instead, the system trained pedagogues needed for institutions created by bureaucratic machinations (MacDonald, 1970). These pedagogues would in turn teach others to teach design--and perhaps, but almost incidentally, turn out a few designers to actually work in industry. Visual art instruction tied to American public schools became the captive of a narrow view of education which in turn catered to a felt need to control parts of the population that were becoming in the eyes of the middle-class Protestant "natives"--despite American rhetoric--the unworthy poor (Greer, 1972; Greene, 1965).

NOTE

1. Thus, much of the argument presented in the beginning of Albert William Levi and Ralph Smith's *Art Education: A Critical Necessity* (1991) seems a trifle specious. To state that a few, a very few eighteenth-century aristocrats liked art is to prove nothing about some supposed superior status of art in the United States before the "Jacksonian Revolution" referred to in Levi and Smith's book.

The Dismissal of Walter Smith: Historiographic Explanation, the American Art Scene, and Visual Arts Education in the Late Nineteenth Century

As I have said, histories devoted to art education in the United States schools sometimes spend considerable time and space describing attempts to get art into the schools before 1870, but the so-called Industrial Drawing Act of 1870, or more accurately, the Massachusetts Free Instruction in Drawing Act, is ordinarily regarded as a benchmark at the least, or even as the real beginning of serious attempts to include art in the curriculum. It is no wonder then that a great deal of attention has been given Walter Smith, the person hired to see to the implementation of the act. The materials covering the era of Walter Smith are so abundant art education historians have used and reused them, giving to them the most varied interpretations. Unfortunately, the results have not necessarily been clarifications, although the luxuriant number of them has added to the richness of our picture of Smith's era. Rather than repeat a narrative of Smith's hiring, development of his career in America and eventual exile back to his native England, all of which can be found in many places,[1] I will reflect on what his dismissal tells us about histories of visual art education and the relationship of art education to the changing art and education worlds. I hope that this will lead us all to look more carefully at the fluctuating fortunes and forms of visual art education rather than accept simple narrative accounts, and I will try to lead the reader to ponder what Smith's story tells us about art in America.

THE MEANING OF WALTER SMITH'S DISMISSAL: HISTORIOGRAPHIC ISSUES

Walter Smith was a drawing master brought from England in 1871 to put the Drawing Act into effect in Massachusetts. Despite his energetic leadership and some widespread, initial favorable response to his efforts, made widely known to the public through the 1876 centennial exhibition in Philadelphia,

by the 1880s he fell from grace and returned to England, where he died shortly after (Wygant, 1993).

The story of Walter Smith and the fate of drawing or design art education he introduced into the schools not only help us to understand the uneasy place of art in American education but also the difficulty of extracting a convincing explanation from the various facts offered in evidence by the many people who have tried to write histories about Smith. By extension, the example of the histories about Smith illustrate the difficulty of historical explanation about any period of art education history, or any other history. The various accounts of what happened add up to an almost comedic confusion, reminding this writer of a play by Luigi Pirandello, *Right You Are If You Think You Are*.

Yet, history's basic claim to be a valuable discipline lies in explanation. That is, the raw data of history, what we call fact, usually can be ascertained with little recourse to the highest intellectual skills. Searching for records is a tedious and time-consuming task but requires more ingenuity than wisdom. Records are, of course, subject to falsification or inadvertent error. However, despite deliberately falsified records or accidental flukes, for the most part mere facts are not a major conceptual concern of most historians. The historian is concerned, rather, with the more philosophical questions of a convincing explanation of why the facts came to be, what the facts mean, and how the facts relate one to the other.

When we try to connect this need for true-sounding explanation to real historical practice we find that there are indeed difficulties, and we must use those higher cognitive skills that mere fact grubbing did not require. It will probably be impossible to assemble all the facts about any particular occurrence in the flow of history but, even if it were possible, I cannot imagine the historian who would do it. Even the maker of a chronology must select the facts to be listed. She or he must make a judgment about relevance and greater or lesser relationship to events of concern. Despite Leopold von Ranke's often cited claim that the historian must show history as it was, to present all that happened would be to merely represent the muddled confusion of events as their contemporaries saw them. It would merely constitute resurrection of dead events, many of which had little or no connection to each other. The historian, then, must interpret even as she or he selects the facts that might help form an understandable image of the past. Obviously this will ignite the issue of subjectivity versus objectivity in historical work, and I will get to that in due time.

Throughout this chapter and the rest of this book I try to look at issues of explanation and of selection as they relate to the history of American visual arts education. In order to avoid vague abstractions and the type of theorizing that causes working historians to mutter about airy-fairy theory not applicable in practice, I use specific examples. I want to illustrate the peculiar difficulty of explaining events in education in the visual arts. Here, pursuing a chronological path, I am going to discuss actual explanations about an art education history

event through accounts of the dismissal of Walter Smith. Of course, precise historians will point out that I mean events and dismissals in the plural since Smith was forced out of three positions: supervisor of drawing in the schools of the State of Massachusetts and in the City of Boston, and Principalship of the Massachusetts Normal Art School. However, since these positions were interdependent and more or less all shaped by Smith, and for simplicity of presentation, I will discuss them as if they were one.

As I said, the Massachusetts Free Instruction in Drawing Act of 1870 is often cited as the "official" start of art education in American schools. This act was the immediate cause of Smith's hiring. The act was the result of a petition to the Massachusetts Legislature which read as follows:

To the Honorable General Court of the State of Massachusetts.

Your petitioners respectfully represent that every branch of manufacturers in which the citizens of Massachusetts are engaged, requires in the details of the process connected with it, some knowledge of drawing and other arts of design on the part of skilled workmen engaged.

At the present time no wide provision is made for instruction in drawing in the public schools.

Our manufacturers therefore compete under disadvantages with the manufacturers of Europe; for in all the manufacturing countries of Europe free provision is made for instructing workmen of all classes in drawing. At this time, almost all the best draughtsmen in our shops are thus trained abroad.

In England, within the last ten years, very large additions have been made to the provisions, which were before very generous, for free public instruction of workmen in drawing. Your petitioners are assured that boys and girls, by the time they are sixteen years of age, acquire great proficiency in mechanical drawing and in other arts of design.

We are also assured that men and women who have been long engaged in the processes of manufacture, learn readily and with pleasure, enough of the arts of design to assist them materially in their work.

For such reasons we ask that the Board of Education may be directed to report, in detail, to the next general court, some definite plan for introducing schools for drawing, or instruction in drawing, free to all men, women and children, in all towns of the Commonwealth of more than five thousand inhabitants.

And your petitioners will ever pray.

Jacob Bigelow	John Amory Lowell
J. Thos. Stevenson	E. B. Bigelow
William A. Burke	Francis C. Lowell
James Lawrence	John H. Clifford
Edw. E. Hale	Wm. Gray
Theodore Lyman	F. H. Peabody
Jordan, Marsh & Co.	A.A. Lawrence & Co.

Boston, June, 1869 (quoted in Bolin, 1986, pp. 74-75)

The baldness of this appeal to economic self-interest may be dulled in our

minds by later recourse to similar arguments and the force of the names of the signers may be dimmed for us by time. We have become used to almost daily complaints that the schools do not prepare students with particular skills for whatever industry is ascendant at the moment. We may not recognize that most of the men signing the petition were among the most powerful in Massachusetts at the time and came from a fairly closed and self-reaffirming group of textile manufacturers (Bolin, 1986), perhaps incapable of recognizing the selfishness and narrowness of their own demands.

Almost thirty years before this Horace Mann had articulated a far more generous rationale for inclusion of drawing in the schools. His statement could have related school art programs to then contemporary American art, even the mystical luminists.

[T]o be able to represent by lines and shadows what no words can depict, is only a minor part of the benefit of learning to draw. The study of this art develops the talent of observing, even more than that of delineating. Although a man may have but comparatively few occasions to picture forth what he has observed, yet the power of observation should be cultivated by every rational being. The skillful delineator is not only able to describe far better what he has seen, but he sees twice as many things in the world as he would otherwise do. To one whose eye has never been accustomed to mark the form, color or peculiarities of objects, all external nature is enveloped in a haze, which no sunshine, however bright, will ever dissipate. The light which dispels this obscurity must come from within. Teaching a child to draw, then, is the development in him of a new talent,-- the conferring upon him, as it were, of a new sense,-- by means of which he is not only better enabled to attend to the common duties of life, and to be more serviceable to his fellow-men, but he is more likely to appreciate the beauties and magnificence of nature, which everywhere reflect the glories of the Creator into his soul. When accompanied by appropriate instruction of a moral and religious character, this accomplishment becomes a quickener to devotion. (Mann, 1844, p. 135)

However, the decision to turn away from such a humanistic vision to comply with the restrictive demands of the industrialists dashed the possibility of a rapproachment between school art and the art world of nineteenth-century America. The decision to provide industrial drawing was, therefore, not only a capitulation to the power of a few persons of special interest, but an act which drove any so-called art education in the schools away from the most vital movements in American art. Industrial drawing was unlike anything in the American art world of its day. It did nothing to prepare students to understand that world or the heritage of art, aside from some copying of historic ornament.

Smith was indeed, not only a foreigner in American society, but he was also unfamiliar with the American art scene. An 1881 newspaper editorial also attacked his insensitivity towards American social beliefs:

Your English educator more conveniently classifies the children in the public schools at once into those who are "going to college" and those who are "intended for

employment in the constructive industries." Having assumed the existence of these classes, the rest of his convictions follow easily...We have no class "intended for employment in the constructive industries." Every mother's son of our Yankee schoolboys is intended for the United States Senate. If not, which one is not? Would anybody dare to go into the public schools of Quincy and pick out and set aside those boys who "are going to college" and those who are intended for Mr. Walter Smith's artisan class? (An Un-American System, p. 4)

Revisionist educational histories would dismiss such populist journalistic rhetoric as a verbal smokescreen hiding a reality of a repressive, bureaucracy-ridden, and class-enforcing school system (Katz, 1971). The newspaper writer certainly never stopped to consider that only white Anglo-Saxon boys were who he (most certainly not "she") was expressing an opinion about. Nevertheless, a basis for Walter Smith's eventual failure can be traced to his misreading of the culture he entered but did not understand.

Smith's forced departure brought out the reasons why his system was rejected and why art programs of any kind were suspect in American schools. In order to discuss Smith's place in American visual art education history as it is explained by art educators, I will examine writings by Frances Belshe (1946), Arthur Efland (1985), Harry Green (1948), James Parton Haney (1908), Diana Korzenik (1987), Gordon Plummer (1985), and Foster Wygant (1983).

Stripped of extraneous narrative, what do these authors offer as significant explanations for Smith's fall from grace? Let me briefly summarize their stances.

Belshe. A cabal of Massachusetts drawing teacher specialists lobbied powerful authorities to unseat Smith because Smith advocated drawing instruction by generalist teachers. In other words, self-interest led to political action. The specialists were afraid they would lose their jobs, and the jobs for specialists in art were very few.

Efland. Smith's ideas reflected a view among the socioeconomic elite that the schools should train the working classes to be economically useful. After Smith's hiring a faction of another, perhaps more idealistic elite came to power (circa 1878) and saw education as a means of social mobility, a key to upward striving. Thus, a changed view of education's role in society undermined Smith's role. If I may interject a very loose use of language, I will label this a change from utilitarianism to idealism. In any case, Efland suggests shifts in socioeconomicoeducational philosophy as Smith's undoing. But neither utilitarian appeal nor appeals to socially uplifting aspects of knowledge of art were sufficiently strong to keep drawing in the schools.

Green. Green's dissertation deals with Smith at great length and is, therefore, more complex in explanation than the other works I am discussing and uses many more explanations than I can indicate here. However, one of the most interesting explanations Green offers is that Smith was done in by political demagoguery. A shrewd candidate for the governorship of Massachusetts singled out drawing as one of the expensive frills of the educational establishment and

ran against it, appealing to the public's dislike of paying taxes and its prejudice against the value of any school subject that could not be called directly utilitarian. There had been a financial panic in 1873 and education's ineffectualness and costliness had been criticized in its wake. That Smith's notion of drawing education was many times more puritanical than the Puritans and that he rejected "idle" imaginative drawing in schools never came to widespread appreciation. Green (1948) put a finger on one of the tricks of an issueless politician: Single out a theme that appeals to prejudice but hardly merits the attention of a chief executive. Harp on that issue and people will become convinced it is true and important. This is a strategy often used in local, state, and national politics. Green's reasons for Smith's dismissal are several, but political demagoguery is one. Yet the politician must attack that which is weak, even as he exaggerates his target's importance, cost, or degree of threat.

Haney. Commercial publishers were jealous of the market available to Smith for his drawing manuals. Various publishers, including Louis Prang, tried to get in on the market for drawing books, but Smith's positions suggested to many that he held a monopoly. The publishers began to campaign against Smith, and Smith, a proud and obstinate man, fought their claims tooth and nail. This campaign and counter attack were carried on in acrimonious newspaper exchanges. Commercial avarice might be noted as Haney's reason for Smith's firing. Of course, public officials never like to harbor in their bosoms controversial and opinionated appointees.

Korzenik. Smith's personality was the greatest stumbling block. He began his campaign to sell his program by saying America had no art--or designers--and he had a sure cure for that malady. As a starter this was a successful tactic. He had, after all, been hired because some wealthy and influential industrialists felt they needed a pool of better designers. Unfortunately, energetic and articulate though he was, Smith did not realize that telling Americans he felt they were artless could be done just so many times before they got tired of a foreigner criticizing them. This irritation with Smith is certainly supported by the editorial previously quoted. I suppose Korzenik's explanation could be reduced to the "pain-in-the-neck syndrome." That is, Smith became irksome, so no one was sorry to see him go when the opportunity arose to drop him.

Plummer. A certain clergyman named A. A. Miner wanted the Normal Art School to rent a building his church owned. Smith claimed it was not suitable for his school, in part because female students kept getting confused with residents of the building who seemed to be pursuing a profession even older than teaching. Miner was a member of a governmental oversight body having power over education in Boston, and he wanted income for his church from an educational institution overseen by that body. We might perceive a conflict of interest as Plummer's chief explanation.

Wygant. In his history of nineteenth-century art education Wygant singles out two conflicting reasons for Smith's fall. Samuel Eliot, superintendent in Boston after Smith supporter John Philbrick was ousted, deplored the lack of

allowance for imagination in Smith's program and the dreary quality of his books. Wygant also pointed to school board and media opposition to the pursuit of beauty. Since these notions seem to be coming from opposite directions, I might label Wygant's theory the "brick-bat effect." That is, enough criticism was thrown at Smith to destroy him, no matter what the validity or consistency of that criticism.

After allowing for a certain oversimplification on my part--after all, these writers could not be so naive as to claim causes in history are often single--these are seven explanations for one result. What does this diversity tell us about history, whether it be history in some large sense or the history of art in American schools?

SELECTIVITY IN HISTORIC EVIDENCE

First of all, as I said previously, the authors could not merely assemble all the data available. They had to select, and their very selection constituted a type of interpretation. However, taking for granted the competence of these historians, this selection-interpretation was not capricious.

The historian E. H. Carr (1961) likens the historian's task to that of a fisherman who lowers his net and then sees what fish-facts he hauls in. Nets do not hold water, and I think Carr's metaphor does not either, despite the reliance of many art education historians on his historiographic theory. An historian has a background that gives her or him the power, the skill, the feeling for what bits of information are significant. Thus, all the writers mentioned are or were art educators, well-versed in the field's literature, familiar with its concerns and practices.

Let me switch metaphors and drop the net. The mosaicist develops an eye for the pieces that will help form a comprehensible and vivid image. The pieces *do* exist outside the artist's use for them, just as, despite Carr, historical facts exist outside the little black box between the historian's ears. The historian does not create facts anymore than I would create the pieces if I were doing a pebble mosaic. Nor did the historians here considered create historical facts. They searched records and other debris of past life, some of that debris including what Korzenik (1985a) calls ephemera.

I am told that at the University of Arizona archaeology students are given bags of garbage taken from the streets of Tucson and asked to reconstruct the lives of those who produced the garbage. That is something like one of the historian's tasks. However, while the trash may be ephemeral and subject to accidents of survival, the trained or experienced archaeologist or historian is not random, is not capricious, and is not subjective in selection or in interpretation of the significant pieces of garbage. When her or his readers get the feeling that the selection has been guided by something other than the desire for a sensible and balanced explanation, they put the book down and look elsewhere for real history.

SUBJECTIVITY IN INTERPRETATION

One of the most pernicious accusations that can be brought against historical reports is that they are subjective. In 1985, in a very subtle and interesting reflection on art education history, the contemporary art educator Karen Hamblen seemed to imply that all histories of visual art education are subjective because they are at every stage interpretative. As I listed the seven causes for Smith's dismissal, the reader may have come to the conclusion that the variety of explanations proves such a charge.

However, if they could be quizzed, I'm sure each of the historians discussed would list the usual procedures for safeguards against falsification, from critical examination of evidence through self-examination for presentism. Yet someone might still charge that differing explanations show subjectivity and it is undeniably true that the different writers did seize upon different factors for their attempts at significant explanation. Although the seven authors did not see things in exactly the same way, what would have been the alternative? Isaiah Berlin (1967) has asked just what is implied by these charges of subjectivity and turned the argument around to attack the premise of the accusers:

We are told...every judgment is relative, every evaluation subjective, made what and as it is by the interplay of the factors of its own time and place, individual or collective. But relative to what? Subjective in contrast to what? Involved in some ephemeral pattern as opposed to what conceivable, presumably timeless, independence of such distracting factors? Relative terms (especially pejoratives) need correlatives, or else they turn out to be without meaning themselves, mere gibes, propagandistic phrases designed to throw discredit and not to describe or analyze. (p. 59)

For our visual art education historians to satisfy those who cry historical research is subjective, the seven writers would have to adhere to some universally accepted standard for analysis and judgment. Where does this standard exist in any area related to study of human behaviors? In psychology? Psychology's practitioners claim it is a science and is not science popularly thought to be *objective*? But are there not Freudians, Marxist-oriented theorists, Jungians, Adlerians, and Rogerians? I have already mentioned the futility of complete reconstruction of the past, so it seems to me that criers of subjectivity are asking historians to interpret, to give explanations of reality itself, to attain to an eternal omniscience possible to God alone, and the Deity has not granted to any historian, or anybody else I know, the complete Divine Wisdom.

Instead, each historian must use frames of reference to make a bit of actuality understandable. These frames of reference or theoretical referents are necessary to understanding, even as they, like a picture frame, exclude parts of the larger world of happenings (Goodman, 1978). If the seven historians could be faulted, their error might consist in their failure to place Smith within the larger sphere

of nineteenth-century art and design, or, more importantly, the still larger arena of American culture and society in the urbanizing and industrializing late nineteenth century. Only Korzenik's *Drawn to Art* (1985b) presents a fleshed-out picture of American art and Walter Smith's impact on schooling in art in this era in any even moderately complete sense. Indeed, she pictures an America in which many people longed for some form of education in art, mostly outside schools. Scores of drawing books were published and bought up by an eager public, while the schoolmen in choosing the Walter Smith industrial drawing program narrowed their art curriculums to drill-ridden drawing lessons bearing no relationship to the expressive-descriptive drawing the public had appeared to want through purchase of self-help drawing books, nor was the schools' choice of drawing program related to the world of the professional artist.

LOOKING FOR MEANING

In the fin-de-siècle era in which I write, we still often naively assume that science is objective and we have a quasi-religious awe toward it, but Danforth (1982) has called the science of anthropology an *interpretative* science. Interpretation is quite different from some hypothetical mere reporting of observation. The anthropologist, Danforth claims, translates the actions and observed beliefs of one culture into terms that can be understood by his or her own culture. The historian, to continue to borrow from Danforth, also attempts to translate culture, the culture of the past, into terms the present can understand. Because the historian does this translation his or her history is, therefore, obviously not the past as it was to its actors and contemporary observers. However, that does not mean that the history is false, or subjective, anymore than a translation is always a lie. It can be a process of falsification, but it does not necessarily follow that it is, despite the fact that a translation from one language to another can not be a word-for-word equivalent.

Danforth further explains the anthropologist's relationship to her or his data and its meaning in this way:

Any serious inquiry into another culture leads to a greater understanding of one's own culture. An investigation of the other involves an exploration of the self as well. The central problem of anthropology is thus, in Paul Ricoeur's words, "The comprehension of the self by the detour of the comprehension of the other."...The anthropologist sets out to investigate the other, only to find the other in himself and himself in the other. (1982, p. 6)

While there is no simple relationship between the study of the history of visual art education in America and making decisions for the present, a deeper understanding of ourselves through history does serve a function, a use, if you will. Thus, each of the investigators of Smith's dismissal has provided an

explanation that could help us understand our times, although that process may have been unconscious on their part and may sometimes have slipped into presentism. We could probably go through the list of seven and find a parallel for each explanation in some present-day situation. Of course, this may also be a process of recognizing a pattern in a series of events because we have experienced the conformation in our own time. Thus history can use as its subject matter the same happenings again and again. The danger is, of course, that unless the environment of the happenings is understood, they really cannot be either rightly explained or understood. Many historical explanations by specialists in art education appear to lack a sense of the world beyond schooling, even beyond school art.

EVALUATIONS OF HISTORICAL EXPLANATIONS

Of the historians considered here, I suspect that all the explanations given did touch on some aspect of the dismissals of Smith. I am inclined to give more weight to Efland's notion of a changed view of education over the years Smith worked in America, but I also feel Smith's position was fatally weakened by, as Korzenik proposed, the irksome nature of his personality. Thus, both the impressively profound and the seemingly trivial, but psychologically convincing, may play a part in explanations of causality. I am struck that none of the writers stated that Smith's (and his industrialist supporters') goal was really impossible to achieve. It seems absurd to have believed that a state's whole educational system could have been commandeered to produce over many years, at considerable effort, designers for one industry, given the necessary diversity of society's interests. In his doctoral dissertation Paul Bolin (1986) pointed to evidence he found in records of hearings held before the passage of the "Act Relating to Free Instruction in Drawing" indicating significant resistance to the idea of strictly industrial drawing. The frequent references in art education literature to the work of Smith as industrial drawing--or what we would call industrial or graphic design--does not represent the full *intent* of the act. Smith's insistence on industrial drawing, therefore, had prior resistance. It seems unreasonable to have assumed that generalist teachers already burdened with preparations for teaching a number of subjects, all of which were more or less "literary" (or arithmetical) in method of presentation and in content, should also have been expected to acquire mastery in a subject requiring great manual dexterity, expertise in visual concerns, and a nonverbal mode of presentation. That would have required a cadre of drawing specialists, something Smith declared unnecessary. After all, if educated adults could not master his drawing curriculum, how could it be mastered by every schoolchild?

Aside from these single cause-effect explanations examined so far I want to add an idea suggested by Kenneth Clark (1969) in *Civilisation*. Clark felt that any movement tends to have strength for only about half a generation. The great

period of Athenian ascendancy lasted for just part of the adult life of Pericles. On a smaller scale, from the Drawing Act of 1870 to Smith's dismissal of 1883 was a period of approximately half a generation. In other words, we should not have expected enthusiasm for the industrial drawing movement to have lasted longer. Of course, historicist ideas, including Clark's, have to be viewed with extreme caution. They do not explain why the ending of Smith's tenure was so bitter. But the use of Clark's notion does help us to see that while industrial drawing in America had a "life" beyond the career of Walter Smith, that "life" had little vitality or energy. Unlike the abrupt termination of Smith's American career, industrial drawing continued but gradually wore thin, and in a threadbare state, eventually fell out of American schools.[2]

THE SMITH ERA AND ITS IMPLICATIONS

As I said in my introduction, the easy way to explain art's failure to find a niche near the center of American public school curriculums has been to blame the influence of puritanism. I have already pointed out that this was too restrictive an excuse, the broader British heritage being just as much the cause, if we want to find a scapegoat to blame.

However, as I have also pointed out, various forms of out-of-school visual art education always took place in what is now the United States. Most of these forms seem more like distant ancestors of the design fields rather than the fine arts. They were those activities associated with the enhancement of everyday objects, quilts, chests, furniture, teapots, business signs, metal work, and so on. Smith's own education prevented him from seeing these humble objects as art. His education taught him to respect only historic ornament, derived from antiquity, or the gothic, or so on, not the still vital art of the American folk of his own time.

When industrialization developed to the point of shaping American life, then home or apprentice training in making of functional and decorative objects became impractical. A single item's manufacture would be broken down into discrete steps, each the work of a person unaware of how to do the other steps. The worker became an anonymous, easily replaced cog in the system of manufacturing. At the same time, Western fine art had exalted the individualistic artist, the person whose work was so unique and marked by "personality" that only he or she could produce all its parts and shape it from start to finish. This autonomous individualism was the ideal in every field in society for those who aspired to have a full life above the ceaseless toil of the lowest depths of society, and the survival of the fittest economic mutations of Darwinism reinforced its seeming validity. Romanticism's heroic artist experiencing life's extremes became a model for the autonomous individual.

Smith's insistence on drawing for preparation for work in industry touched a nerve in American beliefs. Smith's ideas denied social mobility. Americans

wanted to see all individuals capable of heroic achievement. Smith seemed to believe in each individual having a predestined place in the social order. His supporters may very well have simultaneously combined belief in fixed roles for working classes and in social mobility for those who could acquire money without consciously realizing the contradictions of their beliefs. Thus, the Smith-Industrial Drawing system was out of step with American educational rhetoric and the American art scene. It seemed to fall somewhere between art (the autonomous individual) and worker training (the individual as anonymous cog). In one sense, it fitted nineteenth-century industrial reality. In another sense, it violated American myths about life, individualism, and art.

THEORIES OF ART IN SMITH'S ERA AND TODAY

Although there were a number of theories of art in Walter Smith's day, each was hotly contested as *the* proper theory of art. Whatever was claimed as the true definition of art, it was, of course, derived from the European tradition. A hundred years after the Smith era, ideas have changed, but no one theory has attained an unquestioned ascendancy.

Closer to our time Morris Weitz (1956) declared that art was an open-ended concept. It could not be defined. That is, what constitutes art is always in flux. In a time dominated by multicultural rhetoric we believe that art is a socially constructed concept and that fine art in particular is a more or less Western European-derived notion. However, I feel very cautious about pressing notions about what is European-derived and what behaviors are non-European very far. Recall that Bunzel (1929) found Native American potters who were "artistic" in their behaviors. Although the art rhetoric expected by us in Europe and the United States may be absent in other cultures, the intent to produce objects for aesthetic response may be present in any culture, and the heightened sensibilities of the artist (as, for example, Bunzel's so-called primitive artists) may transcend the expected behaviors of specific cultures.

In late twentieth-century art education literature three historic theories of art are frequently used to explain the features to be attended to in art.[3] They are crude categories, very untidy in their parameters and in practice frequently mixed. However, for use in classrooms and general discussion of the history of art, they are helpful. For my purpose they will provide a framework for discussion of ideas about art in the Smith era and in subsequent times. These three theories are mimetic art, emotionalist art, and formalist art.

The ancient Romans developed a realistic portrait tradition. This was mimetic art. In many times and places the imitation of the appearance of the real world has been an important function for art. In the Western world, the influence of the Greco-Roman tradition has provided the basis for this. In Smith's era, the French academicians such as Jean-Leon Gerome, embraced the mimetic or, as it is sometimes called, imitationalist theory of art.

However, the emotionalist idea of art has also been important, at lease since the early nineteenth century. Emotionalism can refer to anything from eighteenth-century Rococo pretty, happy sweetness, or early twentieth-century sprightly Raoul Dufy watercolors, to a nineteenth century Frederic Church volcanic eruption, to George Rouault's twentieth century horrifying prostitutes and to mid-twentieth century Jackson Pollack's frenzied drip paintings. In the nineteenth-century of Walter Smith, Romanticism fit this emotionalist category.

The third theory of art is formalism. In this the basic structure of art, its "elements" and "principles" are the overriding concern of artist and onlooker. Art education's Arthur Wesley Dow from about 1900 to 1922 was the first important American teacher to propose a theory suited to formalist practice, although he did not use the term. An example of formalism can be seen in the semiabstract New Mexico landscapes of Dow's student, Georgia O'Keeffe. An extreme example of formalism was the mature work of Piet Mondrian. Formalism as a dominant theory was the most influential theoretical underpinning for modernism.

At the start of the white settlement of America, the European invaders and their descendants would probably have thought of art in mimetic terms. Art was to record the look of the world. Portraits were necessary to fix for ages to come the appearance of the holders of power or status. The extreme deduction from this notion was the English economist Jeremy Bentham's suggestion that the great at death be stuffed and their actual bodies placed on pedestals in public places. A logical result of this theory was the development of photography. Primitive or naive artists who practiced their art in America from colonial days on might be described as failed mimetic artists or as unconsciously successful formalists, since the best of their work was unrealistic, yet strong in design.

If mimesis was the chief focus of art as far as the white population of America cared, then (in precamera days) the content of art education was mastery of representation in its most realistic or naturalistic form. Drawing, especially drawing of the figure (since humans, or so we might think, are most interested in humans) would be the core of a school curriculum in art. Here it is necessary to refer to Gombrich (1961) and *Art and Illusion*. Gombrich claimed that representing the world was a matter of learning the devices artists had previously used to create the illusion of realism. The mimetic artist would need to study the art of the past to learn the proper techniques. Schooling would be mastering of skills exemplified in models of past art. The method of teaching would be to require study of the "old masters" and setting up of problems to copy the skills of these artists and of requirement for drills to perfect skills.

So far as possible, individual quirks in representation would need to be suppressed. Of course, from at least the time of Giorgio Vasari, "manner" or individual styles were noted and sometimes prized. But because these were deviations from realistic representation, artists were under some compulsion to make it clear that they could represent the world "objectively," if they so chose.

In training, the student either strove to achieve realism without idiosyncratic style or emulate the style of his (rarely her) master. However, looking at the products of such past attempts, we see a style, the style of an age, a problem I will discuss in another context in Chapter 4. We also see that the emulation of reality was not undiluted, but was "compromised" by concerns for good organization, color harmony, and other concepts not found in nature. Self-expression was beside the point in an art education appropriate under the mimetic theory of art.

The mastery of the skills for representing the world are still highly regarded and awarded. The "class artist" in elementary or secondary school is usually the student who has mastered to a higher degree than his or her fellow students some of these skills, and the general public more readily accepts a realistic rendering as "art" than the finest design or most dynamic but distorted image. Duane Hanson's photorealist sculpture is extremely popular because it appeals to this love of mastery of illusionism.

The student of the Walter Smith era was required to master skills of representation, that is, to be schooled under the mimetic theory of art. This may seem curious to us because we would presently expect textile designers to be masters of design, which to us (post-Bauhaus and A. W. Dow) implies mastery of abstract design elements, organized under what are called principles of art.

Even in Smith's time, a training strictly confined to mimesis was not an adequate preparation for the art world of 1870. Romanticism in art had reached a full expression in the Hudson River School of American painters. Smith felt obliged to announce that industrial drawing had nothing to do with picture making, perhaps referring to romanticism in art. Inconsistently enough, of course, he also claimed Americans had no art (Korzenik, 1987) and his methods would correct that. This denial of the existence of American art was very curious since some American artists (Benjamin West was one) had long been recognized in Europe, even in England.

Romantic art glories in the extremes of human experience as in Edgar Allan Poe's Roderick and Madelaine Usher or Herman Melville's Ahab. Wild adventure, drugs, or the inhuman grandeur of landscape are ripe material for romantic art. Romanticism (and its descendent, expressionism) has a strong emphasis on the individual, although its emotionalist appeal has been utilized in the twentieth century for state and commercial propaganda. Its allure is in the attraction, the charisma, of the individual who becomes promethean through heroic experience or communication of extremes of experience. Romanticism is emotionalist or expressivist art. The individual and the individual's reactions, emotions and unique voice, are its core concerns. Subjectivity in drawing--that is, distortion--is a distinguishing characteristic. While representation in visual romantic art might still be a necessary concern in 1870, imitation of the real world was not the only or supreme goal. Thomas Cole's *The Titan's Goblet*, an image of a gigantic goblet formed from the mountains and holding a lake, is a powerful romantic art work because of its convincing visualization of a dream-

like image, not because it is an absolutely "photographic" painting.

Education in the emotionalist scheme of things requires development of a unique mode of work. This is difficult to teach directly since it requires an indirect cultivation of *attitude* in the student, rather than direct training and drill. Romanticism has within it the seeds of antirealism. Feeling, not direct representation, is the romantic's goal. It also contains the seeds of anti-formalism and tends to degenerate into a spewing forth of emotion without control of the formal elements of art.

When the birth dates of Vincent Van Gogh and Paul Gauguin are considered-- 1853 and 1848, respectively--the lateness and nearly outmoded aesthetic context of Smith's ideas can be understood. If Van Gogh is regarded as a proto-expressionist and Gauguin as a proto-formalist (or if the reader will let me claim this for the sake of argument), the change in the art world at the end of the nineteenth-century Smith era can be better understood. As long as schools held onto practices associated with Smith's methods, they drifted further and further from the art world.

As I will mention in analyzing Lowenfeld's intellectual foundation in later chapters, anti-realism in art found theoreticians able to devise rationales for this change. In German-speaking countries, Alois Riegl (Austrian, worked circa 1900) claimed that changes from realistic (optic) art to nonrealistic (haptic art) were cyclical and inevitable. They were part of an "art-will" that moved where it would regardless of what individual artists wanted to do. Thus epochs of distortion and subjectivity were natural, to be accepted as an organic part of art history. In English-speaking countries, Clive Bell (early twentieth century) formulated the notion that the only important concern in art was "significant form." Subject matter, skill in representation, and emotional expression were not of primary interest, or not of interest at all. Significant form was not easy to perceive and was graspable only by those who looked at a lot of art. In practice it meant that the artist and the sophisticated art audience paid attention only to the design of the art work and virtually nothing else. Indeed, some claimed that madonnas and oranges were equal as far as true artists were concerned.

In art education Arthur Wesley Dow's formulation (*Composition*, 1925) of what constituted proper method and content to be studied was an expression of formalist notions. Composition or the complete control of design elements in whatever medium was the basis of all true art. For Dow the rise of individualist artists, emotionalist in intent or imitationalist in concentration, was a mistake beginning in the Renaissance in the West, but happily avoided in Oriental, especially Japanese art. While many art educators followed Dow's formulas for teaching about elements and principles as the "alphabet of art," few were willing to embrace the implication of anti-emotionalism in his theory. However, the simplicity of his rhetoric, the apparent teachability of his ideas, and his strategically influential position at Columbia University's Teachers College, in its golden age of educational intellectual leadership, were factors that led many

art teachers to try to impose an anti-mimetic practice in school art curriculums.

THE PURPOSE OF ART AND SCHOOLING IN ART

Art in public schools must have a reason for being. Smith's reason was to develop a working class capable of designing for an important industry. The narrowness of this goal could, of course, be a sufficient reason for the program's eventual failure and Smith's becoming regarded as a burdensome nuisance. However, Smith did claim drawing was important because it could provide something in the American economic sphere that was needed. Studying drawing had a definite social and cash value. That is something that has rarely been claimed for art in American schools; yet supporters of American schools have frequently justified the schools on the basis of economic benefit. The lack of direct connection between making money and doing or liking art has certainly helped to weaken art's place in American school and life. Romantics may see the divorce of art and money making as the badge of spirituality, but others see it as the proof of unimportance.

In the twentieth century, the adherents of self-expression claimed that art was valuable to the individual because, believing in the emotionalist theory of art, they felt art allowed the student to vent her or his feelings in a constructive manner. Art, therefore, was of some use, although the use was more or less private. The believers in self-expression were sincere enough in their faith, but they rarely convinced the population as a whole that emotional venting was needed enough to establish curriculums in the schools and pay for specialist teachers, especially when those teachers claimed not to teach, but to merely "take the lid off," to use a phrase attributed to the twentieth century art educator Franz Cizek (see Chapter 4). In the late 1940s Lowenfeld extended the psychological rationale to claim that art would lead to a healthy individual who could build a healthy society. In a society reeling from the trauma of World War II, this rationale based on a generally felt need for emotional health and general stability achieved remarkable popularity, although expressionism in painting and sculpture never displaced the popularity of mimetic art with the general public. In the art world of the 1950s, Sir Herbert Read (1957) claimed that two-thirds of all American artists were expressionists.

Formalism, the theory of modernism, was never a concept appealing to a majority of the population. In the Owatonna project of the 1930s its principles, or at least Dow's version of them, were used, and some success was claimed for it, especially in its applied art form. Indeed, formalism in design fields, such as textile or automobile design, did become accepted, but the more the fine arts community emphasized and embraced formalism, the further it moved from acceptance by the average person. The public was willing to discard ornament in furniture or vehicles. It was all too happy to discard pictorialism dependent on a learned set of symbols from mythology in architecture, but in painting or sculp-

ture the public could not swallow the notion that narrative or reference to representation of the world is superfluous.

Given the latent prejudices of a culture still inheriting many British notions-- at the end of the twentieth century almost as much as at the end of the nineteenth--art programs in the public schools must still find a way to claim that art has an important function. Aside from Smith's fleeting success--if it was a success--the attitudes associated with romanticism and formalism have been very unhelpful in attempts to overcome art's marginal status in American schools.

Beyond the label of "British" or "Puritan," what can be said about art's marginalization in American culture? To explain the type of thinking that keeps art in the curricular margins John Michael has cited the philosophy of Herbert Spencer and explained it as follows:

Spencer (1911), in logically analyzing what knowledge is of most worth in his first essay on education, proposed the following activities/subjects in order of their importance for the good life:

1. Activities related to staying well and the preservation of life: physiology and hygiene. One must first have good health.
2. Vocational activities: math, chemistry, physics, and biology. One must then have knowledge and skills for earning a living.
3. Domestic activities related to family life: physiology, psychology, and ethics. After assuring good health and a job, one then should establish a home and family.
4. Social and political activities related to citizenship: history, economics, politics. One now should become interested in community and government affairs--be a good citizen.
5. Leisure activities related to the gratification of taste and feelings: music, art, literature. Spencer argues that as the arts "occupy the leisure of life, so should they occupy the leisure part of education." (Michael, 1983b, p. 10)

Michael goes on to state that, "Spencer's work had a profound influence on Americans, including his contemporary, Charles W. Eliot, president of Harvard University" (p. 11).

While Michael's analysis has merit, I cannot help but counter it with the example of sport. Sports would have been as thoroughly rejected by the Puritans as fine art, but sports became a major fixture in British life and acquired what I consider an inordinate amount of public attention in the United States. Sports are leisure activities, yet they attract great public support in the schools, and despite Michael's belief that most people would accept the Spencerian hierarchy, there seems to be some fault in the judgment that apparent utility forms the public judgment of what is valuable in education. I suspect that in many persons' opinions, sport is the most interesting thing schools do. Of course, when I talk about sports I am not referring to physical education, which, properly conducted, would be health education. However, sport in Amer-

ican life is mostly a spectator activity. The few participants, furthermore, are often self-centered hedonists rather than pursuers of health and self-discipline, the Spencerian ideals.

The art-for-art's-sake beliefs characteristic of formalism held no potential for persuading even a large minority of the public that art was an important area of study in the schools. As in the case of sport and, despite Spencer, proof of importance in earning a living is not a necessary condition for support of an area of interest in education, although it is often an effective rationale. The sufficient condition is an affective one. Sport arouses enthusiasms of various kinds (not excluding the aesthetic). That is enough.

If art could emotionally engage many students and parents in one of its forms, it might be able to generate enthusiasm. The school art activity, however, would have to have a real connection to the art world or the attraction to art would fall apart with a disillusioned realization that school art had no function in the extraschool world. Recent art world trends suggest that there may be a way out of the dilemma posed by the common historic and nonengaging theories of art.

The post modern art world has become much more concerned with art as the tool for social change, even as a weapon in the struggle for social change. The art world of the early 1990s became more and more engaged. This attitude makes it possible to clearly identify art with vitally important and socially visible areas of human activity, albeit some that are fraught with political difficulties. Whatever these difficulties, the abandonment of formalism, a theory that allowed art in capitalist societies to be trivialized into meaningless, more or less decorative objects for sale, allows the art teacher to demonstrate the power of imagery. If art is seen to be used widely in social causes, then it has a demonstrable function in real life, the life of the community, in contrast to its sterile canonization in elite sanctuaries--the museums.

It is ironic that totalitarian societies of the twentieth century have readily acknowledged the power of the arts by a vigilant, even ferocious censorship. It is sad that segments of our contemporary society acknowledge the power of the arts only by a demand for suppression. It is horrifying that a number of artists and art supporters in our late twentieth century have claimed, in trying to fight censors, that art has no effect, or that art can say anything and cause no harm (and by implication, no good). Whatever opportunities are seized or let go in the post modern era in education in the visual arts, for nearly the first time the orphan of art and education may have some chance to claim that it is a true offspring of a real art world that can make a difference in American society.

NOTES

1. See, for example, H. B. Green (1948), *The Introduction of Art as a General Education Subject in American Schools.*

2. An art educator teaching at the University of British Columbia, Graeme Chalmers, has claimed that Smith's influence remained very strong in Canada long after it had faded in the United States. Perhaps Canada was sufficiently still British enough in culture to remain a good setting for Smith's ideas.

3. One example of this three-theory categorization is John Canaday's (1983) *What Is Art?*

3

Germanic Influences

As enthusiasm for industrial drawing became a thing of the past, other interests developed in the United States and in Europe that were eventually to strongly shape American art education. Some have felt that these concerns led American art education away from the goal of teaching students about art as a discipline. Some have disparaged the psychologizing element these interests brought to American visual art education, claiming they eventually caused art educators to replace all concern for art with pedagogical fixations (Manzella, 1963).

What I am referring to is what became known as the child study movement. Art education histories, as a matter of course, cite the child study movement as one of the foundations of American art education in the twentieth century (Logan, 1955; Efland, 1990). This movement reached its first full tide in the very late nineteenth century, led in the United States by G. Stanley Hall at Clark University, but its origin was in European studies. It was the beginning of developmental psychology.

The work outside the United States that was to reach America during the nineteenth century and which also served as a foundation for the thinking of twentieth-century immigrant art educators fleeing from Adolph Hitler to the United States, including the extraordinarily influential Lowenfeld and the somewhat less influential Henry Schaefer-Simmern, was carried on in Germanic countries, especially Austria and Germany. To illustrate this double influence, I will mention two examples. G. Stanley Hall studied with Wilhelm Wundt, one of the pioneers of developmental psychology, in Germany. He later returned to the United States where he founded *The Pedagogical Seminary*, a journal that published numerous child study articles, including many that used children's art work for data. A second and later influence can be seen in the writings of Lowenfeld who studied with Karl Buhler, another developmental psychologist, in Vienna in the late 1920s and early 1930s. Buhler also came to the United States as an immigrant fleeing the Nazis, but he never developed an American career of

note, although his wife, Charlotte, became well known. Since the German language was the common factor in much of this child study research, I will frequently refer to *Germanic* influences, whatever nation-state is the point of origin.

GERMANIC FOUNDATIONS:
SCHAEFER-SIMMERN AND LOWENFELD

German-born Schaefer-Simmern and Austrian-born Lowenfeld arrived in the United States in 1937 (Abrahamson, 1980a, 1980b) and 1938 (Saunders, 1960), respectively, and both became highly conspicuous Germanic contributors to American art education. Previously, as Saunders (1961) has demonstrated (and I have already stated), various direct Germanic influences such as the publication of Peter Schmid's drawing lessons in *The Common School Journal* and more indirect influences such as the introduction of Froebel's kindergarten theories had produced some effect. Neither Schaefer-Simmern nor Lowenfeld would have denied Germanic intellectual influence in their backgrounds, especially in the sense used here, even though both were forced to flee from Germanic societies after the triumph of Nazism. Neither entirely shed his Germanic behaviors nor Germanic accent.

Schaefer-Simmern was forty-one, Lowenfeld thirty-five on arriving in the United States. It is probable that they were fully formed intellectually at these times of transition in their lives, and unlikely to drop all the concepts they had developed, although they were doubtless capable of the modification and refinement. They were, after all, persons of high intelligence, combined with sensitivity, and they were immersed in entirely new surroundings which required major adjustments.

Lowenfeld had already published a brief study of the blind and had collaborated with Ludwig Münz on a more extensive treatment of the sculpture of the blind (Michael, 1981) and Lowenfeld had completed the manuscript of *The Nature of Creative Activity* (Lowenfeld, 1939) before leaving Austria. I will treat the matter of the forming of Lowenfeld's concepts in depth later in this study. Schaefer-Simmern had definitely settled on the major foundational theories that shaped the rest of his lifework. Unless we believe Schaefer-Simmern's and Lowenfeld's ideas to have been somehow parthenogenic, it would seem probable that the origins of these ideas took form within the places of origin of these two men and that many of the studies they had learned about in Germany and Austria were late nineteenth and early twentieth-century German language research projects or reports.

John Michael and Jerry Morris (1985; 1986) used taped lectures by Lowenfeld, including one that was autobiographical, as the basis of journal articles on intellectual influences on Lowenfeld. Roy Abrahamson (1980a, 1980b) has documented Schaefer-Simmern's conceptual formation, using materi-

als gathered through long association with Schaefer-Simmern and through study
of materials provided by Schaefer-Simmern's widow.

SCHAEFER-SIMMERN'S SOURCES OF THEORY:
THE INFLUENCE OF GUSTAV BRITSCH AND OTHERS

Schaefer-Simmern may not have stressed the importance of his early
experiences in recorded lectures as Lowenfeld had done, yet he always forthrightly
acknowledged Gustaf Britsch (1879-1923) as his theoretical mentor and chief
source of his ideas about art education. He dedicated *The Unfolding of Artistic
Activity* (1948) to him. It might be more accurate to say that Schaefer-Simmern
claimed the Britsch-Kornmann theory for the basis of his life work, for it seems
unlikely that Schaefer-Simmern actually came in contact with Britsch. He did,
however, hear Britsch's student and colleague, Egon Kornmann, on at least two
occasions (Abrahamson, 1980a, p. 13; Schaefer-Simmern, 1953).

Perhaps Schaefer-Simmern's unfinished book mentioned by Abrahamson
(1980a) included a more complete analysis of Britsch's theories, differentiating
them from any Kornmann extensions. As it is, the best English language
explications of Britsch and his *Theorie der bildenden Kunst*, besides *The
Unfolding of Artistic Activity*, seem to be "The Gustaf Britsch Theory of the
Visual Arts" (Munson, 1971), and "A Neglected Theory of Art History" (W.
Andersen, 1962). Scattered through other publications are historical and
occasionally analytical references to the Britsch theory (for example Bassett,
1971). Bruinhilde Kraus's 1968 *History of German Art Education and
Contemporary Trends* (especially pages 52-54, 160-162, and appendices A and B)
described the theory and post-World War II controversies about it:

According to the theory of fine art by Gustaf Britsch, a product of the individual's
effort is a work of art if it is internally unified. Britsch explains by reference to
primitive art and child art that the fine arts have to do with a process by which an
object in nature is perceived in an individual manner and reconstructed in one's mind
in a pre-intellectual process. The work of art results from an intellectual effort at
reporting on the construct which exists in one's mind. This product is a work of art if
it shows unity throughout. This unity must extend both to the prethought and the
intellectual processes and to the action which creates the work of art. (p. 52)

This quotation touches on only part of the theory, but the sentence
beginning "Britsch explains by reference to primitive and child art" should be
noted. Wilhelm Viola's (1944) statement that the Britsch-Kornmann position
held that the "mental attitude of the child is the same as in all early cultures, the
Egyptian and the early Greek, e.g., when pictures and image were one" (p. 66)
clarifies this a bit more. Besides raising problems attendant on phylogeny-
ontogeny theories, Kraus's (1968) analysis brings up the issue of Britsch's
theory as it relates to children's art education. In an article in *Journal of*

Aesthetics and Art Criticism, Andersen reported that Britsch's widow claimed that her husband had been "diverted" into art education because he had some insurmountable block in writing about his "pure science of art" (Andersen, 1962, p. 401). Richard Munson speculated that "the static linear structure of Kornmann's theory of art education, as developed from the Britsch theory, is perhaps not the most satisfactory interpretation that could be attributed to Britsch's original theory of art" (Munson, 1971, p. 14). Munson's explanation of Britsch remains the most helpful for a non German-reading audience:

> Britsch contends that the individual and historical style, as subject to artistic laws of change, go through the following transformation: from the simple to the complex, from outer to inner form, from static to moving forms, and from homogeneous to heterogeneous structure.
>
> This is the basis of the Britsch theory of the visual arts. That such a similar and parallel process exists in the artistic development of a child becomes the basis for the application of the theory to art education. As he stated it: similar mental recurrence occurs in the artistic development of the child. He therefore established guidelines for furthering the advancing of the child toward the predicted later stages. Kornmann seems to have interpreted this into developmental stages that made the theory more applicable to art education. (Munson, 1971, p. 10)

Apparently Munson felt that Kornmann's extrapolation of an art education theory from the art theory of Britsch involved some arbitrary deductions. The notion of artistic *law,* the predicting of the artistic expressions of the child, the establishing of guidelines to further advancement to later stages led, according to Helmut Lehmann-Haupt, in *Art Under a Dictatorship* (1954), to the Britsch theory's being manipulated under the National Socialist regime to justify an authoritarian method. Except that *descriptive* was changed to *prescriptive*, it is not clear how these developmental categories made possible a rigid insistence on step by lockstep procedures.

Lehmann-Haupt claimed this manipulation of description into iron-clad requirements is illustrated in his book's reproductions of children's work. One of these, however, is certainly problematical (Lehmann-Haupt, 1954 p. 174). It is a drawing (apparently in pen and ink) with a central panel showing apple picking around a very symmetrical tree which is exactly centered and serves as a dominant form holding together other, subordinate elements. A panel at the left shows two scenes, with apple peeling above and apple cooking below. A right-hand panel shows a stack of preserved fruit in what appear to be jars, with more on shelves. A grandmotherly figure stands to one side, a somewhat oddly buttocked military-looking youth (he is shorter than the old lady) stands on the other. Beneath all this is writing, which includes "1935." Except for the steatopygic cadet, it appears very innocuous--in fact, very much like those appealing artistic efforts of retarded inmates of a hospital illustrating *The Unfolding of Artistic Activity.*

Both the art work done by children in Nazi Germany and the work produced

in an American clinical setting under Schaefer-Simmern's guidance could be described in Lehmann-Haupt's words: "The drawings are always carefully and diligently worked out and they are finished down to the last detail. Every fencepost, every window pane, every brick in a wall or tile on a roof, every pine needle on every branch of every tree is set down" (Lehmann-Haupt, 1954, p. 173).

Lehmann-Haupt lumps this illustration with the others as an example of a tragic document of Nazism's abuse of education (p. 173), but it should be noted that Lehmann-Haupt produced this book in the chilly years of post-World War II and the cold war and was all too willing to equate Nazi practices with Soviet totalitarianism. Kraus says of the uses of Britsch's theory during this period merely that its "reference to folk art...allowed the influence of Britsch to continue throughout the National Socialist era" (Kraus, 1968, p. 53). What results for the reader is confusion. Without a firsthand study of Britsch's writing what evaluation can we make? Yet, decisions for practice in visual art education have been made on the basis of such unexamined information.

Schaefer-Simmern's description of his methods in *The Unfolding of Artistic Activity* seems the opposite of the totalitarian. In each of his case studies a student (or client, if you will) selects a subject of interest. Usually she or he draws the thing of interest. After doing a line drawing, the subject is then done in silhouette. The teacher leads the student to carefully inspect the image. Gradually a refined image is developed, allegedly through self-criticism on the part of the maker. The self-criticism is based on the inborn aesthetic sensibilities posited by the Britsch theory.

Surely no one would link Schaefer-Simmern's approach with totalitarian methods. Still, there is no getting around the similarity of Lehmann-Haupt's example and a number of drawings in Schaefer-Simmern's book, many of which have a "Pennsylvania Dutch" look. Is this folk art-like drawing used in illustrating Lehmann-Haupt's book the result of Britsch's theory, the result of National Socialist dictates, or some other cause-effect variable? One obvious deduction is that Lehmann-Haupt allowed his honest horror toward all things Nazi to cloud his view of evidence and that his examples actually reflect German folk art far more than any political influence, or even that of Britsch's theory. Still, that leaves a puzzle about why Americans taught by Schaefer-Simmern should have produced works that look like German folk art. Was this the end result of Britsch's theory? (To be fair, it should be mentioned that Schaefer-Simmern's book includes reproductions of other work that are not at all Pennsylvania Dutch in appearance.) Or was it the result of some unregarded-- perhaps even to Schaefer-Simmern himself--practice in teaching?

Readers not having access to Britsch's original writings are quite unable to evaluate Schaefer-Simmern's claim to be putting the Britsch theory into practice. Interesting as Schaefer-Simmern's book is, it is difficult to use it to form any generalizations related to Britsch's theory. The illustrations seem evidence of great success in teaching, especially considering the subjects involved in the

experiments (including the severely retarded), but was that success due to theory or the teaching of a supportive, warm, and magnetic person? Perhaps the questions Howard Gardner raised about Schaefer-Simmern in *Artful Scribbles* (1980) might better have been addressed to Gustaf Britsch:

Does he really feel that the resemblances in surface features of works of art produced in millennia past in entirely different cultural settings must necessarily reflect the same factors as those produced by students today...? Is it not equally parsimonious to assume that apparent similarities may reflect the fact that *any* set of works must have certain properties in common, rather than assert a "preset harmony" between the hands, eyes, and minds of artists everywhere? (p. 258)

Schaefer-Simmern provided an invaluable first step in approaching Britsch, by making a translation of Conrad Fiedler's *On Judging Works of Visual Art* (Fiedler, 1876; First English-language version 1949). Both Wayne Andersen (1962, p. 395) and Munson (1971, p. 7) discuss Britsch's use of Fiedler's theories and his indebtedness to those theories. It is worth pointing out that, writing in 1876, Fiedler made such comments as "interest in art begins only at the moment when interest in literary content vanishes." (Fiedler, 1949, p. 11) and "man can attain the mental mastery of the world not only by the creation of concepts but also by the creation of visual conceptions" (p. 40). Schaefer-Simmern claimed, "To everyone who would gain an understanding of the mental laws underlying the creation of works of visual art [Fiedler's] writings are of fundamental significance. Unfortunately, most of them are not translated into the English language" (In Fiedler 1949, pp. xix and xx). Of the works by Fiedler that Schaefer-Simmern then listed *Moderner Naturalismus und Künstlerische Wahrheit (Modern Naturalism and Artistic Truth)* and *Uber den Ursprung der Künstlerischen Thätigkeit (On the Origin of Artistic Activity)* seem to suggest the greatest possibilities for being foundations for Britsch's theories. Apparently Fiedler was one of those persons, found in many countries at about the time nineteenth-century academic painting had worn thin, who sought out an alternative approach to art. They developed the foundations of formalism, the rationale for modernist anti-realistic art.

Raymond Berta (1993) has written a very thorough study of Schaefer-Simmern and his career. Of special note is the account of the conflict between Schaefer-Simmern and the painting teachers at the University of California at Berkeley. Schaefer-Simmern could not accept their abstract expressionist notions because their work seemed to lack formal control--they did not fit his Britsch theory. The studio-based teachers could not tolerate Schaefer-Simmern's theories or interference with "their" students. Schaefer-Simmern saw abstract expressionism as an unaesthetic false step. Abstract expressionists saw Schaefer-Simmern's insistence on representation, no matter how much his theory spurned *realistic* representation, as an intolerable rejection of their insistence on the totally nonrepresentational as a tenet of artistic truth. Schaefer-Simmern's insist-

ence on carefully developed forms refuted their spontaneous action theories. The abstract expressionists denied any roots in art history. Schaefer-Simmern insisted that laws of artistic growth, in a hierarchal sequence, were revealed in history. Given the artists' emphasis on the primitive and intuitive, it might have been expected that the teachers' self-expression backgrounds and teaching beliefs in this era would have endeared them to the artists. Schaefer-Simmern, however, appeared to be a believer in an alien system, based on universal laws beyond the individual freedom the abstract expressionists embraced, and calling for a precision, clarity of form, and conscious choice at odds with the spontaneous, unconscious automatism affected by many of Berkeley's studio faculty. The episode not only puts Schaefer-Simmern in the light of a rigid zealot, but shows the studio teachers to have been provincial, intolerant, and grossly undemocratic egoists. The division between the art world and art education could not have been more sharply exemplified. (I will discuss this further in chapter 11.)

LOWENFELD'S SOURCES OF INFLUENCE: BRITSCH AND OTHERS

Viktor Lowenfeld's *Creative and Mental Growth* (1947, 1st ed.) was the most important textbook in American art education for decades. Lowenfeld, in this book, made two highly approving references to Gustaf Britsch (1957, 3rd ed. pp. 65 and 128). The first reference used a quotation to illustrate one of Britsch's basic theories, the differentiation of an area into visually meaningful and meaningless space. As Rudolf Arnheim pointed out, Britsch "formulated the earliest condition of visual thinking as follows: 'An intended spot is detached from a nonintended environment by means of a boundary'" (Arnheim, 1969, p. 284). The second Lowenfeld reference mentions Britsch's "excellent book." The tone of the two Lowenfeld references suggests at least enthusiasm for Britsch on Lowenfeld's part and naturally leads to wondering about what the relationship Britsch's developmental theories might have had to those of Lowenfeld.

Lowenfeld became such an "American" art educator, dominating school visual arts education theory for the 1950s, that it is easy to forget that he began his publishing in the German language. His book on the sculpture of the blind, in collaboration with Ludwig Münz, was never translated (Saunders, 1960, p. 6), despite the growth of advocacy in recent years in issues related to the education of the handicapped. It is also easy to forget that *The Nature of Creative Activity* is a translation of a manuscript Lowenfeld titled *Vom Wesen des Gestaltens* (Lowenfeld, 1951, p. 4). Michael (1981, p. 19) listed *Die Eststehung der Plastik* a work not previously cited even in A. P. Simons's *Viktor Lowenfeld: Biography of Ideas* (1968). However, this seems to be identical with Part 2 of *Plastische Arbeiten Blinder* (1934, pp. 105-115), which was translated in the Simons study of Lowenfeld's theories. Because Americans lack knowledge of Lowenfeld's earliest expositions of his theories, it is difficult to judge whether his thought

changed over the years as he underwent many drastic changes in his life.

One work that Lowenfeld must have been fully aware of, but which is not referred to in *Creative and Mental Growth* where it would seem to be an appropriate reference if only for notes of confirmation or disagreement, is the monumental 1905 study of children's drawing development by Georg Kerschensteiner, *Die Entwicklung der Zeicherischen Begabung* (roughly, *The Development of Drawing Ability*.) Why this analysis of perhaps 300,000 pieces of work by Munich schoolchildren has not been translated is unfathomable.[1] Helga Eng's *The Psychology of Children's Drawings* (1931) contains a quotation about the development of spatial representation from this mammoth work (pp. 154-155) and *Understanding Children's Art for Better Teaching* (Lark-Horovitz, Lewis, and Luca, 1967) includes illustrations drawn from it. Wilhelm Viola (1944) thought Kerschensteiner "progressive" in art education and described Kerschensteiner's work as that of a great pioneer in the study of child art (pp. 14-15). To grasp the scale of his research, compare, for example, the fact that Carrado Ricci's 1887 *L'Arte dei Bambini* had been based on 1,250 examples (Barnes, 1895).

Page after page in Kerschensteiner's book is devoted to reproductions of drawings by children about specific themes. For example, snowball fights by children from the earliest representational stages through the teenage years are included. Decorative works (Easter eggs, plates, etc.) are also reproduced in color.

N. R. Smith (1983) pointed out one of the outrageously mistaken areas of theory and practice arising from American ignorance of Kerschensteiner's work and secondary sources' misreading of his book. Following a statement by Eng, N. R. Smith tells us, it was repeated for many years that young children did not draw from observation. Kerschensteiner was cited as a source by Eng, but in fact Kerschensteiner had said no such thing. His numbers had been grossly misinterpreted. What Kerschensteiner had said was that a few, a very few, children did not draw from models. Following Eng's interpretation, art teachers were taught for decades that children were not interested in drawing from models before the gang age. Thus for decades the concept of representationalism or imitationalism was not introduced in the classroom for several years at the least, perhaps not until late elementary or even middle school.

Herbert Read seemed to find something distasteful about Kerschensteiner's opus. In *Education Through Art* (1943) he was critical of Kerschensteiner's giving portentous significance to the word "schema," claiming the term had been taken from James Sully's work, where it had been used with modest intention (p. 120). Perhaps even the cosmopolitan Read, in 1943, was infected with a certain Germanophobia. Also, considering Read's general approach, he would hardly be pleased with Kerschensteiner's doubts about the reality of moral enoblement brought about through art (D. Simons, 1966, p. 77). Kerschensteiner had a concept of social education that involved teaching about the duty of the citizen to the state (or The State, as it might come out in the German language, which tends to reify), which in the hindsight of history may

help explain an Englishman's aversion to Kerschensteiner's ideas in the midst of World War II. Even in his own day and country, Kerschensteiner attracted a lot of adverse criticisms to his ideas about education (D. Simons, 1966, p. 79).

Kerschensteiner denied that children's art was ipso facto expressive, another deduction hardly compatible with Read's message. However, a present-day analysis of Kerschensteiner's book and a reconsideration of the rhetoric of the self-expression advocates, combined with study of the findings of Brent and Marjorie Wilson (see 1982), may lead us to doubt the given nature of expressiveness in children's art. Expressiveness in art is probably just as much a matter of learning visual cues as naturalistic representation is. In Kerschensteiner's case, an examination of the plates in his book reveals that the author thought all art development was toward mastering realistic drawing skills, if somewhat modified by sentimental middle-class German tastes. Kerschensteiner was not prepared to read exaggerations of size or uses of omissions as expressive cues, as Lowenfeld was to do later (Lowenfeld, 1939). All studies of children's artistic development, of course, are plagued by the prevailing artistic tastes and art theories the investigator accepts, sometimes without examination or even the realization that the ideas of the moment are neither forever or for everywhere.

Kerschensteiner believed that the pleasure children derived from art activity was a major justification for it. It satisfied the child's inclination toward productive self-activity (a la Froebel). In 1966 Dianne Simons said "[Kerschensteiner in] 1903 as chairman of the conference on art education, held in Weimar...quoted the aims of art teaching as being to increase the pupil's power of self-expression, and...to bring the child to appreciate and enjoy art, the last-mentioned being a very difficult task to accomplish" (p. 78).

As superintendent of the Munich schools, Kerschensteiner was a theoretician and researcher with unique opportunities. He happily discarded in practice what he disapproved of--geometric drawing, for example in the Schmid mode, which had been a pestiferous feature of art classes in his own school days (Ashwin, 1981). He advocated memory drawing to strengthen powers of observation, a needful skill for the good citizen. Objects would be shown, discussed, and then hidden while the student drew what she or he recalled about the appearance of the object.

HAMBURG: ART EDUCATION AND EDUCATIONAL REFORM

The memory method may have been introduced to Kerschensteiner by Johannes Ehlers, one of three remarkable art educators working in Hamburg in the late nineteenth century and early twentieth century. Ehlers claimed to have derived his ideas from a work published in Germany in 1899 under the title of *Neue Wege zue Kunstlerishen Erziehung den Jugend: Zeichnen-Handfertigkeit*

Naturstudium-Kunst, which had been written by an American, J. Liberty Tadd, director of the Philadelphia Public School of Industrial Art, and originally titled *New Methods in Education: Art, Real Manual Training, Nature Study* in 1899 (Fishman, 1976, p. 23). David Baker (1984) has published a brief study of Tadd's work, claiming it had an immediate influence in Hamburg and later became known to the founders of the Bauhaus. Although an art education movement centered in Hamburg at the turn of the century could hardly have had a direct influence on Lowenfeld, Schaefer-Simmern, or most other immigrant art educators of the 1930s and 1940s, most of whom were born around 1900, the art educators of that city provided a model for serious research and study about art education for children in Germany.

The late nineteenth century heard the cry that German schools had too long emphasized rote learning, the head-cramming theory of education, and a complete emphasis on intellectual, verbal training to the exclusion of values, or feelings, or anything truly humanistic (Hearnden, 1976, pp. 28-29). *Rembrandt als Erzieher*, by Julius Langbehn, (1891, 33rd. ed.) began the attack on the educational establishment. This rather incoherent book claimed Rembrandt as the protoypical "German" artist whose work could teach true German spirit. According to *The Abuse of Learning* (Lilge, 1948), the book had undergone sixty editions by 1925, but possessed "no merit of any kind" (p. 112). Though Frederic Lilge commented that "standard German encyclopedias in pre-Hitler editions describe Langbehn as the sincere prophet of a new inwardness and idealism" (p. 114), he found the book stained with anti-Semitism.[2] From our vantage point, Langbehn's ecstatic prophecies about a "great child" who would arise to lead the true Germans, seems a twisted variation on Isaiah ("A little child shall lead them") and an ominous foreshadowing of the antirationalism of Nazi rhetoric.

The three Hamburg educators, Johannes Ehlers, Karl Götze, and Alfred Lichtwark, while also trying to tip German education away from what they too felt to be excessive emphasis on the verbal, had more constructive aims and programs. Lichtwark, according to MacDonald (1970), had noted certain similarities between child art and what was called, in those more self-assured days, primitive, or even "savage" art. As director of the Hamburg Art Museum Lichtwark felt that intimate acquaintance with art could be an educational force. He believed in the creation of a total artistic environment, starting in the nursery and continuing into the schools. He enjoyed lecturing to groups of women in an age that belittled educating women, pointing out that women could provide for the artistically informed childhood he envisioned (Fishman, 1976, p. 16).

The eminent American photographer A. L. Coburn described Lichtwark as "the first official to collect photographs as pictures in their own right" (1966, p. 22). Besides photography, Lichtwark saw utilitarian objects as well as fine art deserving aesthetic appreciation, a view partly related to the elevation of folklore to a level worthy of scholarship (as in the work of the Brothers Grimm) and partly to the influence of William Morris. Lichtwark admired the English, and

Hamburg was a trade center especially open to foreign influence.

Lichtwark invited teachers to study art within his own museum, where he also lectured, and urged educational use of the municipal museum that his mentor, Max Brinckmann, had formed. Both these museums included "applied art" objects. We are told his lectures were characterized by their dynamic quality and their avoidance of emphasis on history and narrative at the expense of aesthetic response--an uncommon approach, circa 1900, but another sign of the rise of modernism (Fishman, 1976). We can only regret that Lichtwark's writings are unavailable in English. A brief look into the *National Union Catalog* shows that his other publications ranged from books on photography to flower arranging.

In 1898 Lichtwark's colleague Karl Götze published *Das Kind als Künstler*, which Fishman (1976) described as emphasizing creative activity and placing little emphasis on technical achievement in drawing. The teacher was not to criticize drawing, "artistic permissiveness" being the ideal (Fishman, 1976). Both *A Cyclopedia of Education* (Monroe, 1911) and *The Pedagogical Seminary* (Monroe, 1899) have references to the book.

A teachers' association, of which [Götze] is the secretary, invited students of childhood in different countries to send for exhibition purposes sets of children's spontaneous drawings. The numerous inductive studies by [the Americans] Lukens, Barnes...Mrs. Maitland, and others were summarized and discussed, as were the spontaneous drawings submitted by the children in kindergartens at Brussels and in Japan; in the elementary schools of Hamburg and West Springfield, Massachusetts, and from the American Indians, and the Hovas (in Madagascar). (Monroe, 1899, p. 264)

That a 1898 book could be called *The Child as Artist* sounds intriguing; the description of its contents adds to one's wonder. The book, of course, was an outstanding example of the child study work which so much influenced early twentieth-century art education and continued for a long time to influence the developmental emphasis typical of Americans' approach to teaching art in the public schools during the Progressive Education era.

Karl Götze had founded the Teachers' Union for Art Education (Fishman, 1976), which was to hold three national art conventions and an 1898 exhibition of children's work for which Götze wrote *The Child as Artist*. Later, Götze's praise of the work done by Cizek's Viennese Juvenile Class students seems to have moved Viennese authorities to provide for Cizek's famous weekend classes at the School of Applied Arts (Viola, 1944).

Of all these pre-Lowenfeld or pre-Schaefer-Simmern "Germanic" art educators, Franz Cizek has probably received the most English-language coverage. I shall have much to say about Cizek in other chapters since I believe this famous art educator is badly interpreted in English-language literature, and the misinterpretations led to American practices not necessarily consistent with Cizek's own notions. Besides being the subject of articles by various hands,

Cizek had an English-language champion in Wilhelm Viola, who wrote the beautifully illustrated *Child Art and Franz Cizek* (1936) and the somewhat grayer *Child Art* (1944). The latter book included summaries of Cizek lessons. Even in more recent years an occasional article draws attention to Cizek's work (Anderson, 1969; Duncum, 1982; Smith, 1985a). Rochowanski's charming *Die Wiener Jugendkunst* (1946) with its illustrations of not so well-known three-dimensional work from Cizek classes would be interesting to have translated. A book by Cizek thought by some (for example, Reynolds, 1933) to be scheduled for publication by Yale in 1934 never materialized. We are left only with *Children's Coloured Paper Work* (1927) from Cizek's own pen, but it is little more than a portfolio with a brief introduction. In 1985 the Museum of the City of Vienna presented a Cizek exhibition and published the exhibition catalog, *Franz Cizek, Pioneer der Kunsterziehung* (Historisches Museum der Stadt wien, 1985). This was illustrated by work from the children's class and work by college-age students at the School of Applied Art.

Cizek claimed to have guided the child to grow according to "eternal innate laws" (Viola, 1944, p. 45). These laws, which Cizek said he had found in practice, he acknowledged had been evolved into theory by Britsch and Kornmann (Viola, 1944, p. 15). A re-reading of *Education Through Art* (1943), with its review of pre-1943 studies on children's drawings, so many of them Germanic, or of Viola's *Child Art* (1944), with its pages of references to German-language studies (the titles somewhat misleadingly listed in English without complete citation) supports my contention that a vast area of foundational importance to art education has been hidden from Americans who cannot read German. Much German language material that served as the basis of art education publications in the United States remains to be translated, and only if it is will Americans be able to build a complete picture of the foundations on which American art education stands. This is the material on which Lowenfeld, Schaefer-Simmern, and Rudolf Arnheim built. Lowenfeld, Schaefer-Simmern, and Arnheim have been the foundations for many in two generations of American art educators. In areas involving the education of the handicapped, theories of child development, theories about cognitive and aesthetic development, matters related to many areas of history of art education and the history of education, the barrier of language keeps us from materials that would enlighten the field of visual arts education and enable us to critically analyze the assumptions of leaders in the field.

At least some of the apparent mystery of the disconnection between the American art world and the art education practices in American schools could be clarified if these materials were accessible. However, it is also sadly true that American art teachers are frequently unaware that many of their own practices are based on unquestioned notions derived from theoretical sources unknown to them, sources they might find strange, even of doubtful validity. Are notions of how to teach art derived from research carried out in a culture very different from one's own necessarily appropriate? The anti-authoritarianism of the Froebel heritage (or at least late nineteenth-century interpretation of that heritage), for

example, might seem out of place in a nation that has had a tradition of anti-authortarianism since the earliest days of the white intrusion in North America. Or, an examination of Froebel's "gifts" and the very structured directions that go with them might suggest the interpretations of Froebel given in American education literature were *misinterpretations*, and the kindergarten movement was built on unexamined conceptual sandboxes.

This chapter has stressed Germanic foundations and American ignorance of them. Art educators' knowledge of the assumptions behind many of their practices-whatever the origin of these assumptions-remains weak.

NOTES

1. There seems to be some confusion about Kerschensteiner's total collection. Simons (1966, p. 77) put the total of works in it at a half million; Fishman (1976, p. 32) puts the total at 6 million. The latter seems unlikely, even with "busy little hands," as Fishman puts it. Viola stated that 58,000 Munich schoolchildren did 300,000 drawings and pictures (1944, pp. 14-15). Since Viola's account is the most conservative and most directly grounded in circumstances, it seems the most likely.

2. Lilge gives the title as *Der Rembrandtdeutsche*. Since the book was published anonymously, its author was nicknamed der Rembrandtdeutsche. Lilge's style is very emotional, but his estimation of this book probably is a convincing argument that Langbehn's book is one Germanic work which can safely remain untranslated.

4

Franz Cizek and the Elusiveness of Historical Knowledge

Because Franz Cizek (1865-1946) is always discussed in American and English history of art education texts and since there has been a widespread resurgence of interest in Austrian culture (outside art education) and in the turn-of-the-century Vienna milieu, a historical interest that might be dated to about the 1980 publication of Carl Schorske's *Fin-de-Siècle Vienna*, it is important to look closely at Cizek. During the 1920s and 1930s he was a special hero of art educators endorsing creative or self-expression rhetoric. The undoubted beauty of the published work from his classes provided glamor and apparent documentation to affirm the possibility of the anti-academic practice many of the advocates of self-expression urged. Since approximately 1960, however, and despite the growing awareness and appreciation of Austrian early modernism and Cizek's association with it, Cizek's name has become attached to practices now in bad odor. I contend that we know a lot less about Cizek than we think and that his role in art education history is problematic because of our ignorance of our ignorance. Some of the very things for which we praise or condemn Cizek may not have been his actual practice. To know that one of the founders of the field of twentieth-century art education is Cizek; to know that Lowenfeld, America's most influential art educator at midcentury, studied with him; and yet not to know what Cizek did or did not accomplish and why he succeeded or failed is not to know the true history or the basis of cherished myths about art in American schooling. In this chapter I will examine the historical record to explore Cizek's real identity and accomplishment as an art educator. In so doing I will try to illustrate the difficulty of assessing his work.

THE PATRIARCH

Franz Cizek has been called "the 'father' of creative art teaching" (J. P. Anderson, 1969, p. 29) and yet condemned for bringing a false notion of creative

expression in children's art work to education (Duncum, 1982). He was described by his advocate, Francesca Mary Wilson (1921b), as giving exact, lawlike directions, though labeled by his critic, Thomas Munro (1929b), as a free-expression teacher who mistakenly thought he allowed the child to reveal a supposed inner creative self without imposition of teaching. Because Cizek never published a book that addressed the issue of practice in the sense of building an art program, such miscellaneous and sometimes contradictory statements are the usual sources of information about him and his work. The two lengthiest books about Cizek and his methods, both by Viola (1936, 1944), seem riddled with inner contradictions. All sources acknowledge that Cizek was one of the wellsprings of contemporary art education, but assign his contribution widely ranging value. Contradictions in art teaching literature demonstrate that Cizek is not the well-known quantity that his fame might imply.

Other sources of information about Cizek suggest an alternative method for learning about him other than exclusive dependence on published literature. In 1976, Efland used his mother-in-law's recollections of Cizek to try to establish what Cizek's practice as a teacher had been. She had been a student of Cizek and described Cizek methods that Efland felt were evidence of rigorous and demanding design training rather than laissez-faire methods (Efland, 1976a). Another Cizek student, Nora Zweybruck, wrote a brief article about her memories of Cizek (1953) suggesting he was a laissez-faire teacher of children, but, inconsistently enough, one whose students' work over the years revealed their teacher's changing interests and emphases. These statements suggest that research might turn to student recollections to determine what Cizek said and did, not because these provide irrefutable evidence, but because they offer a greater range of material on which to base historical analysis. From these, analysis and comparison might provide the basis for understanding what Cizek's contribution to art education really was. Although fraught with difficulties related to lapse of time, language differences, and the disruptive effects of World War II, perhaps a study of students' memories of Cizek would provide a better record of what he did than accounts by occasional visitors, such as Munro. After all, students benefited or suffered from consequences of his practices.

Munro (1929b) implied that no prominent adult artist had come from among Cizek's Juvenile Class students and that this was proof the free-expression method was fruitless. One way of finding Cizek's former students, however, is to identify Austrian designers who might have been about seven to fifteen, and might have participated in the Juvenile Class during the 1920s and 1930s. Nora Zweybruck is one example. I have interviewed another former Cizek student who has attained some prominence in design work, Ruth Kalmar Wilson. Besides her fabric design work, Wilson taught art education at Tufts University and at the Boston Museum of Fine Arts and maintained an interest in Cizek's work. The following is based on a transcript of an interview conducted in October of 1983.

MEMORIES OF CIZEK

Smith: Would you tell something about yourself?

Wilson: Before my marriage my name was Kalmar. I was a student of Professor Cizek from 1926 to 1930 in the Juvenile Class.

Smith: Did you know that Cizek also taught in the College of Applied Arts, or Kunstgewerbeschule, as it was called then?

Wilson: I was not aware at that time [while I was in the Juvenile Class] that Professor Cizek taught in the Kunstgewerbeschule itself. You know how children are. He was just our professor. The class was a part of the School, but it was physically located some half mile away, and the only thing going on in this [building], at this time (Saturday afternoons) was this art class. When I was older, I became aware that Professor Cizek taught classes at the Kunstgewerbeschule. He lived near us, and occasionally we would see him in the street.

 Later I attended the Kunstgewerbeschule in a class of painting and decorative design which turned out to be more graphics than I had anticipated, but I was open to it and liked the school very much. I was very happy there.

Smith: According to Schorske (1980) and Lowenfeld,[1] Cizek was in charge of art teacher education at the Kunstgewerbeschule and Munro [1929b] mentioned that he taught a controversial design course for college age students. You mentioned that you went on from the Juvenile Class to study art, and yet Munro, after observing Cizek, implied that Cizek's methods would never lead to the development of artists. Would you tell a little about your career and what you think about Munro's notions?

Wilson: I've done quite a bit of book illustrating, but I've done many different things, including crafts. Right after the Second World War, I made a series of designs for figures which were turned out of wood. I've done advertising art, letterheads, wrapping papers, and illustrations. For four years, I had my own publishing firm for children's books.

 I know of a number of Cizek's students who were successful artists. All of Cizek's students had a basic sense of art and creativity, design basics without its being design, implanted by the things we saw in his class around the walls. That was as much of the teaching as the class itself. The teaching was really minimal, but the surroundings were wonderful.

Smith: The Juvenile Class is the activity with which Cizek is most closely associated. Would you describe this class?

Wilson: We met in this class for two hours. It was from four to six. There was another class before us from two to four. Those were the small ones, from three and a half to seven years, I would say. Our group was from eight to fourteen.

Smith: One person [Eckford, 1933a] who wrote about Cizek mentioned a Sunday class.

Wilson: I never heard there was a class on Sundays, and I doubt it, because Austria is a Catholic country, and everything is totally closed on Sundays.

Smith: I guess that's an example of how uncertain our information about Cizek is as gathered from English-language publications.

Wilson: There were about fifty students in my class, and it's true that no outstanding artist like Kokoschka[2] did come from those classes--at least we don't know of any. Cizek's class was not directed at all to creating artists but, rather, to unfolding of the artistic personality of each individual. The classes were really to show creative and latent talent in the growing child--as a matter of fact, in the small child. Cizek was the first person to have done that so completely and exhaustively.

Smith: How did a child get to become a Juvenile Class student? One writer (Matson, 1923) has said that hundreds of children were turned away who wanted to join the Cizek class.

Wilson: Every once in a while something was printed in the paper about Cizek's class, and anyone could apply; hundreds did apply, and it was very difficult to get in. I must admit that I did not enter the class on my own merits. My father had been a student of Cizek when he was a boy, when Cizek was teaching secondary school. Cizek recognized our name, and he accepted my sister and myself. Ordinarily, it was difficult to get into Cizek's class. You had to submit work that he would look through, and, with Cizek's knowledge, he could see if there was potential there or not. If children had already begun to imitate work they had seen, he would not bother with them.

Smith: Lowenfeld said that Cizek would brusquely dismiss a child from the class who did not, or could not, work to the standard he demanded.

Wilson: I was never aware that any child, once admitted to the class, was asked to leave. It might have happened, but I was never aware of it.

Smith: Lowenfeld also said that both he and Viola were Cizek assistants or student teachers in the middle 1920s.

Wilson: There were assistants in the class. Were these persons undergoing teacher training? I cannot say. I think they were persons who worked with him. I can only remember that there were oceans of foreign people, like Americans, who came and sat in on classes and went and talked to students, and made notes and so forth. I could never figure out what in the world these people were doing! I was mystified. I never met Lowenfeld. If he was an assistant in the 1924-1926 period, I missed him. My time as a student began in 1926. Everything else in the class was so much more important than the assistants.

Smith: You said before that "the teaching was minimal." Would you explain

Wilson: this a little further?
When Cizek, himself, came around, the procedure was that you were encouraged to draw something or he would tell a story or ask some questions or say "draw whatever you want." That was always in a small format. Then you would draw and make several drawings. Then when Cizek came through after about half an hour, he would go around and look at what people did. When he found something he liked, he asked us to make it big.

What was used to work on was white wrapping paper stretched over frames. There were squares three feet by three feet or rectangles three feet by four feet or more.

Everybody wanted to be able to make one of their drawings big and painted. So if Cizek liked a drawing, he would tell you to go and see if the man who prepared the stretched paper would make you a frame or if he had one ready the right size. Then you were to transfer your drawing, not by any other means than by looking and doing it big. Then you got your paints and you could go ahead and paint. Of course, this went on all over the class. You could always see other people's work and how it progressed and how much paint they took. Professor Cizek would never point out anything as a standard; when the pictures were finished they were put up on the wall. It was like the Sistine Chapel; from top to bottom it was nothing but these paintings.

Smith: Were the paintings all by your class?

Wilson: The pictures on the wall were not all current pictures. There were some from past years, and this was an incredible stimulus. This was how the classes went, from one big painting to another. These paintings took several Saturdays to complete. If one got stuck, Professor Cizek would point out what a solution might be, but, of course, he never showed anything himself. Also, one would see other students' work and could talk over problems with other students. There was, however, not much getting up and going around. There were too many people to be able to move around much. The assistants, by the way, really only assisted and did not do any teaching. The assistant only helped with things like stretching the paper, giving out materials, etc.

We did other things than painting. I did not do needlework, but I did other things. The son of Barlach was an assistant. He gave me a piece of plaster and asked me to cut a figure out of it. We did linoleum cuts and such things. There was a person in the class who did needlework.

Smith: Wilhelm Viola wrote two books about Cizek that purported to give descriptions of Cizek classes. The second of these [1944] had very lengthy descriptions and many reproductions of student work. Would

you comment on Viola's work?

Wilson: I know the Viola books. I met him, of course. I got Cizek's book on paper cutting only two or three years ago. As a matter of fact, that's what I'm doing now--paper cutting--because I was so stimulated by that book.

I don't feel Viola gives an entirely accurate picture of Cizek. I think he is quite good in what he says but not 100 % correct. As a general feeling, I have to say that the books show the way Viola saw it. But, of course, he knew Cizek very well. You see, he was never in the class as a student and didn't experience it the way a student did.

I do think Cizek's classes must have undergone changes over the years. Cizek would give very exact directions at times, but I also experienced him as not teaching in the conventional way. He had a number of demands. Figures should be big, at least three quarters of the height of the paper. Pencil or charcoal lines had to remain visible; the paint had to be applied very carefully within or around them. Colors were opaque and flat. A quarter inch border line, painted in a color of one's choice was to serve the picture as a natural frame. In comparison to the way kids are let loose in some art classes nowadays, perhaps these seem like restrictions. I never felt it that way, and I never heard anyone else complain.

We must not forget that the Sezession [Austrian version of Art Nouveau] was still very much evident in arts and crafts, especially through the *Wiener Werkstätte*, as were the influences of painters like Klimt, Schiele, and early Kokoschka. Even though we were never shown any work by these artists, their style had invaded everyday life in architecture, home furnishings, and crafts. Being encouraged to adhere to some of the features of this contemporary art gave us-even if only unconsciously-the feeling of growing up with the avant-garde. And avant-garde it was.

There was a lot of indirect and subtle teaching. This is what Cizek's secret was. Sometimes he would say to the child "you do it this way" and "no, you only put it flat and you don't do this" and you would think it is totally interfering with the freedom of the child...he could say such things that would give the child more freedom. Of course, even the way he spoke made a difference. He often used the third person. He used expressions so old-fashioned they sounded like the seventeenth century. He addressed the child formally. As soon as the child was halfway big, he no longer used the familiar *Du*. He would say *Sie*. This made a huge impression on me. He was the first person who addressed me as *Sie*. All of a sudden, I was counted on as equal, a respected person. This is already a kind of teaching. Then the way he could make a joke-he had a fine sense of humor that children loved. They were never just silly, pointless

jokes. One day I said, "Professor, I cannot find my big painting." He looked up with his bushy eyebrows and said, "Oh, I saw a man with the painting under his arm walking down the street." Professor Cizek would say such a thing. Then you knew you had to ask the assistant or look for it yourself.

Smith: An American art teacher, Eugenia Eckford (1933b), wrote that Cizek spoke to the child as if the child were as much an artist as he was.

Wilson: He did speak to the child as one artist to another. That is what I mean when I refer to "respect." This is the tone.

Smith: Was Cizek an artist?

Wilson: One time I saw one of his paintings. It was a little water color of a jar. It was such a masterpiece. My father said he knew more of Cizek's art work and he thought it was absolutely wonderful. I don't know of any place in Austria where his own art work can be publicly seen, but I believe the Museum fur Angewandte Kunst would have some.

Smith: Several writers mentioned that Cizek worked on a book about children's art (Reynolds, 1933; Todd, 1933 and Viola, 1944). Do you know about the fate of that work?

Wilson: Cizek was working on a book for some years that he did not finish. Materials were supposed to be in the Archives of the City of Vienna, but I don't believe they are. The work the children did belongs to the school. These were masses and masses of drawings, and they were all kept. After Cizek's death, the city did not know what to do with these materials. I don't know where these are now, but two years ago they were still in the City Archives.

[The Historical Museum of the City of Vienna displayed part of this collection in 1985 and issued the catalog, *Franz Cizek: Pioneer der Kunsterziehung.*]

Smith: Do you have any concluding reflections about Cizek and his work?

Wilson: There was, in the art work from the Juvenile Class, a Cizek style. You cannot deny it. On the other hand, 50 years from now if we look at what students do now, we may see a similarity of style in their work. Style comes with or becomes apparent with distance in time. Cizek's students' drawings were really very different, one student from another. There were some students who made drawings that were published so frequently you might think that was all there was to the Cizek students. That was not at all true. There were many different ones. When you get into the archives [of the Historical Museum of the City of Vienna], you can see. There were very different things done.

FRANZ CIZEK: PROBLEMS OF INTERPRETATION

Ruth Kalmar Wilson's remarks have touched upon aspects of Cizek's work that have been frequently discussed in American art education literature. She seemed to contradict Efland's (1976a) claims about rigorous design training, and, at the same time, Wilson's eyewitness report appeared to refute Munro's (1929b) claim that Cizek was a free-expression or laissez-faire teacher. She also seemed to dispute the contention that there was too much similarity of style in the work of Cizek's students (Duncum, 1982). Wilson traced this apparent similarity of style to the pervasiveness of certain stylistic elements in Viennese society in the 1920s and 1930s. Note that she claimed there were differences from student to student and blamed erroneous impressions gained from reproductions for "similarity." The concept Wilson implied--the style of a period in history--is difficult and open to debate. Note also that Wilson denied Lowenfeld's claim that Cizek treated some children harshly or cruelly.

Wilson seemed to claim that Cizek was innovative *within the framework of his time and culture*. Perhaps we might see in Cizek a transitional figure, a person struggling to break away from the authoritarian and teacher-centered schooling of his own day, which was characterized by lectures and teacher demonstrations with students in a passive role, toward the use of a more student-centered and discovery-oriented model for art education. This one student interview does not lay to rest the contradictions of our knowledge of Cizek. It led me, however to look again at the existing literature, the source of our supposed knowledge of Cizek, but which I feel has compounded our ignorance of his career and practices.

An interpretation of the meaning of the career of Franz Cizek, must deal with the difficulty of examining the work of a man dead for over half a century, after a career lasting more than forty years in a faraway country and perhaps in a different linquistic and cultural tradition from one's own. Certainly I am not going to claim to solve these problems. Rather, I am going to point out what we need to know or need to look into before we can claim a sound historical understanding of Cizek, his career, and his contribution to American art education.

The beliefs about Cizek's ideas and practices that have proliferated over the years and reported or repeated in art education literature have had consequences in American schooling in art. These ideas associated with Cizek spread beyond the world of professional art teachers and into the world of the middle class--that is, the class with sufficient education and time to care about education and the arts. Even those who do not know the name Cizek have inherited notions derived from the creative expression days and thus base their beliefs on undocumented and unresearched historical phantoms, including ghostlike residues of beliefs about Cizek behaviors.

THE MUNRO REPORT: EXAMINING A SOURCE

To enter into a discussion about Cizek's practices beyond what Ruth Kalmer Wilson described, I am going to look at one of the best-known American criticisms of Cizek written by a person who was very influential in American school art education, aesthetics, criticism, and museum education. I hope this familiar piece will give a framework of manageable proportions, let me point out areas of concern, and provide reference points for further discussion and future research. The article I am going to use is Thomas Munro's article "Franz Cizek and the Free-Expression Method" (1956; originally published October 1925, in the *Journal of the Barnes Foundation* and reprinted in *Art and Education*, 1929). Apparently, Munro felt his own judgment definitive.

Aside from Munro, the authors who wrote the most widely distributed works about Cizek were Francesca Mary Wilson (1921a; 1921b; 1921c; 1945) and the previously cited Wilhelm Viola (1936, 1944). There are many other miscellaneous English-language sources, but perhaps the clearest explanation of why Cizek has been given so much attention can be found in that already mentioned 1969 article by J. P. Anderson in which he stated Cizek was regarded as "the 'father' of creative art teaching" (p. 29). For American art educators the possibility of his having had a strong influence here is suggested by knowledge that he was one of Lowenfeld's teachers (Michael & Morris, 1985; Smith, 1982a). That he and his notions are still of concern is suggested by a 1982 *Art Education* piece about his work entitled "The Origins of Self-Expression: A Case of Self-Deception" (Duncum,1982), and three years later in the same journal appeared "Franz Cizek: The Patriarch" (Smith, 1985a), the basis for the materials I have presented in the first part of this chapter.

Both "The Origins of Self-Expression" and "Franz Cizek: The Patriarch" referred to Munro's article on Cizek and my inspection of the literature on Cizek suggests that it has been often cited; indeed it may be the most often cited study of Cizek in English. Thus Munro's description of Cizek has provided most students of American school art with their information (or misinformation) about the practices and results of the Cizek methods. I also want to use Munro's article as my gate to the past and at the same time as a means to reflect on what I think many reports on Cizek based on Munro have not considered.

Munro did not dismiss Cizek's work out of hand, as some references to his article seem to imply. He claimed in the 1929 reprint of his original article to be found in *Art and Education*, edited by John Dewey, that American schools in 1925 showed a glaring need for what Cizek stood for, "more freedom for the child to look at the world and to experiment in congenial ways of expressing himself in some artistic medium" (1929, p. 311). Munro contrasted the happy, productive atmosphere in the Juvenile Class room to the atmosphere in the old art classes with their dreary copying exercises. Of Cizek as a person Munro wrote, "Cizek himself is a man to command respect: assured, quiet and intent in manner, he strikes one as an intelligent enthusiast, quite confident that the road

he has mapped out is the best one" (Munro, 1929 p. 311).

Munro's major negative reaction to Cizek's work was that he felt Cizek's attempt to shield children from adult art work was both ill-conceived and impossible to actually accomplish. He saw in the children's work too great an influence of one child on another (note R. K. Wilson's evaluation of this), and despite Cizek's belief that he shielded the child from adult work, Munro saw such influences. His listing of the influences he perceived is interesting: "[R]eminiscences of Austrian handicraft...echoes of the romantic colored illustrations in *Jugend*, of Böcklin and Thoma, of newer expressionist grotesqueries that have become a current formula in German exhibitions. Even the striking obviousness of street-posters blurted out here and there" (Munro, 1929, p. 312).

Munro found that "the most original and appealing designs are those of the youngest pupils" and a "teacher" in the classroom told him that older students tended to drop out. He then stated: "After its twenty years of existence no prominent artist could be named who had received his early training at the Cizek school" (Munro, 1929, p. 315). Munro concluded that in his attempt to fight the restrictions of the old school, Cizek had failed to produce a healthy alternative. Munro felt such an alternative should have included introducing children to "a broad study of traditions."

Before I could accept Munro's article as a completely sound historical piece on Cizek, I would need to find answers to some questions it raises in my mind. I repeat them as examples of the historical questions art educators have frequently ignored:

1. How long did Munro observe Cizek?

If he had watched Cizek for long enough to make a judgment of Cizek's practice over, for example, a few weeks, or under circumstances related by Efland (1976a), would he have called Cizek a "free expression" educator? During a conversation with me, a then-Fulbright scholar Wanda Bubriski, working on the summer 1985 Cizek exhibit in Vienna, dismissed Munro's article as "superficial" and questioned whether he had spent more than one day in observation. Bubriski, is an art historian trained in matters of historical evidence, and so, her judgment in this case has weight, if not final authority.

2. Did Munro speak German?

Wanda Bubriski asked me this question because she knew that Cizek did not speak English. An understanding of German and Germanic cultural styles would certainly have aided Munro as an observer. Even if Munro had understood the words, it is difficult to know whether he could have analyzed the situation behind the words. It has been observed more than once that words and behaviors need more than mere translation from Germanic to American cultural settings (Lewin, 1973; Smith, 1982b). Again, would Munro have equated Cizek with the free-expression teachers he knew about in the United States, such as Florence Cane and Margaret Naumburg, if he understood or observed a representative sample of the proceedings of the class?

3. Was all the Cizek student art work as overly similar as Munro maintained, or were there variant and individual styles?

Carefully examining the illustration in Viola's *Child Art and Franz Cizek* (1936), "In the Strange Brave World of Children," a 1923 magazine article by N. H. Matson, or L. W. Rochowanski's *Die Wiener Jugendkunst* (1946), I have had doubts that this often-proclaimed uniformity of style is a fact, although R. K. Wilson (Smith, 1985) admitted with reservations that there may have been a Cizek period style. Recall that she countered that *we* cannot see the style of our day. Of course, Munro contended that he did see a style in the work of the Cizek class of his day, perhaps the geographic separation acting somewhat like a temporal separation--an idea suggested by an historian Gilbert Highet (1954). I suspect in Munro's ability to see sameness and environmental influence and Cizek's inability to see these features there may have been a process involved that I call the originality syndrome. To clarify what I mean I will repeat a reference to the work of an early anthropologist, Ruth Bunzel.

In 1929 Bunzel reported that pueblo potters evidenced behaviors similar to those of artists brought up in Western culture's individualistic tradition. The potters spent sleepless nights trying to create new designs, they had dreams about designs and expressed frustration when they could not actually recreate the mental image, and they were constantly preoccupied with design patterns (p. 51). Bunzel, however, on first looking at these works as a person raised in a different cultural milieu, saw the designs as far more similar than original, as conventionalized, tradition bound, and so forth. Others, including a person who ran a trading post in which the work of many potters was sold, could differentiate one potter's work from another with the greatest accuracy. Constant exposure and a necessary development of skill had brought about this connoiseurlike discernment. If I can use a geographically inappropriate piece of folk wisdom in reference to Pueblo Native Americans, the potters may not have been able to see the forest for the trees. Bunzel's cultural distance allowed her to see the forest, but she failed to distinguish the individualism of the trees.

Perhaps Munro saw forestly and Cizek saw treely (like the manager of the pueblo trading post). In the children's work Munro could see the similarities; Cizek saw the dissimilarities. This is not to say Munro was wrong in seeing influences. Brent and Marjorie Wilson in the last quarter of the twentieth century, following the lead of Gombrich's *Art and Illusion* (1961), have gone quite far in demonstrating that art is derived from art, or whatever imagery a child sees about in her or his environment, not untutored observation or pure inner-generated expressiveness. However, while claiming similarity of style, Munro also claims influences from a number of artists whose works showed great disparities of style.

Having mentioned the name of the Viennese art historian Gombrich, I want to quote a statement he made about the relation of Cizek's class to modern art: "The results he achieved were so spectacular that the originality and charm of the children's work became the envy of trained artists" (1972, p. 488).

Schorske pointed out that a student of Cizek's in the teacher-training course in the Kunstgewerbeschule, Kokoschka, used childlike elements in his early graphic work. This suggests to me that some art historians might study the influence of the Cizek class on adult artists. If this was carried further, to the point that the historian examined the influence of child-art-influenced adults on children in the Juvenile Class, we might get an interesting study indeed.

Implicit in Gombrich's remark is an evaluation that the children's work was regarded as *original*, and by that I assume he meant unlike the work of the professional artists all about them in a city famed for arts activities. Should we put more faith in the historical evaluations of Gombrich or Munro?

Before leaving mention of Gombrich, I note that a passage from another publication is about Cizek and reveals the results of the acceptance of that art educator's notions as dogma:

In contrast to an elder sister who was and is very imaginative and produced very imaginative drawings much admired by my parents, I had taken to copying pictures of animals in a favourite animal book. I was quite proud of my efforts and somewhat mortified when I discovered from the tone of voice in which these drawings were duly "praised" that my parents disapproved of copying. Those were the days of Cizek in Vienna.... As you see, I never got over this grievance. (1979, p. 175)

I have gone a little afield and I want to return to my listing of questions about Munro's report.

4. What was Munro's attitude toward Viennese art of his time?

Munro's phrase "expressionistic grotesqueries that had become a current formula in German exhibitions" causes me to wonder whether there was not some resistance to Viennese art in the United States in the 1920s. Whatever his attitude, Munro does not tell us here, or in his reference to Arnold Böcklin and Hans Thoma, what the children did that showed this influence. Indeed, Munro's listing of many diverse influences shows that the "Cizek style" was not one thing, thus somewhat contradicting his own evaluation. Efland (1990) challenged me on this issue, preferring the more conventional notion that there was a Cizek style.

To be sure, after examining the Viola books, the booklets by F. M. Wilson, the Historical Museum of the City of Vienna catalog for the 1985 Cizek exhibit, and other publications, I have concluded that Munro in a very limited sense was right. Cizek's students had undergone adult influence, but there was no one Cizek style. Even though Cizek's *Children's Coloured Paper Work* (1927) has definite folk art elements, the work in it is not all one style; and no one knows how much or how little control Cizek had in selecting the illustrations. In Viola's *Child Art and Franz Cizek* (1944), there are definite Secessionist elements, including a horror of empty spaces often cited in Gustav Klimt's work, and there are angular treatments of figures traceable to the postSecessionist mannerisms of Egon Schiele and his imitators (e.g., Max Oppenheim).

Not unrelated to question 4 is Munro's judgment that no prominent artist had

come from the ranks of the Juvenile Class. First, of course, Cizek did not intend that his children's class be a training ground for artists (Viola, 1936). Second, Munro did not state what he would regard as a prominent artist, or even what he would include as an artist. That is, would a designer or craft worker be an artist in Munro's definition of the art field? R. K. Wilson claimed that many Austrian designers did come from a Juvenile Class background and at least one of Austria's outstanding art scholars, Christian Nebehay, was a Juvenile Class student. Perhaps we should look to how Austrian art was regarded in America in Munro's day. For example, Sheldon Cheney in 1923 (14th ed., 1966) wrote the following general evaluation of Viennese art: "[I]n the absolute arts--not crafts arts--style and ornament are the last things the modernists want. Vienna can decorate a given surface--canvas, gold, textile, or built wall--more charmingly than any other city in the world. But modern art, of the serious sort, must go *below* the surface or die" (1966, pp. 227-228).

If Munro could be shown to have held a view similar to Cheney's, then how could he have accepted anyone Viennese as an outstanding artist? In his reference to "decorated" walls, did Cheney refer to Klimt's work in the Palais Stoclet and, if he did intend to refer to it, how would that opinion be greeted in an art world that has now inspected Viennese modernism and become able to interpret Klimt as an artist whose work has a multiplicity of levels of meaning beyond "charming" surface? In discussing Lowenfeld as a visual artist, I will return to the theme of Americans' lack of knowledge of Viennese modernism. Besides, I would ask art educators if the development of outstanding artists is the proper criterion for the success or failure of a children's class, free expression or not. With production of outstanding artists as a criterion, how many art educators could hold their heads high? Yet, using that criterion, if Munro were alive, he would have to acclaim Arthur Wesley Dow, another target of his criticism, as an outstanding art teacher. After all, Dow was the teacher of the painters Georgia O'Keeffe and Max Weber, and the photographer, Alvin Langdon Coburn.

Finally, I must confess I do not find Munro's piece intellectually honest. Note, for example, that he quotes a teenage boy as dismissing art as childish. But who was this boy? Was he a former Cizek student, or was he in fact a former student in the Cleveland Museum School Munro was long associated with? There is a slippery quality to the article that should have been—but never was—cleaned up during its reprinting. Nor have careful historical researchers bothered to note it.

In the foregoing I have implied what I felt would constitute some of the ingredients of a sound report on Cizek. Let me list them before I go on to points not directly connected to Munro's article. A historical study of Cizek's work should include consideration of the linguistic tradition within which he worked, the cultural and historical and educational setting of his work, and some examination of Cizek's professional development or lack of it.

For the rest of this discussion I am going to look at these three concerns. I believe there can be seen, if these areas are analyzed, evidence of changes and

transformations, and influences peculiar to Cizek's time and place. Again, I will make no pretense of being able to offer definite answers but will raise issues, at least some of which could be answered by further archival and possible oral history research. My remarks will be restricted to a review of the available English-language literature on Cizek.

FRANZ CIZEK: A BIOGRAPHICAL SKETCH

Born in the polyethnic Habsburg Empire and of Bohemian origin, Cizek received his art training at Vienna's Academy of Fine Arts and, like many members of minorities from other parts of the Empire, Cizek settled in the capital. He became closely associated while still a young man with the Secessionists, including the architect Joseph Maria Olbrich and the painter Klimt. He opened a private Juvenile Class in 1897, after having received grudging permission from conservative authorities. Karl Götze, the leader of the progressive Hamburg-based Society for Art Education discussed in chapter 3, urged the Austrian minister of education to note Cizek's work and the Secessionist-dominated School of Applied Arts (Kunstgewerbeschule) provided a room in one of its buildings for the Juvenile Class in 1904 (Smith, 1982b; Viola, 1936).

In the Klimt-dominated Art Show of 1908 the first room was devoted to "The Art of the Child," prepared by Cizek. According to Schorske (1980), Cizek then headed the "department of education" in the Kunstgewerbeschule (p. 327). Among his students in this school were numbered at one time or another Kokoschka, Viola, and Lowenfeld.

Before going on, I feel it important to point out that most statements attributed to Cizek are quotations or paraphrases, at least as far as English language publications go. One short work by Cizek has been translated, *Children's Coloured Paper Work* (1927). This was a portfolio of reproductions of children's work with an introductory essay on the nature of the medium. Paper cutting was a very narrow medium and hardly reflected the variety of work done in Cizek's class, but in a footnote appears one general statement about the Juvenile Class: "The chief purpose of [the Class] is to educate a generation of the public, which will have acquired artistic tastes and a sense of aesthetics, through work of its own" (p. 4).

Of Cizek's work as a teacher of college-age art students little has been reported in English, except in Marcel Fransicono's (1971) study of the Bauhaus. In that publication, samples of exercises by students of Cizek are reproduced, and the author speculates on the relationship between Cizek's methods and Johannes Itten's *Vorkurs*. Unfortunately the reproductions are of a very poor quality, but the inferences about Cizek as a college teacher are stimulating, if inconclusive. Fransicono feels that Johannes Itten had access to knowledge of Cizek's methods while residing and teaching in Vienna. However, Fransicono seems to believe

Cizek used methods at the college level similar to those in the Juvenile Class. The examples of visual exercises are different from anything known to have been done in the children's class. Munro mentioned that authorities sometime prior to 1925 had forced Cizek to give up an unconventional course for college students. Munro said that Cizek had these students study expressionism, cubism, and futurism "to express the spirit of the present age" (1956, p. 313) and added in the same place, "Professor Cizek himself originated a form of art in this spirit which he called 'constructivism or dynamic rhythm.'" L. W. Rochowanski's untranslated *Der Formwille Der Zeit in Der Angewandten Kunst* (1922) has descriptive material about Cizek's course, and the Museum of the City of Vienna catalog mentioned before shows examples of students' exercises from the class, as well as form the Juvenile Class.

Cizek continued the Juvenile Class until 1938 (Viola, 1944). Zweybruck (1953) indicated that the later years were devoted to younger students, under nine years of age. Throughout his years of teaching children Cizek maintained that his approach was simply to 'take off the lid' (see F. M. Wilson's writings). What this lid was seems never really defined--in English, anyway. Perhaps it was the stringent copying exercises practiced in Austrian turn of the century schools described by Viola (1936, p. 14). These practices were frequent features of nineteenth- and early twentieth-century schools in German-speaking countries. I have already mentioned the rigid drawing schemes of Schmid in German schools and examples from textbooks used in these schools can be seen in Clive Ashwin's *Drawing and Education in German Speaking Europe, 1800-1900* (1981).

Of the Austrian schools of his childhood and early adulthood, Cizek said: "I have extracted children from school in order to make a home for them, where they may really be children. I was the first person to talk about 'unschooling the school.' School is good only when it commits suicide and transforms itself into active life" (Viola, 1936, p. 38).

THE AUSTRIAN "CULTURE OF THE SCHOOLS"

Allan Janik and Stephen Toulmin (1973) in *Wittgenstein's Vienna* stated, "those who are ignorant of the context of ideas...are destined to misunderstand them" (p. 27). Since the Cizek quotation just given brings up Austrian schooling and Cizek's beliefs about his relationship to it, I need to sketch the Austrian school scene during Cizek's lifetime. Obviously this will be a highly telescoped view of a complex area, and I hope that readers will accept the premise that educational institutions reflect a culture, change in the institutions reflecting change in the culture--although not necessarily in exact synchrony. When Cizek arrived in Vienna, it may have seemed to many that the world of the Habsburgs would continue forever unchanged, but the years of his career saw some of the most violent changes in intellectual, political, and cultural history any time or

area has undergone. The following can only claim to be a reminder of complex events:

Austria went from an ossified political and social structure under the Habsburg monarchy (circa 1900) into a disastrous war (1914-1918), through collapse of the old order (1918), into a period of protracted ideological, social, and economic tension (1920s to 1937), through a civil war (late 1920s) and a conservative reaction (late 1920s-1938). The Nazi takeover (1938) constituted a political and cultural subjugation, Austria being reduced from nation-state to a province labeled Ostmark.

Austrian education circa 1900 has been described by Stefan Zweig (1943) as relentlessly rigid. Every detail was supervised by the Ministry of Religion and Education. The spirit--if that word can be used in such a context--was authoritarian. Learning was handed down to the students. Schooling was very "literary" and consisted in great part of reading and listening to lectures. Art lessons were usually exercises in precise rendering of objects, often geometric solids. The life experiences and psychological interests of the students were ignored. The teacher sat above the students on a platform; students sat on lower benches. No personal interaction was allowed between teachers and students.

Cizek began his teaching career in this setting. As a licensed secondary school art teacher he taught the prescribed curriculum, but, according to Viola (1936), allowed students to realize he disagreed with it. When Cizek was able to hold the Juvenile Class he not only changed the curriculum but also changed more subtle aspects of behavior. One of these was manner of speaking to the students. As I have reported, R. K. Wilson pointed out that Cizek was the first person to address her as "a person." German usage could reveal or induce what might in other times or cultures seem peculiar attitudes. For example, in English the child is "he" or "she," but in German a child is "it" (*Das Kind*). In addressing the child the proper "you" to use is, in part, a matter of how subordinant or equal one considers a child. Thus R. K. Wilson, as a child, felt Cizek respected her just by his mode of address. An account of Oskar Kokoschka's misadventures as a secondary teacher referred to parental horror over what was felt to be Kokoschka's inappropriate "you" (Schleiffer, 1960). Eugenia Eckford (1933a) described Cizek as speaking to the child as an equal. Cizek then, in both method and attitude attempted to create a model of teaching as different as possible from what had existed in the schools he observed before World War I.

A student of Viennese culture has characterized the period prior to World War I and the Habsburg collapse as a time of collective Oedipal revolt (Schorske, 1980). Whether we care to use such Freudian terminology or not, the patriarchal quality of Viennese society at that time is generally acknowledged. The First World War brought discredit on "the fathers" and in its aftermath a new era of "the sons" (to continue Schorske's terms) seemed to dawn. The teacher was now to be a friend and education was to be democratized, although women had to wait for true democracy to reach them.

This educational reform program was associatedwith the Social Democrats.

After the first excitement of the new world of post-World War I, postimperial days in Austria, revolutionary fervor wore off and reaction set in. The progressive Social Democrats lost control of the nation. As they lost control to the politically and socially conservative Christian-Socialist Party, the educational program also changed. Policy changed from encouragement of educational experimentation to a return in the early 1930s to restrictions on the methods and even religious and social views expressed by teachers (Cox, 1934; Fadrus, 1927; McMury, 1935). Under the government of Engelbert Dollfuss and his successors the schools reverted to an authoritarian structure and curriculum (Rath, 1943). However, the reform period remained in the memory of many educators, so this "regression" was always tainted by awareness of an alternative that had existed and might again be reborn.

To reconstruct the various social climates during Cizek's long career is a difficult matter, one requiring an extensive acquaintance with events apparently far distant from the little Juvenile Class. For example, in a tape now in the Center for the Study of the History of Art Education at Miami University, Oxford, Ohio, Lowenfeld reads passages from Viola's *Child Art* in a disparaging tone, interspersing acerbic comments. One passage in which Cizek talks about the Austrian baroque Lowenfeld points to as an example of Cizek's pompous ways, and Lowenfeld adds that the assembled parents had no idea what Cizek was going on about. Now Lowenfeld may have been quite right that by the time Viola made his notes about the Juvenile Class, time and educational developments had passed Cizek by, but despite Lowenfeld, the Austrian parents did know what a reference to Austrian baroque meant. An invocation of the Austrian baroque in the 1920s and 1930s was a political statement. It was a call to *Austrian* nationalism and a rejection of the Pan-Germanism *anschluss* idea. That is, Cizek meant that Austria had an invaluable heritage and was not a second-class German state. I refer the reader to Herman Broch's *Hugo von Hofmannsthal and His Time: The European Imagination 1860-1920* (1984) for an explanation of the attempts to develop an Austrian identity through attention to and celebration of the Austrian baroque after the collapse of the Austro-Hungarian Empire. (The Salzberg Festival is the most prominent remaining evidence of the efforts of this movement.)

Lowenfeld claimed that Cizek in the mid 1920s was rather harsh in his treatment of some children, as I have said. Viola, despite his admiration for Cizek, in 1944 published some transcribed Cizek remarks to children that may now seem surprisingly brusque. Viola, of course, made these records of Cizek lessons between 1935 and 1938, when Cizek was in his seventies and perhaps suffering from the condition that eventually led to blindness.

During a 1936 conversation with Francesca M. Wilson, Cizek expressed distress that the often-reproduced work of his adolescent students had given a false impression of his work in the Juvenile Class (Wilson, 1945). Neither Wilson herself nor Cizek seemed aware that, since the choices of work to be reproduced during the 1920s had been made by Wilson, her tastes might have

been the cause of this impression. Zweybruck, a former Juvenile Class member, wrote that the 1930s Juvenile Class work became less illustrational than in earlier years. In addition, R. K. Wilson mentioned that media choices underwent changes over the decades the Class existed.

These symptoms of change, as well as the political, social and educational transformations I have tried to sketch suggest that our picture of Cizek and his Class may be too superficial. It would seem, even without historical research, nearly impossible that Cizek and his Class went unchanged over four decades. I think it would be correct to say, however, that American writers about Cizek have tended to treat his career as all of a piece and uneffected by any different intellectual or cultural events than those that might have been found in New York, Cleveland, or Minneapolis of the early 1900s. Like Munro, they tend to label Cizek as a free-expression teacher identical to the Americans Florence Cane or Margaret Naumburg. Yet in the year of Munro's report, 1925, which was the heyday of Cane and Naumburg's Walden School, more than half of Cizek's career was over. The shattered political, social, and cultural scene in Vienna was entirely different from the Greenwich Village scene in prosperous post-World War I America. Lowenfeld (in the tape mentioned before) stated that he and his contemporaries felt Cizek to be a leftover from the late 1890 and early 1900 days when Cizek had been a true reformer. While I have not found or told the cause-effect relationship between Austrian culture at various stages and changes in Cizek's career, I hope I have suggested the need to try to look into the relationship.

CIZEK AND VIENNA'S INTELLECTUAL CLIMATE

Cizek was the originator of a few ideas in visual art education. Without his personality and pedagogical skills these ideas would not have taken quite the glamorous form they did. However, the Austrian historical scene in which Cizek lived also "authored" many of the ideas, behaviors, and opportunities that made Cizek and the Juvenile Class possible. His location, his happening to be there at the right time, were also important authors of Cizek's fame and influence.

Schorske has noted that Cizek's phrase for what the children were to do in the class--*sich auszusprechen*, or express themselves--suggested "psychoanalytic talk-therapy" (1980, p. 364). Vienna was of course the birthplace of psychoanalysis and although I doubt there was a direct connection between psychoanalysis pioneers and Cizek, I suspect that it and other notions current in Vienna in Cizek's day were reflected in his rhetoric and, perhaps, his approach to the Juvenile Class. The Secessionists' urge to find the essential in art and to break from academic formulations has a resemblance to Freud's peeling away of the social veneer and Ludwig Wittgenstein's search for the meaning of language in actual use. All three were pursuing a kind of intellectual archaeology. This is especially easy to see in the art world in Gustav Klimt's visual references to

archaic Greek and ancient Assyrian art.

Cizek showed children's work to his Secessionist colleagues and seems to have told them that they need not search through examples of ancient and primitive art for the essential, the wellspring of art. The wellspring could be found in the work of the child (Schorske, 1980). The Secessionists accepted this and in doing so did what the contemporary writer on aesthetics Timothy Binkley (1978) calls indexing. That is, since the Secessionists were artists, by declaring children's efforts to be art, the children's work became art. Although the Secessionists did not have the benefit of Binkley's late twentieth-century wisdom, they did in effect accomplish indexing of children's work as art.

If we look at Cizek's statement that child art is the art that only children can do, although some of our contemporaries may be troubled by the notion of child art (DiBlasio, 1983), we might also see a sort of Wittgensteinian reasoning in Cizek's definition. That is, if we learn what games are by going out and looking at games, we can learn what art is by looking at what is called art. Thus, the Secessionists called children's work art; therefore it was art. Janik and Toulmin in *Wittgenstein's Vienna* (1973) have described a setting in which aesthetics, a search for essentials and a comparatively small arena (Vienna) made such cross-fertilization a possibility. The Secessionists were so concerned about the search for the origin of art and the essential nature of art that they had the phrase *Ver Sacrum*, the Sacred Spring, inscribed on the building Olbrich designed for their exhibitions.

CONCLUSION

Although Franz Cizek's work was disparaged somewhat by Lowenfeld, the Cizek and Lowenfeld rhetorics were more than coincidentally similar. Now we see that the notions of those who would imagine the child unfolding creatively like a vegetable growing without thought ignore the necessity of learning what a culture accepts and values in art. We are now constantly told (see, for example, Wilson, Hurwitz, & Wilson, 1987) that we learn from art how to make art, curiously enough because the Viennese Gombrich told us so to begin with. I would protest a little that this does not mean there is no self-expression. However, after Grombrich we cannot go back to Cizek's rhetoric. Coincidentally, how curious it is to speculate about Gombrich's childhood "failure" to do Cizek imaginative drawing as a cause for a large strand of art education contemporary theory!

The notion of child art, which Viola claimed Cizek was the first to proclaim,[3] is a cultural phenomenon that has proved educationally troublesome for Americans. In the midst of the glut of sophisticated artistic virtuosity of fin-de-siècle Vienna, an escape to innocence and simplicity via children's imagery is understandable. A thoughtful walk up the grand staircase of Vienna's nineteenth-century Art Historical Museum, with its lavish historicist architectural detail in

multicolored marbles and gold leaf and its early Klimt decorative paintings, is in itself almost enough to arouse a desire for a less history burdened, less oppressively theorized and overschooled world.

However, in relation to the American art world, what is the function of child art? In 1900 American artists were still trying to assert their place in American culture, trying to attain a better level of recognition as learned practitioners in their own right. The number of public commissions in which American architects, painters, and sculptors had been able to demonstrate their status as intellectual workers and definers of American culture had been comparatively few and scattered. Such commissions had little permanent impact on American society. Even the 1893 Columbian Exposition in Chicago had been a temporary affair, although it had made some (not necessarily good) impact. Its historicist and largely European style effected American architecture for decades after (Scully, 1960) and some of the finest art work, for example, Cassatt's mural for the Woman's Building, was discarded after the Exposition ended (Buser, 1995).

In America, the concept of child art, therefore, while pedagogically useful and intellectually interesting, and after the introduction of modernism through the Armory Show of 1913, influential in the work of a few artists, did not function in the same way as it did in European cultures. It was always a troublesome idea that might be used to attach the negative association of childishness to art in general.[4] In retrospect, it has even been used to attack Viennese art of the late 1920s (Kallir, 1986).

What I have been attempting is not a defense of Cizek's approach, but an explanation of why we might look more thoroughly at the cultural background and intellectual formation of Cizek as a foundation figure for modern visual arts education. I suspect that as Freud's work is now seen to have been shaped by Austrian culture, so was Cizek's. If we could examine the cultural context and personal experience of Cizek we might better understand the use and uselessness of his notions. And, by understanding Cizek and his environment, by comparison and contrast, we might better understand how art education is shaped by our own culture and current understandings.

NOTES

1. A Lowenfeld autobiographical tape is held at the Center for the Study of the History of Art Education, Miami University, Oxford, Ohio. A Lowenfeld tape devoted to Cizek is held in the same archive.

2. However, Schorske (1980) implies Cizek taught Kokoschka at the Kunstgewerbeschule.

3. I hope Chapter 3 has demonstrated that this claim was open to dispute. However, the notion of child art was, I claim, a product of Germanic culture.

4. When I discuss the career of Viktor Lowenfeld, I will continue this examination of the dissonance between Germanic culture and American experience.

5

American Attempts to Democratize Art: Picture Study

Before continuing with further analyses of Germanic art education and American interpretations or misinterpretations of Germanic-based practices, I want to turn back to the main focus of this book, American art education and the historical explanation of its place in American culture.

The practice of Picture Study was in many ways typically American, an attempt to deal with art in a democratic manner, to take it away from an aristocratic European tradition and insert it into the supposedly egalitarian American society. At least in its beginning, Picture Study ignored the non-Eurocentric art traditions and never discussed the rich Native-American or Hispanic-American heritage. Yet, compared to what had gone before it, it was a major attempt to democratize--to give access to--the visual arts, to bring art from the salons of the rich and upper class into the schools and thus to all Americans, or as many as could be reached in schools. I want to describe this practice in its temporal and geographical setting and try to explain and analyze why and how it came into being.

THE ECOLOGY OF PICTURE STUDY

Picture Study was one of the outstanding elements in art education in public schools in the United States for more than fifty years. Although Efland (1990) questioned its importance in practice, wondering if it was actually done as much as, for example, Mary Ann Stankiewicz (1983) had implied, he did not substantiate the basis of his doubt. The plethora of literature published for Picture Study, whether for texts or discussion of its content and methods, seems to reinforce my belief that it was important, despite Efland's assertion to the contrary. Although published material does not always reflect real practice, these many Picture Study publications would not have been produced by commercial

publishers over a period of decades if there had been no market for them.

Picture Study appeared sometime in the late 1800s and began to fade at the end of the 1920s (Stankiewicz, 1983). It was, therefore, a feature in the formative years of American art education, and yet its practices have led later art educators to look on it with attitudes ranging from skepticism to distaste (Mathias, 1924; Hendrickson & Waymack, 1932; Eisner, 1972; Hurwitz & Madeja, 1977). Most of these writers, however, expressed their opinions within the theoretical framework of the modernist aesthetic. In the following, I intend to examine this movement, with as little presentism as possible and with the hope that I can evoke an image of the time the Picture Study practitioners lived in.

The practice of Picture Study seems to have been widespread (Morrison, 1935) and doubtless involved many individuals, as studies by Robert Saunders (1966) and Stankiewicz (1983; 1985) indicate. The movement at one time or another related to a number of other features of American society and education. In regard to this, Stankiewicz (1983) has listed factors that she felt shaped Picture Study, including (a) new and improved technologies of reproduction and dissemination of printed images, (b) growing interest in art fostered by the Columbian Exposition of 1893, (c) idealism in both philosophy of education and aesthetic theories, (d) growing feminization of the classroom and school cultures as women began to take over more and more teaching jobs, and (e) growing numbers of immigrant children who understood the language of pictures better than English.

This is a daunting list, and I am not sure I agree with it all or that it all could be demonstrated. For example, I do not believe feminization of the classroom had a direct effect on encouraging Picture Study. Stankiewicz has thoroughly covered the first of these considerations, improved means to produce reproductions (1985) and touched on the others (1983). I will not respond to all the issues listed but will concentrate on the concerns related to the work of one Picture Study writer, his publications and career. I believe that this account will clarify many of the practices of Picture Study and the environment of Picture Study as it was carried on in a particular place and time within a framework of specific American beliefs and social limitations.

The focus of this chapter will be Oscar W. Neale (1873-1957). His work has been cited repeatedly as an example of Picture Study in significant art education publications (Eisner, 1965a; 1965b; 1972; Eisner & Ecker, 1966; 1970). Neale's publications were widely distributed, this author having come upon one copy of his *Picture Study in the Grades* (1927) at Arizona State University and another copy at the teachers' college in North Adams, Massachusetts. I have read, in Neale's personal correspondence, that his *World Famous Pictures* (1933) had sales of more than 30,000 copies in Texas alone, even during the depression years.[1] Finally, Neale's publications came late enough in the movement so that other practices with very different theoretical bases can be cited for contrast without danger of anachronism.

WHO WAS OSCAR W. NEALE?

Neale's background and experience obviously influenced his actions, choices of approach, and style, and help us understand the ecology of Picture Study. Study of this ecology raises questions about parts b, d, and e in Stankiewicz's formulation, but I want to picture the context of the movement, not belabor too much issues difficult to "prove."

Neale was never an artist or an art-specialist teacher. From 1917 to 1944, he was director of rural education at Stevens Point Normal School, which later became part of the University of Wisconsin system. After his death, one of the buildings at Stevens Point was named in his memory (Dowd, 1976). His interest in art probably began in 1896 at Doane Academy, a prep school associated with Denison University in Ohio. While at Doane, Neale elected to take drawing, an unusual step for a student following the classical course of study. He may have attended the public art appreciation courses given by faculty members from Shepherdson College, an institution affiliated with Denison.[2]

Neale became a county school superintendent in Nebraska and later joined the faculty of a teacher training school in Kearney, Nebraska. His period of superintendency, in the Platte area, had quite an impact on the rest of his career. In later years he liked to recall that he became acquainted there with Buffalo Bill and had discussed Rosa Bonheur with him (Neale, 1927).

More important, Neale came to feel that the arts were neglected in teacher education and children's education, and he determined to do something about it. The incident that triggered this decision, Neale claimed, was the discovery of a young teacher in a one-room rural school covering the walls of her classroom with pictures clipped from the pages of a dressmaker's magazine. She had no source for attractive and aesthetically valuable educational visual aids, nor standards for choosing such aids. Neale reacted very strongly to what he felt was a demeaning situation for the teacher and a lost educational experience for the students. Years later, he was reported as saying that this incident had shown him that there had been too much emphasis on the three Rs, and he set about remedying this through a one-man crusade. He bought reproductions on credit, then toured schools to give talks about these pictures. Incidentally, he also carted about a phonograph, thus becoming a kind of early arts educator (Neale Retires, 1944).

Neale became a speaker on the tent Chautauqua circuit. A newspaper clipping of 1927 described his two decades on the Chautauqua platforms and continued: "Today Mr. Neale's 200 reproductions are still intact, enclosed in two iron trunks that have traveled with him all over the nation where he has been called to give picture study interpretations. Iron stands and racks are part of his equipment and the entire display can be erected and made ready for use in an hour's time." The article describes something of the structure and content of these presentations: "The exhibit starts with masterpieces for the little folk, the children who are taught to correlate them with their studies in music, history,

geography and literature. Another group is for high school age and still another division appeals to the adult age, in relation to music and song."

Neale seems to have been an outgoing personality and a persuasive speaker. A former student recalled his teaching with enthusiasm, remarking that Neale's classroom was in the un-air-conditioned upper floor of a Stevens Point building, but students flocked to his classes and were not distracted by the summer heat during his presentations.[3] Neale's postretirement career as a Wisconsin state senator also suggests that he could attract and hold an audience.

NEALE'S STATEMENTS ABOUT ART AND PICTURE STUDY

The actual statements Neale made about art works in his classes and public lectures are difficult to determine, though something about them can be imagined by examining his publications. Neale's Preface to *Picture Study in the Grades* (1927) included this declaration: "Picture Study in the Grades aims primarily to develop in the children of our schools an appreciation of the great masterpieces of art so that they may know the joy that comes from such an appreciation and so that their ideas may be influenced by the patriotism, the piety and the beauty which the great artists of different ages have given the world" (n.p.). In the same preface, Neale quoted G. Stanley Hall's discussion of Picture Study:

Teachers do not realize how much more important, not only for children but for everyone who has not special artistic training, the subject matter of a picture is than its execution, style or technique. The good picture from an educational standpoint of view is either like a sermon teaching a great moral truth or like a poem, idealizing some important aspect of life. It must palpitate with human interest. (Neale, 1927, n.p.)

Hall held a position of esteem in the early years of the century somewhat similar to that of Jean Piaget or Howard Gardner of Harvard's Project Zero at the present. He had articulated the latest and most convincing theories about children's intellectual and psychological development. Although Neale did not list a citation for the Hall quotation, it was from the last in a four-part series of articles, "The Ministry of Pictures," in *The Perry Magazine* of 1900 (pp. 387-388). The title Hall chose indicated his belief about the role of art.

In Neale's *World-Famous Pictures* (1933) the religiosity suggested by Hall's title was modified by Neale toward a more general moral or ethical attitude. This can be seen in Neale's comments about a painting by Gerrit Beneker entitled *Men Are Square*. The reproduction shows a noble workman, muscular arms folded, looking forthrightly at the viewer. The painting could easily pass as an example of roughly contemporary Stalinist socialist realism. According to Neale:

The artist Beneker has chosen the American City working man as the subject for his

picture "Men are Square." The laboring man forms a great bulk of our citizenry. Forty percent of our wage earners depend upon our industries for a living. The great thought which the painter has expressed is the dignity of labor. He has presented a working man, a familiar everyday sight, but portrayed with a grandeur and power that suggests thoughts far beyond the commonplace. (1933, p. 296)

As was often the practice in Picture Study texts, Neale included a literary quotation in his commentary: "Ill fares the land, to hastening ills a prey, Where wealth accumulates and men decay" (p. 298).

Apparently Neale felt compelled to bear further witness to his awareness of the relationship of this idealization of workers and the Depression, in an astonishing statement for a Republican: "Another implication...is that big business today is forcing the profit motive. Who will dare question the whole notion of unbounded private profits?" (p. 298).

Neale's earlier book, *Picture Studies in the Grades*, is more often cited than *World-Famous Pictures*. The earlier book dealt with 47 artists and had 63 reproductions, all printed in half-tone on a pale yellow background. The pages of the book are about 5" x 8-1/2" and the picture areas smaller. *The Angelus* (a favorite Picture Study choice) is reproduced in a 4-1/2" x 3-5/8" size. This can be compared to a typical reproduction in the Perry Picture series with a sepia tone picture area of 2-3/4" x 2". Neale listed each picture's representational content, and a few biographical details about the artist. Several discussion questions to be used while studying the pictures were given. There were a few suggestions for language arts projects and questions that would motivate discussion or essay writing rather than studio art activity or aesthetic analysis. The later *World-Famous Pictures*, in contrast, did have some suggestions for studio activities.

Eisner and Ecker (1966) stated that Picture Study "was directed to issues that present-day art educators would be inclined to call extraneous to concerns of art" (p. 6). If they meant by this that formal values (composition, color, etc.) were not considered, such a statement is not entirely true. In approximately fourteen instances in *Picture Study in the Grades*, Neale did point out formal features. Moreover, Picture Study writers as a whole did not always exclude features considered important to a formalist theory of art or to the art education concerns associated with Arthur Wesley Dow, an art educator highly regarded in the 1920s.

Al Hurwitz and Stanley Madeja (1977) disparagingly pointed out Picture Study's emphasis on French genre paintings. At least twelve artists whose work could be so labeled were included in *Picture Study in the Grades*. There is nothing included before Raphael and no artist considered who, in 1927, could have been termed "modern." A comparable text, *Masterpieces in Art*, by William Casey (1926), also included twelve genre painters. In Casey's book Millet was represented by four reproductions. When this is compared to one Michelangelo (a surprisingly unfigleafed *David*) and no artist before Donatello, a certain imbalance is evident. John Singer Sargent, who died in 1925 could then be

considered almost contemporary and was represented in Casey's book.

Some of the limitations of Neale's fellow Picture Study writers are astonishing. For example, in 1923 the director of drawing for the New York City public schools stated, in a manual for teachers, "The ancient Egyptians, over 4000 years ago, were, as far as known, the first to practice painting" (Collins, p. 15). Belle Boas (1924), who taught in New York City in a school associated with Columbia's Teachers College, listed (but did not include reproductions as examples) a far more wide-ranging and comprehensive group of artists than did Neale or most other Picture Study texts. The New York City director of drawing aside, authors of Picture Study texts may have been constrained less by lack of knowledge than by a lack of choices in reproductions available and economic restrictions, a problem not unknown to art appreciation or art history text writers today.

THE FRAMEWORK OF TIME AND PLACE
FOR NEALE'S WORK

Having outlined Neale's career and discussed the nature of his writing, I now want to explain the relationship between Neale's environment and his approach to Picture Study. I use the word "environment" to refer to both time and place. "Time" refers to Neale's Picture Study activities, a little after 1900 through the 1930s. Place refers mainly to the American rural Middle West, even though his texts were distributed all about the country.

Neale's education included the time at the prep school related to Denison University. In the 1890s, Denison was a small, Baptist-sponsored college. It was from there that William Rainey Harper moved on to direct the Chautauqua Institute and then to serve as president of the University of Chicago. Harper was an educational enthusiast who believed that masses of people can engorge vast amounts of learning (Gould, 1961). I believe that Neale, besides being exposed to visual art, picked up the idea that cultural concerns could be vividly presented to a public that, in turn, would be infected by enthusiasm and would respond positively. Of course, an assertion that Neale chose to be enthusiastic must be made with acknowledgement that there is evidence he was attracted to public persuasion and advocacy and had plenty of energy.

Although the Chautauqua Institute of Harper and the tent Chautauqua of Neale have to be differentiated (Gould, 1961), both aimed at a combination of entertainment and adult education. Both presented cultural events or performances and informative lectures dealing with cultural or social concerns. The Chautauqua Institute was founded by a Protestant denomination that, like others in America, had some evangelical strands. Neale on the tent Chautauqua circuit shared platforms with William Jennings Bryan and the famous evangelist Billie Sunday. Neale sometimes substituted as a preacher which suggests the possibility that he could, perhaps did, adopt a rather evangelical style for his art discussions.[4]

Gould (1961) pictured the whole Chautauqua movement as a semi-evangelical enterprise that sought to bring intellectual and cultural stimulation to "the incredibly isolated communities of our then new Middle West" (p. vii). The Chautauqua idea, as the Institute was around 1900 or the tent Chautauquas (which had no formal association beyond the name) depended on the belief that certain monuments of Western culture could and should be known if one were to be considered educated. The Bible, of course, was widely known and was both a religious and literary monument in its King James translation; many other books were also recognized as monuments. These ideas obviously were the antecedents of today's notions of "cultural literacy." Cheap reproduction of paintings made it possible to claim that visual art, at least in its two dimensional form, could also be included among the portable monuments. When Eisner (1965b) wrote that "Neale...was the 'great looks' advocate of art education" (p. 7), he may have been thinking along these lines.

Behind any program claiming that education entails a familiarity with great books or "great looks" there is a notion of authority. The works cited as great must have received that honor through some persons or institutions accepted as authorities. There are implications of a hierarchy of wisdom in this process. A work so selected must evidence qualities that are thought to be standards of excellence. In terms of education, the Great Books advocates saw education as a transporting of received knowledge from one generation to another; they felt that wisdom was passed down from wiser to less wise, from older to young, from the elite to the common.

Chautauqua and the Great Books were movements to make what had been elite and exclusive works accessible to all social classes. In that way, they were great democratizing movements. Gould (1961) subtitled his book about the Chautauqua movement *An Episode in the Continuing American Revolution*. In a sense, the Chautauqua and Great Books movements, nevertheless, retained an elitist attitude toward learning and culture. In schools, this meant that valuable thoughts came from adults who had already received the acceptable bundle of wisdom. Children were presented the bundle but had little of value to give in return. Their best response was to show that they had absorbed all the given ideas. Such an attitude was incompatible with the creative expression notions of art education exemplified in Neale's own day by the efforts of Florence Cane and Margaret Naumberg in the Walden School in New York (Rugg and Shumaker, 1928). The attitude that the children's self expression was not valuable, or at least as not of equal value to what was being handed down to them, would explain the absence of suggested studio art activities in *Picture Study in the Grades*. However, even where creative expression theory did not hold sway, it would be wrong to think that Picture Study was always accepted.

The editor of the widely distributed magazine *School Arts Book*, Henry Turner Bailey, had been educated at the Massachusetts Normal Art School established by Walter Smith, and he never embraced creative expression, but Bailey published others' criticisms of Picture Study ("Picture Study, A symposi-

um," 1907). While creative expression advocates sometimes denounced exposure of children to any adult work, others held a neoromantic distaste for analysis, or "rending" (Hagarty, 1907) they detected in Picture Study texts. Margaret Mathias (1924) decried the lack of awareness of children's intellectual development shown in some Picture Study lessons.

It is undeniable that Picture Study texts did tend toward anecdotes and a type of personal response that seems to us excessively sentimental and not very informative about the work of art under consideration. Neale's writing about Rosa Bonheur's paintings included a marginally related anecdote about Buffalo Bill. In other texts, Edwin Landseer's *Shoeing the Bay Mare* inevitably brought a quotation from Henry Wadsworth Longfellow's *The Village Blacksmith* (Lemos, 1925). Indeed, a reader may wonder whether the text was found to fit the picture or pictures selected to illustrate texts. Neale's explanation, however, sometimes approached the description-interpretation-evaluation structure many present-day teachers use. For example, while Millet's *The Gleaners* caused Neale to quote the Bible, he carefully inventoried the representational content of the picture, described the artist's composition, and discussed the use of color in the original painting. It was probably one of a very small number of paintings in his books which Neale had been able to see in other than reproduction form. Given the hierarchal presuppositions already mentioned, it follows that Neale's evaluation at the conclusion could simply be, "All this has placed 'The Gleaners' among the masterpieces of the world" (1927, p. 228).

Neale felt that art works had a moral, ethical, and sometimes patriotic function (although he may not have separated the latter from the first two). This sort of thinking was not just a provincial Wisconsin or even American notion. Leo Tolstoy's *What Is Art?* (1930, originally published in 1898) contains a discussion of a painting by Walter Langley that could be placed in a Picture Study text. Tolstoy gave very little description of the composition of the painting and no reference to color or texture. The whole purpose of the discussion seems to have been to claim that art should concentrate on the need for loving relationships among peoples (p. 225). Art, according to Tolstoy, should be engaged in moral, ethical, and social concerns, a stance not unlike the one by G. Stanley Hall quoted before and not overly distant from the rhetoric of later Russian socialist realism.

Hurwitz and Madeja (1977) pointed out that many Picture Study texts reflected the approach of professional critics of their time (although they did not note the logical corollary that their own considerations reflected the preoccupations and prejudice of our day). Some picture study writers, as well as some critics of the era, did indulge in excesses, by any standard. Even as a Picture Study writer, Neale might have found the following quotation relating to Landseer's *A Distinguished Member of the Humane Society* rather out of proportion: "The mission of the dog--I say it with all reverence--is the same as the mission of Christianity, namely to teach mankind that the universe is ruled by love" (Casey, 1926, p. 37).

Bailey, the long-term editor of *School Arts*, wrote a Picture Study series for that magazine that included an article about Edward Burne-Jones' *The Golden Stairs* (1909). The rhapsodizing that Hurwitz and Madeja (1977) had claimed as a general fault in Picture Study texts, in Bailey's piece went well beyond anything Neale wrote and even beyond the Casey quotation just given. Bailey included quotations from John Ruskin and Ralph Waldo Emerson and two pages of personal response to the painting. The conclusion of Bailey's article shows something of choice of content, tone, and the technical resources of Picture Study:

As I sat before [the original painting for the first time], something of the peace that passes understanding stole upon my spirit, a peace that glowed with joy when I discovered that the lowly portal in the lower left side of the painting did not give entrance to a darkened room as I had thought [because of previous acquaintance with a reproduction], but to a hall whose golden roof was upheld by polished shafts of precious marble. Perhaps at last, what seemed to be the iron gate of a tomb, may prove to be the pillars in the temple of my God. (p. 800)

Bailey seemed to miss entirely the deliberate ambiguity of "narrative" in the art of Burne-Jones, and this painting--despite Bailey--may have no religious message. Whatever our reaction to this particular excerpt, the faith of Picture Study writers in the power of the image, whether the painting or its reproduction, now seems astonishing.

In a 1983 National Art Education Association Conference presentation, Stankiewicz showed examples of Picture Study text illustrations that demonstrated that Picture Study reproductions sometimes falsified visual information. Bailey admitted he had misinterpreted *The Golden Stairs* because of a dim reproduction. Neale, in referring to a reproduction in *Picture Study in the Grades* of Jules Breton's *The Song of the Lark*, implied that it did not provide sufficient visual information and felt obliged to refer to his examination of the original painting in the Chicago Art Institute. The Perry Prints often used in Picture Study lessons were so small that they were useless for deciphering anything but gross representational content.

Neale, and all other Picture Study writers and practitioners, worked within the framework of their own time. I think I have sufficiently indicated attitudes toward art found in much early twentieth century American art world thinking. I have described the somewhat evangelizing approach to culture exemplified by the Chautauqua movement and the limitations on consideration of visual art works imposed by reproductions then available. I do not believe that it is true, as Stankiewicz feels (1983), that Picture Study changed over time into what might be considered less an ancestor of art appreciation than of moral education. I believe Stankiewicz unconsciously slipped into a presentist attitude when she made this statement. Henry Steele Commager (1976) has stated, "the very freedom from the obligation of formal religion [resulting from separation of church and state] and denominational variety in America contributed to create a

special obligation in the schools to inculcate morals. These qualities were to persist: a separation of education from religion, and a concern by education for morality" (p. 11). Moralism, therefore, was an element in all school subjects, not Picture Study alone or especially. Of course moralism and the aesthetic are not the same, but I suspect that the moral and the aesthetic have become artificially segregated, one from the other, since around 1900. I would further suggest that Picture Study meant something different in rural 1920s Wisconsin than it did, for example, in urban New Jersey, where at one time it had been used in acclimating the children of non-English speaking immigrants (Chase, 1906).

The mid-twentieth-century critics of Picture Study all applied a formalist criterion to the movement's rhetoric and choice of images. From a postmodern perspective, however, this may no longer be valid, or at least it may exhibit a provincially narrow and ethnocentric view of art. It is easy to find Picture Study rhetoric that is glibly moralistic, even cloyingly sentimental (to the point of being embarrassing). Nevertheless, the Picture Study writers recognized possible values in visual art beyond the formal elements, beyond "significant form."

While early twentieth-century Picture Study writers in general failed to discuss contemporary artists enough to make a strong link to the American art scene, they did discuss some American art. It is valuable to see how they dealt with it. George Inness was one of the more frequently cited American artists of the Picture Study texts and *almost* a contemporary, although his lack of narrative incident probably gave the less sophisticated writers difficulty. Inness was influenced by the Barbizon genre artists who were favorites of the Picture Study authors. Inness, however, held views sharply distinct from genre painters. He stated, "A story told by a painter must obey the laws of pictorial art.... The painter tells his story with the pathos of his colour, with the delicacies of his *chiaroscuro*, with the suggestions of his form" (quoted in Cikovsky, 1977, p. xx).

Although this may sound very formalist and modern, Inness was also a convinced Swedenborgian whose art was intended to be an embodiment of mystical beliefs (Cikovsky, 1977), and his views were not unrelated to the luminists. Inness believed the sensuous experience parallels or helps humans in a transcendental manner to understand the spiritual through that which could be perceived by the senses.

Inness paintings (at least his later ones) are, therefore, understood best through a rhetoric that includes talk about the spiritual, the mystic. This is not to say that bourgeoisie Victorian moralism explains Inness, but formalism falls far short of leading to an understanding of his work or the work of many of his best contemporaries. Now, contrary to the beliefs of Hurwitz, Madeja, Eisner, and others of just a few years ago, we have begun to see that formalism is not the only standard for art. Nor does school talk about art shorn of moral-ethnical concerns deal adequately with the power of images. What historians of visual art education have not done so far is to evaluate the various approaches to art education in late nineteenth-, early twentieth-century schools within the aestheti-

cally enlarged framework of postmodern thinking or within the framework of activist or engaged art of today.

How does Picture Study stand up against the "art education" of Walter Smith? Which is more democratic? Which is the more socially controlling? Which has the more enlightening aesthetic? Compared to Dow's work, does Picture Study not seem to be less trapped by formalist limitations? Does it seem to reach out a little more (if not enough) toward the social function of art?

Trivialization marred Picture Study. Does it not mar almost every other school subject all too frequently? It is my contention that Picture Study was an important and valuable feature in an attempt to educate the American public about visual art, and its eventual fading away was not necessarily an advancement for the public's understanding of art through the work of the schools.

THE EDUCATION OF TEACHERS OF PICTURE STUDY

The choices of materials and types of discussion and analysis found in Picture Study texts may also have been limited by the level of schooling of teachers and the general population. These would have varied from place to place, in urban to rural areas, North to South and East to West. *The Stevens Point Normal Bulletin* of 1918 revealed that the normal school where Neale taught accepted eighth grade and high school graduates into its teacher education program. High school graduates could obtain life certificates after attending the normal school for two years and teaching for two more and would receive a bonus of $60 to $80 a month. Eighth grade graduates had to attend the normal school for three years to obtain a three-year certificate that could be renewed by attending summer institutes. Even after Stevens Point had become a teachers' college, Neale pointed out that 65 percent of the Wisconsin boys of high school age were not attending school (unidentified newspaper clipping). Given such educational limitations, it is not surprising that Neale, ever the practical educator, did not attempt to go into or advocate too thorough or lengthy analysis in his *Picture Study in the Grades* which, it should be noted, was subtitled *A Manual for Students and Teachers*.

Eisner called his brief review of the history of art education in *Educating Artistic Vision* (1972), "The Roots of Art in Schools: An Historical View from a Contemporary Perspective." While we can hardly escape looking at the past from our own day, perhaps we should try to shake off some present-day assumptions to try to find circumstances that explain the visual art education practices of the past. Also, we should not assume that the past cannot provide examples for present action.

I have attempted to show that aesthetic theory, beliefs about art, social assumptions, educational beliefs, educational limitations, and technology interacted to make Picture Study what it was. Picture Study practitioners had the

limitations of their time, their education, and their aesthetic assumptions, conscious or not. It has been my observation that few present-day students (or art teachers) can go beyond the formalist education still carried out in many schools and colleges. Therefore, most of us are as blinded by our age's bias as were the turn-of-the-century Picture Study practitioners, and many of us are likewise incapable of a discussion about art works unfettered by the restrictive view of art propagated during the reign of modernism.

The recent return to favor of the genre painters dismissed by Hurwitz and Madeja and others should be sufficient warning that the aesthetic concerns of the past should not be sneered at. Indeed, Picture Study advocates, at their best, recognized the power of the image with a message. This power of images was later too blithely dismissed by formalists who came dangerously close to claiming the image had no effect in life. Discussions in the 1980s about morality in art focused on the National Endowment for the Arts' connection to the exhibit of the sexually explicit work of the photographer Robert Mapplethorpe were symptomatic of this problem. At times the political attackers seemed more convinced of the real and affective power of imagery than the artist and art-loving defenders, who often claimed legal, First Amendment defenses rather than taking aesthetic stances. Cannot an art work be a cry of Fire in a crowded theater? Can the artist really say anything and cause no harm? Indeed, formalism in education has led many into a kind of ethical apathy (Todd, 1991) which projects a message to the general populace that art does not really matter in contemporary culture, that it has nothing to do with life. This cannot be the message sent to students if art is to be anything but a malnourished orphan in the curriculum.

NOTES

1. Letter from publisher to O. W. Neale, October 14, 1938. Provided by Joan Krienke, granddaughter of O. W. Neale from personal collection.

2. F. W. Hoffman, letter to Peter Smith, December 30, 1980. Ms. Hoffman was Archivist for Dennison University at the time of correspondence.

3. A. L. Hanson, letter to Peter Smith, September 11, 1981.

4. Letter from "Del" to O. W. Neale, July 27, 1915. Provided by Joan Krienke, granddaughter of O. W. Neale from personal collection.

6

American Women in Visual Arts Education: Outstanding Leaders and the Interaction Between Gender Bias and Art's Status

Stankiewicz (1983) claimed American classrooms became feminized in the late nineteenth century (see Chapter 5). Others have said art has become associated with women and the supposedly feminine (see, for example, Wayne, 1974). These two factors have played a significant role in determining the importance or insignificance of art in the schools. The respect or lack of respect for "women's work" influences the ranking of any activity, including subjects for study in schools, if a subject is associated with women's activities, no matter how far those activities are from biological functions or a particular society's assignment of wifely-motherly roles. This can be truly paradoxical. For example, art has come to be "feminine" despite the near-exclusion of women from professional training as artists prior to the end of the nineteenth century and the dominance of the names of male artists in most art history texts (Wayne, 1974).

Although American public school education has rarely been segregated by sex, it is common knowledge that it has been strongly colored by gender stereotyping. Even at the halfway mark in the twentieth century girls and young women studied some school subjects, but not others. Boys studied particular subjects or were expected to excel in certain subjects but were not expected to show much interest or involvement in other subjects. Women could be secretaries, nurses, and teachers. Boys could grow up to become many things, including manual laborers, executives, soldiers, engineers, doctors, and teachers. The teaching level, however, had to be high enough to exclude any thought of motherly nurturing. The choices for women were few. The types of jobs for boys were limited "only" by their intelligence, wealth of their families, personal ambition, and race.

On the surface this sex stereotyping of subjects eroded during the twentieth century. Schools were supposed to be fully democratic. As Commager wrote, "schools are required to be the surrogate conscience of society" (1976, p. 32), but, as he also said, society expects schools to preach what American society

does not practice. Associations of gender with particular school subjects still linger right into the present.

Art and teaching may be regarded as feminine, but art education at the college level has not been consistent with those two stereotypes. That is, college art education has been dominated by males. In 1982, still a doctoral student, although older than most others, I presented a paper entitled "Five Women of Power in Art Education" at the annual conference of the National Art Education Association in New York City. Later this paper was cited in Georgia Collins and Renee Sandell's *Women, Art and Education* (1984) in reference to the loss of documentation of women art educators. The subjects of my paper were Margaret Mathias, Belle Boas, Florence Naumburg Cane, Margaret Naumburg, and Natalie Cole. The selection was highly arbitrary, omitting such figures as Sallie Tannahill, Mary Alice McKibbie, Rosabel MacDonald, and Marion Quin Dix. The choice was determined by how difficult it seemed to be, while studying in Arizona, to obtain materials about or by these figures, most of whom, excepting Cole, worked in the Northeast. Eventually Boas, Cole, and Dix were to receive published attention while the others I have just named remain uncelebrated. Why this is so I am not sure, although I will speculate on the causes in this and later sections of this book. I feel constrained to point out that some men of the same era, such as Felix Payant, Valentine Kirby, Ralph Pearson, and F. V. Nyquist, are also forgotten, although they too once were leaders in art education.

By the end of 1982 Anne Gregory had published an article on Marion Quin Dix and Zimmerman had presented at the New York City National Art Education Association Conference a paper on Belle Boas, published that same year in *Women Art Educators* (Stankiewicz & Zimmerman, 1984). In 1984 and 1991 I published papers on Natalie Robinson Cole and between these studies turned to research on other women art educators, including Eugenia Eckford Rhoades and Jane Betsey Welling. Thus the silence of history concerning women in the field of visual arts education was somewhat broken, but even to the present many women have not had their due. For example, the outstanding English art educator, Marion Richardson, friend of Kenneth Clark and Roger Fry and others, has been virtually ignored in American histories.

The one thing Mathias, Boas, Cane, Naumburg, and Cole had in common was that during their lifetimes their publications were widely available. They all published significant works that received wide distribution. They were all powerful in the sense that they were influential through their writing and to a considerable degree, they were not hidden in the shadow of a male art educator, although Mathias, Boas, Welling, and Eckford acknowledged the influence of Arthur Wesley Dow. As Zimmerman pointed out, Boas also did tend to be in the shadow of her brother, George Boas. They were not obscured, however, in the sense that Sybil Emerson was virtually eclipsed by the arrival of Lowenfeld at the Pennsylvania State University.

MATHIAS

Of all of the women I did research on for my presentation, I am most puzzled by the disappearance of Margaret Mathias. She was, if nothing else, the author of three widely used art education methodology texts, *Beginnings of Art in the Public Schools* (1924), *Art in the Elementary School* (1929), and *The Teaching of Art* (1932). Since Scribner's published all three I tried to find out something from the publisher's files. It turned out that the historic files had been given to Princeton University, but the university archivist could find nothing related to Mathias.

Mathias had graduated from Ohio State University in 1916 (Cattell, 1948), so it is likely she had the opportunity for considerable contact with Alice Robinson, a figure ironically made well known by Mary Erickson (1979) as a phantom figure in "An Historical Explanation of the Schism Between Research and Practice in Art Education." Erickson had written of Robinson: "Alice Robinson was in charge of the art program at the Ohio State University for thirty-six years from 1911 to 1947. Yet five years after her death, it was difficult to find any concrete evidence of her existence. How is it that this woman appears to have made so little impact on the field of art education in general or even on the art department where she spent most of her life?" (p. 8)

In Chapter 8 I will look critically at Erickson's explanation of why Alice Robinson "disappeared," but here my point is that Mathias, unlike Robinson, through her publications, ensured that she would leave a trace of her existence; yet she has become a shadow becoming grayer and grayer with the passing of each decade and blending into the undifferentiated darkness of the past.

The books Mathias published were typical of the publications for art teachers of her day. They were relatively small and dull colored, except for a very few color reproductions. They waivered somewhat between discussion of art as a school subject to be taught and art as a field for emotional release. Whether the emphasis in any particular case is on the one or the other, it is assumed that art in school is an area of activity, of production. That is, even if color theory, for example, is taught, the students are to make something, not just receive the instruction and memorize the theory.

Mathias's books were for professional teachers. The assumption was that art was a school subject and that it could be taught. The phrase "art is caught, not taught" which floated about for some decades was not something Mathias would have agreed with. Art was discussed in pedagogical terms. The larger concerns, such as the basis for the aesthetic implied by the practices suggested or the controversies in the contemporary art world, were not mentioned. There seemed to be an implication that somewhere in the world were experts who knew what the true nature of art was, and the teacher need only pass this information on, certainly not present art as an arena of problematic conceptual issues (See Chapter 11 for more on this).

When her first book was published, Mathias was elementary art supervisor in

Cleveland Heights.[1] At age twenty-nine she received her master's degree from Columbia Teachers College, Columbia University; obviously the influences of Arthur Wesley Dow and John Dewey at that time were very strong, although Dow had died sometime before. In Chapter 8 I will give Jane Betsey Welling's description of this era.

Mathias became director of art in the schools of Montclair, New Jersey, and head of the Fine Arts Department of New Jersey State College in Upper Montclair (Belshe, 1946). For several summers Mathias also taught at Teachers College, Columbia University, and then at Case Western Reserve. She was active in the Eastern Arts Association and the National Education Association. Despite all this, the Princeton archives[2] and the Montclair College Archives[3] could find no materials on her. She had become as hard to capture as Robert Saunders's Mrs. Minot (1964), a person who may or may not have done this or that and of whom nothing much was left, as far as records go, leaving only ghostly traces of what she might have done, if she ever was.

Mathias lives for us though her publications, if not through anything else we can find. In her writings Mathias presented a simple three-part developmental scheme for children's art work: manipulation, symbolism, and realism (1924). This developmentalism shows her intellectual debt to the child study movement. While Mathias was strongly influenced by Dow, this attention to developmental stages shows that she was aware of the shortcomings of the application of his ideas to children, especially younger children. Dow held that the root of art was design and that design could be taught in discrete steps, combined with logical presentations of art principles. Mathias warned, however, that "The child's composition is not improved by the discussion of principles. It is improved with increasing insight and confidence. The child's respect for the experiences which he expresses stimulates a desire for an arrangement which satisfies him" (1932, p. 146).

Her next words might have been written by Natalie Robinson Cole in 1940 or in the post-World War II era's resurgence of self-expression ideas: "The young child then may be helped in composition through help in having rich experiences and in finding rich enjoyment in these experiences, in being let alone to paint as he wishes, and through the feeling of friendly interest which the teacher takes in his work" (1932, p. 146).

This appears to be an advocacy of laissez-faire "teaching." However, Mathias was an eclectic. That is, she tried to combine philosophies based on different premises. While she seemed to lean more toward the creative or self-expression theory of teaching art, she still tried to include some of the formalist notions of Dow. Dow's theories required a use of step-by-step design exercises assigned and critiqued by the teacher. Since we have only Mathias's books as evidence and no way to observe her actions beyond her books, it is difficult to judge her success in this balancing act, but this split between formalist action and expressivist theory has persisted in American art education down to the present. And, of course, both theories speak little or not at all to the question of

the uses of art in society.

Inconsistencies of theory and practice and of aesthetic foundation are frequently found in American schools' visual art education. Few American educators in any of the arts have had an educational background to deal with such issues and many American teachers (whatever their subject) have a certain contempt for theory. Obviously, inconsistencies and contradictions in the theoretical foundation of educaiton in art tend to call into question the intellectual validity of rationalizations for art's inclusion in the schools' curriculums. And unconsidered conceptual premises lead to miscellaneous and incongruous collections of activities leading to no significant goal.

BOAS

Zimmerman's 1982 study of Boas, "Belle Boas: Her Kindly Spirit Touched All" (Stankiewicz & Zimmerman, 1982) presented a more thorough description of Boas' career than I could give in the brief conference paper about five women art educators in 1982 or will give in this chapter. Zimmerman's article was a narrative. It was strangely devoid of analysis of Boas as a contributor to art education as a woman. Interestingly, Zimmerman at the end of her National Art Education Association presentation of her study admitted that she had difficulty with it because she had come to not like Boas. Nothing of this dislike shows in Zimmerman's published study.

Boas's *Art in the School* (1924) underwent at least seven printings. As art director of the Horace Mann School and associate professor at Teachers College, Columbia University (Belshe, 1946) and editor-in-chief of *Art Education Today*, the annual published under the aegis of Teachers College, Boas held a rather prestigious and influential post. Ironically, neither the Columbiana Collection of Low Memorial Library nor Special Collections of the library of Teachers College possesses more than a few unilluminating odds and ends of information about her career.[4]

Art in the School was dedicated to Arthur Wesley Dow but began with an epigraph from John Dewey: "Education has no more serious responsibility than making adequate provision for enjoyment of recreative leisure." Boas wrote that her book was "based on Professor Dow's theory of art as embodied in his work 'Composition' and 'Theory and Practice of Teaching Art'" (p. xi). Yet, as Thomas Munro (1929a) points out, Boas saw that the seemingly logical, simple- to-complex design course that Dow proposed was not psychologically appropriate to the developing child. While Dow's theory had analytical power and rested firmly on a formalist aesthetic, it seemed completely disconnected from any developmental theory, or even a common sense observation of children's behaviors and capabilities. Like many others Boas did not seem to question whether art's place was in leisure or in a more central place on day-to-day life. Dewey, of course, was later (1934) to describe aesthetic experience as

the very model of true experience.

Like Dow, Boas saw the teaching of art in the schools as the teaching of appreciation of good design (Boas, 1924). Dow had deplored the division of the arts into fine and applied art--a polarity he blamed on the High Renaissance--and saw design as what should be appreciated, whether in a cup or a cathedral ("Excerpts from notes," 1935).[5] Boas drew the conclusion from Dow's views that, "Few children are ever going to be either singers, writers, or painters...but all are human beings, and it is for them that singers, writer and painters produce their works (Boas, 1924, p. 1)" thus just making art was not the only thing students should do in art class. In other words, the critical-appreciative aspects of art and environment should be studied. Unlike some of her contemporaries in the Progressive Education Movement, Boas did not hesitate to expose the child to adult work: "Appreciation comes with study and understanding, and, therefore, is necessarily slow in developing. It should be taught in every unit of art lessons...pictures should be brought into the classroom constantly for reference and study...an intellectual understanding of them can be developed"...(Boas, 1924, p. 90).

Contrast this insistence on the value of adult-made examples with the 1926 statement by Peppino Mangravite which has provided decades of art education histories with a perfect, if unconscious, parody of Progressive Education in art: "Looking at pictures, if it teaches [children] anything, teaches them the art of imitation....Children should not be allowed to go to galleries and museums until they have learned to realize the emotional beauty of the lines of a factory or a locomotive"...(Mangravite, 1926, p. 124).

There is a curiosity in Boas's story that, perhaps in some roundabout way, gives a special color to her life and career. In the acknowledgments in *Art in the School* (p. ix), Boas expresses gratitude for the encouragement she received from her brother George, a philosophy professor at Johns Hopkins University and a well-known writer about, among other things, art criticism. Later, George Boas wrote an article for her for *Art Education Today* (1940) on art appreciation in which he advocated the use of one of the leading popular media of the day, the "funnies." Using "funnies" the teacher could point out matters of drawing, composition, and so forth, that made one comic strip seem better than another. From there on, the teacher would move to such artists as Honoré Daumier. To the argument that the child might never move to the beauties of past achievements, George Boas replied that at least the child would learn that art still was an ongoing activity and was not something that happened long ago. Certainly Belle Boas had urged environmental design awareness (see 1924, pp. 100-101), as had Mathias, but George Boas was leaping ahead to a position that did not surface again in American art education until the 1960s. Should the difference between George Boas's use-the-popular-media-stance and Belle Boas's appreciation-applied-to-environment program be traced to developments in the years between 1924 and 1940, such as the Owattona experiment? That is, should it be considered a natural progression or extension of the idea of appreciation of

what exists in the social environment planted by Dow and mixed with the anti-Picture Study talk of Progressive Educators like Mangravite? Or could we indulge in some would-be psychohistory and venture the opinion that Belle Boas could not feel free enough to accept the crassly popular funnies as worthy of art classes' attention because she felt, as a woman, constrained to stay within respectable bounderies of what constituted art? George could be outrageous, not only because he was not an art educator in the school sense, but because he as a male and a certified philosopher did not risk disgrace by suggesting such novel actions? Males, perhaps, could be innovators with little risk? Women who suggested innovations connected with ordinary things were at risk of being thought "silly," or superficial. Still, as editor of the publication in which the article appeared, Belle Boas could be a little of a risk taker through George.

Boas disappeared from widely distributed art education publications when she left Teachers College. According to Zimmerman, Boas became director of education at the Baltimore Museum of Art in 1943. She seems to have been a highly successful museum educator especially interested in folk crafts and, at the time of her death in 1953, was warmly praised for her work.

The work of the teacher, like that of a stage actor, is ephemeral. Its survival comes about mainly through influence on its observers. If Boas had not published *Art in the School*, had not been editor of *Art Education Today*, had not written a number of widely distributed articles, she would have vanished from history as surely as Alice Robinson did when her students ceased to mention her. Of course, when we check the names of her male colleagues at Teachers College, a similar vanishing process has taken place. It is possible that only Edwin Ziegfeld of the Teachers College art education faculty of the same era stands much of a chance at being part of the memory of art education history. Perhaps Belle Boas may one day be remembered only from E. H. Gombrich's tribute to her brother:

Having taken me to Baltimore...he [George] was kind enough to introduce me also to his sister Belle Boas, with whom we had lunch and talked, if I remember rightly, about the art classes for children given at the Baltimore Museum-or was it the Walter's?-with George, of course, being as well informed about art education as he was about Haydn and fourteenth century cosmology. (1984, p. 167)

Boas lived through an artistically fascinating, economically wrenching, politically horrifying series of changes during the years of her professional career. She passed through them, as far as her publications tell us, like a sleepwalker. Her art education was correct in its academic way, but the light of raw social reality never seemed to touch it.

THE SISTERS NAUMBURG: MARGARET NAUMBURG AND FLORENCE NAUMBURG CANE

It would be easy to caricature Naumburg and Cane. This writer has heard Cane referred to as a "romantic," and there are moments in Cane's *The Artist in Each of Us* (1951), such as the description of the classroom couch on which the troubled student-artist could cast herself or himself for self-analysis while in the travail of bringing forth a creation, which lend themselves to derisive parody. To see Cane in this light, however, is to overlook many ideas which she presented that might still be considered useful. Similarly, Naumburg's Walden School might be satirized as the prototype of *Auntie Mame*'s psychoanalysis-crazed Greenwich Village private school of the 1920s (Cremin, 1962) were it not that, as a school, it had some remarkable intellectual achievements to its credit.

Cane had studied painting with William Chase, Kenyon Cox, and Robert Henri ("Contributors to this Issue," 1926). However, her reading of Jung and her psychoanalysis by Dr. Beatrice Hinkle (Beck, 1959) probably influenced her pedagogical concepts more than any one of the artists named. Indeed, psychological concepts rather than art world issues dominate her writings.

Why Cane was referred to as a romantic can be seen in a quotation that encapsulates a great deal of the mythology of American educational Progressivism:

Creation is a process like life itself. It rises out of a state of quiet, a sacred spot where the miracle is born. Out of the dark of the unconscious, a spring wells forth, and like a stream cutting its own bed through the meadow it flows. After this process a detachment sets in and the artist views, judges and develops according to his task and maturity. In the young child or a great genius a state of unity may exist and the two processes occur at the same time. Because of this simple unity in the young child painting is play for him and he is better off with almost no teaching. The creative fantasy must be respected and allowed free play a long time before any laws of art can be brought to the child without harm. (Cane, 1926, p. 156)

The equation of the child and the artist and the assertion that both have some mystic gift harmed by teaching remained for a long time as an accepted strand in art education. This was an essentially antisocial theory, for it set in opposition nature and society and failed to recognize that what constitutes what is honored as art arises out of society. As Lowenfeld was to do in later years (1957), Cane appeared to believe that an isolated individual could be creative without the stimulation of social interaction.

However, no one reading the quotation should conclude that Cane was a laissez-faire teacher. For one thing, Cane saw this "free play" as applicable mainly to children under ten years of age. For older students, Cane used a variety of techniques that might be considered methods for behavioral modification. Cane warned that "the creative process [will not] be aroused by extreme moderns"--she wrote this in 1951 when she was not the most extreme modern

anymore and had seen others use Progressive Education notions in what she considered bizarre ways--"who turn the child loose to putter about entirely unguided and who indiscriminately admire all his immature products" (1951, p. 33).

Cane taught the child to stand in a well-balanced position before the easel and required exercises to develop large gestures in painting. Exercises included contour drawing but also exercises in breathing and movement: "Sound, chanted, clears the lungs, decarbonizes them of half-used air, lets in fresh oxygen, increases the circulation of the blood which stimulates the body, and, in turn, the mind" (1951, p. 116).

At times Cane almost seems to be about to bring forward a hemispherality argument, but of course that issue surfaced years later. Here is a quotation from a 1924 article: "Sometimes changing hands and using the left hand instead of the right has [a liberating effect], or using both hands [may do the same]. I think that because the right hand has been used so much it often becomes limited as a vehicle of only conscious thought. The left hand, though more awkward, sometimes reveals deeper sources of rhythm and form" (Cane, 1924, p. 96).

In 1928 Cane was labeled as what would nowadays be called an artist in the school. Harold Rugg and Ann Shumaker in *The Child-centered School* (2nd ed., 1932) included a chapter titled "The Creative Artist Enters the Classroom" in which they stated their belief that only the artist could understand the child's creative spirit and understand the philosophy of the then-new schools (1928). Cane was one of the their prime examples of the artist in the child-centered school. Long after I examined the career of Cane I looked again at this assertion (Smith, 1991) and questioned how many artist-teachers are truly artists as well as teachers. It is difficult to see in what sense Cane was a professional artist. In any case, whatever her degree of preparation as an artist, Cane had first come to the attention of educators at the school her sister had founded in 1915, which became known as the Walden School, surely a name with a program.

To understand the rhetoric of Cane and Naumburg, the New York of post-World War I needs to be pictured. The Armory Show had been there and so had Freud, if fleetingly in person, more lastingly in theory (Cremin, 1962). The American reception of Freudianism, or of psychoanalytic ideas, was an arresting phenomenon in its own right. After the 1970s, using the hindsight of third-wave psychologists and the feminist critics of Freudian dicta, Freud's thought began to be seen as framed in a pessimistic Viennese fin-de-siècle authoritarian, patriarchal, decadent setting. That is, Freud was the product of a particular time and culture. The America of the 1920s seems to have missed the Mahlerlike portentous gloom of it all, and Americans seized on Freud's most gore-splattered images of unconscious primordial leftovers as wonderful novelties to play with. The reader will perhaps recall Eugene O'Neill's expressionistic drama *The Great God Brown* (1926), with its masks and the prostitute as earth mother.

Margaret Naumburg saw these then-new psychology theories as vital forces. Naumburg had studied with Dewey (she graduated from Columbia in 1910) and

with Maria Montessori. Her own psychoanalysis with a Dr. Hinkle inspired a lifelong interest in Jungian psychology, and the interest that branch of psychoanalysis had in the power of images deeply influenced Naumburg's view of her school. Art was to "build socially and emotionally mature children" (Beck, 1959, p. 201).

Naumburg said that "These early artistic enterprises serve to bring into conscious life the buried material of the child's emotional problems. Gradually his energies are transformed from unconscious, ego-centric attachments, to the wider intercourses of social life. This, indeed, is the function of all art; self-expression in forms that are of social and communicable value" (1973a, p. 45). Yet, oddly enough, she did not seem to deduce from her Jungian orientation that images may have a power that has nothing to do with individual expression. Visual forms may--according to Carl Jung--echo or evoke symbols that have universal and perennial human significance. While art may be expressive to the Jungian interpretator, the uniqueness of its forms and expressiveness are not original in the sense of the layperson's use of such terms as "self-expression."

Naumburg attracted Lewis Mumford, Hendrik Van Loon, and Ernest Bloch to her Walden School. With her sister as teacher of art Naumburg provided quite a program of cognitive and affective education (Beck, 1959). Robert Beck noted that sometime prior to 1928 Naumburg became disenchanted with the strongly social emphasis of Dewey's ideas about progressivism. Naumburg wrote:

I feel that our entire generation is obsessed with the urge to socialize the world by compulsion...because we lack faith of inner purpose.... This mistaken emphasis springs as I see it, from a diminution of proportionate weight on the inner, the spiritual, value of each separate life, and an exaggeration of the value of the external products of herd existence. (Quoted in Beck, 1959, p. 205)

In the battle that subsequently erupted, Dewey referred to art education that used the laissez-faire approach as "stupid" (Dewey, 1929, p. 180). Whatever the outcome of this particular battle, Naumburg moved away from school art education to become something like the mother of art therapy in the United States (Agell, 1980). Anyone who has a taste for the therapeutic uses of art education has probably consulted at least one of the several books Naumburg wrote on the subject. *The American Journal of Art Therapy* (Kniazzeh, 1978) termed her *Introduction to Art Therapy: Studies of the "Free" Art Expression of Behavior Problem Children and Adolescents as a Means of Diagnosis and Therapy* (1947, revised ed. 1973) the first book in the field and a classic.

If Boas could be thought an avoider of risks, Naumburg was a risk taker hard to equal. She engaged in battle America's most influential educational philosopher, John Dewey. She forged a role for herself in the new field of art therapy. In fact, she helped to define the field.

Both Cane and Naumburg spoke of images rising from the unconscious. Indeed, Naumburg's psychoanalytic approach to art therapy would seem to rely

on such revealing of inner imagery. Cane's Jungian theory also uses the idea of images from within. However, it might be asked what the actual process is which makes images appear in the student's work and where they come from.

In Cane's *The Artist in Each of Us* there are two drawings and a painting by a student who had visited the zoo and sketched a tiger (1951, pp. 146-147). Cane explains that the first sketch did not show a real feeling for the feline movement of the beast and that she sent the student back for more observation. He then produced a much more flowing drawing, which then became part of the painting *Tiger in the Circus Parade*. However, this tiger bears an interesting resemblance to a painting from the Cleveland Museum by a Japanese artist, Ohashi, which happened to be reproduced in Mathias's *The Teaching of Art* (1932, p. 58). After reading Gombrich or Brent and Marjorie Wilson, we may feel quite undisturbed by this similarity, but in the context of the Cane theory, it is perturbing. Gombrich and the Wilsons insist that the way to learn about the creation of imagery in art has always been to examine how other artists have made images. The strictly self-expressionist can hardly advocate the study of adult art works as the basis for students' art, or even admit that we learn to express by recycling and mutating images we have seen.

Naumburg and Cane stood outside the orbit of Teachers College, Columbia University. That institution's visual arts education program was based on Dow's design-oriented and formalist art theories. Dow's ideas could be adapted to fit the social-orientation of Dewey's pre-1934 *Art as Experience* ideas. Thus, in the Owattona project, there seemed to be moments when art questions seemed to become pseudosocial problems. That is, what color to paint the house, or how to trim the hedges, or how to decorate a store window appeared to be all that art was about.

THE END OF AN ERA

In 1939 Belle Boas met Viktor Lowenfeld, a newly arrived refugee, and helped arrange for him to give some lectures at Teachers College. She saw to it that illustrations from *The Nature of Creative Activity* (1939) were published in *Art Education Today* ("Sculpture by the Blind," 1939, pp. 88-89). Shortly after World War II ended, the Lowenfeld era began. Looking back over the history of the post-war era, I feel that as the "heroes" of Eisner's "Age of Heros" (Eisner, 1972) ascended in stature, the prestige of women in art education declined. That Eisner could refer to this era with a male referent in itself shows how much prestige women had lost in post-World War II art education. As I will discuss in the following chapters, despite Eisner's label, there were a number of powerful and influential art educators who were women.

NOTES

1. Letter from R. L. Johnson, Director of Personnel Services, Cleveland Heights, University Heights City School district, February 12, 1982 to Peter Smith.

2. Letter from J. F. Preston, Curator of Manuscripts, Princeton University Library, November 15, 1981 to Peter Smith.

3. Letter from P. D. Sanders, Coordinator of Reference Services, Sprague Library, Montclair State College, November 11, 1981 to Peter Smith.

4. Letters from L. Klein, Manuscripts Curator, University College, November 1, 1981 and January 12, 1982 and letter of P. R. Palmer, Curator of Columbiana Collection, Low Memorial Library, Columbia University, December 21, 1981 to Peter Smith.

5. As Editor of Art Education Today (1935) Boas printed these excerpts as a type of memorial tribute for Dow, who had died about twelve years earlier. A photo of Dow accompanied these "notes."

7

A Charismatic American

In educational work, stars of the field are rarely great innovators as far as foundational ideas or theories go. A star is essentially a performer. If the case of music is considered as a parallel example, innovative ideas may just be too hard to grasp on first (or even tenth) hearing to make enthusiastic response likely. It took a long time before Alban Berg became a major name in the operatic repertory. On the other hand, stars are *personalities* who evoke mostly emotional enthusiastic responses. Their public acclaim may cloud their actual intellectual contribution and, if after the applause has faded into history, the contribution seems indistinguishable from that which went before, the star has, in fact, made little historical difference. Yet what a moment in history applauded shows the color of that particular era.

Natalie Robinson Cole was a star personality and something more. Cole was born in 1901, some ten to twenty years later than Boas, Naumburg, Mathias, and Cane and she was a Californian, not an Easterner. She was also more of a public performer than these other four. I had the good fortune to have direct personal contact with Cole and her place in my history is thus quite distinct from what has gone before in this book.

NATALIE ROBINSON COLE: THE AMERICAN CIZEK?

After seeing Natalie Robinson Cole give a demonstration, it is said that Viktor Lowenfeld characterized her as the American Cizek.[1] In the second edition of Lowenfeld's *The Nature of Creative Activity* (1952), he also compared her to Cizek and described her approach as one which was "merely intuitive," in contrast to his own research-based approach. Lowenfeld stated that "The final product--child art--and not the child stands in the foreground of the discussion" (p. xvii). When Lowenfeld made these statements, they may have seemed

devastating critiques to those who unquestioningly accepted his art education theories. He was the dominant post-World War II figure in American art education to a degree that might astonish both present-day non-art educators and art educators. Now, more than thirty years since Lowenfeld's death, we no longer feel bound by his opinions. His description of Natalie Cole's work has become an interesting framework of historic judgment within which to examine her career rather than a negative evaluation. Whatever one might think of Lowenfeld's dichotomy of the child versus child art, a comparison of the careers of Cole and Cizek will lead to renewed understanding of her achievements and clarification of the limits and possibilities of the individualist teacher in American schools and culture.

NATALIE ROBINSON COLE'S LIFE STORY: 1901-1984

I hesitate to narrate the life story of Natalie Robinson Cole because no one could write it with more verve than she has in her own autobiographical account written for Miami University's Center for the Study of the History of Art Education.[2] Cole, as her two books, *The Arts in the Classroom* (1940) and *Children's Arts from Deep Down Inside* (1966), demonstrate, wrote in a colorful direct style describing incidents that seem to spring to life. While the autobiography remains unpublished, something of the tone and a little of its content can be sampled from Mrs. Cole's[3] second book. In it, she explains how she helped students understand a writing assignment and freed them to describe their inner feelings by relating something about her own upbringing in Santa Ana.

My mother was much older than other mothers [of kindergarten age children] and the teachers thought she was my grandmother. My mother was more interested in reading than she was in how she looked. Although dresses in those days came a way down to the floor, my mother's ruffled black sateen petticoat trailed several inches beyond. In those days there were always two kindergarten teachers working together and I could see them giving each other long meaningful looks. I never have forgotten that unhappy day. I didn't want to feel ashamed of my mother but I did. (1966, p. 153).

In the same book, she also described herself telling a class: "I remember myself as a child--how much of the time I was far from jolly...I'm thinking of myself, a little tow-headed girl, all huddled upon the bench of the school yard, scarcely daring to go out to join the group playing that wonderful singing game, "Go In and Out the Window"...would they want me with my funny snow-white hair, faded little dress, and my big shoes to join them?" (1966, p. 172). The whole story of her upbringing, as narrated by Mrs. Cole in her Miami University presentation, would have to be repeated to give the peculiar combination of buoyant spirit and sensitively recalled hurts that she skillfully evoked.

In 1983, Cole stated that "the first dozen years of [my] teaching were nothing

to write about."[4] In her autobiography Cole spoke of this time in her career: "New Course of Study bulletins came to my box before I had read the last ones. They seemed to bear so little relation to the children before me."[5]

She added that she was "frustrated and resistant."[6] An in-service course for teachers, however, came as revelation of what could be done with children in art activities: "About this time I attended a supervisor's summer class. This was before they called them Workshops and heard Children's Art presented as something unique and fascinating in itself. I gobbled up the idea. My early interest in art may have provided the soil. I began working with the children's art with real zest, always watching for that something that bespoke the child genius."[7]

Cole became interested in psychological counseling and later underwent analysis which she felt made her aware "of the role lack of faith and confidence had played in [my] life."[8] Looking at her experiences with children in the classroom, she felt "sensitized to the toll such feelings take" and began her "therapy approach."[9] She describes her work as an attempt "to remove fear and inhibition, stressing...the honesty and integrity of the individual."[10] A number of art education writers (for example, Naumburg and Cane) had also brought a belief in psychological benefits of art activity to their work. Perhaps one difference between their work and Cole's was that Cole was not working in the elitist atmosphere of an Eastern private school, but in a public school in a slum area of Los Angeles. Cole did not buttress her writing about her work with Freudian or Jungian terminology, as did Naumburg and Cane. Nevertheless, a belief in health-giving benefits of creative activity was, Cole claimed, "fundamental" to her approach.[11] She said, "I was seeing children with new eyes. It wasn't so much their I.Q. or language difficulty. It was feelings of embarrassment due to racial or nationality background, Relief [as welfare was called in those days] and all the other embarrassments of childhood. How wonderful, I thought, if we could write of these feelings and through sharing them with the group find relief and understanding."[12]

Cole also came in contact with a teacher of what might be called creative expression through dance, Gertrude Knight. This teacher's use of frequent encouraging statements and urgings, what Cole called "freeing sentences," became part of the teaching style Cole adapted for her own use: "One day I gathered the courage to put the Course of Study bulletin in my desk drawer and began to work this way. Coupled with our Painting and Dancing our room came alive."[13]

Visual art educators may have missed the emphasis that Cole placed on writing and dance; Cole saw all these as being taught together. While some visual art educators perceive a certain narrowness in Cole's approach, they may have forgotten that she was for a large part of her career an elementary classroom teacher who used visual art as just one--although an important one--of several expressive media. In that classroom, she probably never had to deal with age ranges great enough to require elaborate developmental descriptions and categori-

zations. In light of recent controversies about such developmental theories in the teaching of art, this might now be perfectly acceptable. In the Lowenfeld dominated years, however, beginning in 1947, the impression was given that the method described in *The Arts in the Classroom* was not applicable to the complete age range found in public schools. Cole has rejected this judgment and stated, "My approach covers all age ranges and is always concerned with personal development."[14] She pointed out that besides the elementary classes described in her books, she had "taught many adult classes successfully."[15] Although she never sought to establish herself in a university art education department in the manner of Lowenfeld or Barkan nor founded an independent art education center as did Schaefer-Simmern, she did later teach a number of college classes.[16]

In the most active phase of her teaching career, Cole might have been described better as an arts educator than as a visual art specialist. Discussing her methods, Cole wrote, "I found an approach that brought satisfaction to the children and to me so [I] wasn't too concerned with other educational approaches."[17] Interestingly, the one book that Cole singled out as having great interest to her, found only after she had written *The Arts in the Classroom*, was Hughes Mearns' *Creative Power* (1929), a work concentrating on creative writing. Not surprisingly, Mearns was part of the post-World War I progressive education movement that also brought Naumburg and Cane to the fore.

After publication of *The Arts in the Classroom*, Cole began presenting demonstration lessons while touring across the United States. These lessons or workshops proved to be remarkable attractions. When she was invited to Oxford, Ohio, for the Miami University Center for the Study of the History of Art Education, Cole chose to give a demonstration lesson for videotaping, in addition to narrating her autobiography at a public gathering (May 19, 1976). According to John Michael, Cole was the only art educator honored by the Center who chose to give a lesson rather than a formal interview, and she proved she had lost none of her power to captivate children and amaze those who watched her performance.[18]

COLE AND CIZEK IN COMPARISON

Given Lowenfeld's characterization of Cole and Cizek as somehow identical, how do these two compare as art educators? What statements can be found that would form some picture of their actions? Is it legitimate to give the two a similar place in the history of concepts of teaching in art education, to lump them together as the same in intent, technique, and results? The following is an attempt at such a comparison and evaluation of the usefulness of the idea. I undertook this with awareness of a special problem or obstacle. Cole has given us first-person accounts of her actions and ideas. For the most part (at least in English), Cizek's words and beliefs have been reported by others. As I have already demonstrated, the explanations of Cizek's ideas and practices are riddled

with problems for a historical researcher. Cole's explanations have their own peculiar historical problems, but they are not the same as the second- or third hand Cizek materials.

In Francesca Wilson's booklet *A Class at Professor Cizek's* (1921b) there is a description of the *Klassenarbeit* Cizek held at frequent intervals. This example perhaps represents the Cizek mode of teaching most clearly:

> They must represent Autumn by a figure. First they must draw a narrow margin round their paper, and the figure must be big enough for its head to reach the top of the margin, and its feet the bottom, for, as he explained to them afterwards, when discussing their work with them, a picture looks poverty-stricken and miserable when it has only a tiny figure in it, and is mostly empty. The size of the figure was the law of the Medes and Persians, but otherwise they might make their Autumn just how they liked. (1921b, p. 3)

Natalie Robinson Cole had the teacher, and it must be assumed she meant herself, saying, "Make your picture fill the paper till it bumps the sides" (1940, p. 12). From this example it can be seen that both Cole and Cizek assigned definite tasks for the whole class and insisted on certain definite means for fulfilling those tasks.

Somewhat in contradiction to Lowenfeld's judgment about the purpose of the Cizek and Cole art activities, Cizek had said, "[I]t is the effect on [the children] and on their development that is important and not the final product. That is why I never allow them to keep their own work" (Wilson, 1921b, p. 14). Cole also wrote, "The teacher should remember that the growing process is more important than the end product--the child more important than the picture" (1940, p. 23).

Despite similarities of rhetoric, however, Cizek's and Cole's teaching approaches had little in common, and their careers were as dissimilar as Vienna and Los Angeles. Consider that Cizek's career began in the aesthetically saturated atmosphere Schorske described in *Fin-de-Siècle Vienna* (1980).

Cizek's "discovery" of child art won the support and encouragement of such cosmopolitan leaders of the art world as the architects Otto Wagner and Olbrich, and the painter Klimt (Viola, 1936). The children Cizek worked with were gifted (F. M. Wilson, 1924) or at least highly motivated and creative (Viola, 1936). They may have been "carefully selected from the elementary grades" (Silke, 1909, p. 879), or it may have been that "Any child could come [to the Juvenile Class]" (Hollister, 1926, p. 263). Or, as Ruth Kalmar Wilson admitted, they may have managed to get into the Class through "connections." Whatever uncertainties do exist as to the exact selection process for Cizek's classes or specific descriptions of its makeup (see Chapter 4), it is certain that it was a very special situation. Talented or not, the children went to a Kunstgewerbeschule building for the weekend class solely to do art work. The city in which they lived had a rich artistic heritage and was the setting of some of the most innovative modernist movements in the arts. It needs little scholarly background to recall that Vienna was the city of Gustav Mahler,

Arnold Schöenberg, the Secessionists, Oskar Kokoschka, Adolf Loos, and Egon Schiele, The Kunstgewerbeschule was a focus for innovation in the arts. The *Wiener Werkstätte*, which was closely associated with the school, perhaps most strongly through graphic arts, helped spread awareness of modernity in design throughout Europe.

Cole, at least at the time she wrote *The Arts in the Classroom*, was working in a situation that had neither the artistic trappings of Vienna nor any art-centered method of selecting children for participation in Cole's classes. In the foreword to her book, Cole wrote:

The material for this book was contributed by a group of nine-, ten-, and eleven-year old children during their fourth grade and the first half of the fifth at California Street School, Los Angeles. Half of the group were Mexican, a quarter Chinese, and the rest Japanese and American. Their I.Q.'s would have consigned many of them to a rather meager existence, but I found plenty to work with and felt they stopped only where I stopped in my ability and understanding. (1940, p. 1)

Although Cizek claimed he "would rather have the proletariat child--he is less spoiled" ("The Child as Artist," 1924, p. 541), it is probable that his students were far less disadvantaged than Cole's and quite likely that they were much more exposed to a rich and relatively homogeneous culture. Just consider the fact that Cizek had two Primavesi sisters in his class. The Primavesi family was wealthy and patronized the architect Josef Hoffman and the celebrated painter Gustav Klimt. Indeed, Klimt painted portraits of Maida Primavesi, a member of the Juvenile Class, and of her mother.

Both Cole and Cizek seemed to believe that the child was innately an artist. Cole wrote, "Children have genius--yes" (1940, p. 10). A post-World War I visitor to the Juvenile Class wrote, "All children are creative in Dr. Cizek's opinion, and most have some artistic talent" (Matson, 1923, p. 382).

However similar the statements of belief about children's artistic nature, the teaching styles of Cole and Cizek seemed to be sharply contrasting. Cole forthrightly stated that "If anybody thinks teaching children's painting is a negative job, with the teacher sitting at her desk while the children jump at the chance to paint anything you want to, boys and girls, he is all wrong. He will very likely find that most of the children don't want to paint anything very much and those who do seem to want to hash over a picture they made in some former room at an earlier time" (1940, p. 3).

This contrasts with the famous Cizek disclaimer that "I take off the lid and other art masters clap the lid on" (F. M. Wilson, 1921a). Cizek was often des-cribed as if he were the most extreme of laissez-faire educators, as the frequently quoted taking-off-the-lid phrase implies. Cole denied the very possibility that such a negative process would produce any worthwhile results. An observer of Cizek's Juvenile Class said: "It is said that the genius of Professor Cizek's teaching is that he refrains from teaching. He simply encourages the children to

draw and paint as they feel...each is left to his emotions" (Glimpses of Professor Cizek's school in Vienna, 1930, p. 222).

Cole felt that the child had potential for fine work, but that the teacher "must dig to get at it" (1940, p. 10). She saw a need for the teacher to provide or recall vivid experiences for the students. The "child's picture travels on its interest" (1940, p. 5). That is, the child must be excited by the subject in order to sustain his or her drive to produce an art work. Once the art activity had begun, the teacher's work was not finished. Cole maintained a constant stream of encouraging remarks: "The teacher should go about, lifting one picture after another, giving some appreciations, it doesn't matter that many children will not lift their eyes from their own painting. What the teacher says goes in their mind's ear, and they will strive to do as much or better" (1940, p. 7).

Cizek has been recalled as moving about his classroom very quietly (Gutterridge, 1958) and has been described as speaking to his students in a rather unobtrusive and self-effacing manner (Adler, 1929). In 1926, he was characterized as a "slow moving silent man, but his silence is potent" (Hollister, p. 265).

Perhaps "direct" and "indirect" modes of teaching might be terms useful to categorize the styles of, respectively, Cole and Cizek. This labeling runs into some difficulties, however, because of differences in the descriptions of Cizek's teaching, which I have already discussed. Cole, writing of her own beliefs, stated that "The teacher should never seek to help a child by taking brush in hand to show him how something ought to be. She should never attempt to show on the blackboard or by photographs or pictures how something really is" (1940, p. 8).

Apparently Cizek would in some instances sketch for the child (Eckford, 1933a) although Viola (1936) seemed to indicate that Cizek avoided such direct aid. According to Lowenfeld's former students, Lowenfeld felt Cizek's words and actions in this matter were in conflict.[19]

Despite the contradictory nature of the material on Cizek, Lowenfeld's claim that Cole and Cizek were comparable does not seem satisfactory. Evidence seems to indicate that the two educators' classes could not be said to share meaningful correlation of setting or makeup. The intent of the two cannot be matched except superficially. Cole (1940) appeared to be much more concerned with specific psychological aspects of the uses of art in a classroom, especially improvement of self-image and release of harmful emotions. Cizek's aim seemed to be a vague encouragement of general creativity (Viola, 1936). The styles of teaching the two used were almost polar. In her autobiographical statement, Cole mentioned a person doing psychological work who knew nothing of indirect counseling. This phrase, especially in contrast to descriptions of Cizek's behaviors, might seem appropriate for Cole herself. That is, while Cizek was sometimes described as getting results from his mere presence, Cole went about actively encouraging and giving many ongoing classwide (as well as individual) directions.

Although Cizek's classes used a greater variety of art media than Cole's, Cizek did not include dance or writing in his program. Lowenfeld did not consider Cole's work with children outside the area of painting, drawing, and

printmaking. It is possible that Lowenfeld's reactions to Cole's work were gained mostly through watching just one of her workshops with children. Cole attempted a program free of the influence of adult art, a goal Cizek also claimed to want to achieve. Cizek could not accomplish such a scheme in an environment permeated by a rich and innovative art scene which flourished alongside a still living folk art tradition. Some of Cole's students had a Hispanic Catholic tradition of imagery and their work reflected this, but most had a far thinner visual heritage in the Los Angeles environment of 1940 and little opportunity to be exposed to adult fine arts as a matter of everyday experience.

Cole eventually (after *The Arts in the Classroom*) may have become exclusively concerned with product, but at the time of the book's publication she was interested in the arts as tools to help in the psychological development of the child. Cole did want the child to produce beautiful things according to her formulas, but as a classroom teacher, she wanted the child in the fore because she was concerned about all of the children in her class all through the school day, every school day in every subject in the curriculum. Cizek probably chose his students on the grounds of perceived talent. He focused exclusively on the development of that talent. Although he too used formulas to provide a structure for the child to develop effective images, the results had far greater variety than can be seen in the work of Cole's students. The only point of resemblance the two art educators seem to have had was that their students frequently produced striking imagery. Beyond that, the environments, methods, and rationales of the two seem too different to claim they were in any sense significantly similar.

If Cole was not "the American Cizek," how might she be characterized? Her emphasis on freeing the individual, her California exuberance, lack of attachment to the roots of art history, her youth cult, her holistic approach to eduction remind this writer of Isadora Duncan. Frederick Logan wrote of Cole that she was "a true descendent of the early progressiveness" (1955, p. 209). If by that he meant that she saw education, indeed, life, as a unity in which children's art played a major role, she did indeed follow in Progressive Education's footsteps. However, she might just as well be compared to Abraham Maslow and the ideas of education as self-realization advocated by humanistic psychologists and educators in the post-Progressive Education era. Cole, if she represented any group or movement, was an individualizer, almost an educational libertarian. Like Duncan, hers was a unique vision. At this moment in education's history, this vision may not seem sufficiently articulated in "educationese." In contrast to other periods, such as the aftermaths of World Wars I and II or the late depression years when Cole wrote *The Arts in the Classroom*, it appears that present visions of general education aim either to train children to take standardized tests or to use children as tools of nationalistic future economic or political goals. Cole's ideas about education appear of value only when the child, the whole child, and his or her individual self-fulfillment are the goals of education and of the arts activities within that education. Perhaps Cole's educational vision could be characterized as closer in spirit to that of Henry David Thoreau than the age of

Ross Perot.

Cole, as a classroom teacher, used the arts as an element that permeated the year of a child's education she shaped. The theoretical presupposition her work was based on, of course, was the emotionalist or expressive theory of art, reinforced by psychological arguments about the value of and need for emotional relief through the arts. Cole's approach addresses only this category or theory of art. It gives the student no information concerning other notions about the definition or social function of art. Because of this, it gave the student little to use that would lead to a fuller understanding of the adult art world, either of the past or present. The later, discipline-centered notions of education would not very well have suited Cole's notions about the uses of art in classrooms either.

Nevertheless, Cole was an effective teacher. Her very effectiveness blinded many to how this type of teaching may produce immediate and striking results, yet in the end keep school art as an orphan of the art world and, ultimately, of education. Cole's efforts did induce children to produce effective results. The work looked bold and free. It had visual force, within a narrow range that fit within the primitivist strand of modernism. However, despite the delight one might feel on seeing the work of Cole's students, one soon begins to wonder where these children were to go after her guidance. What was done to start them in any direction that would lead the children from fourth grade excellence in art toward an adult understanding of art?

NATALIE ROBINSON COLE AS A "LIVING DOCUMENT"

In 1981 when I decided to do the presentation about Mathias, Boas, Naumburg, Cane, and Cole described in Chapter 6, I discovered that four of the five were dead and had already started to undergo that "vanishing" process that has been the fate of so many women art educators (Erickson, 1979). The one surviving person was Natalie Robinson Cole. After writing the publisher of Cole's *The Arts in the Classroom* (1940) for permission to reproduce some of the illustrations for that book, I received a letter directly from Cole. Since she owned the copyright, she wrote, the publisher had nothing more to do with her or her books. She was pleased to let me reproduce the illustrations for my presentation and would be glad to cooperate with me on a report about her.

I had found a "living document" (Mitchell, 1980, p. 285), and over the next couple of years we corresponded. Cole's first letter mentioned the autobiography written for Miami University's Center for the Study of the History of Art Education in Oxford, Ohio. When I wrote that I would like to read it, she mailed me a copy. Cole had written two books and many articles, and as her letters revealed, despite her age (recall, she was born in 1901), she had a lively and alert mind and a ready pen.

At the start I had four types of materials that I could use to place Cole in a general art education perspective. These included Logan's *The Growth of Art in*

the American Schools (1955) and Belshe's dissertation, *A History of Art Education in the Public Schools of the United States* (1946); Cole's two books (1940, 1966) and comments made to me by people who had seen Cole demonstrate her methods. As time went on I accumulated letters from Cole, prints by her students, and interlinear notes by Cole on pages of my report-in-progress.

What I did not have was some form to present these materials coherently. I lacked a way to explain a career, a viewpoint, a person in an understandable and concise paper to be sent to a journal editor. I faced the problem of trying to shape the materials with artistry. As one writer put it, historians may claim to be scientific in research, but they must try to be artists in presenting their findings (Muller, 1954, p. 35). My form would have to support the reporting of facts and explanations about these facts and provide a coherent interpretive framework for both. The form itself would need to be related to the meaning of the materials. I wanted to describe and analyze Cole's work and show her efforts as they had been within the frame of her time. One day as I read the preface to Lowenfeld's *The Nature of Creative Activity*, I came upon this: "Natalie Cole in her book, *The Arts in the Classroom*, still uses mere intuitive approaches, much as Franz Cizek did years ago in Vienna" (1952, p. xviii).

I had found my useful and expressive form! I would put Cole and Cizek side by side, as if doing a diptych showing two Byzantine saints, and I would compare them. After all, they were figures in the hagiography of art education. After some scribbling I ended up by telling how they were different far more than how they were alike, but the diptych form, simple and easy to use, remained. I asked if Cole was an American version of Cizek and proceeded to answer that question, as in the opening pages of this chapter, which echo the article wrought from my research on Cole.

Logan (1955) had seen Cole as in the same Progressive Education boat as Mathias and Boas. I suppose a general history of the field, such as *The Growth of Art in American Schools*, should be allowed some leeway to group figures together in gross categories. However, the time between Cole's major publications (1940 and 1966) and those of Boas (1924) and Mathias (last book, 1932) and the geographic separation between the Easterners (Boas and Mathias) and the Westerner (Cole) should have induced caution. Logan might also have looked at the types of schools in which many Progressive Education visual art specialists taught, and then he should have pondered where Cole had developed her practices. Frequently, the best-known Progressive Education teachers had taught in elitist private or practice schools. Cole taught in a California inner-city slum public school.

Belshe's attempt to make a few analytical summary comments about a lot of people led to error. When Belshe wrote, "The first step in teaching a child to create (according to Cole) is to be sure the child has experiences vital to him" (1946, p. 175), he correctly described Cole's approach; but when he stated, "'Make it your own way' is practically the only direction Mrs. Cole gives her

students" (p. 175), he was just plain wrong. Even a casual reading of Cole's writings (to say nothing of eyewitness reports) shows a determinedly directive teacher who, from motivation through evaluation, set up strong guidelines. Belshe and Logan gave clues as to how Cole was perceived at the time they wrote, but they were either lacking in sufficient concrete details or too unfocused in their attention to her work to have made judgments helpful for my understanding.

Cole's books, *The Arts in the Classroom* (1940) and *Children's Art from Deep Down Inside* (1966) are historic documents. They can speak to us directly, giving examples of and prescriptions for classroom practice, but they may also be viewed as relics. That is, they are remains from a past that is no longer functioning. In examining them we find the rhetoric of yesterday, but doing so we must remember we view these works as they have become obscured or colored by the veil of our age's atmosphere. However, if we turn this viewpoint around and realize that in her first book Cole was speaking to readers who had no knowledge of the ideas of Lowenfeld, Barkan, Eisner, Feldman, or Chapman, to name a few later visual art education leaders, the text brings to the reader an awareness of an individual speaking in the environment of another age.

Cole's autobiography is invaluable, but problematic. It is very personal (what else should an autobiography be?) and so it is self-centered. This may have been a very truthful presentation of herself. As Jerome Hausman has described his recollection of Cole, "Alas, my memories [of Cole] are those of a rather self-centered personality [Cole] that was deeply committed to what she did and how she did it" (correspondence with author, October 22, 1989). This self-centeredness makes the autobiography foreground with no middle background. It is distorted in the same sense that Stankiewicz (1987) deplored in many biographical studies. There little social or historical context. Cole moves from family to career to marriage and through emotional crises and into the time she became famous. She speaks from her restricted circle of observation, and there is little or no reference to what was going on in the field of art education during the most active years of her career. There is no clue as to what was happening in American art at the time, or how much or little Cole knew about the art world.

Cole does mention some personal contacts. One of these was Galka Scheyer, a German immigrant and friend, collector and sales representative of Bauhaus painters, including Paul Klee and Wassily Kandinsky. Scheyer also taught art to Los Angeles children in what she called the creative and imaginative painting method. It would have been interesting to know whether Cole gained more than a general reinforcement of her enthusiasm for child art from her contact with Scheyer. What theories and methods did Scheyer explain to her? Were they derived from any of the art education ideas that had grown up in German-speaking countries in the early years of this century? However interesting that might have been for another study, my chosen form demanded that I focus on Cole and Cizek and not confuse the form with too many other figures.[20]

Cole was something of a literary stylist. Her books give a very lively impres-

sion and reveal her interest in writing as well as visual art as a medium for self-expression. The style of Cole's autobiography reminded me of the writing of a roughly contemporary author, William Saroyan. Cole wrote a narrative that moved quickly from one vignette to another, that singled out a few simply described features, often with a grotesque detail or two, and that combined a certain absurdity with a tone of compassion. Cole wrote me that she did not want me to use my original characterization of this autobiography, "Bittersweet flavor...childhood at once difficult and filled with affection," and I replaced it with "buoyant spirit and sensitively recalled hurts" (1984, p. 36), but I think either description is just.

Going through the autobiography for helpful information, I found myself reading it with a pleasure I might have experienced in reading a short story, accepting the author's created world. Could that be why I thought of a writer of fiction as a comparison? Looking back with love on her experiences, including a healthy self-love, Cole's view of her life evidenced the palimpsest effect Proust described in *The Guermantes Way* (vol. 1 of *Remembrance of Times Past*, 1934).[21] The image that love has molded and the physical facts the eye sees intermingle, both present but sometimes in conflict, never exactly alike.

I suspect that the overall unity and consistency of tone in Cole's autobiography, although it was pleasing aesthetically, was not completely credible from a commonsense, ordinary-experience standpoint. It did not have the disjointedness and dissonances of raw fact, the miscellaneous conglomeration of happenings we all experience in our day-to-day lives. It was rather too polished, the interpretation already done. While I examined Cole's autobiography with some suspicions about artifice, my suspicions were those of a historian who wanted to keep at enough distance to judge the plausibility of the author's explanations and choices of facts in her life story, not necessarily a desire to reject on the basis of a priori theory.

Data for an historical report is selected by the researcher through a kind of lens formed by the researcher's world view, experience, education, and sensibilities. From what he or she selects, the historian builds up an image of the past. William Walsh (1960) has compared this process to what an artist does. He refers to the historian's interweaving of related events, actions, thoughts, and so on, as "colligation," a process of nonlinear explanation more similar to the interdependent and mutually effecting elements of a work of art than the cause-effect explanations of the sciences. However, neither Walsh nor I would admit that this method produces less true results than the work of the natural scientist.

While E. H. Carr (1962), a historical theorist, seemed to suggest that historians select their facts in a rather haphazard, very subjective manner, he failed to emphasize that historians do their searching for information in waters they have carefully explored. If the historian cannot find sufficient material to form a background--and perhaps middle ground and foreground--for her or his attempt to do a historical report, generally the material that has been accumulated is placed in the Needs More Study file and the historian goes on to more or to

other research. The well-prepared historian knows a typical or important fact when he or she spots it. The historian has studied a period's events, actions, thoughts, and so on, until fit or lack of fit of what he or she examines is apparent. The historian of art education, therefore, knows his or her well-recognized figures, issues the field has emphasized, and the various cultural, educational, and historical settings art education has passed through. Thus, the writers about Walter Smith I discussed in Chapter 2 knew a great deal about art education's history, traditions, and outstanding figures.

Of course, the historian of visual art education may be all too prone to accept the conventional opinions of the field, to repeat the received secondhand history passed along within the field. Such historians may (and have) ignored the effects of the culture within which art and education in the visual arts exists. They report about isolated personalities or movements as if either could be unaffected by the intellectual, historical, economic, or political currents of their times. So, while Cole herself in her publications ignored much of the larger world about her, to understand her place in art education history, we must see her framed by Progressive Education notions and rhetoric, by the expressionist bias of American art from the 1920s through the 1950s (see Cremin, 1962; and Chapter 6 for explanations about the connections between Progressivism and expressivism in America), the popular interest in psychological theories, in part spurred by the many cases of psychological breakdown in the wake of World War I and the Depression, the social disorientation in the wake of the Depression, and the differences between Eastern middle class and elite, Progressive Education, and Cole's Californian perspectives.

WRITING THE REPORT

Having read published materials and Cole's autobiography, I began writing my report within the diptych form I had chosen. I continued corresponding with Cole and received letters in which she provided additional information. On drafts I had sent her she wrote interlinear notes. I soon discovered this "living document" was a person open to negotiation (witness our exchange about how to describe her autobiography), but far from lacking opinions on everything from her teaching days, to a current art teacher, to my writing skills.

In her first letter to me (November, 1981), Mrs. Cole mentioned that "every week for several years I have been volunteering a dance program in one of our local schools. It has received quite a lot of interest...it is indeed wonderful to see how the little sentences still work."[22] Enclosed was a brochure advertising Cole's availability to lead school programs.[23] One photo in it showed a whirling, laughing, and suitably multiracial group of girls and Cole in the middledistance, her arms upraised and a large roll of hair at the back of her head. Having read her autobiography, I noticed this hair and realized its significance for Cole, recalling that her mother's concern about the thinness of her hair had wor-

ried Cole as a child. Surely the detail is a small one, yet it does show how background information illuminates what one examines.

In my letters I asked Cole a number of questions. Some of her responses did not all fit the final article, but show something about her career, and so I wish to relate a few of these. Contrasting her work with Galka Scheyer's, she stated, "I believe my approach was even stronger as I worked to bring out principles-- always first waiting until they came from the children, then praising and naming them." If we take this mention of art principles as important, we might think Cole was an advocate of formalism in art, but if we use Stankiewicz's (1984) notion that rhetoric should be tested against an art educator's students' products through stylistic analysis, I think we would have to see Cole as (1) influencing the style of art her students produced and (2) encouraging an expressionistic art.

I tried to lure Cole into a discussion of what art educators the late 1950s and early 1960s used to call the process or product controversy. That is, should a teacher work to get his or her students to produce striking art products, or should the teacher concentrate on leading the students to use either psychologically healthful or creative thinking strategies while working on art-like projects. Cole replied that she was "sorry to be ignorant of the controversy. I have no contact with Art Educators--and never have had. I was surprised to hear the Art teacher at the local Free School where I volunteer my dance program, say proudly that this year she was stressing technique, perspective no. 1, 2, and 3. I never knew there was such and that the technique approach was still about. I have seen such fine honest children's art everywhere."

Continuing on with the theme of not being familiar with art education literature, Cole wrote that she had not read Logan's book on the history of art education and so could not comment on his evaluation of her place in art education, although she was "honored" that she was mentioned. Her explanation for this lack of interest in the field of art education was, "I found an approach that brought satisfaction to the children and to me so wasn't too concerned with other educational approaches."

I asked Cole what her reaction was to increased emphasis on the critical-appreciative and historical aspects of art in school during the 1980s. Her reply was this:

I feel children have time enough later for the critical-historical approaches. I feel they need the warmth and confidence building that can be done so well in the art program. It has always distressed me to hear tell of Museum docents ushering children through halls of Adult art to see what the artist does. It would be far more rewarding to spend this time stressing that the child's own honest expression is recognized as true art the world over and that he is an artist.

At the time I wrote my paper I missed the chance to relate this to Cizek's admonition against exposing the child to adult art works. It was not quite the same thing though, was it? Cizek felt adult art would corrupt the child's art.

Cole just felt that it would give the children the notion that their own work was not important. Curiously, her statement does in a sense fulfill Lowenfeld's idea that Cole looked toward the product made by the child, and yet, at the same time, it undermines his notion that she did not center her attention on the child. In her letters in the 1980s Cole labeled her own work a "therapy approach." In other words, she saw her goal as the building of a good self-image for the child rather than developing a knowledge of art as a discipline.

I pressed Cole a little further about her knowledge of art educators, hoping she could contrast her ideas with those of others. I just did not believe she had been that isolated from art educators. I asked if she knew Lowenfeld or Schaefer-Simmern. In reference to the former Cole stated:

There was an Art Conference years ago in Los Angeles. People wrote from the East hoping I would be on it. It seems there was no room so I was free to meet and enjoy everyone including Lowenfeld. There was to be a trip to meet the Modern Architects in their homes--something he would dearly have loved. Instead he came home and had lunch with me. It seems he couldn't have gone because he had made an engagement to talk with some Black students at that hour. I found him a beautiful, delightful man but never tried more than once to read his books.

I asked Cole to give her reaction to the work of Schaefer-Simmern (1948). Unlike Cole, Schaefer-Simmern had his students repeat an image over and over, claiming that the changes seen were evidence of a natural growth in artistic visual perception. Cole, however, complained that she liked the earlier pictures in the series reproduced in Schaefer-Simmern's publication better than the later ones, stating: "The earlier ones seemed to me to have more life and child quality than the last ones." This was a curious response because it would seem that both Cole and Schaefer-Simmern shared the opinion that a good art product leads to a happier child. However, I would propose that these two educators had very different aesthetic ideas that divided the very way they looked at art, Schaefer-Simmern seeing art from a peculiar quasi-formalist viewpoint (based on the Britsch theory) despite his psychological orientation, Cole seeing art within an expressionist frame.

After I sent my first draft to Cole, I received three pages of comments, criticisms, and new information, plus interlinear and marginal notes. Her suggestions ranged from what she perceived to be a need for further explanation (i.e., who Cizek was) to directions to cut words or whole paragraphs. The latter even included a suggestion to cut a quotation of the remarkable second paragraph of *The Arts in the Classroom*. The paragraph had bluntly stated Cole's activist credo. The teacher cannot sit around while the children create out of some hidden wellspring. They will produce nothing of value if the teacher is passive. See Cole's phrasing of this quoted earlier in this chapter beginning with "If anybody thinks teaching children's painting is a negative job..." At this point I decided I would always cut what Cole pointed out as a factual error, would sometimes cut when her argument made good sense in style or strengthening of the article, but I

would be tactfully stubborn about matters of historical selection and judgment. Cole knew herself and could spot clumsy writing, but I had read many issues of art education journals. So the first paragraph of *The Arts in the Classroom* stayed and, on the assumption that the readers of art education journals knew some of the history of the field, I added nothing more to what I was afraid was too much about Cizek.

Some of the miscellaneous comments Cole made show her manner of thinking about her career. For example, after quoting Lowenfeld's evaluation of her first book, I pointed out the negative tone of it. Cole wrote, "What is devastating about being 'intuitive'? Such is the finest type of expression in art." As a statement about art, that has one kind of interest, but the fact that Cole missed or deliberately ignored that Lowenfeld was talking about the approach to teaching art in her book is surprising. Cole felt the joining of her name with that of Cizek was an honor.

Earlier I mentioned Cole's "freeing sentences." She wanted me to include a number of examples of these, and she provided a list. I was getting concerned that my article might sink into a shapeless string of quotations, and so I silently forgot the list in revision and wrote, "Cole maintained a constant stream of encouraging remarks" (1984, p. 38). One of these sentences, or in this case, connected phrases, was, "weaving them--stretching them--to fill the whole paper beautifully." When I compared these sentences to Cizek's directions and called both "rule-like," Cole objected and wrote, "These little sentences are different from *rules*!" She did not see that directions on how to fill the page and so on ended up being a set of regulations. Later when I interviewed Ruth Kalmar Wilson, she told me that Cizek's directions were also freeing. I am still trying to understand these opinions. It is true that strong rules allow the worker to think about other things and negate the need to worry about structure. In that sense they are freeing.

Sometimes Cole caught me in a blunder. I wrote that she taught "in an urban West Coast public school." Cole crossed that out and wrote "a public school in a slum area of Los Angeles." Since I was comparing Vienna and Los Angeles, Cizek students and Cole students, Cizek's elite class and Cole's "unchosen" class, she was right. I was writing in vague bureaucratese. In another place, by contrast, I quoted Cole from *The Arts in the Classroom* saying, "Don't let us see little stingy 'fraidy cat' pictures. Make your pictures fill your paper till it bumps the sides" (1940). Cole wrote, "I don't like this sentence. Have never used it since. Instead, could you use 'make your pictures as big as your paper will let you'?" There Cole was substituting limpness for vigor, but polite compliance was a problem. After all, Cole had used the first statement in her book. It was, therefore, a historic fact. My solution was to leave out the phrase about "fraidy cat" pictures and not remind Cole about the problem.

We did some more of this sort of thing, but finally we got down to a few pages, and then Cole told me to decide when I felt the article was in good shape. Given this permission, I sent off the manuscript to the journal, and after the edi-

tor had his chance to point out my lapses from good writing style, the article was published in January 1984. In February Cole wrote me a warm thank you, and, "to celebrate," as she put it, she sent prints made by her students of decades before.

In the fall of 1984 I wrote a letter to Cole and received no answer. In February of 1985 I received a note from Harry Cole, her husband, informing me that Mrs. Cole had suffered a stroke on September 23, and had remained in a coma until her death on December 12, 1984. My work with "the living document" was finished.

In past decades that would be that. All that could be done would be to collect memories (via interviews), miscellaneous articles, and personal papers. Nowadays, further research is possible through observing Cole teaching on videotape (Michael, 1983), and thanks to researchers such as Robin Alexander (1983) that teaching can be analyzed and evaluated and, perhaps, examined from an artistic standpoint.

COLE'S LIFE AND THE USES OF
ART EDUCATION HISTORY

Michael (1983)[24] has made the point that a profession should show an awareness of itself as a profession by keeping and building up a record of its experience. A recorded history is one form of professional identity. Art teachers need not be "poor little me's" in this school or college or that one; they are the heirs of Cole or Barkan, of the ideas of Progressive Educators, and art-as-a-discipline educators. They have a body of experiences, theories, and practices. Some from the past seem odd, perhaps, but art teachers need not hang their professional heads in a world where doctors used to bleed or blister their hapless patients. In other words, every field--even the sciences we so often worship--had what now seem the oddest notions in their pasts (see, for example, Schwartz, 1993). The best art teachers have always focused on the eternal humaness of their subject.

Art educators must, however, have faith in the truth-bearing strength of the arts and that the history of art education can also use many disciplines of the field of art. Stylistic analysis, for example, can be used to ascertain realities (i.e., Was the result of Cole practice in line with Cole rhetoric, using student work as evidence?). What was the artistic quality of Cole's performance as a teacher? Do the facts presented in a historical report hang together in an artistic whole (colligation) to form a convincing explanation, an expression of truth?

A life or a history can never be related in the objective and formulaic manner of the explanations of natural science. Rather the historians of visual art education should look to the multilayered meaning of a work of art for our model. It is not an accident that the roster of past great historians is composed of persons of great artistry, from the sharp vignettes of Herodotus through the roll-

ing Augustan prose of Edward Gibbon down to and including the lean lucidity of art education's Stankiewicz (to single out one of several current writers). As in visual art, the historian must be aware of what is going on everywhere in his or her area of attention. Not just the surface action, but the meaning behind it must be elucidated. Not just the undigested fact or feeling can be presented. The form must embody the meaning. The key to writing and understanding history in general may be approaches similar to the disciplines of art. If we look to a work of art, we may see this directly if nonverbally. Thomas Eakins's *The Gross Clinic* is not a subjective fantasy, yet its meaning is not carried to us on the back of devices or concepts borrowed from science or any other field. It is truth as truth is related in visual terms.

The story of Natalie Robinson Cole can be retold in countless ways. Her life and work can be examined within as many frames for understanding as there are imaginative devisers of frameworks. It is a tale of vigor and remarkable individual achievement, but it is also the story of a person who was "authored" by her era and place.

If Natalie Cole had not matured in the Progressive Education era, absorbing its child-centered rhetoric, could she have written *The Arts in the Classroom*? Certainly *Children's Arts from Deep Down Inside* (1966) is the attempt of a person from the Progressive Education era to capitalize on the 1960s rhetorical efforts to reinstate child-centered education. That is part of the explanation, I think, of why it seems a strained rehash, rather than an advance on the earlier book.

The Arts in the Classroom was also a product of the Great Depression era. It was an attempt to give color and richness to the lives of poor children. Strangely--but maybe significantly--except for a reference to "relief," Cole seemed to ignore economic conditions. Her children vividly recall experience, yet that experience never seems to include evidence of poverty or deprivation. The slums of Los Angeles seemed a little too antiseptic. Of course, as in *Days of Hope and Glory*, the British film about London during the blitz days of World War II, children may have accepted what seemed to adults dreadful as the regular, as the ordinary way of life.

Finally, Cole's belief in self-expression ultimately denied to her one of the richest sources of children's experience: their cultural heritage. Although some students' work did show the influence of art work seen in Catholic churches, no other culture than the dominant one were reflected in her book's illustrations. It never seemed to enter Cole's consciousness that she and her students should seek out the historic art work of Native Americans, Mexicans, or Asians to use in learning about art. Yet her students were heirs to these and other cultures. Interestingly, Cole used the slang associated with jazz ("Make it swing!") in her teaching, and she had African American students (Dover, 1960). At the time Cole wrote *The Arts in the Classroom* there were or had been a number of well-known African American artists (for example, Henry O. Tanner and Raymond Barthé) and a good measure of African American folk art. Perhaps in her later

book, *Children's Arts from Deep Down Inside* (1966), Cole showed some, though slight, awareness of cultural heritage. For the most part she was resolutely Eurocentric, insofar as she showed any interest in the majority of the world's art. Again, despite the vividness of Cole's contribution to teaching art in public schools, her methods were not sufficiently connected to visual art as a whole community uses it, past or contemporary, to help free art education from the orphan status. Her students never learned that art, as they made it, was the child of their families' cultures, or even of the dominant culture of America of their time.

Considering that these children lived in Los Angeles, it might seem rather strange that movies are never mentioned in *The Arts in the Classroom*. Although the children may have been too poor to go to a movie theater, Disney cartoons and cowboy imagery were everywhere. Such popular imagery is part of the child's experience but did not find expression in the art work Cole chose to recognize.

NOTES

1. This information was obtained from an interview (1982) with John Michael, one of Lowenfeld's doctoral students. A transcript of the interview with Michael is in the author's possession and can be obtained by a third party if permission is granted by Michael.

2. I wish to express gratitude to John A. Michael and the Miami University Center for the Study of the History of Art Education for use of materials from the autobiographical statement of Natalie Robinson Cole, who also most kindly and patiently helped me, provided photographs, and did all in her power to improve the article.

3. Natalie Robinson Cole in interlinear notes on my drafts, always wrote her name as Mrs. Cole.

4. Cole, personal communication, July 9, 1983 (hereafter cited by date).

5. Cole, *Autobiography*, paper presented at Miami University, Oxford, Ohio, May 19, 1976.

6. Cole, July 9, 1983.

7. *Autobiography*.

8. Cole, July 9, 1983.

9. Ibid.

10. Ibid.

11. Cole, personal communication, May 26, 1983 (hereafter cited by date).

12. *Autobiography*.

13. *Autobiography*.

14. Cole, May 26, 1983.

15. Ibid.

16. Ibid.

17. Cole, personal communication, n.d., 1981.

18. J. A. Michael, *Development of a Center for Historical Research in Art Educa-*

tion. presentation at the National Art Education Association Convention, Detroit, March 1983.

19. Michael interview.

20. However, now I feel that another study should have been undertaken with the possibility in mind that Cizek and Scheyer shared knowledge of some German-language studies or that Scheyer believed in some of Cizek's notions. Thus Cole would have been more closely related to Cizek than I thought.

21. Proust's narrator mused: "We never see the people who are dear to us save in the animated motion of our incessant love for them, which before allowing the images that their faces present to reach us catches them in its vortex, flings them back upon the idea that we have always had of them, makes them adhere to it, coincide with it" (p. 815).

22. The "little sentences" are explained later in the chapter.

23. Cole was over seventy years old at the time.

24. Michael, *Development of a Center*, 1983.

8

Gender and the History of Visual Arts Education: Survival and Disappearance

When one considers the population of art teachers in public or private elementary and secondary schools and then looks at the usual listing of "heroes" of art education in, for example, Eisner's *Educating Artistic Vision* (1972), there seems to be something askew. Dow, Victor D'Amico, Read, Lowenfeld, and Barkan leap from the page but it takes rather longer to find women's names. The prominence of Natalie Robinson Cole is the exception that suggests the rule. Part of the exception's cause was the unusually attractive format of *The Arts in the Classroom*, and part of it was the effective and frequent public performances Cole undertook. She publicized herself, while the names of many women art educators less inclined to public performance have sunk out of sight. What are the causes of these disappearences? In this chapter and the next I will attempt an explanation through an examination of the careers of Jane Betsey Welling and Eugenia Eckford Rhoads, two once-prominent women art educators.

ISSUES OF GENDER: JANE BETSEY WELLING

Both Erickson (1979) and Stankiewicz (1982) have described the phenomenon of the woman art educator prominent in her own time, but absent from later histories of art education. Both have presented reasons for this fading away. While I accept the strong possibility that the invisibility of certain women in the history of art education is linked to their gender, in this chapter I will critically examine the characteristics that Erickson and Stankiewicz felt to be the causes of this vanishing. I will do this by comparing and contrasting these characteristics with the art educator Jane Betsey Welling, a figure who has vanished as thoroughly as Erickson's Miss Robinson of the Ohio State University or Stankiewicz's Syracuse Ladies. In the next chapter I will discuss an "alternative" career similar to that pursued by many women who are not

mentioned in conventional histories of visual arts education.

Erickson advanced, and Stankiewicz adapted, a set of seven characteristics to account for their subjects' vanishing. Erickson especially emphasized Robinson's lack of self-identification as an art education researcher (see Chapter 6). However, I am sure that when the name of a once well-known art educator no longer seems to be readily recognized, few-Erickson, Stankiewicz, or this writer--would claim that being a woman ipso facto makes for invisibility. If gender inevitably meant that women become unpersons in art education history, we would not recall Belle Boas or Natalie Cole. Nevertheless, it is noteworthy that the male art educators Herbert Read and Lowenfeld have been subjects of lengthy dissertations (Hollingsworth, 1988; Keel, 1960; A.P. Simons, 1968; Smith, 1983), but Margaret Mathias has not. Mathias wrote three widely used art education texts, and her lack of place in recent art education history publications is evidence that some historical process that might include gender prejudice could be at work. My purpose in this place, however, is to examine the power of explanation offered by the Erickson-Stankiewicz list of characteristics, which I will later restate, in light of the case of a once significant and powerful, but now forgotten woman art educator.

To test the Erickson-Stankiewicz descriptors I will first briefly narrate happenings in the life of Jane Betsey Welling (1897-1970), one-time head of art education at Wayne State University. I will then compare Welling's behaviors, beliefs, and actions to the characteristics that Erickson and Stankiewicz identify as causal factors in obscuring the careers of Robinson and the Syracuse Ladies (Stankiewicz, 1982). I will treat the Erickson-Stankiewicz formulation as if it were meant to be a covering-law (Hempel, 1941). Erickson (1977) describes such a notion as a "Model of [historical] explanation according to which a particular event can be explained by demonstrating that the event manifests conditions under which some law or generalization applies" (p. 24).

Neither Stankiewicz nor Erickson claims the seven characteristics are necessary or sufficient conditions for one predictable result. Indeed, there exists a danger of exaggeration if we claim that the intent of Erickson and Stankiewicz, in their respective studies, is to prove certain behaviors supposed to be characteristic of women can be absolutely equated with career failure, in the sense of their work being forgotten. However, by raising this question, I hope to stimulate thought on what I regard as an important issue in the history of art education.

WELLING'S LIFE AND CAREER

Welling was a descendent of Quakers who had settled in upstate New York's Washington County, an area several centuries later made familiar to the general public by the paintings of Grandma Moses. Upon her retirement, Welling became president of the county historical society and wrote a four-volume

history of Washington County, *They Were Here Too* (Herrington, 1971). These volumes were not Welling's first books. She had co-authored a book in 1923 (Welling & Calkins, 1923), had written a book by herself in 1927, and had co-authored a three-volume series for elementary school teachers in 1939 (Welling & Pelikan, 1939). During her career she published articles in *Progressive Education* (1937a, 1939b), *Design* (1935a; 1935b; 1935c; 1937c; 1938; 1943a; 1943b; 1945; 1949b; 1953), *Childhood Education* (1931; 1949a), *School Arts* (1924; 1930; 1939a), and various states' education publications (1932; 1937b). From the 1930s until 1968 she was listed as a member of the editorial board of *Design*. During her retirement Welling began a book, never published, that would have been titled, *The Art of It All*.[1]

Like Erickson's Robinson, Welling was a Columbia graduate, receiving her bachelor's degree in 1917 and her master's in 1929. The Columbia Teachers College of her undergraduate days was that of Frederick Bonser, Edward Thorndike, William H. Kilpatrick, Patty Hill, Sallie Tannahill, George Cox, Arthur Wesley Dow, and John Dewey. It was one of the most intellectually powerful education and art education institutions American education has ever produced.

In Welling's final and unpublished manuscript she describes the intellectual excitement of her undergraduate days, mixed with the restrictions on young women's freedom, the abrupt changes in American society wrought by World War I, and her personal reactions to Columbia. A section from this manuscript preserved by Welling's former assistant and student, Erika Ochsner Luitweiler, provides a wonderful picture of a great moment in American education:

Teacher's College, in my day, was divided into two co-equal schools--Education for the older and "graduate," and Practical Arts for freshmen, young and green. The School of P.A. was a new venture into a new area of curriculum. No one knew what to do with its student body. Those becalmed on the upper levels were aghast at the exuberance of those younger. Neither group realized that it had anything in common.

Arthur Wesley Dow came from Brooklyn's Pratt Institute to build an Art Department for Teacher's College, Columbia, when it was a new idea in the professional education of teachers. He was a great teacher. His influence stretched nation-wide. He said to us often:

"Art is choice. The quality of the art depends on the fineness of each choice. That is all, but all must be free to choose and by choosing come to know what equality and truth are."

By 1913, Frederick Gordon Bonser was influencing an elementary school program in which the child was focus and core; all of man's rich heritage was the content; and active participation was the method. Each classroom was alive with material for creative activity and research. Dr. Bonser called the area "Industrial Arts." The name matters little. It was the vitality and depth of the concept which counted. There was so much to experience, to learn, to do, to be. For him, widening horizons was as important as breathing. His quiet humor, warm smile, and strong convictions about the worth of each individual were stimulators to learning more and more.

I owe to Dr. Bonser, my first actual flight into the upper air. The plane was an

open one-engine wooden crate. The flight was over New York City and its harbor. As the pilot took off, I threw my pocketbook over the side. It seemed that I could have no use for it up there. The overall view which came with that first flight was so exhilarating that I have never since been satisfied with seeing only facades from the ground.

In my day, the problem of the undergraduate had not yet been solved by assigning incipient doctoral candidates to teach him. We had "The Masters" themselves. John Dewey taught Philosophy down the hall. Elsie Clapp, later a pioneer in Community Schools, read "the papers." We followed Dewey as he made his way slowly across campus, talking his thoughts aloud and pausing regularly at the same tree as if to get its reaction to *The Idea* which [he] was laboriously formulating. His lectures required attentive listening. We heard "Art as Experience" being structured into what later became the book.

Edward L. Thorndike, at the other end of the hall, was setting up measurement practices using students, not rats or apes as "subjects." His procedures were as the Laws of the Medes and Persians to educational psychology for thirty years. His courses wore me down. When the hour ended, I ran fast for a chocolate soda pick-me-up. Dr. Thorndike always arrived a few minutes later. He drank a chocolate soda too, and read Adventure Magazine. On a high stool with his heavy black mustache dripping, he had a twinkle in his eye which never came with a desk and class before him.

William Heard Kilpatrick was then beginning his long service in interpreting the Dewey Philosophy for classroom use. He could teach as he talked about teaching. That is a rare gift. "Kilpat" used group participation, discussion and dynamics effectively and significantly, even when his classes were so large that they overflowed into the halls around the Horace Mann Auditorium.

James E. Russell, "The Old Dean," managed the college expertly. His self-appointed helper was Housekeeper Fanny Morton, who explained in cockney accents, keys jangling at her snug belt: "Me'n the Dean run things here." She was a staunch friend if she liked you, but an implacable foe if she suspected you of disrespect for her polished precincts.

Professor Patty Hill's Kindergarten was nearby. It was child-centered and crowded. It became festive for teas, formal for visiting celebrities, and giddy with impromptu dances "after hours." Paderewski, sometimes, played the piano there. It was before he was called to be Premier of Poland. Organization was simple then. Things happened without much publicity, pre-planning, and elaborate committee work.

F. M. McMurray held seminars in Problems in Education. The discussions were heated and humorous; the groups were small. Willistyne Goodsell taught History of Education related closely to the larger fabric of history which Prof. Bambrill tied into the happenings of that day. Anna Cooley and her staff were setting up Household Arts as reputable studies dependent on science, sociology, art and other fields of endeavor. Mary Schwartz Rose gave a bottle to her baby on the window ledge at proper intervals while she lectured on "Feeding and Family." Mary Barber, later to devise Kellogg's Educational Services and act as Chief Dietician for the Army in World War II, taught short elective courses in food conservation and demonstrated how each ingredient contributed to the mix. We were at that hungry age, and Marilyn Miller had not yet strolled down the center ramp at the Ziegfeld Follies and made "the boyish figure" the style. Annie Goodrich was beginning to see Public Health Nursing as a need on a

national scale, but she found time to be a personal friend and to confess that she wrote poems.

Sallie Tannahill had copper hair, a faintly Southern accent, and wore burnt orange scarves. She saw design in space so convincingly that her "P's and Q's" of lettering helped us to earn extra on the side for lay-out and poster making. George Cox went off to England to "do his bit" in the war and returned to teach ceramics, life drawing and sculpture with his immaculate kerchief still tucked up his sleeve. He loaned his fine books generously. Edward Thatcher taught metalcraft and sometimes, of an evening, played his one-man-orchestra contraption at impromptu dances. Charles Martin studied in Paris and returned so "modern" that his most scathing comment was: "That's impressionistic." Claggett Wilson's suave manners knocked us for a loop. He was our dream of that sophisticated outer world we aimed to reach some day.

In later years, Irwin Edman called 120th Street "the widest street in the world." It separates Teacher's College from the Columbia campus. There was little crossing for a long, long period. Every school, even every department within a school, chose to go it alone regardless of students who had to face lives which held no such easy compartmentalization.

As always, some few shopped around cautiously. I found John Erskine before he wrote "All About Eve"; James Harvey Robinson and "The Mind in the Making" before he opened the New School for Social Research after being relieved of his contract at Columbia because he thought war a foolish, and not inevitable, way to settle disputes between nations; Hugh Black and "Comparative Religions" at Union Theological; Lewis Brown and "This Believing World"; John Haynes Holmes of the earliest Community Church; Rabbi Stephen Wise; Chinese Poetry; food at the old Bamboo Forest; the Provincetown Players next door at MacDougall St. with Eugene O'Neill's "Great God Brown"; Slavic Literature; Montaigne in Philosophy and the School of Architecture's Avery Library. There was time for extras in those days.

When I was struggling with practice teaching, I had two extra-curricular experiences which helped me to overcome the defeating grind. One was with George Luks in his old loft studio in downtown New York. Another student had told me you could go there for a small fee to paint from a model. Luks found his "subjects" on the streets outside. He was a lusty, heavy man who revelled in wet paint. One afternoon, within a few hours' span, we saw him make three pictures on a huge canvas from a decrepit rag-bag of an old woman, battered straw hat awry and a fat hen on her ample lap. Each time as we gasped at his success, he smeared the picture back into the canvas and slung on more paint to bring it out again in another form. It was magic. Someone had to grab the product to save it as a permanent picture. Luks, in that mood, cared not at all for the finish. He worked until his energy was gone.

Another salutary experience was with William Zorach, the sculptor who was a first to find remunerative satisfaction in teaching young children in the elementary grades as well as older students at The Art Students' League. I journeyed by train to Rosemary Junior School at Greenwich, Connecticut, because I knew Ellen Steele and Florence House, who taught regularly there. Zorach could produce miracles with children. He had no "methods" in terms of the pre-ordained and clumsy method which I was being taught to practice. He only knew how to help children to express themselves in art materials and forms. I still cherish a "Madonna and Child" block print which I saw a six year old create before my eyes. She gave one of the prints to me because, as she remarked, "The block is mine and I can make more." The children cut directly into the

wood "like real artists" and carried out the entire process to "pulling off" the final print. Zorach was relaxed and never acted like the teacher. I caught the glimmer of a star that December day on that unofficial observation which gave me an impetus which even the sad hours in practice teaching at a dreary public school in Harlem never dimmed.

Ours was the generation on the brink of World War I. Childhood and early adolescence had followed familiar patterns in use since our grandparents' time. Our anchors were in the nineteenth century. Now *A New Age*, teeming with firsts, caught up with us. The maelstrom swept us, willy-nilly, out of the groove and along with the "Whoopee." We were in our late teens.

Those older had much to do--war work, Liberty bond drives, farewells to 4,000,000 "boys" off to army camps-drafted, jobs for women never open to them before, food conservation, rationing, victory gardens.

Those younger were growing up to be "Flaming Youth"-the Flappers and Ha-cha Boys of John Held's cartoons in the "rarin'-to-go" twenties. We were either too young or too old for what shaped up so tumultuously and without warning. We stood by, watched, and wondered what had happened to those formalities and people we thought we knew. Ours was later called "The Lost Generation."

Our early college years had seemed so sure and secure. Our problems were strictly personal. There was no outer world, though T.N.T. was quietly accumulating which would smash the smug, cautious isolationism of 1910 into irretrievable bits.

On week days, the rule was: "At study alone in one's room at nine." That caused manipulation, for the Little Nemo's first show lasted to 9:15. We either missed "The Final Clutch" or we were late. It was worth demerits in that era of John Gilbert and Theda Bara. We solved the dilemma by climbing up the fire escape until the night we were summoned to a special session and told, mysteriously, that the Little Nemo was "out of bounds." It cost a dime for admission, and was within walking distance down Broadway. Neither whys nor wherefores were given. Our most diligent research failed to uncover a more reasonable reason than a rumor that a door inside led into an adjoining bar. We were warned never to sit on a Riverside Drive bench nor to go out to mail a letter after dark.

On Saturdays, we were allowed "time out" with special written permission signed by The Office. The night watchman had a duplicate record. The minutes after 11:00 were hard to explain. One evening, the Columbia Gym burst into flame just as we came by "on time." It was a circular stone building which became a kettle of sparks, smoke and fire. At midnight, it was under control, but we could not go in so late. We pooled our resources and slept three in a bed at a nearby hotel to which the boys escorted us. Our return for breakfast was unheralded. Anyone could enter day-times, even from a night out.

There was an approved list of public dining places, but, unchaperoned, we could go "only with a relative closer than a cousin" or the home town clergy. Chaperones cost dearly then, and college boys are perennially low in funds. There were signs near the elevators which read: "Any young lady found smoking will have her trunk packed automatically."

With World War I, the Grand Change began, abruptly and hectically for us. We were sent off in small bevies, without chaperones and in full evening dress, to entertain "The Boys in Uniform" as a patriotic duty. We had no experience, and the lectures in Hygiene never seemed to fit the case in hand. We went because the drums

were beating everywhere. Life was promptly without structure or rules. We ran, like breathless players in a game we couldn't grasp, improvising and hoping there would eventually be "time-off" to total up the score.

World War I had no aftermath of jobs galore. There was no G. I. Bill for further education. Some veterans, even war heroes who had volunteered, sold apples on the street corners. Some retreated into local jobs and uncommunicative habits. Others, hurt by neglect in the midst of plenty, succumbed to "pie-in-the-sky" and clutched at any pipe dream as vent for their thwarted unused energies. Still others hoed assiduously whatever rows were near and lived on the faith that time would change all things with little conscious help from mortals.

The twenties were, in retrospect at least, "The Great Awakening." Geographic horizons crossed the oceans and became the whole world round. The Depression was world-wide. It hit us all. We learned on our own doorsteps that our economy depended on that of others far away and unseen.

When I returned to my Alma Mater in about 1929 to take a Master's Degree, I had become a number in a seat. No one knew my name except on a record. No one cared whether I, in the flesh, personally, was there or not. All informality was gone. The lecture method, to large class groups, was in full swing. The marks on tests were posted by number. No one knew anybody, nor much of anything except the routines. The lectures were on how and what to teach people. (Welling, in unpublished manuscript)

Despite the impressionistic style of Welling's manuscript, she gave sufficient information to piece together a historical picture of Teachers College and the era of her professional education. By the time Welling was ready to continue her studies she had matured professionally enough to try to record and disseminate some of the ideas about teaching art she had developed in practice. Before she returned to Teachers College for her master's degree, Welling and Charlotte Calkins published *Social and Industrial Studies for the Elementary Grades* (1923). The subject of this book is what we would now call integrated or correlated studies. To avert the danger that art would be submerged in such studies (Freyberger, 1985), this careful statement was included in the Preface:

The art teacher has a large contribution to make, for art as well as language is a necessary means of expressing feelings and ideas. Written records at best are sometimes inconvenient or inadequate tools. Because art is graphic and can be seen at a glance, it is many times the more vivid way of conveying feelings and ideas to others. Art is never separated from life because the moment one expresses himself in any visible way, the expression has to do with choices and arrangement. (1923, p. xxvi)

In her autobiographical statement Welling recalled Arthur Wesley Dow saying, "Art is choice. The quality of the art depends on the fineness of each choice." In her first book she continued from this Dowish notion with a more Deweyish strain: "Experiences and activities like those connected with social and industrial studies stir the imagination and arouse the desire for personal

expression. They supply the joy that makes even crude results of definite art value." (Calkins & Welling, 1923, p. xxvi).

At about this time Progressive Education had split in the aforementioned Naumburg-Dewey debate about the role of art in the schools. Followers of Naumburg saw art as a means of self-expression serving a psychological function for the individual. Followers of Dewey saw art as an area of study helping in the understanding of societies, social relationships, and so forth (Beck, 1959). Welling proved to be a Deweyite in this book and in most of her writings.

The same year that her first book was published, Welling (1923) spoke at a meeting of the American Federation of the Arts and urged that art work not be isolated from other school subjects. She referred to Dow's emphasis on awareness of design in the environment and in everyday life. She deplored the reduction of art history to picture study and wanted architecture and industrial and craft objects studied as well. In contrast to some creative expression advocates of her time, Welling called for teachers to acquaint children with the art works in museums.

In 1924 Welling again addressed the issue of art's peripheral role in the schools, but this time in more political terms. The Carnegie Foundation had issued a report "claiming art to be non-essential" (Welling, 1924, p. 181). She searched through the National Education Association's *Journal of Education* to find out what sort of things were being said to administrators and teachers about art in general education. She found art rarely mentioned. Her reaction was to urge art teachers to form one of the committees that headed departments in the National Education Association so that the views of art teachers could be put before the whole membership. Welling carried through the desire to see art teachers organize, and from 1938 through 1940 she was vice-president of the Art Education Department of the NEA, the forerunner of the National Art Education Association. She was also active as a member and officer in the Western Art Association, including serving as the organization's president.

She published her only solo art education text in 1927, *More Color for You: Color Study Developed by the Experimental Method.* In this she describes a number of projects for grades one through six. The book presented a series of investigations she had conducted earlier to see how color preference changed with age (Welling, 1927), from which she concluded that choices grow more timorous as students advance through the grades. The book seems to have grown from lessons intended to counteract fear of using color freely. Despite the book's subtitle, the lessons are exploratory or discovery-learning activities rather than experiments meant to develop new knowledge. The methodology presented avoids lectures or excessively long explanations meant to be read by students: "We are slowly pulling away from books and printed words as substitutes for experiences and actions" (1927, p. 13), a typical Progressive Education statement.

Welling always wrote in a forthright style, avoiding the rhapsodic affecta-

tions of, for example, a Henry Turner Bailey. In social situations she was described as "outspoken,"[2] and her writing style had unabashed directness, touched at times with humor. She held an interest in visual humor, and in *More Color for You* she used chapter tailpiece drawings-little cartoon figures. She had a lifelong interest in cartooning[3] which was to show up again in an article published during World War II (1945).

By May 1930 Welling was prominent enough in the art education field to write one of a series of statements of belief published in the beginning pages of each issue of *School Arts*. By 1930 she had been director of art education for Detroit Teachers College for three years.[4] In September 1930, Teachers College merged with City College, forming an institution named in 1934 Wayne University (Hanawalt, 1968).

In 1939 Welling co-authored with Arthur Pelikan a three-volume series called *Creative Arts*. Filled with stereotypical images lacking the freshness of Welling's drawings in *More Color for You*, these volumes suggest a lack of faith in teachers' ability to set up open-ended situations that might lead their students to discover art-related concepts or that might allow students freedom to arrive at individual solutions to visual challenges. These *Creative Arts* volumes were recipe books of the most deadening kind, presenting stereotypical imagery and rigid directions for producing equally stereotypical pictures. Since Welling elsewhere seemed to want to empower the teacher and student, I am reluctant to believe she had control in this publication, but I cannot understand why she allowed her name to be associated with it.

In that same year Welling published an analysis of what the Progressive Education Movement had done with and for art education that was far more stimulating than *Creative Arts*. This article comes close to being a statement of Welling's philosophy. Referring to the need for art in education, she writes that the arts "must be there as means and not as ends; as experience, as ways of working for many or for few, not as objects for themselves, or as research for itself, or as time fillers when one is weary, or distraught, or unbalanced, or handicapped" (1939b, p. 312).

Although Welling saw art as "preventive" as well as possessing "curative values" (p. 308), her focus in 1939, as it remained to the end of her career, was on art for everyone in everyday life. As her one-time student Harlan Hoffa points out, Welling was a product of Teachers College, Columbia University, and "her own thinking was probably influenced...by the Owatonna Project and [the] Faulkner-Ziegfeld-Hill book, *Art Today*" (Hoffa, personal letter to author, February 27, 1987).

After 1939 there came a gap of a few years in Welling's published work. The reason for this has to be guessed, but one event in her life may be sufficient to explain it. Unlike Robinson, or for that matter Mathias or Belle Boas, Welling made a decision to obtain her doctorate in art education. While she pursued her studies at Columbia, her name was mentioned in the acknowledgments of New York art educator Rosabell MacDonald's *Art as Education* (1941). The disserta-

tion that climaxed Welling's doctoral studies had a distinctive title, *The Art Workshop: '166 and All That, a Study of Education in Democracy* (1942). Since dissertations are usually earnest if not dour efforts to prove the writer is a serious scholar, it must have taken some force of character to propose a humorous title. It is probably not a coincidence that in the November 1942 listing of editorial board members for *Design*, Welling's academic rank changed from associate professor (as listed in the previous issue) to full professor. In art-related fields the doctorate was not common in the early 1940s.[5] Welling demonstrated her mastery of the male-dominated and usually inartistic world of academe.

WELLING'S LATER CAREER: FROM WORLD WAR II TO 1970

Welling completed her doctoral studies after the United States entered World War II. Like so many other art educators, she urged teachers to participate in the war effort through classroom projects (1943b). Her own response to the war was to organize a pan-American display (1943a) to stress consciousness of the peoples of the hemisphere. This nonjingoistic response might be traced to her Quaker background.

Beyond Dow and Dewey, Welling made few published comments on art educators who were her contemporaries. While she made statements about the psychological value of art education (1949b) that might have been stimulated by Lowenfeld's *Creative and Mental Growth* (1947), she did not cite him. She continued to stress the ultimate social function of art, saying "individual art expression makes its way into group consciousness and becomes part of the group's resources and values" (1949a, p. 300). One figure Welling did name was Natalie Cole, and she singled out Cole's *The Arts in the Classroom* as "amazing" (1949b, p. 7), even though Cole's lack of emphasis on the social role of art was not entirely congruent with Welling's writings.

Looking at her career, it seems a great loss that she never saw fit to use her interest in history, as manifested in her role as a local historian during her retirement years in her ancestral home in Easton, New York, to write about art education history beyond the excerpt from her unpublished book I have included in this chapter. She might have given firsthand accounts of the period from the 1920s through the depression, World War II, and the dawn of the Lowenfeld era. She did not write such a history, so I am left wondering what circumstances led Manuel Barkan to express gratitude for her criticisms of the manuscript of *A Foundation for Art Education* (1955, p. viii). Why did another art educator, Rosabell MacDonald (1941), state that Welling had been of great assistance in the preparation of her text, *Art as Education*? What was there about her ideas that Barkan and MacDonald found so valuable, helpful, or insightful? These questions remain unanswered. If they could be, they might tell us more about the "vanishing" of Jane Betsey Welling than the quasi-feminist covering-law that has

been advanced to explain other disappearances from the history of American visual art education.

THE ERICKSON-STANKIEWICZ ANALYSIS AND JANE BETSEY WELLING

What is the Erickson-Stankiewicz listing of characteristics that have supposedly proved fatal to the survival of women art education's fame?

Stankiewicz (1982) lists seven characteristics of the Syracuse Ladies (women who were faculty members in the early years of Syracuse University's art department). Stankiewicz feels that these characteristics, based in Erickson's 1979 study of the career of Alice Robinson, led to the Syracuse art educators being forgotten, as they had caused Robinson to be forgotten according to Erickson's analysis. Having presented a narrative of Welling's career, I am now going to list Stankiewicz's seven characteristics and check them against the experiences and behaviors of Welling. As I have already stated, my intention in doing this is to see how effective the Erickson-Stankiewicz formulation might be in explaining the phenomenon of the vanishing woman art educator, but my ultimate goal is to think about why women are not better remembered in the history of visual art education.

1. The subject seems not to have made a distinction between personal and professional life (Stankiewicz, 1982, p. 31).

 This was certainly true of Welling. Interviews with Welling's neighbors indicate that she formed life-long friendships with her students.[6] An undated alumni publication from the Wayne State University archives mentions that during the depression years she often fed her students and entertained them in her home. However, I believe this first-listed characteristic to be the least convincing descriptor Stankiewicz presented. Some types of female and male art educators do not differentiate between their professional and personal lives. For example, Lowenfeld sometimes had students living in his home (Smith, 1983), and he explicitly stated he did not cease to be an art educator in or out of the classroom (Mattil, 1982).

2. The subject was an unmarried woman with personality traits which fit the stereotype of an "old maid" in the culture of early twentieth-century America (Stankiewicz, 1982, p. 32).

 While Welling never married, she does not fit the stereotypical reserved and rather reticent "old maid" Stankiewicz had in mind. Her direct, slightly brusque writing style suggests a very strong personality, and her students (Hoffa, personal letter to author, February 27, 1987) corroborate this. There was nothing frail or wispy about her personality. If we look to another age, she might be compared to the redoubtable Elizabeth Peabody, the unmarried sister-in-law of Horace Mann and Nathaniel Hawthorne. Or perhaps in a

different era she might have become a powerful abbess, striking terror in the hearts of the local clergy. In dedicatory remarks on the occasion of the opening of a sculpture garden named in honor of Welling, there are phrases to the effect that she was both "loved and admired" and "hated and feared."[7] These are hardly the retiring and timid attributes of the stereotypical spinster who made no lasting personal impression.

3. The subject had little professional power or recognition. (Stankiewicz, 1982, p. 32)

As Welling's work in NEA and her leadership in art education at Wayne State suggest, Welling knew how to obtain power. As suggested by the preceding references to MacDonald and Barkan, she was recognized as an important colleague in her lifetime by outstanding women and men in her field. Indeed, this author owns a copy of Barkan's *Foundation for Art Education* with Barkan's handwritten thanks for Welling's advice.

4. The subject seems to have viewed herself as an artist or art historian, spending her free time making and studying art (Stankiewicz, 1982, p. 32).

While there is no reason to believe Welling did not develop studio skills and she did in fact teach art history, she concentrated on how and what to teach in her writings, urging art teachers to organize as teachers for the schools. Hoffa has stated, "I must...confess that, at this point in time...several decades after the fact...I cannot remember a solitary piece of factual information that I ever learned from her, though clearly there must have been some" (Hoffa, personal letter to the author, February 27, 1987). However, Hoffa has not suggested that Welling as a teacher ever ignored issues related to teaching art. In the sculpture garden dedication ceremony her strength as an educator was described as her ability to infuse people with the belief that they could accomplish everything they needed to in their life tasks. In other words, she seems to have embodied the-teacher-as-inspirer model. Hoffa recalls her as a teacher of energy and drive, a model for behavior, if not a teacher with very obvious theoretical ideas. He felt Welling had interpreted contemporary art education thoughts to her students, rather than trying to make them into researchers or theoreticians (Hoffa, personal letter to the author, February 27, 1987).

5. The subject saw advanced academic work in art education as less important than practical or studio work (Stankiewicz, 1982, p. 32).

Welling's successful effort to obtain a doctorate in art education from a prestigious university seems to fly in the face of this characteristic.

6. The subject held a fatalistic view of art teachers, believing that they are born, not made (Stankiewicz, 1982, p. 32).

I have found no explicit refutation of this view in Welling's writings--nor any support for it. Yet her supervision of art teacher education at Wayne State and her responsibility for the development of art teaching skills in her students at least imply a belief in the utility of teacher preparation.

7. The subject taught about art or how to make art in her art education classes

but paid little attention to talk about art teaching (Stankiewicz, 1982, p. 32).

Welling's interest in didactic exhibits (1943b; 1937a) suggests that she demonstrated how to teach with art. She was interested in her students' developing studio skills and knowledge of art history. However, she also made them aware of the ideas of then-contemporary art educators, although she seems not to have insisted on much reading in the field's literature (Hoffa, personal letter to the author, February 27, 1987).

To summarize, Welling does not clearly fit these seven characteristics applied by Erickson and Stankiewicz to Alice Robinson and the Syracuse Ladies. Welling was assertive. She did not, according to her niece,[8] accept male dominance in her personal or professional life nor subscribe to Robinson's notion that men are the natural leaders (Erickson, 1979). Her niece recalled Welling's derisive description of her meeting with other university department heads as "getting together with 'the boys'." Further, Welling's niece went on to say that Welling had given her a "feminist education." Despite assertiveness and intellect, her ability to wield power and win the respect of her male and female peers, memory of Welling is fading away with the retirements or deaths of former students. Logan (1955) failed even to mention her in his history of the field published only five years after her retirement. Part of this might be traced to American art education's neglect of its own history, and perhaps part to Welling's sex. But despite her gender, her disappearance cannot be satisfactorily explained by the Stankiewicz-Erickson formula used for Alice Robinson and the Syracuse Ladies.

EPILOGUE

The one characteristic that I have not addressed that was listed in the Erickson-Stankiewicz (Stankiewicz, 1982) set of characteristics is the female art educator's self-identification as an art education researcher. Erickson (1979) implied that Miss Robinson, as Erickson refers to her, might have been a less-forgotten figure if she had been more of a researcher in art education and had published her findings. Alice Robinson (1923) vigorously urged abolishing supervision which interfered with well-trained teachers' selections of appropriate lessons; Robinson urged incorporation of library research skills into teacher training and regional supervisors of art in each state who could be in constant contact with the schools. Yet Erickson argues that Robinson lived in a more or less primitive age of art education in which the field was preparadigmatic and lacking a pervasive theory and that Robinson identified with the roles of artist and historian, not educator. An alternate reading of the Robinson article cited by Erickson, "The Passing of the City Supervisor of Art," could suggest a figure of some force, but Erickson felt the article hinted at modes of thought which, when combined with the seven characteristics already discussed, led to Robinson's

suprisingly swift oblivion.

I would trace Welling's disappearance to quite different weaknesses. What Welling lacked was a powerful idea that (1) seemed markedly different from prevailing notions in the art education field of her time and (2) that met her time's most intense yearnings. Despite her apparent independence of personality and professional action, Welling was held in intellectual thrall by her Dow-Dewey background. Although that background had considerable theoretical and practical force, as can be seen in the continued respect for Dewey's *Art As Experience* (1934), Welling never seemed to be able to give fresh emphasis to it, to make it a new thing that would be attached in people's memories to her name. She did not have the anthropological-sociological background of June King McFee or Manuel Barkan, for example, to give new vitality to the social-concerns strand of American art education. Although Welling was certainly humanistic in her outlook, she never drew together in one text notions about psychology, child development, the uses of art, and a vision of education, as did Lowenfeld (1947). After all, Lowenfeld's most important ideas were hardly more original than Welling's, but *Creative and Mental Growth* succinctly drew together various strands of creative expression in American art education and met the concerns of the field and society after World War II. Welling did some individual research (see 1927), but she published only a miscellaneous and unfocused group of articles that give no clear picture of her forceful personality nor an indication of why she was once a figure to be reckoned with by Wayne State colleagues and leading art educators. Barkan staked out a claim for intellectual independence in *A Foundation for Art Education* (1955) by a new emphasis on the social (in contrast to the individual) and by a reasoned criticism of Lowenfeld's visual-haptic theory. Even Belle Boas (1924) had differentiated her work from the creative expressionists and from the theories of Dow. Both Barkan and Boas had made their contributions visible and permanent in book form.

Have I said that gender has no relationship to the lack of prominence of many women in American art education? To that question I give an emphatic No. What I have wanted to demonstrate is that, so far, even the explanations of Erickson and Stankiewicz have not sufficiently clarified thet role of gender in the history of art education. No one can use these descriptors as if they could be a part of a covering-law that would predict the fate of an individual in art education's history or explain away without qualification the disappearance of so many persons who have made worthy contributions to the field.

And, as each generation of art educators passes, it is sadly significant that these names never seem to enter into the history of American education beyond the parochial boundaries of visual art education history, nor--unfortunately--do their names crop up in American artistic and cultural history despite all they did to keep American aware of art in our culture.

NOTES

1. I wish to thank Erika Ochsner Luitweiler of Doylestown, Pennsylvania, for information about Welling's courses and her unpublished book. Luitweiler was a student of Welling and was also her assistant. She maintained her friendship with Welling up to the time of Welling's death in 1970.

2. Genevieve Leone of Cambridge, New York, provided me with this characterization of Welling.

3. I wish to thank Betsey Reid, Welling's niece, for sharing her memories of her aunt as well as many suggestions for sources of information.

4. Patricia Bartkowski, assistant university archivist in the Walter P. Reuther Library of Wayne State University, provided me with many materials on Welling, including copies of a history of art education at Wayne State, "Up from the Basement, 1927-1977 (unpublished)."

5. An article on Welling from the *Detroit Free Press*, June 18, 1950 (n.p.) claims only 25 persons held a Ph.D. "in the art area."

6. I wish to thank Mary L. Smith, formerly of the Cambridge, NY, area for much preliminary research and for interviewing Welling's neighbors in Easton, NY, in 1986.

7. Dedication program for the Jane Betsey Welling Memorial Court. The sculpture court was dedicated May 16, 1976, and is located adjacent to Wayne State University's Art Center.

8. Betsy Reid in a personal telephone communication provided this and subsequent information about her aunt.

9

Of Women and Art Education: Roles of Importance

I repeat, the roles of women in American art and art education have been significant and ever present, yet the historical record of women art educators can only be seen as troubled by many vexing questions. Some of these issues have been related to the feminine stereotyping of art and the artist in the United States (Wayne, 1974). Some must be related to what might be termed sexist undervaluing of the contributions of women art educators in institutional settings (Lovano-Kerr, Semler & Zimmerman, 1977). The issue of women's lack of lasting impact on art education programs, especially in higher education, has been raised in the preceding chapter and elsewhere (Erickson, 1979), and the evanescence of memory of their work in the art education field has been decried (Smith, 1982; 1988).

Stankiewicz and Enid Zimmerman (1984) have looked at the complexities, the interrelationships, and the compounding effects of these issues. They have tried to make some sense of the peculiarities of women's roles in art education history by using the categories of "mainstream" and "hiddenstream" "Mainstream contributors to art education are those recognized by standard historical accounts of the field...In the mainstream, achievement is generally defined in masculine terms. Contributions are made to art education nationally, and the contributor participates in recognized power structures...The sphere of achievement is competitive, there is an emphasis on personal recognition and upward career mobility" (pp. 114-115). The characteristics are contrasted to the often unrecognized achievements of others:

Hiddenstream contributions often occur at the local grassroots level. They are personal, sometimes known only to a few people, or they may be cooperative, shared achievements. Hiddenstream contributors often seem anonymous to those outside the local area because they are rarely documented in standard written sources or journals that have national readership...a notable hiddenstream woman art educator could be

the retired art teacher whose contributions to art education are recognized by former colleagues and pupils who recount stories of lessons she taught, exhibits she staged, her contributions to a local art society, and her overall aesthetic influence on her community. (p. 115)

Stankiewicz and Zimmerman sought to persuade their readers that the hiddenstream contributors' achievements were very significant, perhaps as important to art education as a whole as those of the mainstream contributors. However, if "significant" and "important" are linked to mainstream notions of recognition and successful operation within power structures, a different and, historically for women, negative factor is added. Behind the various studies of the role of women art educators lurks the suggestion of success/failure. In other words, there is at least implied judgment of the worth of the careers examined. Jessie Lovano-Kerr, Vicki Semler, and Enid Zimmerman (1979), for example, documented that up to the near present, women's art careers in academe, as a whole, could not be considered as successful as men. Yet, success or failure are terms open to various interpretations and based on particular notions of what is worthwhile or worthless. There may be values that transcend the salary and rank criteria of the academic world. A wider public might view these concerns about rank, for example, as commotions in ivory towers. Often journal authors (i.e., academics) forget they are a tiny percentage of a larger field and that their views may not be shared even by elementary and secondary school teachers who outnumber them, to say nothing of the members of the art world or of the public beyond the schools.

In what follows I will look at the career of a woman art educator who chose a route that was not that of the male mode of "success." Yet, following certain "women's" roles, this person pursued a rounded art education career of significant impact. Indeed, she may have reached more persons in need of guidance in art teaching than most individual college art educators ever do, and she was an active supporter and patron in the art world, the world beyond the ivory tower.

AN ART EDUCATOR FOR ALL SEASONS: THE MANY ROLES OF EUGENIA ECKFORD RHOADS

The art educator whose career is to be described and analyzed is Eugenia Eckford Rhoads.[1] She was born in 1901 in Columbus, Mississippi, and lived most of her adult life in Wilmington, Delaware.[2] Although her father died while she was young, leaving her family with limited resources, Rhoad's mother, Corine Jamison Eckford, was a person of intellectual curiosity and vigor, and she saw to it that her children had every cultural opportunity. In the 1890s Mrs. Eckford had become aware of progressive education methods and used them in educating her own children. The family often went to an "unusual," as Rhoads put it, summer program in Monteagle, Tennessee. There Corine Eckford found

inspiration in the Progressive Educator Madge Bingham. Eugenia Eckford Rhoads fondly recalls afternoon concerts by members of the Bowling Green Conservatory of Music and the feeling of being surrounded by the arts. In honor of her mother, Rhoads was to dedicate her book, *Wonder Windows* (Eckford, 1931b), in these terms:

> To a mother who knows
> how little children
> love to make things
> this book
> is joyfully dedicated.
> This mother belongs to me.

Rhoads graduated in 1923 from the Mississippi State College for Women. Although the art department was so small that Rhoads had to major in English, she stated, "The head of the English department was Miss Mary Pennell from Boston (a cousin of Joseph Pennell).... Her enthusiasm for the arts and especially pottery was an inspiration for me. The hills around Columbus had fine clay deposits and Miss Pennell stressed using what we had right in our backyard".

One of Rhoads's (Eckford 1924) first publications, "The Baby Art Museum", came from her work in the Practice School of the Mississippi State College for Women and was published under the series heading "Helps for Primary and Grade Teachers" in *School Arts*. This article described students utilizing Picture Study in a manner rather different from the usual procedures of the time: "During the first session, as different pictures were studied, the children became interested as to where these pictures are now, and in what style of place such valued pieces of art were kept. Thus developed the subject of art museums...and the desire to build a little museum where they might put tiny copies of the masterpieces that they studied" (p. 432).

Although later Rhoads was to be a teacher in a Progressive Education setting, this early writing foreshadows the years of work she was to do in introducing adult art to children and, later, the general public. She seems never to have succumbed to the notion, promulgated in some Progressive Education circles, as mentioned before, that children should not be exposed to adult art.

From the Mississippi State College for Women, Rhoads went in the fall of 1923 to Teachers College, Columbia for her masters degree. She said, "It was a very inspiring year, for being in New York City was an education in itself. Also, under the philosophy of Arthur Wesley Dow, the art education at Teachers College dedicated itself to new methods of teaching art. Dow died in 1922, but his presence was felt in every class."

While Rhoads was attending Columbia, one of her teachers was Belle Boas and it was likely that Rhoads experienced some of the same educational stimulus described by Jane Betsey Welling (Chapter 8). As Welling described it, Teachers

College was then dominated by some of the greatest figures in the pantheon of American educational history. The art scene in New York was in one of its most vital periods. Rhoads later regretted that she missed a chance that year to meet an earlier student of Dow, Georgia O'Keeffe, by turning down a fellow student's invitation to go to an exhibition of that artist's work at the Stieglitz Gallery.

After graduating from Teachers College in June 1924, Rhoads began teaching at the North Carolina College for Women in Greensboro. After two years, Rhoads went to the Maryland State Normal School in Towson to teach and there made a major decision. Rather than continuing to teach teachers to teach children, she decided to teach children directly at the Tower Hill School in Wilmington, Delaware. "Some thought I was stepping down professionally," she explained to this writer, "but Tower Hill was one of the country's most outstanding progressive schools."

Indeed, the Tower Hill School's reputation was similar to that of the famed Walden School in New York City. Like that school, it was an elite Eastern school educating the children of the well educated. In *Creative Expression* (Hartman & Shumaker, 1932) reproductions of Tower Hill students' work appear beside work by students of Naumburg and Cane of the Walden School and other leading educators of the time. In a review of the Tower Hill yearbook for 1929-1930 Coe (1930) stated: "Art and Music are admirably presented in their range throughout the school, showing a consistent attempt toward the "making of a happy heart and clear thinking as he (the child) adjusts himself to this social world" (p. 51).

If this part of Coe's review makes the Tower Hill School seem to be a place centered on the group rather than the individual (in the Dewey mode of art teaching), she also wrote that for the individual child this school was a place for "opening out a way whence the imprisoned splendour may escape" (p. 50). This sort of rhetoric may now seem overwrought, but the reader of today might also see it as a real testament to the enthusiasm that was characteristic among persons interested in education during the heydays of Progressivism.

During her years of teaching at Tower Hill School, Rhoads had the opportunity to give in-service art workshops for teachers in Washington, D.C. There Rhoads met Helen Owen, editor of *The Normal Instructor and Primary Plans*, which in May of 1931 became *The Instructor*, a nationally distributed magazine aimed at providing instructional ideas and news for elementary school teachers. Owen wanted the magazine to offer teachers more information about teaching art, and so Rhoads began an association with *The Instructor* that lasted through June of 1942. Rhoads wrote monthly art appreciation lessons and numerous descriptions of art lessons for use by classroom teachers.

While Rhoads had already been a college art education instructor and an elementary- and secondary-level art teacher, by writing for *The Instructor* she began a phase of her career that might be termed mass in-service education. This included writing a series of Picture Study lessons. However, on saying that, it should be noted that Rhoads was able to do some things not common to Picture

Study practice (Smith, 1986), although the beginning years of her tenure at *The Instructor* coincided with the last years of Oscar Neale's Picture Study work. Recalling this period, Rhoads explained:

Many teachers had no materials, especially those in the Midwest. We got letters from teachers saying the articles on how to do art lessons with children were the first to awaken them to what art could be in the classroom.... For the [color reproduction] cover of *The Instructor* each month most pictures were work from the nineteenth century and only a few were contemporary. I did some discussion of elements and principles. I also did a biographical sketch of the artist.... The co-editors selected the pictures. At one point we wanted a N. C. Wyeth. I had become acquainted with Wyeth and we went out to his studio to select it. The cover picture was reproduced in color. Inside it was reproduced in black and white, about two by three inches...I was fortunate in having gone to Columbia for this analysis. We did not go into the more abstract, non-representational art.

While Rhoads did often discuss the nineteenth-century art that has been singled out as overemphasized in Picture Study (Hurwitz & Madeja, 1977), she used the very twentieth century formalist analytical method of Dow.[3] She also had the advantage of a large color reproduction (the magazine cover) rather than the often inadequate little images of the Perry Prints and other Picture Study providers of reproductions (Stankiewicz, 1983).

A WITNESS TO HER TIMES

After several years at Tower Hill School, in 1932, Rhoads felt her "life was at a crossroads." She considered going to a site in Michigan where a cathedral was being built and where the chance to live surrounded by craftspersons was "considered something...However, the experience of going abroad was more inviting. I didn't picture myself being cloistered!" She decided to break away from her American scene.

Rhoads had heard about the amazing work from the Cizek classes that had been exhibited during an international education conference held in Europe the previous year. The talk about this work made Rhoads decide to go to Europe. For half of 1932 Rhoads traveled in France, England, Germany, and Austria, the first six weeks studying painting at Fontainebleau. She then visited London to observe English teaching methods and then traveled to Vienna and stayed for nearly two months, where she observed both public school classes and the famous Cizek Juvenile Class. Rhoads apparently observed Cizek's class over a longer period of time than any other American visitor-writer concerned about art education.[4] Most certainly she spent considerably more time than Munro did for his frequently reprinted report (Munro, 1956; and see Chapter 4).

Austria at the time of Rhoads's visit had been financially ruined by World War I and its aftermath, and then it was dealt another blow by the worldwide de-

pression beginning in 1929. Speaking from memory of the Cizek classes of more than fifty years before, Rhoads stated:

I attended Cizek's classes on Saturdays. Cizek collected materials that were being thrown out by stores and so forth, paper and cloth. The children would do what they wanted *with his guidance*. I also visited the public schools in Vienna. If anyone wonders why the children in Cizek's class drew so well, it is because they were taught drawing in the schools. They were taught drawing in a rigid academic way. I saw a lesson where they drew a shoe. They had to render it with precision! The drawing knowledge seen in the work from Cizek's classes did not come out of the blue. They had all the knowledge from the schools.

Rhoads saw this skill used for "imaginative creation" when guided by Cizek and she continued, "His gift was [in] releasing the feelings and abilities of his students." Elsewhere Rhoads (Eckford, 1933a) spoke of Cizek speaking to the child "as one artist to another" (p. 73).

After her visit to Europe, Rhoads (1935) wrote:

Almost as an unwritten law, this philosophy or creed is accepted-that there shall be no pseudo-attitude, no slipshod work. The child is to grow through his work…The educational reformers in Germany and Austria have tried to be very careful in considering the freedom in class procedure that no dilettantism be allowed. With an understanding teacher (and by that I mean one who understands both the child and the subject) the child soon learns that he is not just working with his hands, but with the best that is in him. Experimenting in ways of working is encouraged, but crudeness of results is frowned upon. (p. 263)

Obviously Cizek, both by education (he was, after all, a graduate of Vienna's Academy of Fine Arts) and by association with the Vienna Secession leaders (Viola, 1936) was knowledgeable in his subject. Thus he fulfilled at least part of Rhoads's requirements for the "understanding teacher." Rhoads went on to explain: "Certainly Cizek holds the children to a high respect for craftsmanship. By questions they are stimulated to self-criticism in the use of tools, and thus have a big part in determining whether or not their work is good" (Eckford, 1933a, p. 73). Rhoads did not blindly accept Cizek's work or his rhetoric: "Considering his negative attitude toward art museums and the harm that can be done by impressing young minds with adult standards, I felt an inconsistency in the fact that the work of his children filled the room from floor to ceiling thus unconsciously stimulating children to work in a like manner. Their work has great value but they should not be surrounded by it" (Eckford, 1933b, p. 218).

LIFE OUTSIDE THE ART CLASSROOM
AS AN ART EDUCATOR

A year after her return to the United States, Rhoads married Philip G. Rhoads. "My life," she said, "took on new dimensions; a family with a daughter and son, the Second World War. Teaching came to an end and my art interests developed in the field of being a patron of the arts through the Wilmington Art Museum, an association of some 50 years."

When Rhoads first arrived at Tower Hill in 1929, she went to a show of work of the famed illustrator Howard Pyle. "Wilmington was an illustrators' town and illustration was dominated by Pyle." There Rhoads met N. C. Wyeth. Although Rhoads never studied with N. C. Wyeth or his daughter, Caroline, she was well acquainted with the Wyeth family, including Andrew. She recalls a youthful Andrew arriving at a formal art opening in a Confederate uniform and, comparing it to speculation raised by the publicity for the Helga pictures, she dryly remarked, "Last summer [1986] he stirred things up again--made for exciting days in a long hot summer."

Although Rhoads never returned to the classroom after her marriage, she was active as a founding member of the Rehoboth Art League from 1939 (Cope, 1984). This league was a private educational project for "a sleepy section of lower Delaware." A bus was converted into a museum to go from school to school. An historic house was also obtained for headquarters and summer exhibitions and classes for adults and children were held. Rhoads felt the League "made a difference" in the vitalization of the area.

From 1969 to 1977 Rhoads was a board member for the Delaware State Arts Council. She was a member of the education committee of the Delaware Art Museum for a number of years and Chairperson of the Museum Board in 1980. Obviously, though not formally a teacher, Rhoads remained an art educator.

No longer directly teaching, Rhoads pursued her personal development in art:

I became a member of The Studio Group in 1935. Out of that grew a group of women painters.... Other groups started because we were successful in ours. Andrew Wyeth gave demonstrations for our group, as well as artists from New York. We haven't had any great "achievers" from the group, but it gave warmth, support, and it gave the opportunity to share with others. I remember when World War II was declared. The next day we had a class. It was wonderful to shut out the fears that flooded in with that declaration of war. Members of our group had tragic experiences in the war, but the group and its work was a way to deal with that reality. It gave other people a feeling they could achieve as well.

Rhoads was actively exhibiting up to the time of my talks with her in 1987.[5] Often using children, flowers, and landscapes as subjects, Rhoads is quoted as describing her work as realistic: "Though in the enjoyment of pattern I have a strong feeling for what is being called contemporary, a lover of light, I am an impressionist. The excitement I feel for texture directs the materials and

techniques I use to express an idea" (Cope, 1984, n.p.). In 1984 Rhoads received the Delaware Governor's Award for the Arts, an acknowledgement of her status as an outstanding person in the arts community.

THE PUBLISHED WORK OF EUGENIA ECKFORD RHOADS

Rhoads was a writer of articles intended for teachers in the schools, not for university educators. In reading "The Baby Art Museum" (1924), "Art as It Functions" (Eckford, 1928), and "Youthful Mural Painters" (Eckford, 1929), there seems to be a certain Deweyesque quality to the approach. That is, art is perceived as part of one's life experience, not as an isolated occurrence in an aesthetic sanctuary. In her 1929 article, Rhoads wrote:

He [the student] learns to draw by making carbons for such murals as I have discussed...or designs for bowls, rugs or hand work that he is actually constructing. He meets a difficulty and solves it. Is this the right method? That we will not say, except that it is as near right as we know, since our aim is to have the child enjoy the creative spirit of the artist--not for the making of great works of art but rather for the making of a happy heart and clear thinking as he adjusts himself to this social world. (pp. 523-24)

Rhoads rejected unbounded laissez-faire notions, perhaps showing the influence of Dewey.

Neither, when we allow a freedom and informal atmosphere necessary to creative art, must we forget that the grown person has much to give and that art never lowers her standards. It goes without saying that the grown person must have a working knowledge of art and an understanding and appreciation of children if he or she is really to guide the child in self-development. (Eckford 1929, p. 524)

In "Art as It Functions" Rhoads (Eckford 1928) described a third-grade project at the Tower Hill School in which children studied Wilmington. Art was a part of this project. Rhoads felt that "When art comes into the classroom as a vital, inseparable part of the work, the child gains in knowledge and the love of creating as he could not so easily do were art just another subject. It is now a language for him" (p. 348).

In 1931, Rhoads was a group leader for a discussion about "The Bearing of the Rollins Conference on the College of the Future." Her report for *Progressive Education* was "Art as Another Language in the Secondary School." Explaining her title Rhoads stated, "Art as a second language is another way of saying art for life's sake, when we are thinking of the life of the child' (Eckford, 1931a, p. 339). Rhoads advocated an integration of art with other subjects to show students that art has a role to play in relation to "English, mathematics, Latin, history or music" (p. 339). Art should not be a class just in learning to draw, divorced from

all other school life and, therefore, students' interests. Rhoads was aware that some persons rejected integration and correlation, but she felt that since art always had played a role in everyday life and had a service to perform, it would not, ipso facto, stifle art to deal with it in school in relation to other subjects or use it to understand history and civilization.

Rhoads' one full-length book, *Wonder Windows* (Eckford, 1931b), was a picture book for children intended to introduce them to various folk crafts from around the world. A brief story introduced each craft. An anecdote about Hokusai, for example, is followed by directions for how to do a block print. Other crafts described are Japanese stencil printing, Dutch tile making, Zuni pottery, Navajo weaving, and Eskimo carving. The book implies that the art or craft of a people gives an understanding of that peoples' society and that active art work teaches more than merely reading about, or listening to talk about, people or their art. Rhoads's line drawing illustrations are very clean and have considerable charm, although she did not attempt to be perfectly "in the style" of the culture whose craft was under discussion. What the illustrations do show was Rhoads's active interest in doing art work.

Again, while this book had the attraction of easy-to-read stories, it was essentially a book intended for a nonscholarly public, an audience this time of parents and children. A discussion of philosophy of art education would have been out of place, or at least unlikely to be of interest for such an audience.

I gather from Rhoads's published writings that she had absorbed much of the Progressive Education outlook as defined by Dewey and Dow at Teachers College, Columbia University. Her considerable interest in painting and her more specialized attention to art appreciation as required by her work for *The Instructor* might have modified Rhoads's thinking if she had remained in the classroom. She might, for example, have developed her work away from the creative expression model and toward a goal of understanding of adult-made art. The criticism might be leveled at her that she did not arrive at a very original art education theory, but how many art educators, even well-known, present-day, university-level ones, can be accused of that achievement? Indeed, could it be possible that some who have mastered the art of making conspicuous contributions on the national scene and have successfully scaled power structures have also been quite uninnovative, despite their prominence? Could *performance* substitute for subtance? Could "masculine" assertiveness sometimes hide unoriginality?

THE ROLES OF EUGENIA ECKFORD RHOADS

It is tempting to say that Rhoads had a very "feminine" career. Although she had writing skills that would have made a university career easier than it is for many persons in art-related college positions, she chose to work in the elementary and secondary levels of education. She opted for marriage and parent-

hood rather than the life-long pursuit of a teaching career. In regard to her interest in doing painting, Rhoads did not choose it as a full-time profession, either.

To describe Rhoads's efforts this way is, however, to give a negative and "masculine" cast to what she has accomplished. It is to state matters as if her life necessarily was a matter of giving up things for "womanly" duties. Her career should be viewed in quite a different and to my mind more truthful light.

The Stankiewicz and Zimmerman categories, mainstream and hiddenstream, are helpful in thinking about Rhoads and her place in art education history. Her extensive publishing record, which included a book, literally scores of separate pieces in *The Instructor* and important articles in *Progressive Education*, *American Childhood*, and *School Arts* might place her in the mainstream. Her rejection of an academic career moved her toward the hiddenstream where her participation in supportive arts-related groups for women seem to be best categorized.

I would suggest that Rhoads made four major contributions to American visual art education. First, her writings had wide distribution from 1924 to 1942. To the last days of her long life (she died in the fall of 1995) Rhoads recalled letters of appreciation from teachers who had read *The Instructor* and found her published lessons helpful and meaningful for their students. Present-day historians of art education should be especially grateful to her for her careful and analytical descriptions of Cizek and his class (Eckford, 1933a; 1933b). Well-known and influential during the years of her writing career, she still has importance for the art education field as a witness for her times.

Second, through the Rehoboth Art League, the Delaware State Arts Council, and the Delaware Art Museum Rhoads influenced or directed city and state community art education. She reached out to help form community and state attitudes about art as an ongoing public concern. This fits the hiddenstream notion of the role of women in art education, but what sensible person, whether or not concerned by the "hiddenstream" label, could deny the importance of anyone who undertakes such tasks? Can a person who accomplishes such tasks then not be labeled successful in the field of art education?

Third, through her work in the Studio Group, she not only continued her own development as an artist, but sustained and supported other women in their work as painters, sculptors, and so on. In an art world dominated by males (Collins & Sandell, 1984), she helped provide breathing space for women who wanted to work in the field of art. This group also provided a collective force that its individual members lacked or were hesitant to assert.

Fourth, Rhoads acted as a bridge between artists and the larger community. She was well acquainted with the artists of the Wilmington area and, as a recognized patron of the arts, helped to make these artists visible to the public.

If Rhoads had chosen to follow a conventional teaching career, even at the college level, would she have been able to make so many positive contributions? This question has no perfect answer, but consider the life-long art education career she did build. If she had remained in the teachers' colleges she began her

career in, would she have been able to develop such rich connections among mass education, museum education, school education, community education, and the artists' world?

It seems to me that a more careful examination of what constitutes a successful art education career is called for. We need to be more clear about standards and more aware of hitherto unexamined sexism in judging success. Does not the mainstream need the hiddenstream? It is the hiddenstream that welcomes the artist, that provides her or his audience, that nurtures the fledgling artist. It is the hiddenstream that somehow maintains a place for art during the most adverse times, as Eugenia Eckford Rhoads did through the Great Depression and World War II. It is the hiddenstream, quite often, that keeps alive forms that may seem craftsy now, or in the past, but which may yet be moved into the mainstream's place of honor.

Thus, I would say that Eugenia Eckford Rhoads had an art education career both long-lasting and multi-faceted. Without the highly structured modes of academic honors, she flourished in all seasons.

NOTES

1. In 1934 Eugenia Eckford married Philip G. Rhoads, a Delaware businessman. From that time on Eugenia Eckford used her husband's surname in some published work but retained her birth surname for other publications. Readers should be aware, therefore, that citations of "Eckford" and "Rhoads" in this study refer to the same person.

2. Unless otherwise noted, biographical details and quotations of Eugenia Eckford Rhoads are from an interview with me held on November 17, 1987. Other sources of biographical materials are from letters to me from Eugenia Eckford Rhoads and a statement in response to the transcript of the interview, dated February 17, 1988. The interview transcript is in my possession.

3. By this I mean that Rhoads placed emphasis more on design and structure than on narrative, which was a typical nineteenth-century concern.

4. After extensive research on Cizek, I could find no American writer who indicated observing Cizek for more than one or two days other than Eugenia Eckford. None indicated they spoke to Cizek without the need of translators, including Eugenia Eckford.

5. Eugenia Eckford Rhoads gave me this information in letters and exhibition announcements.

10

A Colossus of Sorts

> Why, man, he doth bestride the narrow world
> Like a Colossus, and we petty men
> Walk under his huge legs and peep about
>
> The fault, dear Brutus, is not in our stars,
> But in ourselves, that we are underlings.
> Brutus and Caesar: What should be in that 'Caesar'?
> Why should that name be sounded more than yours?
> Write them together, yours is as fair a name;
> Sound them, it doth become the mouth as well;
> Weigh them, it is as heavy; conjure with'em,
> 'Brutus' will start a spirit as soon as 'Caesar.'"
>
> —William Shakespeare
> *Julius Caesar*, Act I, Scene 2

In 1983 I finished my dissertation about the American teaching career of Viktor Lowenfeld. I had chosen the subject of the dissertation not because I was a Lowenfeldian art teacher--I had always been too attracted to the history of art to be completely wrapped up in self-expressive pedagogic theories--but because Lowenfeld had been and continued to be such a potent force in American art education. The year before I finished my dissertation, 1982, I heard the nationally known art educator Mary Erickson, at the National Art Education Association Conference in New York City, say that she detected the ghost of Viktor Lowenfeld hovering about. That was twenty-two years after his death and one year before Lelani Lattin Duke, the director of the Getty Center for Education in the Arts, publicized at the next annual National Art Education Association Conference the type of art education that was to be called "discipline-based."

Discipline-based art education (DBAE) was seen to be a conscious antithesis of Lowenfeld's child-centered approach, and in 1987 Peter London, among others, chose to carry into the counterattack a banner labeled Lowenfeld, as he and others embraced an anti-DBAE stance that has the characteristics, associated with Lowenfeld, of student-centeredness, therapeutic intent, and psychological orientation. Lowenfeld is still with us in the schools' art programs, if perhaps in ways strangely eroded by time.

It has been about half a century since Lowenfeld's astonishingly popular *Creative and Mental Growth* (1947) first was published. For many years, as I will explain in Chapter 11, this was the principal text for preservice education for art teaching. If we arbitrarily claim that 1870 was the starting date for public school art education in America, the tenure of the influence of this one individual is impressive in proportion to the time span of the field of visual art education up to the present.

LOWENFELD AND LOWENFELDIANISM

My doctoral committee advised me not to attempt to build a great pyramid in writing a dissertation. A study of an essentially biographical nature appeared to be small-scale enough to avoid grandiosity, or so we all thought. However, as is often the case in historical research, one thing led to another, and I came to see that I must explain the person and his notions through a quasi-cultural history. It was obvious that this one individual carried an immense freight of cultural and historical burdens (or gifts, if you will) and that he had moved through times now distant enough to be very different from our own.

Unfortunately, while Lowenfeld's former students might be accused of turning their beloved mentor into a creature of heroic mythology, his opponents (or those who want to oppose his ideas) sometimes seem not to have tried to understand his work within the context of his times, or even to have read his publications carefully. Disciples and thoughtful opponents would probably be willing to say that Lowenfeld has proved to be a colossus in American art education. June King McFee, at one time regarded as the figure who first significantly refuted Lowenfeld's ideas (not necessarily an accurate notion), was to say of Lowenfeld: "[Kenneth Beittel] asked me to take my dissertation to his great teacher, Viktor Lowenfeld, to read and then to meet with them the next morning...[Lowenfeld] was encouraging about the inquiry I was pursuing. That inspired me because, even though his perspectives were quite different than mine, his concepts of the field were more inclusive" (McFee, 1991, p. 70). Thus, even the individuals who criticized his ideas recognized the importance of his work. If the notion of Lowenfeld as a giant in American art education is judged to be distasteful by some, still it is one of the inescapable features of the landscape of twentieth-century American education in the visual arts. Therefore, understanding Lowenfeld's ideas and assumptions is a necessity for anyone wanting to know

this country's art education.

As will become obvious, I feel the fact that Lowenfeld grew up in an environment so culturally and linguistically different from the United States was significant, but unfortunately that has never been carefully examined. I find it curious that American art educators, Lowenfeld friends or foes, appeared to be blind to certain incongruities between Lowenfeld's worldview and American culture, especially the culture of the schools. Nor has anyone looked closely at Lowenfeld's vision of art as it related to the American art scene of his day.

A BRIEF REVIEW OF LOWENFELD'S LIFE STORY PRIOR TO *CREATIVE AND MENTAL GROWTH* (1947)

Lowenfeld narrated his own life story in some of his Pennsylvania State University classes, and a transcription of at least one of these occasions is available. Further material on his life can be found in dissertations (A. P. Simons, 1968; Smith, 1983) and in journal articles (for example, Michael, 1981). While primary documents on Lowenfeld's life in Austria are difficult to retrieve, some are obtainable.

Lowenfeld was one of four children--the second boy. He attended an elementary and secondary school in Linz and went on to his tertiary education in Vienna after the First World War. At one time or another Lowenfeld took classes in the Academy of Fine Arts, the University of Vienna, and the Kunstgewerbeschule (School of Applied Arts). As its name implies, the Academy of Fine Arts was a place to educate painters, sculptors, and architects. Excepting its architectural division, led for a time by pioneering modernist Otto Wagner, it was a notoriously conservative institution, slighting Klimt until he was near death (Shedel, 1981) and driving Schiele to rebellion (Comini, 1974). It was also the school that rejected Hitler, dashing his hopes to become an artist or architect, much to the world's regret. The Kunstgewerbeschule, on the other hand, was closely associated with Austrian modernism (Vergo, 1981) and, also, was a place that educated art teachers (Schorske, 1980).

After his initial college-level studies, Lowenfeld taught in Vienna schools and in a school for Jewish blind children. Curiously, at the Chajes Gymnasium he taught secondary school mathematics. His work at the school for the blind attracted the art historian Ludwig Münz. Münz wrote a book, *Plastische Arbeiten Blinder* (1934), with one final chapter by Lowenfeld and with photographs of Lowenfeld's blind students' clay sculptures.

In 1938, as a result of the violent persecution of Jews following the *Anschluss*, Lowenfeld fled first to England, where his first full-length book, *The Nature of Creative Activity* (1939), was published. Then Lowenfeld and his family moved on to the United states. His brother, Berthold, had begun a career as an educator of the blind in the United States in the mid 1930s.

His first full-time American college-level position was at Hampton Institute

(now Hampton University) in Virginia from 1939 to 1946. He then became head of Art Education at the Pennsylvania State University and remained there until his death in 1960.

These are the facts that outline Lowenfeld's life story up into his American years. In many ways they are similar to the facts in the lives of many other Germanic immigrants of the same period (A. P. Simons, 1968; Smith, 1983) and in other ways, Lowenfeld's life story, both in its European and American phases, was strongly formed by his Viennese years. Thus, while Lowenfeld and Schaefer-Simmern were both German speakers, Lowenfeld's Viennese experiences provided an intellectual background sharply distinct from Schaefer-Simmern's.

LOWENFELD AND GERMANIC LANGUAGE

Lowenfeld's education and early surroundings were strongly Germanic. This gives to everything he did and said for his whole career a very special perspective. I am aware that there might be some objection to referring to Lowenfeld, an Austrian and a Jew, as being "Germanic". I intend to use the term initially only in the sense of language, although later I will use it in a more expanded sense. I will argue that this Germanic quality was very important and attempt to explain as I do so the meanings of "Germanic."

The fact that *Creative and Mental Growth* (1947) was the first book Lowenfeld wrote in English may surprise those who have forgotten that *The Nature of Creative Activity* (1939, second edition 1952), although first published in English, was actually translated into English by Oscar Oeser, a scholar from Scotland. *Your Child and His Art* (1954), Lowenfeld's third book-length English language work (the second he wrote in English), has been described as "an excised portion from the first edition of *Creative and Mental Growth*".[1] Using Michael's bibliographical listing (Michael, 1982, pp. 405-406), this would mean that, by any count, more than half of Lowenfeld's book-length works were in German. As late as 1946, Lowenfeld was considered to have some difficulty in speaking English (Emerson, 1961), and Michael, in editing Lowenfeld's 1958 lectures, remarked on there being Germanisms of construction even then (1982, p. xix). Although I have disclaimed any intent in my use of "Germanic" beyond language, I will now admit that I believe that language has a profound influence on behaviors.

Writing on the relationship of language and thought to culture, C. Wright Mills has said, "The stuff of ideas is not merely sensory experiences, but meanings which have back of them collective habits" (1939, p. 675). Language, the product of collective habits, controls thought, or so Mills wrote, and along with language are acquired norms and values. Some may question whether Mills's theory always holds true, but it probably can be accepted that a language does select and shape a person's thoughts and even perceptions strongly.

Lowenfeld did not always recognize the effects of language on formation of concepts--and many of his friends and critics have been similarly blind. Carol Ast (1982) called attention to the possibility that the responses to Lowenfeld's word association test for haptic traits may have been deeply affected by translation from German to English. German, Ast explained, does not have the gerunds that confused the scoring of the tests of English-language respondents. Lowenfeld's thought might be said to be framed in the German language and the Germanic culture of Austria. As an example of this, I recall reading somewhere a derisive remark that the German language capitalization system had led German language speakers into thinking many words (for example, *Warheit*, or truth) actually named palpable things in the world.

AUSTRIA AND ITS GERMANIC CULTURE

At the time of Lowenfeld's birth in Linz, in 1903, Austria was a part of the Austro-Hungarian Empire. However, the influential German nineteenth-century historian Leopold van Ranke had characterized Austria as German (Diamant, 1960). Crown Prince Rudolf (of Mayerling fame) believed Austria's mission was to bring German culture to the East (Jaszi, 1929), and the sinister Georg Ritter von Schönerer during a session of the Austrian Reichsrat (December 18, 1873) had cried for Austrian union with Germany (Whiteside, 1975). Pan-Germanism, as this idea that all German people should be in one political unit was called, was a chronic Austrian political theme until it actually happened in 1938, and Austrian nationalism took on real life. The Treaty of Saint Germain thwarted the popular desire, expressed in a vote in 1919, to become a state in the then-new German Republic (Braunthal, 1948). If the Treaty of St. Germain had not prevented it, as an alternative to the German Republic, Bavaria and Austria might have formed a new nation, perhaps capable of a self-suffiency Austria alone could not attain after losing her natural resource-rich Eastern European territories.

Although there were strands in the Austrian tradition differing from those of some German states, especially the Protestant ones, still Austria's heritage was essentially German (Schnitzler, 1954; Diamant, 1960). Johann Gottfried von Herder (1744-1803), a philosopher whose writings were familiar to Lowenfeld (see Lowenfeld, 1951), had said the basis of nationhood was commonness of language, culture, and "historical mission" (Steiner, 1972). Even if the present-day American reader does not care to accept that definition wholeheartedly, it was part of the German language heritage and, as the reference to Prince Rudolph above suggests, was taken quite seriously by persons with political power.

Even though it can be demonstrated that Austria was linguistically and culturally German, the reader might still object that Lowenfeld's family was Jewish and that, therefore, the term "Germanic" was not applicable. Sigmund Freud as a fellow Austrian had traced the origin of some of his willingness to go

against the grain of Germanic culture to his being a Jew (M. Freud, 1970). For Freud, Jewishness within the dominant Germanic culture, yet contrasting to it, was an important motivating factor. However, Freud did not have his family engage in Jewish religious celebrations. Lowenfeld's family, in somewhat the same way, did not seem to practice any specifically Jewish customs or identify much with Jewish culture during his earlier childhood (A. P. Simons, 1968). The Lowenfelds appeared to have been assimilated into the Austrian branch of Germanic culture. Even the Chief Rabbi of Vienna, Adolf Jellinek, in 1883 had described Austrian Jews as "the embodiment of German Austrianism," and educated Jews were said to identify themselves with "the humanist philosophy of the German enlightenment" (Wistrich, 1979). For Viktor Lowenfeld, assimilation might be said to have been modified by his participation as a teenager in the Jewish Youth Movement, *Blau Weiss*, but even that movement originated in Germany (A. P. Simons, 1968).

GERMANIC BEHAVIORS

Abruptness and directness in speech and social interaction were two behaviors that were singled out by observers of World War II German and Austrian refugees. These Germanic behaviors were at variance with Americans' tendency to try to make all social exchanges as smooth as possible (Kent, 1953). Lowenfeld noted this American devotion to restraint, in his eyes perhaps harmful overrestraint (Michael, 1982). The German language itself is produced with greater physical intensity than American English, and German culture allows for a degree of emotional intensity that might seem quite inappropriate in American eyes (Whyte, 1943). In this regard Whyte notes that: "Whereas the German scholar likes to state the conclusions of his scholarly research forcefully and often dogmatically, the American scholar, even when he is convinced of their invulnerability, will often put them forth hesitantly, reservedly, and modestly, at times even equivocally" (p. 147). Given this description, it can be seen that the Germanic scholar might seem to an American somewhat arrogant, or oversure of research results and conclusions. He or she might seem dogmatic. When this is combined with a German's tendency to react very strongly to remarks suggesting doubt about the value or validity of his or her work (Whyte, 1943), it is easy to imagine misunderstandings between Americans and Germanic persons. And it is also not difficult to see that cultural misinterpretations could arise on either linguistic side.

Did the Germanic cultural style appear in Lowenfeld's work? It is my contention that it did. A statement such as "Natalie Cole in her book, *The Arts in the Classroom*, still uses mere intuitive approaches" (Lowenfeld, 1952, p. xviii) has an abrasive quality that seems somewhat out of proportion. It would be interesting to devise some method to determine whether Lowenfeld understood that "mere" in this context sounded like a harsh dismissal of worth. If we look

elsewhere in his writings he acknowledged there was no single approach to enabling children to realize their creative potential. His listing of three factors to make this possible--a teacher's creativity and sensitivity, empathic ability, and understanding and knowledge of the needs of students (1957)--all seem to be demonstrated in Cole's *The Arts in the Classroom* (1940) and *Children's Arts from Deep Down Inside* (1966). Another example of dogmatic overstatement is to be found in Lowenfeld's injunctions to "Never prefer one child's creative work over that of another! Never give the work of one child as an example to another! Never let a child copy anything!" (Lowenfeld, 1957, p. 15). These words seem to bristle with a dictatorial style. In another instance Lowenfeld wrote "It can be said that creative art processes stimulate creativeness in general" (1957), a statement that was sharply criticized by American scholars for its seeming lack of caution. Rudolf Arnheim (1983) described Lowenfeld as a zealot.

Even Lowenfeld's frequently mentioned and often questioned haptic and visual theory (Arnheim, 1983; Barkan, 1955; Gaitskell, 1958, etc.) might never have evolved if he had not lived in an intellectual community very familiar with the writings of "the brilliant and widely influential Viennese scholar and teacher Alois Riegl (1858-1905)" (Kleinbauer, 1971). It is doubtful that the rarely translated Riegl would have provided terms for an English speaking art educator of Lowenfeld's era. If Riegl's original art history theory had been formulated in English, perhaps it would have found a more ready acceptance among English and American art educators, but perhaps it would not have had for Lowenfeld the aura of scholarly prestige that it must have had for him in the Vienna of his student days, when his basic conceptual foundation was in the process of being developed.

LOWENFELD AND A CRITIC

In 1965 Manuel Barkan presented the Viktor Lowenfeld Memorial Lecture at the National Art Education Association Conference (Barkan, 1966). The speech summed up many of the objections that had been raised in regard to Lowenfeld's approach, including David Ecker's contention that Lowenfeld had confused fact and value in his prescriptions for evaluation of students' art works (Barkan, 1966) and McFee's (1961) anthropologically based questioning of the comprehensiveness of Lowenfeld's developmental stage theory.

Barkan's own comments on Lowenfeld included remarks about Lowenfeld's egocentricity and capacity for angry response--"immediate and sharp"--to criticism, and his "evangelism" (1966, p. 6). Aside from the still argued questions of the validity of these and other criticisms of Lowenfeld's theories, Barkan's references to egocentricity, angry response, and evangelistic tone in asserting ideas could be translated into the very terms already used to describe Germanic behaviors. They are essentially criticisms of a style foreign to that found in the socialization of the American male scholar. Lowenfeld overstated,

by the standards of American scholarship. He asserted his findings in a manner that violated the customary caution of American scholarly reports. And incidentally, he did not mumble into a written speech, as so many American scholars do during conference presentations. His presentations were forceful, self-assured, even theatrical. When his work was questioned, he reacted as if he had been personally affronted although he willingly argued his points with opponents, sometimes endlessly, and opponents sometimes failed to note his Buberian desire to be reconciled to his opponents. Lowenfeld's writings and speeches might be reexamined, looked at with the understanding that they were by a person who was neither by background nor education an American and who thereby saw and spoke about the world with a different accent in a different way. If such a reexamination took place, the meaning for Americans of Lowenfeld's message would take on a very different perspective.

LOWENFELD IN A VIENNESE PERSPECTIVE

If Lowenfeld was Germanic, he was also specifically Austrian and even more specifically, by intellectual preparation, Viennese. I will now look more closely at the influence of his education on Lowenfeld's work in the United States.

Lowenfeld grew up in Linz, the city which was not only the place where Hitler had been schooled half a generation before, but also the place where the unification of the German-speaking peoples (later called *Anschluss*) had been formulated in the so-called Linz Doctrine (Pauley, 1981). Pan-Germanism in politics and the arts had an interconnection in Austria which may seem odd indeed to Americans, but which has been explained in *Dionysian Art and Populist Politics in Austria* (McGrath, 1974) and *The Politics of Cultural Despair* (Stern, 1961). The progressively vicious and increasingly shrill tone of the politics of pan-Germanism in the first four decades of the 1900s is an exceedingly complex issue and, therefore, I have to leave the reader with a suggestion rather than a complete explanation of it. This matter has background relevance to the concerns of this study, but for reasons of simplicity I ask readers to keep this issue in mind as best they can, while I will emphasize here only the anti-Semitism that seemed to cling parasitically to the notion of a union of Germanic people (Whiteside, 1975).

Many present-day Western intellectuals rightfully associate the arts and anti-Semitism with Richard Wagner (1813-83). Certainly his polemic "Judaism in Music" (see Kapp, 1911) is an infamous example of this twisted thinking and an example of the cancerous participation of Germanic intellectuals in building a foundation for some of the great crimes of history. In the Austro-Hungarian Empire, a dizzying combination of emotion-laden notions involving political frustration and flight from reality into the arts as a realm alternative to political and social restriction (Johnston, 1972; Schnitzler, 1954; Schorske, 1980) rallied around Wagnerism, especially around the concept of the *Gesamtkunstwerk* (total

work of art). This concept, later taken up by the Vienna Secessionists and the *Wiener Werkstätte*, pictured the arts as informing and shaping--therefore educating--all social life (McGrath, 1974). When the *Gesamtkunstwerk* concept became metamorphosed into politics, it became "expressive" in a terrible sense, a politics in a "sharper key" as Schorske (1980) put it. In politics the total work of art was transformed into totalitarian social theories. From Plato to Benito Mussolini the notion of the well-designed state, the totalitarian dream, has had a twisted aesthetic appeal, at least to many.

The new Viennese politics were led by the city's mayor, Karl Lueger, who created and used mass politics in a way that Hitler admired greatly. Lueger's stated goal was to move the inert social and political hierarchy to better the desperate social situation of the "little man." The effective means to get this "little man" into political action was anti-Semitism. Schorske explained this by pointing to an epigraph used by (of all people) Freud for *The Interpretation of Dreams*. The words came from Virgil's *Aeneid*: "If I cannot bend the higher powers, I shall stir up hell" (Schorske, 1980, p. 200). In other words, Lueger found the aristocrats and cultured middle-class liberals of Austria would do nothing to improve the lot of the poor and of the small businessperson, for all their grand humanism, so he would appeal to the lowest prejudices of the poor to form a dangerous, therefore powerful, force. The "little man" saw the easily identifiable Jewish newcomers from Eastern Europe as an economic threat. At the same time, many middle-class Jews occupying more or less comfortable and highly visible professional positions could be singled out. Anti-Semitism was a tool to motivate a confused and frustrated populace. Lueger himself never believed in any claims for a factual basis for it. Like the many early twentieth-century American politicians in the pre-Civil Rights era, he knew that racial prejudices could be manipulated to get what he wanted and felt no conpunction to educate the public or to disabuse them of notions based on ignorance or lies.

As a graduate of a prestigious gymnasium, the Theresianum, and the University of Vienna Lueger was the recipient of an intensive education of the finest classical type. His was surely the European equivalent of a Great Books education. He was culturally literate. He combined this with his handsome appearance (*der schöne Karl*) to create an irresistible image. Although he rose from the lowest ranks, he presented an image like that of the highest. The Emperor Franz Josef detested his politics, but Lueger could move suavely even in Court circles.

Now what has all this to do with Lowenfeld? What it meant was that he grew up in a culture dominated by the idea that Germanism represented the best element of the nation or Empire, that he was a member of a minority despised by Germanophiles, and that political power rested in the hands of an enemy--advocates of Germanism, which was the culture his family had assimilated. There is no need to venture into psychohistory to understand that an ego-bruising internal conflict would arise from this situation.

Lowenfeld's brother, Berthold, told of his brother's youthful attraction to the

Blau Weiss movement (A. P. Simons, 1968), a youth movement that developed in response to the Pan-German, therefore anti-Semitic, *Wandervogel* movement. *Blau Weiss* provided an identity for Jewish youth, as had the so-called *volkisch* notions for non-Jewish German youth (Mosse, 1947; A. P. Simons, 1968).

During *Blau Weiss* activities, Lowenfeld had some exposure to Martin Buber, a figure who held certain ideas that Lowenfeld absorbed, although, as an adolescent of no recorded intellectual distinction (see Berthold Lowenfeld's comments in A. P. Simons, 1968), Lowenfeld was probably too immature on first exposure to grasp Buber's philosophy. However, in adulthood, Lowenfeld's talk about self-identification (1957) reflects Buber's ideas as explained in *I and Thou*. It certainly could be asserted that Lowenfeld, like Buber, regarded good teaching as dialogue. Lowenfeld was also eager to seek to embrace his opponent, however heated the debate between them might have been (Beittel, 1972). In other words, in rhetoric and behavior he emulated Buber.

In America Lowenfeld was to speak of his Austrian experience of persecution (1945). He attempted to use that experience to identify with the experience of African Americans (Biggers & Simms, 1978). What Lowenfeld was strangely silent about was the virulent anti-Semitism present in Viennese higher education institutions among students and faculties during his college days (M. Freud, 1970; Haag, 1976). This academic anti-Semitism in the late 1920s and 1930s not infrequently took the form of violence against the Jewish students (Fabricant, 1931). Lowenfeld was also silent about Zionism, although, through *Blau Weiss* and through living in Theodor Herzl's home city, Vienna, he must have been acquainted with it. Indeed, one of his sisters was to make her home in Israel (A. P. Simons, 1968).

Even in his precollege days, Lowenfeld had experienced segregation. During religious classes in the Linz *Realschule* he was directed to leave his Catholic classmates and sit in the custodian's room in the school basement as long as religious instruction classes were in session (A. P. Simons, 1968). Of Lowenfeld's precollege schooling, we can be certain that it was authoritarian, with all courses taught according to highly structured and sequential, centrally determined curricula. Although Stefan Zweig (1943) described his own schooling in a classical *gymnasium* that emphasized Latin and Greek-centered studies and Lowenfeld attended a type of school (*Realschule*) that emphasized math and science, the educational picture that Zweig painted probably matched in tone what Lowenfeld underwent. The rigidity of curriculum, the stiffly maintained distance between teachers and students, and the unconcern for students' overall physical or psychological well-being are both shocking and suggestive as to the origins of Lowenfeld's educational concerns. From this grim background we can see why Lowenfeld felt the total mental and bodily health and welfare, perhaps more than merely intellectual growth of the student, to be such a pressing issue. It might even be deduced that an exaggerated concern for the total health of the student might have been one result of his own childhood ordeal.

Indeed, even in Austria, once the Habsburgs were overthrown in the aftermath

of the collapse of the old order in 1918, a highly therapeutic education was initiated (Cox, 1934), one aimed not only at the individual's well-being, but at the development of a better society (Meyer, 1934). Of course, by the time the *Anschluss* came about in 1938, this educational idealism had undergone a conservative regression as part of what has been called a provincialization of Viennese society and Austrian politics (Riedl, 1985). Thus, once having undergone the old authoritarian schooling as a child, Lowenfeld received his teaching preparation and professional induction during a great reform period, only to see a reemergence of the sectarian old order he had left behind in Linz.

Lowenfeld's emphasis on the role of schooling in relation to the students' development and the ultimate impact of schooling on society served him well in his work with African Americans during his years at Hampton Institute (A. P. Simons, 1968), where he also came upon segregation and a cruelly treated minority. However, it is legitimate to ask whether this concern was exactly what was needed for *mainstream* American art education even in Lowenfeld's own day, from 1939 to 1960. Did Lowenfeld's Austrian social and educational experience have great relevance to the American educational scene in the post-World War II era? While the emotional power of his experiences may have energized Lowenfeld, giving him a feeling of mission, did the bitterness of his Austrian years blind him to the new situation he found in America?

LOWENFELD'S PSYCHOLOGICAL PREOCCUPATION

Lowenfeld's social experiences may have led him to a concern for psychology, and certainly Vienna was a fertile ground for psychological theorizing. Lowenfeld documented a number of child study works he was familiar with while in Vienna (Lowenfeld, 1939), and he claimed to have studied with Karl Buhler, a developmental psychologist at the University of Vienna (A. P. Simons, 1968). He also claimed to have been visited by Freud while working with blind children in the Hohe Warte section of Vienna. The association of Vienna and Freud perhaps misled some Americans into connecting the psychologism of Lowenfeld's art education with Freudianism (Biggers & Simms, 1978; Efland, 1976a), but *Creative and Mental Growth* (1957) has but two superficial references to Freud. The work has an organismic or "gestaltish" (Harris, 1963) approach, not a psychoanalytic one. In his Pennsylvania State University days, Lowenfeld sometimes expressed irritation that attempts were made to see Freudianism in his approach to analyzing children's art work (Michael, 1982).

However, the fame of Freud in the new world Lowenfeld found himself in after 1938 must have made the psychoanalyst an attractive figure to identify with, perhaps doubly so since Freud also fled to England from *Anschluss* Vienna, as had Lowenfeld. Lowenfeld may have wished to couple his name with Freud's even to the point of hinting he had contributed to Freud's data (A. P.

Simons, 1968). Whatever substance lay behind Lowenfeld's references to Freud, he could not claim a *strong* association, as for example, Erik Erickson could. Erikson also had taught art to children in Vienna, but in a school cofounded by Anna Freud. What Freudian psychoanalytic art education might have been like must be guessed from Erikson's analysis of block constructions and so forth (Smith, 1983). However insubstantial his association with Freud, Lowenfeld's psychological training had been sufficient to gain him positions as a therapist in his early months in America (A. P. Simons, 1968) and to lead *Time* to label him a Viennese psychologist ("Are You Haptical?" 1945).

However, Lowenfeld's views could be traced to the widespread belief in fin-de-siècle Austria that society had become an irrational accretion of repressive and meaningless forms that crushed the true and good natural instincts, rather than to a specific theorist (Schorske, 1980). Freud would have accepted the accretion part of this feeling, but hardly that the organism is essentially true and good. That notion seems to have floated about German countries in the wake of Froebel, Pestalozzi, and romanticism. The questions that have to be asked of Lowenfeld as a student of Viennese psychological concerns are related to his social and educational background. How relevant is a psychology rooted in one particular culture when it is transferred whole to a very different culture? William Johnston (1972) has shown how deeply embedded Freudianism was in late nineteenth-century Viennese culture; therefore, it would seem that the less Freudian Lowenfeld's work appears, the better for its possible relevance to American culture--perhaps. However, Lowenfeld's social views about the oppressive and distorting effects of adult culture on the natural human, the child, seem just as Viennese as any supposed Freudianism. Finally, Stefan Zweig's (1943) description of the Austrian culture of Lowenfeld's youth shows how very alien in almost every aspect it was to American twentieth century social experience.

LOWENFELD AND VIENNESE ART AND ART EDUCATION

Perhaps it is significant that in this discussion of Lowenfeld's background and its effect on his theoretical positions I have placed his relationship to art as one of my last considerations. However, I feel that many of Lowenfeld's art education notions and efforts, as distinct from adaptations of his ideas made by American students, are best understood in terms of the art world of Vienna. I contend that his ideas grew out of that Viennese art world and would not have been anything comparable had Lowenfeld grown up in the United States, France, or even Germany. In other words, the Viennese art scene shaped his concept of art, and he never developed a new concept after coming to live in the United States.

Lowenfeld's relationship to Viennese art can be studied as three categories. These are (1) the role of child art, (2) the uses of art history theory, and (3) practicing artists of Lowenfeld's day. The three aspects are, however, interwoven,

and their effect on Lowenfeld may have been as a whole, not as discrete units as I must describe them.

First, child art and Vienna inevitably call forth the name of Cizek. By the time Lowenfeld observed his work, Cizek had taught children's classes for about a quarter of a century. He was no longer a youthful associate of the avant garde of Viennese art (Viola, 1936), but an established professor in the state-supported School of Applied Art, where, among his college-level students prior to World War I, he had taught the well-known (by the 1920s) Oskar Kokoschka. Sometime during the post-World War I period Cizek taught an innovative college-level course that was later suppressed by reactionary elements in the Austrian government-perhaps as a result of the "provincialization" referred to above (Munro, 1929b; Rochowanski, 1922; and see Chapter 4).

Cizek's original position in regard to children's art had been that the wellspring of art could be found in children's work, just as much as it could be found in any ancient or exotic primitive art. Children's art was pure and not tainted by the historicist culture all about them in Vienna (Viola, 1944). Historicism in cultural matters was probably felt to be more of a problem in art in Vienna than in any other late nineteenth-century European city. The *Ringstrasse* development brought the issue to a very large and very conspicuous climax (Shedel, 1981; Vergo, 1981). Certainly, if degree of cause can be equated with degree of reaction, the city of Adolf Loos, Arnold Schönberg, Gustav Mahler, Ludwig Wittgenstein, Ernst Mach, Sigmund Freud, and so on must have felt the weight of ossifying traditions to be unbearable and a reaction pressingly necessary. In the case of each one of the pioneering figures named, a search for essentials and truths buried under historical debris was an important element. In visual arts, however, the Secessionists' inclusion of certain influences of Byzantine mosaics (as in Klimt's golden backgrounds) or Mycenaean art works seemed to retain some of the historicist taint. Cizek's alternative offered a new ahistoricist source.

By the 1920s Lowenfeld saw Cizek as a conservative, even reactionary figure, despite the observed similarity of their rhetoric (Smith, 1983). In both Lowenfeld and Cizek we find statements to the effect that society leads the child away from his or her pure roots, that the less absorption of adult art, the better. In a city that Loos labeled a "Potemkin town" (Schorske, 1980) because of the false historicist facades of *Ringstrasse* late nineteenth-century architecture, this might be understandable, if not practical, but in vast stretches of America, during Lowenfeld's lifetime, it seems unlikely that a child's gifts would have been smothered by a surfeit of high art or veneration of historical architecture. Nor did the majority of American children come from backgrounds rich in folk art or religious iconography.

In Lowenfeld's Viennese days in the 1920s and 1930s Cizek was by no means the only visual arts educational theorist in the city (Tomlinson, 1934). Lowenfeld seemed to prefer Richard Rothe, whose work he referred to in *The Nature of Creative Activity* (1939). Rothe, as did Lowenfeld, held to a bipolar

theory of psychological types which he called visuals and constructives. Rothe also appeared to be concerned with child development and teaching appropriate to each developmental level. However, descriptions of his work suggest that instruction in drawing was important and carried on by a curious mixture of teacher and peer instruction (Dottrens, 1930), obviously a very un-Lowenfeldian means.

Second, Lowenfeld's connection with *art history* of the Viennese variety was quite direct. He was closely associated while he worked with blind students at the Jewish School for the Blind in Vienna with Ludwig Münz. Either directly from Münz or from other sources of information on art history he might have encountered in formal classes or informal conversations with his contemporaries, Lowenfeld acquired a knowledge of the visual-haptic theory of Alois Riegl which perhaps also informed Rothe's visual-constructive notion. Lowenfeld's use and possible distortions of this theory have been discussed thoroughly by Arnheim (1983) and this author (1987), and I will analyze it in due course. What is of concern here is that the theory was devised by a *Viennese* art historian (Pächt, 1963), very much a part of the Viennese school of art history (Kleinbauer, 1971). The theory has been seen as useful for vindicating new art (Arnheim, 1983; Smith, 1987), since Riegl saw art inevitably moving from emphasis on visual or optic art (naturalistic) through haptic art (expressive). The Secessionist motto, which Lowenfeld must have seen many times as he passed the Viennese Secessionist building next to the Academy of Fine Arts, was To Each Age Its Art, To Art Its Freedom. This was essentially Riegl's message.

Riegl died in 1905. Although he may have intended his theory as an explanation of the first generation of Viennese modernists, the Secessionists, he could not have intended it for a second generation whose work he never saw. That generation could be seen as appearing publicly only in the 1908 *Kunstschau* which, although largely still Klimtian, marked the debut of Kokoschka. Interestingly, Schorske (1980) saw children's art being given first place in the exhibit. With Kokoschka the second, the expressionist modernist generation, came to the fore. However, even if his dates are slightly awry, Arnheim (1983) was correct in saying Riegl's work could have been used after the fact to explain expressionism's right to be.

Third, Lowenfeld's own artistic efforts included study at Vienna's two most important art schools (A. P. Simons, 1968). My inquiries could not bring about a disclosure of any Lowenfeld study at the Academy, but the Kunstgewerbeschule provided information about his work from 1921 through 1925. In the school's records Lowenfeld indicated that his career choice was to be a painter, and he studied painting for four years with W. Muller Hofmann, and took various drawing classes, an art history course and a class in stained glass with Reinhold Klaus. Lowenfeld claimed that, as a result of his Kunstgewerbeschule studies, he made a stained glass window for the Paris Exposition of 1925. Since the *Wiener Werkstätte* was responsible for the Austrian exhibit and it had a close association with the Kunstgewerbeschule (Kallir, 1986), this is not surprising. One room

was given over to a Cizek Juvenile Class exhibit (MacDougall, 1926).

A 1930 publication about the Kunstgewerbeschule (Rochowanski) listed other courses that Lowenfeld did not take, including Cizek's General Principles of Form (*Allgemeine Formlehre*), probably the course mentioned by Munro (1929). The accompanying illustrations for this course and those in Rochowanski's *Der formwille der Zeit in der Angewandten Kunst* (1922) have a strong futurist stylistic quality. Another course Lowenfeld did not take was architecture, then led by one of Austria's most widely known architects, Josef Hoffmann; nor did Lowenfeld take the craft courses listed.

In the narrative of his life story Lowenfeld spoke a great deal about classes with a sculpture teacher named Eugene Starnberg (or, alternatively, Steinberg) who required blindfolding of his students to encourage them to experience tridimensionality without visual distractions. Perhaps this teacher was in the Academy of Fine Arts since his name does not appear in available Kunstgewerbeschule documents. Lowenfeld claimed that this led to his desire to work with the blind, and, of course, Riegl's visual-haptic theory could be related to both the teaching approach of the sculptor and the theoretical explanation of what happened. Lowenfeld claimed visualness or hapticness to be inborn (Lowenfeld, 1939), thereby refuting Starnberg's approach, although sometimes Lowenfeld waivered about how innate these characteristics were (Smith, 1987).

Lowenfeld also claimed that he studied with Kokoschka after completing his college studies (A. P. Simons, 1968). This has not been documented, and it is not probable that Lowenfeld took more than a few hours of instruction with Kokoschka at the most or perhaps saw some kind of lecture or demonstration (Smith, 1983). After World War I Kokoschka spent very little time in Austria, which held for him bitter memories. There is no evidence of Kokoschka's influence in any published Lowenfeld art work--indeed, Lowenfeld's work seems even in its surface treatment opposite to Kokoschka's richly painterly work.

In a special issue of *Art Education* devoted to Lowenfeld (1982) three of his paintings from the 1930s were reproduced. This is probably the closest many Americans will come to a public inspection of Lowenfeld's Austrian-made art work, much of the rest of which must have been abandoned in 1938 Vienna. In examining those reproductions one becomes certain that Kokoschka had little or no influence on Lowenfeld's style. Neither do the paintings have the surface-patterning typical of Klimt, nor the raw angularity of Schiele'e figures. If we could count Klimt as the typical artist of the first generation of Viennese modernism and Kokoschka and Egon Schiele of the second, then by date and spirit Lowenfeld's work is of a third generation.

As is the case with Klimt, Schiele, and Kokoschka, the hands have prominence and apparent intended expressiveness, but they do not have the elegant nervousness of Klimt's Viennese ladies, nor the tortured and harsh tenseness seen in the works of both Schiele and Kokoschka. Lowenfeld's hands suggest movement, but little else. The streamlining of forms, the smoothness of surface, and inclination to decorative repetition of shapes and lines suggests art

deco. There appears to be a tendency toward machine-influenced slickness of surface, an avoidance of the ruthless tearing off of all psychological masks that characterized the work of the Richard Gerstl, Schiele, Kokoschka era.

If I may venture an art history generalization, art deco had nostalgic elements, suggesting a desire to return to art nouveau (or *Jugendstil*) forms, without the more Victorian elements of whiplash lines, tendril shapes, or glittering surface, although tightly mechanical patterning and a fondness for machine or metal-like "streamlining" were features of the style. Lowenfeld's work also had echoes of Gozzoli-like stylization in background landscapes, giving some support to A. P. Simons's (1968) claim that he had traveled in Italy as a youth. The rendering is "tight." The spirit is as exhausted as the Rococo after the exuberance of the baroque. However, the exhaustion seems the result of nervous tension, not the feeling of physical and emotional fulfillment that comes after great exertion. Although Lowenfeld is known to have painted at Hampton Institute (A. P. Simons, 1968), he seems to have stopped painting before his Pennsylvania State University days, although one of his students there admired his drawing skills (Smith, 1983).

Now having ventured the opinion in my brief analysis of Lowenfeld's work that he belonged to the art deco period--indeed, having said that he participated in the Exposition Internationale des Arts Decoratifs in Paris in 1925--I now have to admit that his teaching rhetoric was consistently expressionistic. His definition of art was that it consisted "in depicting the relations of the artist to the world of his experience with objects and not the objects themselves" (1952, p. 132). In itself this definition eliminates the importance of the mimetic and the formalist theories that others have emphasized in teaching art. Both in his motivations (Smith, 1985b) and in his evaluations (Ecker, 1963) Lowenfeld shaped an art education that had a strong expressionist bias.

Perhaps Lowenfeld's theories were at variance with his own art products because art deco could have no *strong* reason for being. It was a mixture of nostalgia and superficial attraction to the machined surfaces designed during the 1920s and 1930s. Perhaps his increasingly bitter and eventually traumatic late 1930s experiences turned Lowenfeld back to an adherence to expressionism without the personal artistic means to form it. While Austria's best-known artist, after the deaths of Schiele and Klimt in 1918, was the expressionist Kokoschka, Kokoschka virtually abandoned Austria and, Viennese art drifted towards the empty "charm" Sheldon Cheney (1966) deplored, or the "childishness" Kallir (1986) decried. Lowenfeld's painting might have been directed at the Kunstgewerbeschule towards the art deco style, but his beliefs and theories and personal experiences caused him to form educational notions and practices that led to an expressionist bent noticed in his students' work from the first English-language discussion of his teaching (Arnold, 1932).

IMPLICATIONS FOR AMERICAN EDUCATION
IN THE VISUAL ARTS

From Vienna Lowenfeld absorbed Cizek's Secessionist-influenced attitude toward the negative role of society in artistic development and a more general idea that a culture's historical heritage, whether artistic or social, is an oppressive burden. In addition, he shared Cizek's rhetoric about the desirability of shielding children from adult art standards.

From Viennese art history sources Lowenfeld gained his visual-haptic polarity, using it for what he believed to be a pedagogically useful theory. He also used it to justify certain types of student art products, even to the point of unconsciously favoring haptic-looking results (Ecker, 1963). Pushed on by an expressionistic Viennese heritage, this possible overvaluing or overstressing of work that had an expressionistic echo is understandable, even as it also brings to mind the artificiality of Lowenfeld's claim that the final product is unimportant (Lowenfeld, 1957).

In Vienna Lowenfeld had seen a type of vibrant expressionism that did not reach the United States until after he had begun his professional career in this country and did not become popular there until the end of the United States abstract expressionist years. Lowenfeld retained in his own memory a recollection of what Austrian expressionism had been, a powerful modern movement that smashed the suffocating burden of Viennese fin-de-siècle culture. But how much relevance to the American art scene could the Austrian expressionistic mission hold? Lowenfeld's expressive notions about art, introduced in the elementary and secondary schools in the United States, may have helped to lead to that isolation of school art from the art world that Efland (1976b) has noted. However, Lowenfeld's ideas were sufficiently similar to the child-centered notions of Cane, Naumburg, and Cole to gain acceptance in American schools. Ironically, Secessionist and expressionist Viennese art has now come to seem relevant to Americans as they enter another fin-de-siècle period (Kuspit, 1986).

From Vienna's absorption in the psyche (Johnston, 1972) came Lowenfeld's interest in psychology. From his experience as a Jew in an anti-Semitic society, a youth in a war-torn disintegrating nation, a student in a time of social and economic strife coupled with widespread starvation (F. M. Wilson, 1945), and a young man watching high political ideals fall into fascism, Lowenfeld came to the belief that only through the therapeutic salvation of each child could a good society be built. Only through an area of study severed from empty inherited *verbal* formulations could the child's whole being be reached.

I believe the sum of what I have discussed is that Lowenfeld brought to the United States his seventeen Viennese years, virtually all his adult life in 1938. Having thoroughly internalized his Viennese values, he gave that city's educational, artistic, psychological, aesthetic, and art history heritage. He may not have recognized how Viennese his gifts were, nor did Americans see where

Lowenfeld's concepts were not all suited to their scene. This lack of examination for congruity has been a contributing factor to the uneasy place for art education in American schools long before Lowenfeld's first influence was felt. Lowenfeld did not originate the lack of congruity, but his Germanic background and assumptions added to the alienation of United States schools and the art world in America.

However, the rhetoric of abstract expressionism and the rhetoric of *Creative and Mental Growth* (1947, 1952, 1957) do have a curious similarity. Lowenfeld, like the abstract expressionists, regarded the process of making the most important element in art and saw the good individual (in abstract expressionist terms, the pure, or heroic artist, one with a lack of historical burdens similar to a child) as, ipso facto, producing great and creative results (Fröhlich, 1968). Why there was no rapproachement between school art and the art world through this rhetorical connection cannot be fully explained. Perhaps there simply were too few Lowenfeldian teachers conversant with abstract expressionist theorizers to bring the two worlds closer together. Perhaps the artists felt frightened by taunts of childishness if the work of children was likened to their work.

Lowenfeld is still a name of power in American art education. Although his own death in 1960 and the deaths and retirements of his disciples have lessened Lowenfeldian political power in academe (and therefore in teacher education), his concepts go marching on. This was amply shown at the National Art Education Association Conference of 1987 when one speaker, Peter London, went to remarkable lengths to attempt to prove Lowenfeld to be *the* alternative to discipline-based art education. In the fall of 1987, journal articles appeared reexamining Lowenfeld's uses and transformations of the visual-haptic theory (Smith, 1987) and his role in shaping a socially-oriented art curriculum (Freedman, 1987). London, Smith, and Freedman, respectively, dealt with Lowenfeld's notions of affective education, his aesthetic and psychological theories, and his societal views.

In what I have already said and in what follows I will not argue for or against Lowenfeldism. Rather, I will reinforce my contention that Lowenfeld was truly a child of his times and that his outlook on those areas he made his life's work were shaped, probably more than he knew, by the extraordinary situation in which he grew up and received his education. I will further clarify Lowenfeld's views on society, minorities within society, children and art, education, art history, and aesthetics in light of his own cultural experience.

LOWENFELD'S THEORIES ABOUT ADULT ART

Lowenfeld's time in Vienna following World War I brought him into contact with horrendous social conditions (F. M. Wilson, 1945) and intellectual and aesthetic ferment unequaled in any other place in the twentieth century (Janik & Toulmin, 1973; Rochowanski, 1930). While Lowenfeld's ideas about child art

became familiar to readers of *Creative and Mental Growth*, his notions about adult art are not so well known. The best known of Lowenfeld's general notions about art has to do with hapticness or tactility and while I have already tried to indicate something of the nature of this theory, I will now examine it more fully.

Lowenfeld attributed the idea that tactility was the truest sense (i.e., free of illusions to which the visual sense was prone) to Johannes von Herder (Lowenfeld, 1951; Michael, 1981). The visual-haptic theory originated with Alois Riegl (Arnheim, 1983; Smith, 1983). Despite this, when Lowenfeld mentions Riegl in *The Nature of Creative Activity* (1939, p. 131), he does not do it in connection with this theory, and he does not cite Riegl at all in *Creative and Mental Growth* (1947; 1952; 1957).

However, Lowenfeld's knowledge of Riegl can be connected, as I have said, to his association with Ludwig Münz. Münz was thoroughly acquainted with Riegl's writings (see Kleinbauer, 1971, p. 124), and Münz used the terms *optischen* and *haptischen* in *Plastische Arbeiten Blinder* (p. 13). A less direct but important link is suggested by Gombrich's statement that Riegl's "theories [were the] favorite topic of conversation among the younger [Viennese] generation of art historians" (1979, p. viii) during Lowenfeld's student days.

Although Gombrich described Riegl as "one of the most original thinkers of [art history]" (1979, p. viii) and others have recognized his importance (Berenson, 1950; Johnston, 1972; Kleinbauer, 1971; Pächt, 1963; Schapiro, 1953), he is not widely known through English-language publications. Gombrich described his work as "hard to read" (1961, p. 18) even in the original German, and a person attempting a translation into English declared it an almost impossible task (Kleinbauer, 1971, p. 125). Nevertheless, Bernard Berenson thought a knowledge of Riegl's method as shown in *Late Roman Arts and Crafts* to be "indispensable to thoughtful students" of art history (1950, p. 226).

In 1893 Riegl published a book on oriental carpets in which he described metamorphoses in treatment of plant motifs over periods of time (Pächt, 1963). To account for stylistic change he brought forward the term *Kunstwollen*. I leave the exact meaning of this term to the analytical powers of German-speaking art historians such as Gombrich (1979) and Pächt (1963), but *Kunstwollen* seems to be a cyclical notion covering the passage from tactile concerns to visual concerns in art. Gombrich attributed the origin of Riegl's formulation of the haptic (tactile) to optic (visual) change in art to Adolf von Hildebrand's *The Problem of Form*. This is a curiosity for American art educators since Conrad Fiedler (1841-1895) based his art theories on von Hildebrand. Gustav Britsch based *his* theories on Fiedler and Arnheim. Lowenfeld and Schaefer-Simmern are indebted to Britsch (Smith, 1982b and see Chapter 3).

According to Gombrich (1979), Riegl's thesis was that "the history of art from ancient Egypt to late antiquity [was] the history of the shift of the *Kunstwollen* from tactile (Riegl says haptic) to visual or 'optic' modes of perception" (p. 196). Riegl claimed that such changes are inevitable. Gombrich

noted that this claim of inevitability of change may have been an indirect attempt to undermine the position of those who were attacking the increasingly anti-naturalistic art being produced at the end of the nineteenth century (Arnheim, 1983). Some caution in regard to what Riegl intended to justify has to be exercised. Gombrich implied Riegl was justifying impressionism. Arnheim saw Riegl's theories used by Lowenfeld and others to justify expressionism. The dates of Riegl's life, 1858-1905, have to be considered in attempting to understand his intent, as I have indicated before.

Riegl saw Renaissance art as manifesting a tactile conception of three-dimensional space, changing to a certain degree of visual subjectivity in the baroque era and, in impressionism, showing "the triumph of pure optical sensation" (Gombrich, 1961, p. 19). In *The Nature of Creative Activity* Lowenfeld saw the Middle Ages characterized by haptic emphasis, the Renaissance world, therefore, would have been visual. Riegl conceived of the haptic to visual progression as a matter of hundreds of years, and even to lengths of time corresponding to whole cultures. He imagined various races playing distinctive roles in the change. Furthermore, he saw the history of the West divided into eras marked by predominance of will, feeling, and thought (Schapiro, 1953). Obviously Lowenfeld selected only certain elements of Riegl's theories for his own use. Analyzing Riegl's ideas, Schapiro said that Riegl felt that: "The basic, immanent development from an objective to a subjective standpoint governs the whole of history, so that all contemporary fields have a deep unity with respect to a common determining process" (Schapiro, 1953, p. 302).

As an art historian in an age that tended to interpret history in evolutionary terms (i.e., change equated with development towards higher forms), Riegl brought forward a counterargument. He insisted one must "shed one's aesthetic prejudices and try to discover the historical *raison d'etre* of every work of the past" (Pächt, 1963, p. 190). Art work did not necesarily evolve in an upward qualitative path. It just changed through some inner law or necessity.

It may be that in *Plastische Arbeiten Blinder* it was initially Münz, a leading art history theorist, who used Lowenfeld's work with blind students and Riegl's haptic-visual theory to investigate "the basis of creative activity" (Novotny, 1961, p. 5). However, Lowenfeld's *The Nature of Creative Activity* (1939) was a much more extended treatment of hapticness and visualness related to the origin of forms in art. In this book Lowenfeld applied Riegl's sweeping historical and cultural theory to individuals' psychological makeups. His argument was that people are either haptic or visual in their orientation, regardless of visual acuity of their biological makeup. In his final chapter, he returned more directly to art history theory and advanced the idea that different periods of art favor one or the other type of artist. If the haptic artist lives in a period favoring the visual side of art, her or his work may not match the era's criterion for excellence. If the visual artist lives in a haptic era, there is a similar problem. In such cases of mismatching, it is not that the artist is a producer of "bad" work, but that indi-

vidual inborn potential cannot be appreciated in her or his particular era or culture. Later Lowenfeld was to use this idea to explain that the child may of inborn necessity produce work prone to "realism" or to inward expressiveness. The child "could not help it," and the teacher needed to work with the child within the child's natural haptic or visual orientation.

Lowenfeld treated tactility in a way that Riegl might not have intended. The idea of touch in the haptic mode is transformed by Lowenfeld to bodily feeling. Rudolf Arnheim (1983) has pointed out that Lowenfeld never completely resolved the difference between hand-touch and total-body-sensation. When he considered hapticness as body-feeling, Lowenfeld characterized it as subjective. The theorists von Hildebrand and Riegl regarded tactility as being objective (Gombrich, 1961; 1979). Recall that, according to Lowenfeld, his sculpture teacher at the Kunstgewerbeschule held that touch was the "truest" or least-prone-to-distortion sense in the von Hildebrand-Riegl tradition (Lowenfeld, 1958).

For Lowenfeld the opposition of subjective and objective in art expression were so important that his final chapter in *The Nature of Creative Activity* included the terms in its title. Lowenfeld tried to subsume some of the most prominent categorizations of art up to his time under these headings. As he put it, "The systematic study of art has always been concerned with the fact that in the development of art forms two aims and two styles seem to be traceable" (1939, p. 131).

Following this statement Lowenfeld equated Nietzsche's Apollonian (intellectualizing or classicizing) art with visual and objective orientations and Nietzsche's Dionysian (emotionalist) category of art with subjective and haptic approaches. Lowenfeld cited several other examples for comparison, all from German-language writers. Lowenfeld continued this bipolarism by dividing the whole history of art into impressionistic and expressionistic forms. Impressionistic forms, he declared, were visual, concerned with appearances. expressionistic forms were concerned with feelings, expression, subjective processes. "We shall, therefore, find more and more haptic symbols of form and expression, the more creative activity is bound up with the self and the more immediately the self becomes the centre of artistic experiences" (Lowenfeld, 1939, p. 147).

Although Lowenfeld had previously stated that "the form and mode of representation are deeply rooted psychological characteristics, which can disappear only when the personality ceases to exist" (p. 130), the preceding quotation contains the seeds of an idea he was to develop in America. That is, experience may bring about concentration on the self, and this concentration will "cause" haptic art.

LOWENFELD IN AMERICA: FROM THE EDUCATION OF AFRICAN AMERICANS TO THE PENNSYLVANIA STATE UNIVERSITY

Lowenfeld and his family were forced to flee *Anschluss* Vienna, and in 1939, after some struggles to find a niche in American professional life, he accepted a teaching job at Hampton Institute (now University) in Virginia.

It is difficult to imagine the European Lowenfeld, educated in a cosmopolitan and art-saturated city and struggling with a new language, dealing effectively with the problems of African Americans. His previous teaching experience had been at the prestigious Chajes Gymnasium and in the Jewish School for the Blind in Vienna's Hohe Warte district (Lowenfeld, 1958). Although Lowenfeld's 1939 letter of acceptance for the position at Hampton mentioned only *possible* volunteer art classes, by 1943 there were reported to be "165 students enrolled in Dr. Lowenfeld's department ("Young Negro Art Impresses New York," 1943, p. 25). In October and November of 1943 a show entitled *Young Negro Art: An Exhibition of the Work of Students at Hampton Institute* was held in the Young People's Gallery of the Museum of Modern Art ("Young Negro Artists," November, 1943). A review of the exhibit that appeared in *Art News* (1943, November 15-30, p. 22), gives some idea of the social climate in which Lowenfeld and his African American students had to work:

Young Negro painters who have been working at Hampton Institute learnt [*sic*] there (if we may judge from the show at the Museum of Modern Art) a form of race and social consciousness utterly incompatible with sincere artistic expression. In one picture only--that of Junius Redwood-do we find the great gifts of color, dignity, and sincerity which are the Negro's natural heritage. Of the screaming propaganda of John T. Biggers' picture [*The Dying Soldier*] the less said the better. One cannot help feeling that this is the work of heavy-handed teachers working with over-plastic material. ("Current Exhibitions")

Lowenfeld had to deal with the--to him--unfamiliar conditions of African American experience and the peculiar stereotypes white Americans held about African American life. He responded to these problems in his classes and in two articles, "New Negro Art in America" (1944) and "New Negro Art Expression in America" (1945). "Young Negro Artists" (1943) also contained quotations of Lowenfeld's beliefs about African-American art.

Lowenfeld stressed the importance of the social status of the African American. Black artists who imitated French impressionism, for example, were evidencing a longing to have what the white majority culture had achieved. When the African American really considered his or her own experience, a different style of art was produced:

This art necessarily must be self-centered. It must place the ego into a value relationship with his environment. Thus the self grows or diminishes both in size

and in importance according to the strength of the experience. Thus New Negro Art is not the art of visually minded people who feel as spectators rather than being involved. New Negro Art in its pureness must necessarily be extremely haptic. (1944, p. 21)

Lowenfeld gave no explanation as to the psychological process that caused this to come about, beyond the readily perceivable social experience. In *The Nature of Creative Activity* (1939) hapticness and visualness were inborn psychological types that could not be altered even by blindness. In this American publication Lowenfeld stated that social conditions caused haptic qualities. For example, the restricted space seen in haptic art work expressed the social experience of the African American. "The horizon of the sharecropper is his cottonfield, the horizon of a laundry woman her tub" (1944, p. 29).

Later, touching on a theme that might have been used as an explanation for inducement of hapticness, Lowenfeld referred to his own experience:

Whenever our freedom is restricted or gone, we become self-centered like the prisoner whose only outlook is the walls of his prison or the bars of his cell. I myself, being escaped from the claws of Hitler Germany, remember very well how my whole thinking and doing became paralyzed when Hitler marched into Vienna...and the only thought I was capable of was centered around how to get out of this hell. (1945, p. 29)

Lowenfeld seemed to claim that trauma could induce a haptic viewpoint, although it was not clear whether this was essentially social or psychological or both together. In his Austrian work he had implied haptic or visual types were born that way and were both normal. In turn, this may have shown an inconsistent quality in Lowenfeld's views about the nature of art. He had said that "Art consists in depicting the relations of the artist to the world of his experience-that is, depicting his experiences with objects, not the *objects* themselves" (1945, p. 27; emphasis mine). The implication would be that nonexpressionistic work would not be real art. Mimetic art, in Lowenfeld's opinion, was not truly art. In the United States Lowenfeld saw expressionistic art as the "salvation" for African American artists (1945, p. 31). "It gave the Negro artist confidence in developing his own pictorial creative abilities which were condemned to be suppressed as long as the world of appearances governed the art expression of our culture" (p. 31).

In the 1940s Lowenfeld's thinking was not free of stereotypes about African Americans or their visual art expression. He was, however, willing to try to understand their experience as best he could through the medium of his own education and theory. His record as an educator at Hampton and at Pennsylvania State University shows that he saw no innate educational limitations for persons of any color, a marked contrast to many of his fellow Austrians and his fellow Americans.

In retrospect it is unfortunate that Lowenfeld did not pursue ideas about the effects of social conditions on artistic expression. His two articles "Negro Art

Expression in America" and "New Negro Art in America" included indications that he might have been able to develop this line of thought. In the six years Lowenfeld spent at Hampton he tried to share the experience of his African American students and colleagues, including the humiliations of segregated drinking foundations and toilets. It is interesting to realize that Lowenfeld's first real American home and school experience were in "an all-Negro Southern community" (A. P. Simons, 1968, p. 89). Many of the materials in the first three editions of *Creative and Mental Growth* must have been developed at Hampton.

If Lowenfeld had pursued the study of the effects socialization had on artistic experience, one of the most telling criticisms of his ideas might have been averted. In 1955, in *A Foundation for Art Education*, Barkan objected to Lowenfeld's "rigid typological" haptic-visual distinctions because he had not taken into account social experience and its internalization. Such static types would require, Barkan claimed, "a physiological foundation but...[Lowenfeld] does not demonstrate [it]" (1955, p. 169). Instead of reexamining his Hampton experience and observations, Lowenfeld, by the third edition of *Creative and Mental Growth* (1957) attempted just such a physiological justification for his original Viennese belief (1939) that haptic and visual attitudes are innate. Interestingly, Barkan never seemed to note that in Lowenfeld's published work there had been a theoretical deviation from the doctrine of innate psychological types for visualness or hapticness.

Some art educators still refer to the haptic-visual categorization as a learning theory (see Michael, 1983b). Few, however, would care to defend it on the psychological basis Lowenfeld had brought forth in 1939. From a historical vantage point it is regrettable that Lowenfeld did not subject the theory to more rigorous reexamination. While we may regret his not following up on the effects of socialization on the haptic-visual traits, it is interesting to observe Lowenfeld's adaptation of a typically bipolar Germanic art history theory for his purposes. This necessitated the reductions and adjustments described. However, in a non-European setting Lowenfeld felt the need to modify basic assumptions of his own adaptations. Evidently, his original theory proved too strong for his experience, and his later work (1957) seemed to revert to the European conception of the causes of the visual-haptic traits. Of course, Lowenfeld was not the first or last man in academe to be blinded to reality by theory. His Germanic socialization may have made the possibility of change even more difficult.

FORESHADOWING THE POST-LOWENFELD ERA

Lowenfeld captured the attention of post-World War II Americans and they accepted his message because of his charm and persuasiveness, as Clyde Watson (1993, 1994) would explain. But Americans never examined the foundations of

Lowenfeld's concepts or the presuppositions his theories implied. Once the powerful persuader, Lowenfeld, was gone, through the process of wearing out or eroding with repetition, and through doubts raised by Lowenfeld's critics, a great unease gradually arose among those who were concerned with how to teach art in the public schools.

NOTE

1. Letter from L. C. Chilton, Executive Editor of Macmillan Publishing Company to me, October 7, 1981.

11

The Post-Lowenfeld Era: Radical Dissent and Thoughtful Revisionism

In the years following Lowenfeld's death in 1960, a reaction to child-centered and psychology-centered art education arose. Thus the developmental tradition in art education that had arisen during the child study movement at the end of the nineteenth century, during the age of Alfred Lichtwark and G. Stanley Hall, appeared to be coming to a close. Art education historians usually cite Barkan's (1962) speech "Transition in Art Education: Changing Conceptions of Curriculum Content and Teaching" (Efland, 1987; Kern, 1987; R. Smith, 1987) as the marker for this change. However, Barkan in that speech claimed that there was widespread "skepticism and doubt" and that "established assumptions were being challenged because of misgivings...and opposed because of dissent" (p. 12). Thus, Barkan admitted that he was one among many feeling the field was already in the process of change.

To show this skepticism and doubt, willingness to challenge and oppose, I will turn from Barkan's often if not over-cited piece to describe and analyze the work of two other art educators active at the same time, Clyde Watson[1] and David Manzella. These two contrasting personalities, each feeling discontent in his own way, reacted to then existing conditions and attempted to find a resolution to what each felt to be troubling weaknesses of the field. Their efforts also show why, despite high hopes for reform of art education, the reformations faltered and faded away. Each in his own way felt the preexisting conditions in which art education lived or died must be rejected. These conditions choked off the very lifeblood needed for the change both art educators envisioned.

Watson's story is one of evolving and thoughtful realization of basic conceptual weaknesses in the worlds of art and art education. It is the story of an intelligent and introspective art educator who searched for foundational causes for art education's problems and who saw that the problems of art education could not be changed by merely brushing aside a few current notions about practice.

Manzella's story is that of a rebellious anti-establishment figure, a somewhat

brash individual, who made one explosive assault on the symptoms of the marginality of American art education and then seemingly abandoned the effort as hopeless. This sense of futility probably came about because his suggested reforms could not root out the essential weaknesses of the field which existed at a far deeper level than he had perceived and pervaded not just education (as if it were the enemy of art), but the art world as well.

WATSON'S EDUCATION AND EARLY CAREER

In 1993 and in 1994 I interviewed Clyde Watson, a retired Arizona State University art education professor. This section is based on our conversations.

As did Manzella, Watson served in World War II. As a veteran (although, with typical modesty, Watson pointed out he never was in combat) Watson was able to work for a college degree with the financial aid of the GI Bill, as did many other veterans. The entrance of so many males into the work force, including the profession of teaching, was to have a significant impact on colleges and on the role of women in education. However, at this point I wish to concentrate on the conceptual unrest in art education. At first Watson attended Kansas State.

Watson: [I]n my art courses, with a couple of exceptions...I felt that the teaching was very lackadaisical. An attitude prevailed that those who had talent would prevail and those who didn't, wouldn't.

Dissatisfied with this laissez-faire atmosphere and with the curriculum, Watson transferred to Bethany College in Lindsborg, Kansas.

Watson: [I]t was a liberal arts school, but well known for its art and music programs. In fact, one of the artists long associated with the School was Birger Sandzen. He was well known in the area--and he is just now being recognized as one of America's better impressionists.... The fact he had taught at Bethany for fifty years really impressed me. That kind of dedication along with the strength and consistency in his work meant quite a bit to me.

Watson had married and, faced with the necessity of supporting a family, decided on teaching art at the high school level.

Watson: I did not see much of a future for myself in the "art world," since I just never could find personal satisfaction in the abstract expressionist movement which was *the* only way to be a "true" artist [at that time].

Recalling the art education world of the late 1940s and 1950s, Watson felt it

to be just as dogmatic, prone to claims that one theory alone was worthy of attention.

Watson: In about every institution with an art education program in those years *Creative and Mental Growth* was the bible for art education majors. Graduates at that time knew of no alternatives, except, obviously, that the old ways of teaching were all wrong.

Watson attended a talk by Lowenfeld shortly before Lowenfeld's death in 1960.

Watson: I could certainly see why he was revered as this great authoritative figure in art education. He was a very warm, charismatic person. His speech delivery, with his thick Austrian accent, was mesmerizing. He was particularly skillful in taking one simple idea and elaborating on that one theme in a way that would leave an audience spellbound-and convinced that he was right in his approach to education in the arts.

TEACHING IN THE LOWENFELD ERA

When Watson began teaching, he had two junior high school classes and two senior high classes and, for an hour and a half each day, was art consultant in elementary schools.

Watson: When I went into an elementary classroom to teach a lesson, following Lowenfeld's example, I tried to engage the students verbally in reliving some experience.... After this verbal effort and motivating or stimulation, the thing that was supposed to happen was that there would be this magic moment when the student in a burst of creative energy spilled his or her emotional and intellectual expression out through the art media...an idea consistent with the artistic world of abstract expressionism....

I remember, vividly, after having done this a few times in one elementary school, I was cornered by two maiden sisters who taught fifth and sixth grade. They asked, "When are you going to teach them something?" Needless to say, I did not have a satisfactory answer for them--or for myself.

It is curious that neither Watson at that time nor the two classroom teachers saw that Lowenfeldian teaching came during individual formative evaluations, dialogues between teacher and student, in which the teacher guided the student to develop his or her ability to express the meaning of that student's experience in visual terms. If *Creative and Mental Growth* was a bible, its inner spirit had

been missed.

In the junior and senior high school classes, however, Watson felt he was doing more substantive teaching by concentrating on materials and techniques. Although he felt art history should be included in a good art education program, teaching the history of art was problematic at best, and making any connection to the contemporary art scene, as "found in slick East Coast art magazines," seemed impossible.

Despite a feeling of relative success in secondary school teaching, Watson began to become aware of the conceptual inconsistencies of art education. One of the focuses of this growing awareness was "design."

Watson: I didn't have the vaguest idea...as to how to go about teaching "design" since I had not had a class per se in college as a model to follow, and I was troubled how the few typical design projects I saw practiced didn't seem to relate to other practices in art.

This writer was attending Pratt Institute at the same time that Watson began his teaching career. There and then students were required to do a series of exercises to develop understanding and skill in the use of elements and principles of visual art, in other words, "design." There was some vague talk about these being derived from the Bauhaus, but now I realize they were more directly related to the educational perspectives revealed in *The Art of Color and Design* (2nd ed., 1951) by Maitland Graves. Indeed, Graves was one of my Pratt teachers. Graves's work, in turn, seems to me to be obviously derived from the theories of Arthur Wesley Dow, a number of which are referred to in *The Art of Color and Design*. Dow, of course, began his higher education career at Pratt. Design was the foundation of all art for Graves, as well as Dow--although Dow's principal book was titled *Composition*, rather than, for example, *Design in the Arts*. Design, for both Graves and Dow, was a very teachable, even potentially testable part of the arts, applied or fine. Graves included an art or design judgment test in his book.

However, like Watson puzzling over art magazine reproductions of work from New York avant-garde galleries, we Pratt students looked at the actual current art objects in Manhattan exhibits and were also puzzled, perhaps while we stood in front of a Jackson Pollock and asked each other, "Where's the dominant form in this painting; where's the subordinate?" The type of design theory, which had seemed quasi-scientific to Graves and Dow, had simply been passed by in the real art world. Incidentally, I cannot recall one single teacher telling us to go look at Pollock, Hans Hoffman, or the work of any other artist in the rambunctious New York new art scene.

But to return to the testimony of Clyde Watson, he moved on from his first teaching position to Manhattan, Kansas.

Watson: [The high school principal's chief] interest in me was that I had gone

to Bethany and surely had been instilled with some kind of work ethic from a church-related school. I taught in Manhattan for seven happy years.

Watson succeeded in convincing the school administration that he was indeed a serious, hardworking teacher. Little as the school administrators understood what he was doing, they regarded Watson as a devoted teacher who appeared to know about his subject and how to teach it.

Watson: A listing of my classes from beginning to advanced, reflected largely what my college catalog listings might have been. I assumed, as most such listings did, that a general beginning class was to be a sampling of experiences with drawing, design, painting, various crafts--the materials and techniques approach--and if lucky enough to have the equipment, get in some print making and sculpture. Advanced classes concentrated in one of these areas, but with an underlying assumption accepted by all art quarters, that drawing and design were basic to any art process--although I still didn't know how that "design" stuff should be handled.

Apparently at this time in his career Watson had a number of conflicting assumptions. His education at Bethany College had been more or less traditional in its emphasis on drawing. This traditional strain had been reinforced through the commanding presence of a well-known figurative artist in the small academic community. Yet, "design" was strongly emphasized in much of the post-Dow visual arts education literature. At the same time, Lowenfeld's influence, widely communicated through *Creative and Mental Growth* as a pre-service education text and through a growing network of art education academics graduated from Pennsylvania State University, had come to dominate elementary and, to a lesser degree, secondary art education rhetoric. Yet rhetoric, historic practice, models of teaching derived from college, the pragmatic necessities of life in school, and so forth were in dissonance. While all this was taking place, the practice in the art world was weakening many of the old definitions and so-called laws of art and design.

Eventually, for some art educators (as Watson was to see), the building conceptual crisis was eased to some degree by the theories of Morris Weitz, but few art teachers probably actually were acquainted with this philosopher. Weitz had described art as an open-ended, ever-evolving concept. He had also stated that the many theories of art could still be used as long as they were understood to provide frameworks for examining different facets of a larger whole called art (Weitz, 1956). Weitz's work could have been used as a conceptual framework for easing the dogmatism and rigidity of the stances of artists and art educators, but it was little known outside academe. It was even ignored among 1950s studio teachers in higher education, many of whom rejected verbally articulated theory

of any kind. This, of course, reflected the abstract expressionist myth of the inarticulate heroic artist--a figure unconsciously close to what was then called an idiot savant. Art teachers were the products of institutions where art and art education had been taught dogmatically. The notions of theoretical analysis or philosophic questioning were foreign to the traditions of public school art teaching or even college-level studio instruction.

While Watson now sees his public school teaching as having been the product of unexamined concepts, he does not reject it as without worth.

Watson: One of the greatest compliments that I ever received about my teaching came from one of my high school students who much later as we met again and reminisced about those days, made this statement.... "When I came into your class, I had always thought art was just about drawing and painting. But you were always talking about *life*! Curriculumwise I may have been fumbling around, but this statement [by her] suggests to me that I must have been doing something as well that I still take great pride in.

Was this "something as well" an assertion of an aesthetics related notion (perhaps then unformulated) that art had a dimension beyond design, technique, or autosatisfaction? Art, the student seemed to have heard from Watson, was a vital human activity that made a difference in the world, in "life."

ART EDUCATION IN HIGHER EDUCATION

Watson was not just a committed art teacher isolated in one high school in Kansas. He became professionally active and was elected president of the Kansas Art Education Association. This professional activism brought him in contact with Warren Anderson, a member of the University of Arizona art education faculty and an invitation by Anderson to teach at the university.

Watson: I came to university teaching thinking that I had much to offer my students in the way of practical knowledge. I could...give them much of the practical information I had accumulated in...eleven years of teaching. I soon found, however, as I listened and thought about the ideas they offered about what and how they would teach, that I was asking more and more of them the question "Why?" Why are you going to have the students do gesture drawings, for example, and what are you going to follow up with? It was common in those days for students at some point to do gesture drawings. After all, that's what Nicolaides did in his little book, *The Natural Way to Draw*.... But why? I would ask, "What is being learned and what learning might follow-or should something precede gesture even?"

Watson found the students unquestioning of authoritative statements. He began to doubt the very basis of his own critiques. "Much of it," he felt, "just did not have any particular logic." Watson tried to see or hear what other art instructors said. They all seemed to be making statements about art as announcements of unquestionable facts, yet Watson could not fathom what justified the authoritativeness of tone of such pronouncements.

Watson: But students all learned eventually to speak in this very factual way about these [art project results] either making an aesthetic statement or not. Another example of my amazement about illogical statements so freely made and accepted was to hear another colleague say in response to a student's question, "If you gotta ask, you'll never know." Now that may have been the "right" answer for the person who thought of himself as a gifted artist first and a professor second, but it gave no justification for me as to why that student and that professor needed to be in a formal educational setting wasting somebody's time and money.

Watson had moved from uneasiness about what things he was to teach to disquietude about all statements about art made by the teachers he heard. At the publication of Warren Anderson's *Art Learning Objectives for Elementary Education*, he began to see that there were attractive alternatives to this educational miasma. Of Anderson's book, Watson said:

> Foremost in my mind, it was an excellent attempt to look at art and art behavior from some clear and reasoned perspective.... Before [Anderson's book], curriculum making and educational objectives were the mumbo jumbo province of professional educators, who were talking as equally nonsensical language as many of my art colleagues.

Although Anderson's book was written for use in elementary school--or perhaps because its intended function necessitated clear and succinct statements--it suggested to Watson that a *logical* method for art teaching might be possible.

Despite this break through, at this point Watson feels he was still laboring under the belief that the TRUTH about art could be discovered and explained as the structure of molecules or the number of times the word "blood" appears in *Macbeth* might be discovered through empirical means and reported. Although he heard various individual statements about art that seemed very true, he began to note that some of these very statements seemed to contradict others, and what gave the authoritative basis for the so-called TRUTH Watson could never determine.

At this time June King McFee's *Preparation for Art* (1961) also appeared. This provided an alternative to the Lowenfeld model for art education, and it showed Watson that art and art education might mean different things in different

places. McFee's anthropological approach showed him that art varied with culture. Thus, the notion of an ironclad and universal set of truths about art began to be eroded.

However, it was David Ecker's "The Artistic Process as Qualitative Problem Solving" (1966) that gave Watson a model of the artist as a person, in Watson's words, "with some *intellect* in knowing how to go about something in making a work of art." Watson found it to be, "Much more intellectually satisfying to think of the artist as an intelligent problem solver, and that there was a corresponding educational mission in helping the individual student to build up experience from which inventiveness might more readily occur."

Having come to see that questions about art were not dissimilar to problematic situations in other areas of human interest and that teaching might be a matter of helping the student develop a repertoire of problem-solving strategies, Watson could further analyze the educational processes he saw all about him. Misused language and false assumptions had obfuscated thinking and teaching about art. The givenness of many, many TRUTHS about art, Watson began to see, was an illusion.

From this point on, Watson started on a path which few art educators, even those who sensed that something was truly wrong with the prevailing art and art education rhetoric, chose to pursue. A reading of Stephen Pepper's *The Basis of Criticism in the Arts* (1945) and then *World Hypotheses* (1942) led Watson to believe that a basic philosophical sea change had to take place if people were to adequately understand and talk about art. The practices in education about art, whatever the level, were the results of unthinking acceptance of inherited assumptions that, for any questioning intellect, could not be honestly sustained.

From Watson's experience we can see that there were resources to help the uneasy and inquiring art educator to resolve some of the problems resulting from inadequate doctrines and the inevitable "wearing out" of what had seemed to be helpful practices from a past receding into history. Watson chose the way of thoughtful searching to uncover the hidden elements leading to these weaknesses, while his contemporary, David Manzella, chose the path of the iconoclast--the one who smashes the appearance of that which is perceived to be wrong so that--perhaps--the new may take its place. Yet the iconoclast may see only the suface of problems and not understand the thinking needed to avoid the problems.

I will return to Watson's experience and his evolving thinking, but now I want to turn to the Manzella book *Educationists and the Evisceration of the Visual Arts* (1963), which appeared within a year of Ecker's "the Artistic Process as Qualitative Problem Solving" and Barkan's "Transition in Art Education." The Manzella book gives us a picture of an art educator who saw there was something wrong with the field, but who mistook as his target misguided practice rather than underlying problems that were really of a more theoretical nature.

THE MANZELLA RESPONSE

Although Manzella's *Educationists and the Evisceration of the Visual Arts* (1963) was greeted as one of the most unsettling books ever published about art programs in the American schools (Lanier, 1977), its author is now virtually forgotten by art education historians and his book read only in scattered places. Yet, Manzella's book was symptomatic of an age, of the extreme restlessness that swept through America after the socially complacent 1950's. In order to explain Manzella's place in history, I will describe the contents of his book and, its similarity in style to other comments on education of its time, and draw upon comments Manzella made during an interview in 1988.[2]

Educationists and the Evisceration of the Visual Arts was a ninety-seven-page paperback with a reproduction of Rembrandt's *Flayed Ox* on its cover. As James Anderson (1969) stated, "Manzella shocked the 'creative pants' off art education" (p. 27). In a field with little or no tradition of critical dialogue, Manzella's vehement attack seemed doubly frightening. Not that he said anything especially new for persons who had been in the field of educating about the visual arts--they had just never seen such a public attack or heard such publicly intemperate language.

A number of prominent figures in visual arts education came forward to try to respond to Manzella. Ralph Smith (1964), an individual always regarded as one of the most deeply read in the philosophical concerns of visual arts education, was roused to try to refute Manzella's assertions, finding the tone of the book "intentionally contemptuous" (p. 4), similar to many of the angry and frequently inaccurate criticisms of American education that had sprung up in the wake of Sputnik (1957). Victor D'Amico (1963), with great emotion, protested that Manzella's book might lead to a retreat to older and (in his opinion) harmful teaching approaches. Despite this expression of outrage, the only outstanding mention of Manzella since Anderson's remarks, has been Lanier's (1977) brief mention of Manzella as an example of a muckraker. By never mentioning the book, art educators have successfully nullified the impact of it, but in doing so, they have also avoided examining carefully the bases of Manzella's observations and assertions. Their silence was not part of a conspiracy, but it may have been an unspoken admission of insecurity.

In 1988, Manzella admitted that his book, which was devoid of citations of sources or documentation of any kind, was intended as a polemic, in the eighteenth- and nineteenth-century tradition of small-size tracts deliberately phrased in combative rhetoric. This was done, he claimed, in part as a reaction to the constraints placed on him as he wrote a dissertation for his art education doctorate at Teachers College, Columbia University. The result was a book written in the most strident terms, damning everything in the post-World War II era in art education up to 1963, admitting no virtues in theories, philosophies, or practices of the field at that time. Indeed, Manzella rejected the very term "art education" as bastard terminology.

The book was written in California while Manzella was teaching at the University of California in Los Angeles. At this same time, Max Rafferty was California commissioner of education. Rafferty's rhetoric was well known, both from his campaigns and tenure in office and, doubtless, was familiar to Manzella. Rafferty, writing with what sounds like paranoid fanaticism now popularly associated with the pre-1960's Senator Joseph McCarthy, was a violent critic of anything he associated with Progressive Education. In fact, Rafferty was fond of suggesting that progressivism was a communist plot.

Rafferty was an ideologue with a few ideas, which he repeated with great emphasis, reiterating them without increasing the explanatory depth of his speeches or publications. He wrote a book titled *What They Are Doing to Your Children* (1963), in which he implied the current education scene was a conspiracy by evil anti-true-American leftish plotters. He frequently used the sloganlike phrase "education in depth" when he referred to his own reform schemes. Rafferty and Manzella sound strangely similar in tone, if not exact content, and that similarity may be significant. For comparison, here is an example of a statement by Rafferty that mentions education in the visual arts:

Education in depth stands for the equal dignity and status of each subject, whether it be art or auto mechanics, history or homemaking, mathematics or metal shop. If it is in the school curriculum... it deserves to be accorded exactly the same respect as any other subject. Furthermore, it deserves to be taught by a teacher who is prepared to teach it, who honors it for its own sake. If a subject is not worth this kind of treatment, take it out of the school altogether. But don't set up first- and second-class citizens among our teachers based on imagined superiority of one subject or group of subjects over another. (1963, p. 92)

This sounds rather benign. In one sense the J. Paul Getty Foundation's discipline-based art education--which, incidentally is also the product of a California-based organization--attempted to make art more respected by making it more like other subjects. (Perhaps the Getty Center for Education in the Arts is a theoretical grandchild of Max Rafferty!)

One of the rhetorical devices of the Rafferty type of ideologue is to make the present look deplorable by evoking a glowing mythic past. Rafferty pictured a present in which Progressivism had dragged traditions into a mire of relativism and destroyed respect for teachers as the bearers of received knowledge. Rafferty's myth can be exemplified by one of his questions: "How can educators become again the cultural leaders of the community?" (1963, p. 105). This presumption of past glory boggles the mind. Did Washington Irving sketch Ichabod Crane as a cultural leader in the Hudson Valley? Did Mark Twain describe the schoolmarm or schoolmaster as the cultural leader of the nineteenth-century American community? Rafferty seemed to have little sense that education is forced to change because society changes and, therefore, its educational institutions must adopt new forms and methods. Rafferty had swallowed certain notions about American education found in the writings of figures such as Ellwood Patterson

Cubberley, another figure active in California (Cremin, 1965). He did not see that the image of educators as torchbearers of American democracy was at best greatly exaggerated and, at worst, a misleading and harmful myth.

In a like manner Manzella pictured an art education past in which art was imparted to students by an impassioned master passing technique and mystique on to the younger generation, uncorrupted by educational theory, although, outside private studio instruction, it is hard to imagine where this took place. Manzella, like Rafferty, also created a mythic image of an education in art despoiled in its later years (that is, around 1963) by pernicious educationists joined by a (hard-to-believe) cohesive group of art educators bent on not teaching art in any form Manzella felt was respectable. In itself, the notion of any large group of art educators getting together on any issue is almost laughable to experienced practitioners in the field. In the process of damning the field in Jeremiahlike terms while providing suggested remedies, Manzella was prophetic in a sense. His prophecies foreshadowed or were contemporaneous with denunciations of Vincent Lanier (1963), Elliot Eisner (1965b), and others who decried the conceptually weak state of art education, and Manzella's reformation suggestions adumbrated much that was to be the basis of discipline-based art education thinking in the 1980s.

In 1988, however, Manzella did not--and I suspect, *could* not--give a coherent explanation as to what would constitute a new conceptual basis for art education, indeed, admitting that exactly what should be taught in art after impressionism was a matter of uncertainty. This did not deter Manzella from a very negative but vigorous attack on visual art eduation in America.

THE CONTENT OF *EVISCERATION*

Manzella's premise was boldly set forth in his Introduction: "Art, as it is taught in our elementary and secondary schools, is becoming a disemboweled carcass and…this evisceration is largely the result of the cutting and hacking of professional educators" (p. xiii).

He reinforced this by claiming, "Art education is the teaching of art within the framework of the discipline of education. It is bounded by the insights provided by the profession of education, not of art" (p. 1). To illustrate his belief that the then current art education issues were irrelevant to concerns of the field of art, Manzella related an anecdote about a presentation by a young art education candidate for a faculty position at the University of California. Manzella granted that the young man's research was well conducted but stated the search committee members' reactions revealed the split between education and art. Members from education were impressed by the candidate's work, art faculty members were not. "The reason was obvious…it just had nothing to do with art. As I recall, it had to do with ways in which youngsters placed toothpicks in a lump of clay as a measurement of their creative abilities (1963, pp. 11-12)." In

1988 Manzella claimed that young man was now one of art education's leading figures, thus implying that the field is still dominated by people who do not really know much about art.[3]

In 1963 Manzella perceived signs of dissent against slogans that had dominated the post-World War II era, "art for all, art as a way of life, or art for life adjustment" (p. 8). In this rejection of extrinsic goals for art education, he shared the views of Manuel Barkan in his "Transition in Art Education" address (1962), although he either did not know or did not acknowledge, as Barkan had, that many art educators at that time also felt dissatisfaction and longed for change. Barkan saw a change from the free expression emphasis in art education toward an interest in art history and appreciation, of teaching art as a discipline. Later, at the 1965 Penn State Conference, Barkan was to articulate his views further, suggesting that art could be taught as a discipline in the sense Jerome Bruner had advocated for other school subjects (Efland, 1984).

Manzella wrote that art "educationists" had students use art activities for the students' psychological growth, not to learn about or produce art as an end goal. This meant that learning about art of the past was not even considered. He felt this lack of attention to studying significant art works showed that art education was not a real school subject, but merely an activity. "There is little connection between diddling with art media in the hope that one will experience emotional growth and the disciplined learning of art (p. 18)." Manzella condemned the psychologizing he saw in the actions of many art educators as amateur, and superficial and said it led teachers away from teaching art as a real subject.

I imagine Manzella would have condemned Watson's Lowenfeldian efforts in the elementary school but would have praised his art and design centered high school work. Yet Watson saw that *both* levels of his work, contradictory as they were, had dangerous flaws. These flaws had as much to do with flaws in thinking about art as with pedagogical errors. Watson had no objection to the teaching of art in schools. He felt, however, that the conceptual foundations for thinking about art could not be defended.

Victor D'Amico (1958) previously had warned against the displacement of teaching about art by dilettante psychology. It can be assumed that Manzella was aware that there was significant, if not vocal enough, opposition to a psychological emphasis associated with Lowenfeld, and much of *Evisceration* can be read as anti-Lowenfeldian. While Lowenfeld had died in 1960, his numerous students had become members of a college-level art education faculties and had become leaders in the field, giving speeches, writing texts, and producing teaching aids (film strips, curriculum guides, and so on). The dominance of Teachers College alumni had come to an end in the early 1950s and the ideas of Lowenfeld, disseminated from his Pennsylvania State University graduate program, became the new orthodoxy of art education.

Lowenfeld in *Creative and Mental Growth* (1947; 1952; 1957) claimed that art led to wholeness and through wholeness of the individual, to a saner, better society. One of Manzella's vehement assertions and one almost certainly aimed

at Lowenfeld's followers was that: "The man who creates, and this should be the goal of our education, is a man with passion, and passion is not dependent on wholeness. The artist or scientist is not a whole man. Our world has largely been molded by cripples, not by the well-rounded, well-adjusted, and tranquilized products of the educationists" (p. 28).

Another Lowenfeld-associated issue, creativity stimulation through art education, was also disparaged by Manzella:

Because the educationists can never accept art as worth studying on its own merit, they are only too happy to jump on the creativity bandwagon.... [However] the bulk of a youngster's art experiences in the elementary and secondary schools may be classified as desultory forays into self-expression. The remainder of his time...is spent in superficial exploration of new media and techniques calculated to ensure a high degree of success in producing pleasing effects. (pp. 38-39)

Manzella found art educationists' emphasis on development of individuality among students counterproductive in an excessively individual-centered culture. He questioned the pedagogical logic behind the emphasis on individualism: "Imagine what the results would be if there were an early pressure on uniqueness of handwriting as there is on uniqueness of expression in art education. The results would seem fairly obvious: a breakdown in communication, chaos and gibberish" (p. 26). Manzella seems not to have noticed that art educators *talked* uniqueness, but the products of many, if not most, art programs were (and are) as predictable as the contents of airport gift shops.

Once his views about art education practice had been given, Manzella went on to make a statement that must have been truly disquieting to an audience of art educators:

My own view is that art education, as presently concerned...has no place in general education.... Art education, with its present emphasis on undisciplined self-expression and its superficial exploration of media, certainly has no place in general education. Possibly there are a few places where it can be legitimately used, apart from institutions for the psychotic or maladjusted. (pp. 19-20)

Manzella felt that the most important subject in the public school curriculum was not art and never could be art. The premier subjects had to be those associated with literacy and numeracy. It would not in the long run make any difference if art were not taught in schools, most especially as art was being taught in schools at the time of the writing of *Evisceration*. In 1988, Manzella reasserted his belief that art would survive its total absence from the public school curriculum because art was intrinsic to human nature. Manzella would dispute Eisner's assertion that "art represents the highest of human achievements to which *students* should have access" (1985, p. 64; emphasis added). Manzella found the claims by art educators to the effect that art in the school curriculum was an absolute necessity to be an absurd exaggeration. He had nothing against

art being a part of the curriculum, as long as it met his standards for rigor and substance. After all, Manzella felt, "Works of art possess values beyond surface realities. They move men's souls" (p. 48).

As a product of Teachers College, Columbia University in the post-World War II Edwin Ziegfeld-led era, Manzella might have been expected to espouse the social-environmental amelioration views Ziegfeld had cultivated at Owattona. This stance, to the contrary, angered Manzella as much as the psychological approach. Going full tilt against ideas that could be traced to the Teachers College, Columbia University of his doctoral student days, Manzella rejected any necessary link between art and democracy. He felt the idea that democracy nourished art historically absurd and the assertion that all students were equal in art classes was harmful. "Hand in hand with pointing out to all our students that each of them has some ability is the necessity to underplay the truly talented" (p. 35). Further, Manzella protested educationists' claims to be social benefactors through the development of taste: "The country is concerned about trends toward conformity, and the art educator says he can provide some part of the antidote through encouraging originality. And yet, what is good taste if it is not conformity and modishness?" (p. 51).

Teachers College faculty, in their zeal to democratize art, had in the post-Dow years (1922-1946) emphasized design applied to everyday life. This had been one of the legacies of the work of Arthur Wesley Dow. Owattona had been the most complete demonstration of this approach to art education. Ziegfeld, the on-site leader of that project, had been at one time a landscape architect and was very interested in the design aspects of art. Perhaps a certain preciousness had crept into the rhetoric of the leaders of this approach to art education, but, contrary to Manzella's opinions of 1963, a leading present-day art educator has claimed that the field overemphasizes fine arts. The design fields are actually the areas most art-trained people work in and are the areas that touch the lives of most people on a day-to-day basis (Chapman, 1982). Obviously, Manzella's definition of art was a narrow one and essentially held that art was Western fine art, gallery and museum objects.

Manzella traced some of the vapidity he detected in the field of visual art education to the weak preparation of art teachers. Their education, he claimed, required only:

A superficial acquaintance with the history and practice of art while demanding a great portion of time in education.... The pointed exclusion of depth of knowledge of a subject field as a prerequisite for the prospective teacher is one of the great mysteries of educational philosophy. This philosophy resulted in the usual art education major being a nice young woman of unexceptional abilities and little ambition to do anything with her art on a personal level. (pp. 76-77)

Manzella then went on to make a statement he later (1988 interview) claimed to regret and felt to be the only statement in the book he would delete; and, yet, he

asserted, it was a result of his own observation: "The young man in the program is usually interested in crafts and the decorative rather than painting or sculpture and is often rather low in male hormones" (p. 77).

I need not add that such sexist and homophobic language is now so abhored that it is hard to imagine an art educator once used it, but it was a type of rhetoric used in the early 1960s. It reveals a great deal about the shortcomings and limitations of the age, of the art world, and of the world of art education in the early 1960s.

According to Manzella, once into the schools, teachers educated in the pernicious system he condemned did not believe that art fundamentals needed to be taught in order to make expression possible. Since art fundamentals were not taught, or at least not thought by Manzella to be taught, art teachers at all levels planned projects for which no prior learned information was required. In 1963 Manzella seemed perfectly sure that there were specific and nameable fundamentals that had to be taught, although he actually never named them. However, in the 1988 interview, pressed to list these canonical fundamentals, Manzella admitted that there was a general uncertainty, already mentioned, as to what constituted the necessary and sufficient fundamentals of a modern education in art. This admission revealed a basic if hidden problem with his 1963 book. That is, the art world for generations had harbored vehemently stated but contradictory basic notions of art. If the foundational theories about art are confused, then what educational practice could or can be extrapolated from the theories? This fundamental weakness, of course, is what troubled Watson so much, but Manzella did not seem to be aware that the educationists could not turn to the current art scene and find the basis for a teachable program.

Having heaped scorn on art education's chief 1963 concerns and the then-current preparation of art teachers, Manzella went on to look at the elementary and secondary schools that had art programs:

The art educator is part of an educational system that is primarily interested in the teacher's ability to maintain order.... The charge that art is busy work is monstrous. If, however, one says that the teaching of art in the schools is mostly busy work, he is quite right.... The fault is not the teacher's; it is the philosophy underlying art education which emasculates art and allows it to become meaningless diddle. (p. 79)

Note that Manzella's rhetoric implies that art is male and that its adaptation in schools makes it a eunuch or--by significant, if disgusting extrapolation--somehow *female*.

The unstructured nonsequential characteristics of 1963 art education were features that set it apart from school subjects. Subjects included mathematics, science, and English, while art was an activity, similar to music and physical education. In an activity, Manzella stated: "There is no accepted body of knowledge, no sequential development; there are no examinations, no failures.... The closest parallel to the ineffectual character of art education is physical educa-

tion for girls" (p. 74).

Nowadays, this remark may seem irritatingly sexist, just as Manzella's use of emasculation reveals his assumption that the art is connected to male genitals, but it does have a kind of wayward perceptiveness. The problem with both art and "girl's" physical education as "activities" in 1963 was that neither seemed to relate to anything important in the world outside schools, and both were in dissonance with other school subjects. With the increased importance of women's athletics and rise in interest in fitness for males and females, some of this apparent pointlessness, as far as physical education goes, has faded. But in art, the failure to demonstrate a vital human importance has not gone away. Many art educators, reacting to the efforts of the Getty Foundation for Education in the Arts, have tried to give art the look of academic subjects, replete with structure, sequence, assessment, testing, and so forth, thinking this will make art have the prestige of math or science. I believe it to be wishful thinking.

In *Evisceration*, Manzella explicated some thirteen ideas and practices he claimed constituted the malpractice of art education. Having compiled this list of horrors, he next attempted to suggest a constructive set of reform measures.

MANZELLA'S "APPEAL FOR REFORMATION"

The conclusion of Evisceration was a six-step reform program for art education:

1. Art educators should claim credit only for teaching art.
2. Art educators should stop claiming art to be the most important subject in the curriculum. Manzella, however, insisted that it should be excellently taught by highly qualified art teachers. If such were not available, it was best not to attempt to include it. Here the similarity of Manzella's book and the Rafferty statement previously quoted is obvious.
3. The goal of art education should be aesthetic education and not life adjustment, or some other watered-down psychosocial goal. Unfortunately, the word "aesthetic" was not clearly defined by Manzella, and the several uses of the word since 1963 have obfuscated whatever apparent clarity it had in 1963. Watson claims that the 1970s aesthetic education drive was marred by conceptual confusion. In our 1988 interview, I could not determine what Manzella meant by the term, although he seemed to admit that he had used the word in a loose sense, more or less as the word "artistic" might be employed.
4. Studio experience should be relegated to a less important and time-consuming place. Intellectual and emotional grasp of the content of art should be art education's reason for being. Manzella stated, "I would recommend that we reverse present practice and work toward an understanding of art through lectures, demonstrations, exhibitions, museum visits and readings, with oc-

casional opportunities to deepen insights by way of studio work in various media" (pp. 90-91).

5. Art should be taught in a structured and sequential manner. Students should be required to demonstrate mastery of the material presented.

 Up to this point Manzella's reformation program could be reconciled with most, if not all, of the descriptions of discipline-based art education that have been issued by the Getty Foundation for Education in the Arts or its various spokespersons or admirers. However, Manzella added one more proposal: point 6.

6. All school districts should establish studio classes outside regular school hours for gifted students. These classes should be taught by persons who are producing art works themselves.

The final proposal shows Manzella's own strong studio background and bias. Indeed, by 1988 Manzella had become a studio art teacher with little or nothing to do with the field of American art education outside the college classroom. In the Getty version of discipline-based art education, as it was originally proposed (Getty Center for Education in the Arts, 1984), it was not clear whether studio production would have any more or less prominence than aesthetics, art criticism, or art history. However, in early Getty publications there was no mention of extraschool hours studio classes for the talented. It is difficult to make any certain statement about this, however, because Getty efforts have changed in various details, if not in basic intent, over the years. While Getty discipline-based art education has been accused of elitism (Hamblen, 1987), its four-component makeup did not seem to make it necessarily a program favoring a gifted few students who could make superior art products.

The danger of the all-out scattergun approach to criticism is well illustrated in *Evisceration*. The most glaring example can be found in relation to Manzella's insistence that studio art should be taught by exhibiting artists. Having set up the producing artist as a necessity in art teaching, in another part of his book he states: "In my experience artists have proved to be the most narrow, prejudiced and opinionated people imaginable. The artist at best is an anarchist and at worst a misanthrope.... At other times his concerns are wholly removed from the workday world. While he is a most necessary member of the community, a nation of artists in fact or in temperament would hardly be desirable" (p. 33).

This does not seem to be a description of a desirable teacher. Surely breadth of mind, acceptance of a broad range of art, and encouragement of widely varying opinions expressed by others are closer to the behaviors of good art teachers. Of course, in his book Manzella reflected the nonintellectual image of the artist that had pervaded the late 1950s and very early 1960s.

AUTOPSY OF *EVISCERATION*

At the heart of the Manzella argument is the notion that educationists must necessarily be primarily concerned with developmentalism and psychology, the latter sometimes being bracketed with social adjustment. Thus "art education" became, in Manzella's eyes, a ridiculous label for a field in which art was submerged in therapy or social amelioration. This, of course, is not necessarily so. As Barkan (1962) noted, Bruner had shown one way in which education in a subject could be properly linked to knowledge acquisition and the setting up of structures to facilitate this acquiring of learning. "Art education" in a Barkan-Bruner sense could, therefore, be a legitimate label related to imparting knowledge about the discipline of art. As I will discuss in Chapter 12, there are inherent weaknesses in the notion of "structure-of-the-discipline" schemes in relation to art, but Barkan was developing an art education model that met and answered most of Manzella's objections at almost the same time Manzella published *Evisceration*. In 1988 Manzella did not admit to having seen any change in art educaiton since 1963. This could be seen as ignorance of the field or as the field simply not changing despite the efforts of those leaders feeling intense discontent with it.

While Manzella admits he intended his book to be a polemical pamphlet, not a scholarly tome, the force of his attack was dissipated by his refusal to name specific targets. The lack of citations of art education literature blunted the thrust of his attack within the field. Unfortunately, where a name was named, John Dewey, it was not, in my view, wisely chosen. In Ralph Smith's (1964) refutation of Manzella, Smith's most powerful counterargument consisted in bringing forth examples of Dewey's actual statements about art in education. Dewey was an advocate of a rigorous, evolving education, not the intellectual fluff Manzella decried. When I questioned Manzella about having singled out Dewey as a negative force, especially in light of the continued general respect shown Dewey's *Art As Experience* (1934), Manzella admitted that his real 1963 target was the type of watered-down Deweyism seen in the Ray Faulkner and Ziegfeld textbook, *Art Today* (1941). Faulkner and Ziegfeld's text did seem to reduce everything to the common denominator of pleasing design and good taste. I have no way to discover whether Manzella had read *Art As Experience* before writing *Evisceration*.

Thus Manzella was really railing against the therapeutic-adjustment notions of Lowenfeld (1957) and the art-in-everyday-life ideas of Ziegfeld, the two most easily identified art education models of 1963. Where Manzella was most radical in his criticism of art education was his rejection of the field's all-too-pervasive rhetoric of self-aggrandizement. He would prefer a more modest claim for the role and goals of art in school. Where he was weakest was in his failure to see that the term "art education" could be attacked as conceptually dubious not just because of the questionable arguments of *educators*. The world of *art* was also full of contradictions and unexamined proclamations. Watson at about the same

time, in his quiet way, was beginning to see that the art world was parading ideas and attitudes that could not be sustained on examination and, therefore, provided weak content for the classroom.

While Manzella appeared to think that moving education in the visual arts from the control of educators to the control of practitioners in visual art would "cure" all the ills of post-World War II art education, Watson came to a far more radical conclusion. In a sense Manzella's type of solution had some more, if still relatively slight, influence on art education practice than Watson's profound insights. Later the artists-in-the-schools programs could be seen as an attempt to get students in contact with exhibiting artists (Smith, 1991), somewhat as Manzella had wanted. The whole notion of "discipline-based" art education, with an emphasis on art history and aesthetics (whatever the word's meaning to those who proposed its inclusion), and the shift away from exclusive emphasis on studio production, which are characteristics of the 1980s J. Paul Getty Foundation's program, are ideas also expressed in Manzella's 1963 book. Indeed, in 1988, Manzella angrily claimed the Getty staff should have acknowledged his writings as a foundation for discipline-based art education. Of course, in *Beyond Creating: The Place for Art in America's Schools* (1984), the first published Getty pronunciamento, no antecedents were given acknowledgment.

WATSON'S EXAMINATIONS OF THE CONCEPTUAL FOUNDATIONS OF EDUCATION IN THE VISUAL ARTS

Watson, having felt an ever-increasing unease about the unexamined assumptions of teaching about art he had observed at every level of education, had begun to read some of the books of Stephen Pepper. In *World Hypotheses* (1942) Watson found ideas that helped him to find ways to clarify what the foundations for thinking about visual art education might be and what the fundamental beliefs were which had filled him with restless disbelief. Watson said that, after reading Pepper, "I learned that questions in and around art and art criticism are not insulated, as we might think, from the basic questions we might have about how we view the world and the place of human beings in the world."

Pepper had devised six categories for the ways humans through history have viewed the world. One of these was what Pepper called the dogmatist view, which Watson explained, Pepper rejected. Watson stated this worldview is, "The approach of someone who simply has an unshakable belief about the way the world is...there is no way that new or counter evidence makes a bit of difference in such a closed mind."

Obviously, many of the persons Watson had observed teaching, making pronouncements without logical explanation, must have fallen into this category. However, Pepper accepted some of his six categories as "adequate."[4] Watson explains that they might be contradictory worldviews, but they do "an

adequate job of making sense of the world...in which we live." These are provisional explanation of how to view the world. They are practical frameworks, but subject to erosion and revision.

Watson also read some of Richard Grabau's work. Grabau explained that concepts we accept as givens, such as the theory of gravity, are not immediately and intuitively grasped by all persons. These facts, if we can make use of such a word in this context, must be imaginatively conceived by someone. Then they must be communicated or explained as making sense of the world or parts of it. However, a new explanation may be conceived and communicated that does an even better job. For example, the Ptolemaic explanation of the heavens, which had worked well enough for hundreds of years, was eventually replaced by the Copernican system. The Copernican system accommodated certain facts noted over the years that seemed to contradict the logic of the Ptolemaic system.

Watson summed up what Pepper, Grubau, and Weitz meant to his intellectual development:

> What these people did for me, Pepper, Grabau, and Weitz and others to follow, [was to make] me realize that I--and I have to assume the vast majority of at least my generation if not still today--was searching for something that was unobtainable; that something called "absolute truth." It also opened to me the understanding that most of the really important issues that people want to talk about and have such vehement differences about in art and social issues, are not about factual things. That the issues are largely differences in ways we conceptualize--or want to see the world--and the values we attach to these ideas. *But [it is] the language we used in these disagreements in words and sentences which mislead us into believing that they are about factual matters.* (Emphasis added)

In 1966 Watson attended an institute at Ohio State University for advanced study in art appreciation. Watson was most impressed by Eugene Kaelin, an existentialist who, in Watson's words, "believed he could use the philosophical method of phenomenology to bring scientific rigor to the field of philosophical aesthetics." Watson remarked that Kaelin, "had me almost thinking again that I had found the one true definition--the one true answer," as a basis for talking and teaching about art.

Watson came to feel that one of Kaelin's greatest contributions was the rigor of his attention to the work of art. Perhaps, Watson admitted, Kaelin's analyses were for the most part formalist and, therefore, probably not quite as helpful as the thinking of Morris Weitz; yet there was an element in Kaelin's processes that might be termed *moral*. The discipline Kaelin brought to considering art was similar to the unsparing way (of self or others) a great scientist may strip away all unessential concerns as she or he develops an austere and parsimonious method in seeking a particular kind of truth. So Kaelin discarded glamorous romanticism or convenient deviations from absolute attention to art concepts or art objects. (As a caveat, I must add the personal observation that Watson has

maintained a faith in scientists this writer does not share. In my opinion, for every Einstein there are a thousand Lysenkos.)

Several generations of contact with many cultures with greatly varying value systems, including aesthetic notions completely differing from Western Eurocentric traditions, and the insistence by anthropologists that we should examine other cultures in a nonethnocentric way, had undermined the basis for individuals within our society and for our society as a whole to claim a perfectly and universally applicable set of values. For the teacher who wants to lead students to the highest possible standards the idea that standards can shift from time to time or place to place, that nothing is absolutely good or bad, the idea of a type of provisional value system may seem to be too unstable to use as a platform from which to teach.

Yet, as Watson demonstrated in his own teaching at Arizona State University in the 1970s and 1980s, the teacher who leads students to look at their own assumptions, their value system, to ask the question "Beyond habit, why is this true, or good, or bad?" opens up to the student exciting possibilities for intellectual and artistic exploration denied the acquiescent student of a teacher who believes in and insists on adherence to one canonical system. If the student becomes a teacher in her or his turn, she or he can conceive of curricula of infinite variety and the most varying content, while retaining awareness that every choice of example, everything to be made by the student at the teacher's direction, every word of critical evaluation implies some kind of aesthetic theory. At the same time, the teacher having the type of background Watson provided, can find ways to teach her or his students that there are many approaches to art, many possible excellences and many meanings behind art objects, enough to challenge one's thinking for a lifetime.

Unfortunately, in the 1960s, 1970s, and 1980s relatively few art educators cared to recognize the challenges implicit in the thinking of persons like Weitz and Pepper, and many tried to reclaim or reestablish a safe territory of absolutes, with a canon of safe exemplars and certain sure answers they thought were universally right. They wanted to return to (in some cases remain in) what they perceived as the safer past, such as the conceptually sure-footed era of Arthur Wesley Dow.

Two years after his experience at the summer institute in Columbus Watson entered the art education doctoral program at Ohio State University, hoping to study with David Ecker. However, Watson found that Ecker and Jerome Hausman, another significant figure in visual art education, had departed for New York University. Watson's description of Ohio State University's Art Education Division, or of the ideas current in the 1960s may not be complete--if there could be such a report--or balanced; yet it does draw succinctly together many issues in twentieth-century American art education, and it explains their place of origin.

WATSON'S NARRATIVE: OHIO STATE UNIVERSITY IN THE BARKAN ERA AND AESTHETIC EDUCATION

Watson: Manuel Barkan was head of the Art Education Division; Laura Chapman was there, Arthur Efland, and [others] who made it an intellectual powerhouse. And Morris Weitz was in the Philosophy Department.

When I arrived, Barkan and the entire faculty and graduate students had been working a couple of years on phase one of the CEMREL (Central Midwestern Regional Education Laboratory) project, which was to produce a handbook or guidelines for "aesthetic education." This was a massive undertaking. Barkan was the project director, and the research, meetings, writing of drafts all involved a large number of people from around the country; knowledgeable people from philosophy, psychology, education [and so forth and people] from all of the visual and performing arts--art, music, dance, literature and poetry. The guidelines were to have the input of the best minds and to be neutrally representative of these various inputs.

Ecker and Hausman had left the initial group, maybe through some disagreement or frustrations with the direction things were going--I've heard this but [I cannot corroborate it]. Manuel Barkan was not in good health. He was in and out of the hospital, and there was a suspicion that he had cancer, but he and his wife would never discuss such a possibility. So there were difficulties in the shaping of some kind of consensus as to what the guidelines should be like.

[Meanwhile], one of my first classes was with Laura Chapman. It was a curriculum class, but with some thirty students and her intent to have these advanced students, who were already in teaching situations, develop for themselves a curriculum they could put to practical use, nothing ever seemed to come to a focus in the class. There was such a bewildering variety of needs and approaches expressed, and it didn't seem Chapman had anything concrete to offer in the way of thinking about curriculum making.

Laura Chapman then took a leave of absence, and came back the next year to talk to a conference of the Ohio State Art Education Association. It was an astounding event. She laid out a framework for thinking about curriculum which became the basis of her book *Approaches to Art in Education* [1978]. I had never heard anyone in art education explain better the process of thinking about establishing objectives and building curriculum, and outside of Warren Anderson, give a better or more succinct organization of goals and subgoals for teaching. There was such a simplicity and beauty in her dealing with complicated material, and on that day she earned my [unending] admiration.

A couple of years later, quite by chance, I had an opportunity of looking over a number of draft documents written while Chapman was still working as a part of the CEMREL group. As I read through these documents, and some of the penciled notations by Chapman, Barkan, and others, I began to discern those passages which were largely her writings. I was able to confirm my judgments later with Laura, as we met on other occasions. What was telling and different were the subtle ways she had of writing about complex issues, being able to see the issues, as it were, in various shades of gray, rather than in black or white or needing to accept one position...[while completely] rejecting another. Unfortunately, the subtlety that she contributed to the first drafts were gone from the final version--much to the detriment of the final and published version of the guidelines.

I had chosen to go to Ohio State because I wanted to eventually end up with a doctoral dissertation that was philosophically oriented, rather than one that dealt with the more typical statistical or curriculum approaches. I was not formally schooled, however, as a philosopher, and so had little knowledge how to go about focusing on this in that setting. Most of my professors also seemed to have trouble in giving guidance as to how to make this interest lend itself toward an acceptable dissertation in art education. This problem plagued me throughout my doctoral studies....

As I said before, Morris Weitz was in the Philosophy Department at Ohio State University; Weitz and Kaelin were undoubtedly the two philosophers best known to the CEMREL group [and they were asked] for their input, but they held decidedly different ideas about claims and the possibility of justifying claims about art and the good and the bad in art.

I took several philosophy courses in my studies [at Ohio State University], mostly in aesthetics and ethics. I am most thankful that a couple of these were with Morris Weitz before he went to Brandeis University. He was an amazing thinker, an amazing teacher.

I'm going to get sidetracked here for a moment, but I want to relate one of my favorite remembrances of Morris Weitz. In a class on the history of aesthetics, he made this remark at one point, "Well, I've been teaching this course for twenty-five years, and what these philosophers have had to say is not very interesting. It is more fun to read the criticism of today." Now, one can understand that having gone over certain material time and again in a class setting that it might get boring to the teacher. Yet, with every writer we examined, Weitz would carefully reexamine what this particular person was trying to get at. He seemed to have a dialogue with himself as he lectured, as to what it was that was bothering the writer and what merit there was to the answer or theory he was proposing. For my classmates and my-

self, it was an engrossing process of seeing someone, Mr. Weitz, think through each time what may have been bothering the writer and how he might have come up with this new answer or approach. We saw an active, dynamic-thinking mind at work in front of us, and not someone passively going over the class material.

Morris Weitz is best known in most of the published anthologies in aesthetics for his writing "The Role of Theory in Aesthetics." Another place where his ideas are well laid out is in his little book *Hamlet and the Philosophy of Criticism*. Weitz followed a different methodology from Kaelin's in looking at the issues in art. [Weitz's methodology was] what we would call today the "ordinary language" school of philosophizing. Both the "ordinary language" approach and the "phenomenological" approach of Kaelin, however, had the same kind of battle cry: "get back to the experience." In other words, cut your thinking loose from all of the old myths, expectations, and traditional answers, and see how any of these ideas square up with your real life experiences. Question all previous answers and assumptions. Philosophy, I learned, is always about asking what comes before, what is the prior question. In other words, on what assumptions are on which you are operating when you ask a particular question, which usually led to another round of asking about the assumptions underlying any responses to the first....

Anyway, the "ordinary language" approach in philosophy, starts from the premise that much of our thinking in the past has been a victim of what Weitz will call the "classical theory of language." This kind of thinking can be traced at least back to Plato and his view of the physical world constructed according to some "ideal forms" or metaphysical blueprints. Indeed, Plato also thought much of the non-physical such as examples of goodness and beauty as also emulating some ideal form. *True* knowledge then, came from knowing about such ideal forms such as "rectangleness," "chairness"...as well as "goodness," "beauty" and maybe even "artness." Any word then, according to this classical theory of language, that was a meaningful word, referred to some ideal form. Every...word then, *named* something in this dualistic physical/metaphysical world.

"Ordinary language," says "No!" to this view of all words naming. Only a few words serve to name something, but most words do other things, such as praise, recommend, command.... The great lesson of Weitz, and why his "The Role of Theory in Aesthetics" was so pivotal in American aesthetics, is that Weitz [said] that all theories of art are not--and cannot be--a description of some special property that distinguishes art from non-art. What we are dealing with is a concept that we have historically developed; a concept that may have certain ideas and values attached insofar as we desire to make some kind of

distinction between classes of things. We may have reasons for wanting to say that some things are art, or fine art, or [distinguish] the better from the worse, but what we appeal to in making any such distinction are recommendations or *prescriptions* and not *descriptions* of some defining property. When we claim the work is good for certain properties, for example craftsmanship or inventiveness, we are talking "as if" the work has these properties rather than "has" them, which Weitz [would] claim they do not.

When I understood Weitz in this way, and recognized the validity of his claim that all art theories of the past had this fundamental flaw-- that of trying to describe what cannot be described in the sense of "naming"--I realized that now I had an intellectual way of dealing with all of the conflicting claims and counterclaims in art and art criticism. I could view them for what they were, a series of recommendations which I could examine in a variety of ways and thus enrich my experiences of art but without the flawed concern of asking which claim was right and which was wrong. Such issues were not about right and wrong.

As a way of explaining this a bit further, I often asked in my later university teaching some woman student "Are you a mother?" I was not trying to be rude or personal, but she could usually answer with a simple "yes" or "no" as to whether in fact she had borne a child or not. Then I asked "Are you motherly?" The answer was usually "yes," but this was invariably immediately followed by questions about what it meant to be motherly and whether others such as children, non-mothers, even men could be motherly. My questions of the woman student had shifted from asking about a *factual* matter, to asking about what kind of ideas and values do we typically place within the *concept* of being motherly. Then I asked, when we talk about art and the better from the worse, are we asking about something factual or are we asking about what typically counts for something when we employ the concept "art" or the "better art?" Such a difference in this kind of talk has a lot to say about how educators go so wrong in what they teach.

[But to return to my narrative,] Manuel Barkan died in the summer of 1971. I resigned from the University of Arizona to stay a third year at Ohio State because most things were very unsettled in the Division and I still could not find a satisfactory way to structure my concerns. Evan Kern, a recent Ph.D. graduate, had been given the task in the last few months of Barkan's life to be the major writer of the CEMREL guidelines for aesthetic education. The guidelines were essentially finished before Barkan's death, and I thought the first chapter which laid out the objectives for aesthetic education was extremely flawed. Maybe with more time to finish, or more direct involvement of

Chapman [or persons of her intellectual abilities, the guidelines] might have had a different appearance....

Barkan considered himself a curriculum person, not a theoretician. He certainly was a person committed to excellence--as he saw it. Most of Barkan's students have their own stories of being intellectually bloodied by Barkan, but he certainly made a difference in those days in the changing character of art education. Ross Norris had joined the faculty while I was there. He was more of a philosopher, and while quiet and unassuming he could trap you as well or better than Barkan in your careless statements. He was very skillful in asking "prior questions," ones which would eventually lead you to see that you were in an untenable position with some of your thoughts or assumptions.

CONTRASTING WATSON AND MANZELLA

Watson, at the end of three years, had passed his preliminary written examination for the doctorate but, in order to support his family, left Ohio State and returned to Arizona. This time, however, he began teaching and administrative work at Arizona State University, where he remained until his retirement.

Manzella moved from California to the Rhode Island School of Design where he tried to put into place a reformed pre-service art teacher preparation which, in effect, consisted of training the potential art teacher as an artist for four years, and then adding on a fifth year of specifically pedagogical work.

In 1988 Manzella complained that after a long and difficult period of phasing out an older, conventional pre-service program and getting his reformation in place, he found school administrators simply were not interested in the supposed superior preparation of the graduates of the Rhode Island School of Design. The public school system was not ready to reward the graduates of his program for greater expertise in the content of their subject.

Watson, speaking of his years at Arizona State University after he had developed a sounder basis for thinking and talking about art, explained that

At both the graduate and undergraduate level I taught courses that were principally geared towards what philosophers and then later sociologists and sociobiologists could tell us about art and its role in social affairs. This led to considering what meaning these ideas had for establishing objectives in art education, and how to avoid perpetuating in our teaching much of the romantic and emotional nonsense so prevalent in the art world.

Watson saw that the form of art teacher preparation was not the principal problem causing art education's marginality. To repeat, the unexamined claims made in the art world by teachers, artists, critics, aestheticians, and other people

who thought they knew what art was, and felt they could define it for all time, were the basic problem. No sound goals, either short-term or long-term, could be established if fact and recommendation, claims to universal truth and acceptance of provisional hypotheses were to be confused at every step.

While Manzella's ideas seemed to offer a neat package for change and Watson's appeared to open up the greatest uncertainties, Watson had discovered the basic problems that would have to be met if a sounder basis for art education were to be established. Then--and only then--could a new art education be conceptualized. Watson's ideas if put into action, however, would require teachers, artists, critics, and historians--the whole art world--to ask what assumptions underlay all their talk and all their actions. He did not want just a change in rhetoric or in activities. He wanted art education to build new foundations.

In the 1970s and 1980s art educators were all too often to urge a Manzella style of reformation and, to their surprise, find their efforts failed to meet the needs of education in visual art in the American schools. No one wanted to examine the genetic makeup of the orphan of art and education.

NOTES

1. In 1993 and 1994 I interviewed Clyde Watson on two occasions. Transcripts of the interviews are in the possession of this author but will not be released except by permission of Clyde Watson.

2. Transcripts of the interviews are in my possession but will not be released except by permission of David Manzella.

3. Manzella named the figure, but I see little constructive use in repeating the name. Indeed, I am a little puzzled about the accuracy of Manzella's recall of the identity of the person he named.

4. Since this study has no pretensions to being a philosophical treatise, I do not feel a full explication of Pepper is necessary.

From Aesthetic Education to Discipline-based Art Education: Intellectualizations and Confusions

Writing about the recent past is extremely difficult for the historian. The chaos of day-to-day experience is too much still here to allow perception of the general shape of events, to see what ventures proved fruitless, to see what movements or cluster of ideas had lasting vitality and continued to grow. During the last four decades of the twentieth century, American visual art education appears to have veered first toward a concentration on art, then a concentration on the student and back again. I cannot invoke the image of a pendulum, however, because the swings have had an erratic path, have wandered into different areas of emphasis, rather than back and forth into exactly the same conceptual territories.

Thus, Barkan's 1962 prophecy of art education moving toward study of art as a subject (an antecedent of discipline-based art education) was followed by symptoms of a neo-Lowenfeld approach (McWhinnie, 1972) in part under the influence of the third wave psychologists (Maslow, Rogers, and so forth). An abberant form of the art-centered approach appeared in the artist-in-the-schools program (Eisner, 1974), although, curiously, it was justified by almost the same rhetoric used in progressive education child-centered education and may have had more to do with the public relations needs of school administrators than with real visual arts education needs or theory (Smith, 1991). In the later 1960s and 1970s federally funded programs for aesthetic education, an attempt to teach the various arts in some related form, were discipline centered, although "aesthetic" should not be confused with later uses of the word in discipline-based art education in the 1980s. In the 1980s an art-centered program was proposed by the Getty Center for Education in the Arts, very much in tune with the conservative social and economic trends of that period (Hausman, 1987). By the end of the decade multicultural concerns led many art educators back toward a more child-centered approach (Wasson, Stuhr, & Petrovich-Mwaniki, 1990) and beyond that toward therapeutic concerns (Smith, 1993). Multiculturalism also led some art educators toward an advocacy of social reconstruction, recalling ed-

ucational notions of the 1930s (Eisner, 1994), an era that also had to try to restore social order in the midst of dislocations caused by a preceding decade of vicious capitalist excesses.

None of these trends, or notions, or movements--whatever we are to call them--started without antecedents, and none ceased neatly at some precise time. At the time of writing this book, Getty discipline-based art education and multiculturalism of the most varied types and goals exist side-by-side. The Getty organization has even attempted to reach out and embrace multiculturalism (*Discipline-based Art Education and Cultural Diversity*, 1992), although, if Getty discipline-based art education is to be true to its original conceptual form, it cannot take on the child-centered or social-centered nature many multiculturalists advocate.

What follows then must reflect some of the confused and agitated quality of late twentieth century American visual art education. It cannot be "fair" or "balanced" because it must be viewed far too close up, and many of its elements are still becoming, or perhaps dying, as all living things must. Some of these same elements in a decade's time may seem unimportant because they ceased to grow, or will be seen to have been dead issues, while others that were disregarded may prove to be the vital ones.

A REVIEW OF THE ERA LAUNCHED BY SPUTNIK

After the launching of Sputnik by the Soviet Union in 1957, Americans were told that the schools had failed to provide good enough scientists to compete with our enemies. As the cold war intensified, everything in American life began to be more and more stated in terms of "them" and "us," of baleful confrontation and conflict. Our schools, therefore, had to reform, to become a tool of defense for "us."

This idea rested on the assumption that schools had to be better than the communities that supported and constrained them, although that was never publicly stated. After all, had not these communities shaped their schools? Change was attempted from above, from the national level rather than from the school district, grassroots level. Efforts were made to change the curricula in the schools through federal intervention, rather than through any reconceptualization of American public schooling or criticism of the foundational values of Americans. Indeed it became "un-American" to suggest Americans needed a drastic reformation of their cultural values, or that others possessed values more ethically constructive. It was to take the civil rights movement and the questioning raised by the Vietnam War to make that sort of national self-examination possible.

In the cold war atmosphere of the 1950s and 1960s national defense seemed to be the paramount issue in American life, not the fate of the individual child. In reaction to World War II and its brutalities, the humanistic rhetoric that had

found favor in the late 1940s, revealed in *Creative and Mental Growth* (1st ed., 1947), vanished in the fearful atmosphere built up in reaction to Soviet threats and boasts and through manipulative actions and rhetoric of American politicians. There is probably no way that the measure of actual national danger existing at the time of the cold war can be gauged, but the appearance of menace was sufficient to win support for change, as long as the changes had nothing to do with questioning mainstream American values. Of course, so-called American values were the values of the dominant white middle-class culture.

This call for educational reformation apparently failed to reach its goals in the 1960s or 1970s since in the 1980s a new outcry arose. The schools were again assailed for failing the nation. *A Nation at Risk: The Imperative for Educational Reform* (National Committee on Excellence in Education 1983) declared the state of the schools to be so deplorable that no enemy could have done more to ruin America. Such excessive rhetoric recalled the days of McCarthy and Rafferty. Few, however, noted or objected that in this report the child was assumed to be a kind of bullet to be assembled and perfected for military-economic supremacy. The merest nod was made in the direction of studies, including the arts, thought to emphasize the qualitative side of human life. Unlike the nineteenth- century prejudices against visual art, in the twentieth century there existed a kind of empty space, a lack of concern in society for education informed by moral-ethical and humanistic *values*. The very idea of teaching frankly value-ridden subjects in a society whose only apparent values were economic self-interest became problematic. Occasional references to moral education seemed almost laughable in such a climate.

No one asked the question "If the schools are so bad, how did they get to that state?" No one seemed to want to say that, in an institution unparalleled in American society for local influence, the schools must be, more or less, what the public wanted. Assuredly, the influence of money and its servant, power, made some schools exactly what affluent parents wanted for their children and, in poor school districts, the schools were nothing anyone would want for their children. However, I contend that in the average school district a mixture of complacence and indifference made it possible for the schools to reflect very well the mediocrity and unexamined values of the communities that supported them.

For more than two decades after Sputnik national defense and economic considerations could cancel out every humanistic argument. I can recall conversations in which pleas for permitting children to study the arts or to pursue individualistic and "impractical" goals were silenced by specious slogans along the lines of "If the communists win, there won't be any freedom to do what you want." Car bumper stickers were displayed that said, "Better Dead Than Red", a denial that life itself was worthwhile under a communist regime. Since the threat of the late 1950s and subsequent years as originally symbolized by Sputnik was always pictured in military and technological terms, the response had to be to improve science education in order to produce a cadre of physicists, engineers, and technicians. Science and mathematics, therefore, were to be

emphasized in schools and were to be reformed in content and teaching methodology.

THE DISCIPLINE ERA BEGINS

Jerome Bruner's *The Process of Education* (1960) set the direction for the ensuing reform movement. School reform would be based on the structure of the disciplines. The adult practitioner in a field was to be the model for the student. The student should be introduced to the ways of thinking, the concepts, the typical activities of the adult in a particular field. The traditional school attention to atomistic bits of information (spelling, multiplication tables, isolated facts) was to be pushed to the side, and attention was to be directed toward the student acting as a scientist or mathematician, and so on.

Barkan (1962) became quite enthused by this idea of "structure of the disciplines" and adopted the Bruner model for art education. Few seemed to note that Bruner's ideas did not always work in practice as intended. For example, Bruner's *Man: A Course of Study* (described in Bruner's *Toward a Theory of Education* 1966) worked neither with children in the classroom nor with the larger community that was asked to support this social studies curriculum (Jones, 1968). If art educators had carefully examined this, they might have noted that Bruner's ideas seemed to be difficult to put into practice in areas of the curriculum where values, rather than facts, were central. A certain blindness to beliefs instilled in the home and to local United States social environments, combined with an overdevotion to logical structure and blind adoration of scientific "objectivity" was evident in *Man: A Course of Study*. This same blindness to humans'--especially young students'--inability to stand outside their own culture almost guaranteed trouble in realizing this social studies program's goal. This blindness was to crop up again in the thinking of many multicultural advocates of the 1980s and 1990s.

Efland reexamined the conceptual basis of Barkan's ideas about using the "structure-of-the-disciplines" approach to curriculum formation in art in "How Art Became a Discipline: Looking at Our Recent History" (1988). His observations are applicable to much that followed Barkan's lead in attempting to make art more academic, more like other and more traditionally honored subjects.

Reduced to the simplest level, Efland felt that Bruner's ideas were based on the scientific model of knowledge, which casts humans in the role of observers or on-lookers. That which is studied is outside the scientist or student learning to be scientific. The relationship is a *neutral-emotionless-nonjudging-I* looking at (but not interacting with) *it-the-object*. Artists, however, have a participating mode of working. They are engaged in their work. Their own experience is their context and their content. The artist seeks to know her/himself through working in art, usually though some material means.

According to Stephen Pepper (1945), a characteristic of aesthetic experience

is a feeling of self-forgetfulness and total union with the object, surely the antithesis of the onlooker model. I believe Dewey (1934) and a number of other writers on aesthetics would say much the same, and in Dewey's case, the viewer of art must imaginatively recreate or participate emotionally and intellectually in the artist's creating process.

It is true art history and aesthetics might be approached through the so-called scientific model of mastery of content outside the self--at least to a degree--but to do so would be to kill much of the intrinsic satisfaction accompanying their study. The notion of structure of the disciplines might apply to these two derivative or secondary divisions of art if they are treated as areas in which the behaviors and ideas of others are noted and reported on merely as observable actions. However, art history and aesthetics exist as areas of study only because artists have made art. They could not exist without the participant-artist and a knowledge of aesthetics, and art history is not complete unless this participant mode is understood by the art historian or aesthetician. Art criticism is a logical outgrowth of aesthetics since it is invalid without a theory of art--although some critics may have confused theories--and so the art critic has to grasp the notion of the participant actor also.

The origin of the observer mode, the model of the scientific inquirer for student learner or adult scientist, is dependent on the belief that any human can stand outside her/his own world of experience. The observer model has worked very well in certain areas-physics, astronomy, chemistry, and so on, but often very badly in others, such as history, anthropology, and psychology, where awareness of human valuations, volition, and emotion are of extreme importance.

Another analysis of these conflicting ways to view the world or to obtain true knowledge has been explicated by Jacques Barzun (1974), using a model set forth by Blaise Pascal (1623-1662) in *Pensées*. Pascal talks about the *esprit géométrie* (akin to the observer model) and the *esprit de finesse* (a necessary element of the participating model). Barzun paraphrases Pascal thus:

In science (the geometrical mind), the elements and definitions are clear, abstract, and unchangeable, but stand outside the ordinary ways of thought and speech. Because of this clarity and fixity, it is easy to use these concepts correctly, once the strange artificiality has been firmly grasped; it is then but the application of a method. In the opposite realm of intuitive thought (*finesse*) the elements come out of the common stock and are known by common names, which elude definition.

From the dissimilarity it follows that genius in science consists in adding to the stock of such defined entities and showing their place and meaning within the whole system of science and number; whereas genius in the realm of intuition consists in discovering pattern and significance in the uncomfortable confusion of life and embodying the discovery in intelligible form.

Obviously the two models of thought do not mix well: there are no natural transitions from one to the other, the *movement* of the mind goes counter to the other. (Barzun, 1974, pp. 91-92)

John Manfredi (1982) has also examined this notion of types of thinking needed to talk about the world. He divided the explanatory systems into art, science, and religion. These systems, according to Manfredi, use different languages to explain the world. They have developed different symbol systems to represent the world as it is conceived within their separate frameworks. One system cannot explain the other. Science cannot explain religion. Art cannot explain science. Religion addresses entirely different aspects of the world than science does. Each field asks different questions about the world and gives answers in different languages. Thus, the intrusion of religious explanations of origins of the world in science classes must always be incongruous. Few true believers in religion or science (and scientism is more often a faith system than many scientists care to admit) can see or accept that both explanations of the world may be true--but true within particular explanatory systems. There is no human-devised system of explanation that absolutely equals the world as it exists.

The origins of these categorizations or models for knowing or explaining the world, whether Pascal's, Manfredi's, or Efland's, can be traced to Western European ideas articulated in the Enlightenment era (Bridges, 1991). It was during the Enlightenment that rationality divorced from emotion came to be an ideal. Humanity was thought to be perfectable and that this perfect state would be a person of ice pure rationality. This would be the *esprit géométrie* incarnate.

The observer model was, therefore not only the opposite, or near opposite model of the artist participant model, but it was alien to the purpose and function of the arts. Furthermore, its origin was European and modern, an obviously dangerous restriction in a field that has ancient origins (many non-European), continuous and universal histories, and is in a state of constant flux.

FORMING DISCIPLINE-CENTERED ART EDUCATION

Despite such curriculum models as those set forth by CEMREL and SWRL (Southwestern [Educational] Regional Laboratory), funded through federal monies, it was not until the privately funded Getty Center for Education in the Arts began that scattered attempts at art education reform did more than start with enthusiasm and sputter out in inconclusive collapses of support or interest (see Kunkel, 1972).

"Aesthetic Education" as proposed by the CEMREL staff appeared while this writer was teaching art in typical surroundings for many art teachers, one of a few art teachers for a school district, isolated in an art room and with little guidance from a state art syllabus. I was a member of the New York State Art Teachers Association and of the National Art Education Association. In the state organization for art teachers I was active and attended its conferences--about which I can recall absolutely nothing, as far as ideas, except that they were almost always held in the Catskills in "Borscht Belt" hotels--but I never at-

tempted to attend the national professional organization conferences until 1982. I looked at popular art teacher magazines, *School Arts* and *Arts and Activities*, and the National Art Education Association's *Art Education* journal. I also read *Art News* and art-related items in the *New York Times* and any stories about art in popular magazines (*Life*, *Time*, and so forth), but such publications for the general public, even the art-loving public, never seemed to have any connection to teaching art as art education had been taught at my teacher education colleges, Pratt Institute and the State University College, New Paltz, New York, in the 1950s. It was not until I began doctoral studies, especially the classes in philosophical aesthetics taught by Clyde Watson, that the importance of a theoretical understanding of art for an art teacher dawned on me. But the aesthetic education of the 1970s was not really about careful and philosophical analysis of what art is.

The aesthetic education "movement" never actually reached me in my predoctoral art classroom and there seemed no incentive to try to uncover what on earth a few vague articles about it in *Art Education* might mean in practice. My confusions may have been the result of my own laziness, but part of the problem arose from the use of the word "aesthetic," when the content of the articles I read seemed to be about teaching about several arts in tandem. As Watson later pointed out to me, "aesthetic" is often used where "artistic" would be much more appropriate. Art may or may not have to do with aesthetic issues or experiences. Aesthetic experience may not necessarily be undergone in relation to art objects. In any case, I was not prepared to teach anything beyond visual art and practical application of suggestions to teach about the arts somehow as a conglomerate subject were beyond my mandate as a visual art teacher.

So aesthetic education, in fact, had a very loose connection at the most with aesthetics as a discipline. Furthermore, according to Watson[1], in the *Guidelines: Curriculum Development for Aesthetic Education* (Barkan, Chapman, & Kern, 1970), the "proclaimed goals [were] conceptually misdirected," and Watson stated that the "Authors did not make a distinction between *symptoms* of aesthetic experiences, *causes* of aesthetic experiences, and *typical sources* of aesthetic experiences. Far from being philosophically neutral, as Barkan had hoped, the *Guidelines* were a *formalistic prescription* for what to look for in certain (that is, selected) works of art." A clear direction for sensible teaching and achievable goal setting could not be derived from such confusion.

Watson concluded that the *Guidelines* showed "No great understanding nor consensus on what artists, critics and historians do, let alone what an aesthetian does." Unlike later Getty efforts in curriculum reform, there was no strong and long-sustained effort to disseminate information about the *Guidelines* nationally, nor were there many well-funded and geographically strategic teacher training programs to get ideas about what was meant by aesthetic education into the hands and minds of a large percentage of the art teaching population. I, and many like me, gained no great understanding of the meaning or means of aesthetic education. If we accept Watson's judgment, my confusion and the failure of

others to develop aesthetic education as a regular practice, as it was described in the *Guidelines*, is understandable.

Lelanni Lattin Duke, director of the Getty Center for Education in the Arts, announced the formation of the center and its basic aims at the National Art Education Association conference in Detroit in 1983. I attended the meeting and noted that an African American in the audience questioned the basic ideas described by Duke on the grounds that African Americans had greatly benefited from the student-centered approach associated with Lowenfeld. Lowenfeld, of course, showed a special interest in encouraging African Americans in and through visual art (Saunders, April 1994), and his graduate program at Pennsylvania State University had accepted a number of African Americans seeking advanced degrees in art education at a time when few African Americans could hope for masters or doctoral degrees in any subject area.

This protest was something of a portent of the objections that were to greet the Getty program, later dubbed discipline-based art education, but it was only one aspect of many objections. Somewhat in the same vein, at the 1987 National Art Education Conference, Peter London gave a presentation titled "Lowenfeld vs. Getty" (1987) although the actual content was writings of Eisner, principally *Educating Artistic Vision* (1972), compared to parts of Lowenfeld's *Creative and Mental Growth*. London advocated a therapeutic approach to art education and could find nothing in Eisner that would agree with his view. London was not the only person to make an anti-DBAE stand. As late as 1990 Lou Dubinsky could state, "There have been many critical reactions [to DBAE] in the form of conferences, symposia, analyses, and alternative curricula" (p. 249).

Part of this controversy arose from confusion as to the exact makeup of discipline-based art education and who spoke officially for the Getty organization. In 1987, a special issue of the *Journal of Aesthetic Education*, funded and distributed by the Getty Foundation, was published, apparently with the intent to clarify the Getty concept of discipline-based art education in some official way. An authoritative description was set forth in "Discipline-based Art Education: Becoming Students of Art" by Gilbert Clark, Michael Day, and W. Dwaine Greer (1987). "The term *discipline* in this context," the authors explain, "refers to fields of study that are marked by recognized communities of scholars and practitioners, established conceptual structures, and accepted methods of inquiry" (p. 131). In other words, the adult practitioner, as in Bruner's 1960s discipline-centered education, was to be the model for school practice. Margaret DiBlassio further explained that DBAE "programs would employ the same standards maintained in other academic subjects: written, sequential curriculum; student assessment; and adequate instructional time" (Quoted in Stinespring & Kennedy, 1988, p. 34).

Despite the claim of Clark, Day, and Greer, "discipline" is a problematic concept, and this proved to be one of the areas for arguments about DBAE. The four components of the Getty Foundation's version of discipline-based art educ-

ation, studio production, aesthetics, art criticism and art history, are not so clearly defined as the first advocates of DBAE may have wished. Stinespring (1992) has singled out "art criticism" to demonstrate, with caustic relish, that the boundaries and inner structures of the so-called four discrete disciplines are ragged indeed:

[D]irect examination of the writings of art critics fails to reveal any...systematic approach. In fact, the definition of art critic is not even clear. Since art critics are merely decreed such by the newspaper or magazine that hires the person, there is no clear career path for the art critic, no certification, no registration, no terminal degree expectation, no professional review board. Generally, it requires only the favorable opinion of an editor...the identification of art critics [is] problematic. The terms for persons who comment on art vary: art critic, art reporter, art reviewer. The variety of titles does not seem intended to distinguish clearly between types of art commentary practitioners....Calvin Tomkins [for example] is called an art reporter even though he seems to write materials similar to that written by critics and historians. (Stinespring, 1992, p. 107)

Taking another direction for criticism of discipline-based art education, London joined with several others (Burton, Lederman & London, 1988) to protest narrowness he perceived in the DBAE approach and claimed he was "unconvinced that DBAE fully appreciated the actual thinking required of art critics" (p. 3) and the other role models specified by Getty DBAE.

In the area of aesthetics, the Getty staff first used the "aesthetic scanning" model described by the educational philosopher Harry Broudy in *Enlightened Cherishing* (1972). Despite the use of the word "aesthetic" as an adjective, Broudy's model was a pedagogic strategy for discussions about particular works of art in a classroom setting. It had little to do with the usual activities of aestheticians who, of course, work in or with a subdivision of philosophy. Nor, despite the fact that it was a structure for discussion about an art work at hand, did it have much resemblance to the usual activity of critics.

Broudy's 1972 book was a leftover from the aesthetic education movement, rather than an attempt to model classroom activity on the Bruner notion of working as an adult in a discipline. Broudy claimed aesthetic scanning helped develop "aesthetic perception" and that its end goal was aesthetic literacy. "Aesthetic literacy," he stated in a later book, "begins with learning to perceive the sensory, formal, and expressive properties of aesthetic images--that is, those that convey human impact" (1987). Obviously, this process is based, however unconsciously, on a Western formalist theory of art.

It is also a method that lends itself to merely mechanical repetition. Watson, after watching a demonstration lesson staged by the Getty staff, rather sarcastically informed the presenter that the art work had been used merely as an eye chart. There simply had been no discussion that could be called aesthetic in the sense of anything approaching philosophical issues. The two questions Watson often raised (see Chapter 11), what is to be taught before this and what

next, could not be answered. The Getty Center for Education in the Art's vague use of language caused confusion even among its most hopeful supporters and provided DBAE opponents with plenty of opportunities for critical barbs.

Part of the adverse reaction to DBAE might be traced to the tactical blunder seen in the first major Getty publication about the program, *Beyond Creating: The Place for Art in America's Schools* (1984). By stating that there were virtually no substantive programs in education in visual art in American schools, the Getty Center for Education in the Arts alienated a number of art teachers, although it may have confirmed the opinion of a good many others-- members of the latter group apparently excluding themselves from culpability for the terrible state of art education. Recall that Walter Smith nearly a century before had nettled Americans by claiming the United States had no art. Getty--art already being in the schools, as was not so in Smith's day--irritated art teachers by claiming they had done little that was worthwhile.

The Getty Foundation had sufficient funding, dedicated advocates, a goodly number of art education leaders supporting many or most of its aims, and a program convincing enough in its substance to attract considerable attention. Doubtless historians of the future will see discipline-based art education as one of the most important contributions to twentieth century American art education.

Nevertheless, discipline-based art education as an attempt at curricular reform met but never satisfactorily responded to what may be the major challenge to programs in twentieth- and twenty-first-century schools: What is the basis of the necessary authority to make curricular decisions? This authority must be based on a widespread acceptance of the deciding person or group as authoritative (knowledgeable) and as responsible (of the highest ethical standards). This used to be vested in school administrations, but as Ubbelohde (1977) has pointed out, the status of school administrators as authoritative and responsible has vanished:

The problem is that to base curricular legitimacy on administrative authority is to assume that politically-based administrative authority is itself accepted by the public as an adequate ground for decision making. The acceptance of governmental and bureaucratic authority is itself a canon of a traditional value structure which no longer appears to have unquestioned currency in this country. (Ubbelohde, 1977, p. 23-24)

Given the failure of authority in American society in the 1960s and 1970s, the era of student revolt, Vietnam, and the Watergate debacle, any reform movement aimed at any part of the programs of the public schools would be difficult at best. Ubbelohde (1977) suggested a prior-to-curriculum-decision need for the development of a norm-forming community (parents, teachers, administrators) to decide the entities which were good (things necessary to teach and learn), while acknowledging that the absolute and universal good was impossible to identify. In these terms, a national uniform art curriculum, however substantive, would be neither probable nor desirable (see Smith & Pusch, 1990).

THE RISE OF MULTICULTURALISM

Even the most casual examination of the conference schedules for the National Art Education Association and the tables of contents of journals for art teachers and educators would give a picture of discipline-based art education as a central topic of discussion in the 1980s, but one that lost that intense attention at the start of the 1990s. Multicultural concerns began to take center stage. Frequently citing the anthropologically oriented work of June King McFee (see, for example, Wasson, Stuhr, & Petrovich-Mwaniki, 1990), art educators responded to the changing demographics in late twentieth-century America. However, the form that multiculturalism in art education was to take was not clear, nor was there any type of unanimity even about its basic orientation.

Georgia Collins and Renee Sandell (1991) listed four "political" goals for multiculturalists: "to *attack* the dominant culture; to *escape* it; to *repair* the damage it has inflicted, or to *transform* it into a common culture" (np). The *attack* and *escape* goals are negative strategies; that is, they decry current conditions but do not necessarily offer alternative positive goals. The repair and transformative have a social reconstruction essence.

The advocates of the attack approach use some other culture to criticize the European-derived culture. An example of this is to contrast Native-American reverence for the earth to criticize white-dominated American practices that lead to environmental degradation.

The escape end goal advocates contrast the glamour of other cultures with the crass materialism of modern American culture. They urge study of alternatives. They might contrast the elegance and sensitivity of Balinese traditional ways with New York City street behavior. The advocates of escape or attack goals do not seem to consider that there may be negative elements in every culture.

Some see multiculturalism as healing damaged self-images of marginalized minorities. These advocate multiculturalism as a means to repair what the dominant culture has wounded. For example, positive classroom presentations about cultures from which minorities descended could make the members of those minorities feel better and might increase their dignity in the eyes of members of the dominant culture. Thus studying artistic achievements of African Americans and including the history of African Subsaharan cultures might improve the self-image of African American youth.

Transformationists believe that a syncretic new culture, an improved society, could be constructed or consciously evolved from the best features of many other cultures. Transformationists may not see cultures as organic. That is, they may not have asked whether bits and pieces of disparate cultures could be selected and reassembled mechanistically.

Multiculturalism could probably be further divided and subdivided, but I believe I have demonstrated that it is not one single thing or uniform set of concepts, but a miscellaneous and utopian collection of goals. These goals seem--especially to those brought up on Western formalism--inherently extra-art.

They emphasize social improvement or preferred psychological states and the *use* of art as a vehicle to attain those states, rather than the development of a full knowledge of what any society would regard as art, bearing in mind that it may not mean the same thing in all cultures.

If the study of art is to be seen in psychological or anthropological-sociological terms, Western formalism must be thrown aside. However, this driving force or rationalization for much of the Western modernist aesthetic may prove to be difficult to abandon. The education of many art teachers never went beyond formalism. Formalism was so prevalent, at least from the 1920s into the 1970s, that it was treated as a "given," as the necessary and sufficient explanation of goodness or badness in art. Abandonment of formalism in a multicultural art education may cause regrets among only a few persons in the larger art world, since formalism seems more and more an exhausted and shallow notion as a more engaged socially activist art gains the center.

The origin or basis of multiculturalist thinking, however, is its most often overlooked and in many ways troubling aspect. It is through identification of its origin that multiculturalism may be seen as a conceptually troubling foundation for constructing educational programs. Why this is so is not unrelated to the discussion about Bruner's and Barkan's notions. It was explained in a mock-Socratic dialogue by Thomas Bridges:

Multiculturalists are cultural pluralists whose perspectives and arguments are drawn entirely from the modern European tradition which brought us the Enlightenment and liberal political theory....Far from being free of ethnocentric bias...they are the agents of a particular culture, i.e., Modern European culture, whose essential and defining trait is that it takes its own pluralistic cultural standpoint to be universal and normative, identifying it as the standpoint of Universal Reason, a standpoint beyond, above and neutral toward all local cultural value systems or conceptions of the good which shaped life and choice in particular communities. (1991, pp. 6-7)

Bridges appeared to be saying that multiculturalism is a European-derived middle-class concept. The foundation for multiculturalism is that there is a means to know the world in an objective or somehow *scientific* or *true* way outside the frame of reference built up from our own culturally embedded experience, personal and social. The speaker in Bridges' dialogue implies that multiculturalists believe that we or anyone we can specify can stand outside or above our culture to observe another culture without prejudice or passion. Yet many, including multiculturalists, hold the belief that reality itself is socially constructed (Berger & Luckmann, 1966). Alas, the unexamined assumptions of multiculturalism may manifest the very hierarchal or culturally imperialistic view that multiculturalists deplore. While multiculturalists frequently denounce Western middle-class white culture as patriarchal, hierarchal, and informed only by a narrow European-derived value system, the very possibility of multicultural theory can be seen to rest on modern foundations established by the newly triumphant European middle class of the eighteenth century.

The paradoxical foundations of multiculturalism are most vividly revealed when multiculturalist approaches are related to religious beliefs. The close ties of art to religion historically and in modern non-Western cultures are obvious, and thus those who seek to educate in art multiculturally must come to grips with this issue. To return to Bridges, one of his speakers says, "Claims which assert the ultimate truth of particularistic belief systems whether they be Christian or Islamic or Buddhist or whatever simply no longer wash" (p. 7).

The Eurocentric bourgeois believer in the possibility of a neutral supracultural outlook may think "local belief systems no longer wash," but the many true believers in particular religions still hold their belief system to be the essence of the true and the good. I can imagine the absurd spectacle of multiculturalists looking out from their insulated pluralistic worldview at believers in a particular religion, while the religionist true believers stare out from their insulated "particularistic" world on the alien, if physically nearby, world of multiculturalistic believers, each group equally unaware that there are other belief systems held to be valid. They are as isolated from one another psychically as rival families in the Verona of Romeo and Juliet. Each believer holds to a dogmatic worldview. Each believes she or he looks down on or has a grand overview of the surrounding world, while each believes he or she is standing in a conceptually impregnable position.

Efland (1988) pointed out, in the context of art becoming a discipline in Barkan's theory, there are two modes of consciousness, the onlooker and the participating mode. The true believer in a particularistic faith *participates* in that belief. He or she has internalized a belief system so thoroughly that personhood, the identity of the self, is called into question if the belief system is shattered. I can recall reading about a Native American explaining what Eurocentric culture had done to his people by exclaiming, "You have taken our dreams from us." Religious beliefs are not opinions. They and the myths that clothe them are shared dreams of the meaning of life and death. They cannot be changed by using logical persuasive argumentation.

Multicultural art educators face the dilemma of teaching about cultures and their values while avoiding offending or disrupting the cultural values of those they teach. Yet the multiculturalists may be infected by the hubris of believing they possess a superior set of values that enable them to judge or give specific weight to the values of their students.

Multiculturalists sometimes court the dangerous notion that all members of a particular group share exactly the same values or the equally unsound notion that individuals in America are members of one and only one culture. Is the cultural heritage of all African Americans strictly African? Or is it a mixture of several cultures? Is the cultural heritage of a Native American just that of a tribal unit living as it did before modern times? Anna Kindler (1994) with humorous insight has examined the issue of what is a student's cultural heritage in a pluralistic society. She describes her young "Polish" son, raised in the United States for a few years, beginning his school years in pluralistic Canada but

identifying Haida art with his artistic interests. What, Kindler asks, is her son's cultural heritage?

The multiculturalist art educator longs to celebrate the diverse expressions of humankind and wants to teach about their multifaceted excellences. Yet deeply held beliefs cannot be cut into bits and served up still living and all of equal status. Nor can educators find a validation for proclaiming themselves arbiters of what is most valuable in beliefs. If educators start on that course, they will undermine the diversity and compromise the very beliefs that strengthen diversity. To merely randomly select specimens of beliefs, or the expressions of value systems, is to set up a zoo curriculum, to look at cultures as we look at elephants, pandas, and boa constrictors, all interesting, but safely isolated from our real lives. If art is not about each student's experience, what is it about?

CONCLUSION: WHAT WILL BE THE HISTORY OF THE FUTURE?

The education of Americans in the visual arts continues and continues to be not all it could be. Art still has an orphan status in American schools and in American society. The Spencerian curse referred to in Chapter 1 still hangs over education in the visual arts. Despite Getty DBAE attempts to give art the form of an academic subject, its advocates have not changed society's attitude toward art. The art world and the world of school art still seem miles apart.

No ringing call to action or to hope would be appropriate at the conclusion of this so-often dark study. The components that flow together to form art education are too diverse to prophesy its eventual shape. Yet I cannot help hoping that the rise of engaged art, an art that shows that images move the hearts of peoples, will enter the consciousness and practice of teachers and that art educators will realize that they can and must teach their students that art has a strong and vital relationship to their lives.

As every past great culture and as every tyrant has realized--but as America has often failed to appreciate--art has power. Art as a mere commodity reflects the triviality of our age. We still await the realization that art might represent something more permanent, something more fulfilling. When that time comes, the orphan of the art world and American education will find a true home in the schools of America. Meanwhile, in the place where so many soon-to-be Americans entered the United States, a statue holds up a beacon, an image derived from the ancient art world and the idea that a picture could mean as much as any formula of words, still stands and still means the United States of America.

NOTE

1. Watson's remarks were made during the interview referred to in Chapter 11.

References

Abrahamson, R. (1980a). Henry Schaefer-Simmern: His life and works. *Art Education, 33* (8), 12-16.

——. (1980b). The teaching approach of Henry Schaefer-Simmern. *Studies in Art Education, 22* (1), 42-50.

Adler, F. (1929, May). Visit to the Cizek school in Vienna. *School and Home*, pp. 11-15.

Agell, G. (1980, April). History of art therapy. *Art Education, 33* (4), 8-9.

Alexander, R. (1983). Teacher as shaman: An educational criticism. *Studies in Art Education, 25* (1), 48-57.

Andersen, W. (1962). A neglected theory of art history. *Journal of Aesthetics and Art Criticism, 20* (4), 389-404.

Anderson, J. (1992). Art and the problem of vocationalism in American education. In P. Amburgy, D. Soucy, M. Stankiewicz, B. Wilson, & M. Wilson (Eds.). *The history of art education: Proceedings from the Second Penn State Conference, 1989* (pp. 12-15). Reston, VA: NAEA.

Anderson, J. P. (1969). Franz Cizek, art education's man for all seasons. *Art Education, 22* (7), 27-30.

Are you haptical? (1945, March 12). *Time*, p. 65.

Arnheim, R. (1969). *Visual thinking*. London: Faber & Faber.

——. (1983). Viktor Lowenfeld and tactility. *Journal of Aesthetic Education, 17* (2), 190-29.

Arnold, P. (1932, February). Teaching the blind to model. *Contemporary Review*, pp. 198-203.

Ashwin, C. (1981). *Drawing and education in German-speaking Europe, 1800-1900*. Ann Arbor, MI: UMI Research Press.

Ast, C. (1982). Two tests for haptic-visual aptitude: A discussion of their usefulness for elementary school children. *Studies in Art Education, 23* (1), 47-53.

Bailey, H. T. (1909, April). The golden stairs. *School Arts Book*, pp. 795-800.

Bailyn, B. (1960). *Education in the forming of American society*. Chapel Hill, NC: University of North Carolina.

Baker, D. (1984). J. Liberty Tadd, who are you? *Studies in Art Education, 26* (2), 75-85.

Barkan, M. (1955). *A foundation for art education*. New York: Ronald Press.

——. (1962). Transition in art education: Changing conceptions of curriculum content and teaching. *Art Education, 15,* 12-28.

——. (1966). Viktor Lowenfeld: His impact on art education. In K. Beittel (Ed.), *Research monograph: 2* (pp. 1-9). Washington, DC: NAEA

Barkan, M., Chapman, L., & Kern, E. (1970). *Guidelines: Curriculum development for aesthetic education*. St. Louis, MO: CEMREL

Barnes, E. (1895, October). The art of little children. *Pedagogical Seminary, 3* (2), 302.

Barzun, J. (1974). *Clio and the doctors: Psycho-history, quanto-history & history*. Chicago, IL: University of Chicago Press.

Bassett, R. (Ed.) (1971). *The open eye in general education*. Cambridge, MA: MIT.

Beck, R. H. (1959). Progressive education and American progressivism: Margaret Naumburg. *Teachers College Record, 60* (4), 198-208.

Beittel, K. (1972). *Mind and context in the art of drawing*. New York: Holt, Rinehart & Winston.

Belshe, F. (1946). *A history of art education in the public schools of the United States*. Unpublished doctoral dissertation, Yale University, New Haven, CT.

Berenson, B. (1950). *Aesthetics and history*. London: Constable.

Berger, P., & Luckmann, T. (1966). *The social construction of reality: A treatise in the sociology of knowledge*. Garden City, NY: Doubleday.

Berlin, I. (1967). *Historical inevitability*. London: Oxford University Press.

Berta, R. (1993). *His figure and his ground: An art educational biography of Henry Schaefer-Simmern*. Unpublished doctoral dissertation, Stanford University, Palo Alto, CA.

Biggers, J., & Simms, C. (1978). *Black art in Houston: The Texas Southern University experience*. College Station, TX: Texas A & M Press.

Binkley, T. (1978). Piece: Contra aesthetics. In J. Margolis (Ed.), *Philosophy looks at the arts* (pp. 25-44). Philadelphia: Temple University Press.

Boas, B. (1924). *Art in the school*. Garden City, NY: Doubleday, Doran.

Boas, G. (1940). What is art appreciation? In B. Boas (Ed.), *Art Education Today* (pp. 20-23). New York: Teachers College, Bureau of Publication.

Bolin, P. (1986). *Drawing interpretation: An examination of the 1870 Massachusetts "Act relating to free instruction in drawing."* Unpublished doctoral dissertation, University of Oregon, Eugene, OR.

——. (1988). Introduction. *Journal of Multi-cultural and Cross-cultural Research in Art Education, 6,* (1), 12-14.

Braunthal, J. (1948). *The tragedy of Austria*. London: Victor Gallancz.

Bridges, T. (1991, February). The dizzying dialectics of multiculturalism: A conversation in two parts (Part 2). *Inquiry: Critical Thinking Across the Disciplines, 7* (1), 6-7.

Britsch, G. (1952). *Theorie der bildenden kunst.* Rattigen: Aloys Henn Verlag.

Broch, H. (1984). *Hugo von Hofmannsthal and his time: The European imagination, 1860-1920.* (M. Steinberg, Trans.). Chicago: University of Chicago.

Broudy, H. (1972). *Enlightened cherishing.* Urbana, IL: University of Illinois Press.

——. (1987). *The role of imagery in learning.* Los Angeles, CA: Getty Center for Education in the Arts.

Bruner, J. (1960). *The process of education.* Cambridge, MA: Harvard University Press.

——. (1966). *Toward a theory of education.* Cambridge, MA: Harvard University Press.

Bunzel, R. (1929). *The Pueblo potter.* New York: Columbia University Press.

Burton, J., Lederman, A. & London, P. (Eds.) (1988). *Beyond DBAE: The case for multiple visions of art education.* North Dartmouth, MA: University Council on Art Education.

Buser, T. (1995). *Experiencing art around us.* Minneapolis: West Publishing Company.

Canaday, J. (1983). *What is art?* Englewood Cliffs, NJ: Prentice-Hall.

Cane, F. (1924, August). Teaching children to paint. *The Arts, 6* (2), 95-101.

——. (1926, April-May-June). Art in the life of the child. *Progressive Education, 3* (2), 155-162.

——. (1951). *The artist in each of us.* New York: Pantheon.

Carr, E. H. (1961). *What is history?* New York: Vintage.

Casey, K. (1926). *Masterpieces in art: A manual for teachers and students.* Chicago, IL: A. Flanagan.

Cattell, J. (Ed.). (1948). *Leaders in education.* Lancaster, PA: Science Press.

Chapman, L. (1978). *Approaches to art education.* New York: Harcourt Brace Jovanovich.

——. (1982). *Instant art, instant culture: The unspoken policy for American schools.* New York: Teachers College Press, Columbia University.

Chase, M. J. (1906, January). Picture study. *School Arts Book,* pp. 335-339.

Cheney, S. (1966). *A primer of modern art* (14th rev. ed.). New York: Liveright Publishing Corporation.

Child as artist, The. (1924, December 20). *The Independent,* pp. 541-544.

Cikovsky, N. (1977). *The life and work of George Inness.* New York: Garland.

Cizek, F. (1927) *Children's coloured paper work.* Vienna: Anton Schroll.

Clark, G., Day, M., & Greer, W. (1987). Discipline-based art education: Becoming students of art. *Journal of Aesthetic Education, 21* (2), 129-193.

Clark, K. (1969). *Civilisation.* New York: Harper & Row.

Coburn, A. L. (1966). *Alvin Langdon Coburn, photographer: An autobiography.*

New York: Frederick A. Praeger.

Coe, M. (1930, February). Review of *Tower Hill School Year-Book, 1929-1930. Progressive Education, 7* (1), 50-51.

Cole, N. R. (1940). *The arts in the classroom*, New York: John Day.

———. (1966). *Children's art from deep down inside*. New York: John Day, 1966.

———. (n.d.). Autobiography. Unpublished manuscript prepared for Miami University of Ohio Center for the Study of the History of Art Education.

Collins, F. M. (1923). *Picture study: A manual for teachers*. New York: Brown-Robertson.

Collins, G. & Sandell, R. (1991, September). *Some thoughts on the politics of multicultural art education*. Paper presented at the USSEA Symposium, Columbus, OH.

———. (1984). *Women, art, and education*. Reston, VA: NAEA.

Comini, A. (1974). *Egon Schiele's portraits*. Berkeley, CA: University of California Press.

Commager, H. S. (1976). *The people and their schools*. Bloomington, IN: Phi Delta Kappa.

Contributors to this issue. (1926, April-May-June). *Progressive Education, 3* (2), n.p.

Cope, P. (1984, September 18). Art patrons, symphony are honored. *Wilmington [DE] News Journal*, p. 1.

Cox, P. (1934). Austrian teachers in the crisis. *Progressive Education, 11* (6), 360-368.

Cremin, L. (1962). *The transformation of the school*. New York: Alfred A. Knopf.

———. (1965). *The wonderful world of Ellwood Patterson Cubberley*. New York: Teachers College, Columbia University.

Cronbach, L., & Suppes, P. (1969). *Research for tomorrow's schools: Disciplined inquiry for education*. New York: Macmillan.

Cubberley, E. (1919). *Public education in the United States*. New York: Houghton Mifflin.

Current exhibitions. (1943, November 15-30). *Art News*, p. 22.

D'Amico, V. (1958, September). Coming events cast shadows. *School Arts*, pp. 5-19.

———. (1963). *Does creative education have a future?* Paper presented at the conference of the International Society for Education through Art, Montreal.

Danforth, L. (1982). *The death rituals of rural Greece*. Princeton, NJ: Princeton University Press.

Dewey, J. (1929). Individuality and experience. In J. Dewey (Ed.), *Art and education* (pp. 175-183). Merion, Pennsylvania: Barnes Foundation Press.

———. (1934). *Art as experience*. New York: Capricorn Books.

Diamant, A. (1960). *Austrian Catholics and the First Republic, capitalism and the social order, 1918-1934*. Princeton, NJ: Princeton University Press.

DiBlasio, M. (1983). The troublesome concept of child art: A threefold analysis.

Journal of Aesthetic Education, 17 (3), 71-84.

Dillenberger, J. (1989). *The visual arts and Christianity in America from the colonial period to the present.* New York: Crossroad.

Dottrens, R. (1930). *The new education in Austria.* New York: John Day

Dover, C. (1960). *American Negro art.* Greenwich, CT: New York Graphic Society.

Dow, A. (1911). Art: Methods of teaching. In P. Monroe (Ed.), *A cyclopedia of education* (Vol. 1) (pp. 230-232). New York: Macmillan.

——. (1925). *Composition: A series of exercises in art strucutre for the use of students and teachers* (13th ed.). Garden City, NY: Doubleday, Page.

Dowd, M. (1976, April 12). Neale was Washington bigwig. *The [Stevens Point, WI] Pointer,* n.p.

Dubinsky, L. (1990). The philanthropic vision. *Studies in Art Education, 31* (4), 247-250.

Duke, L. (1983, March). *The Getty programs in the visual arts.* Paper presented at the annual conference of the National Art Education Association, Detroit, MI.

Duncum, P. (1982). The origins of self-expression: A case of self-deception. *Art Education, 35* (5), 32-35.

Ecker, D. (1963). Some inadequate doctrines in art education and a proposed resolution. *Studies in Art Education, 5* (1), 71-81.

——. (1966). The artistic process as qualitative problem solving. In E. Eisner & D. Ecker (Eds.), *Readings in art education,* (pp. 57-68). Waltham, MA: Blaisdell.

Eckford, E. (1924, March). The baby art museum. *School Arts,* pp. 432-435.

——. (1928, March). Art as it functions. *Childhood Education, 4* (7), 343-348.

——. (1929, September). Youthful mural painters. *American Magazine of Art,* pp. 520-524.

——. (1931a). Art as another language in the secondary school. *Progressive Education, 8* (4), 339-341

——. (1931b). *Wonder Windows.* New York: E. P. Dutton.

——. (1933a, May). The child's world of art. *The Instructor,* pp. 32; 73.

——. (1933b, April). Professor Cizek and his art class. *Progressive Education, 10* (4), 215-219.

Efland, A. (1976a). Changing views of children's artistic development: Their impact on curriculum and instruction. In E. W. Eisner (Ed.), *The arts, human development, and education* (pp. 65-85). Berkeley, CA: McCutchan.

——. (1976b). The school art style: A functional analysis. *Studies in Art Education, 17* (2), 37-44.

——. (1984). Curriculum concepts of the Penn State Seminar: An evaluation in retrospect. *Studies in Art Education, 25* (4), 205-211.

——. (1985). The introduction of music and drawing in the Boston schools: Two studies of education reform. In H. Hoffa & B. Wilson (Eds.), *The History of Art Education: Proceedings from the Penn State Conference* (pp. 113-124).

Reston, VA: NAEA.

——. (1987). Curriculum antecedents of discipline-based art education. *Journal of Aesthetic Education, 21* (2), 57-94.

——. (1988). How art became a discipline: Looking at our recent history. *Studies in Art Education,* 29 (3), 262-274.

——. (1990). *A history of art education: Intellectual and social currents in teaching the visual arts.* New York: Teachers College Press, Columbia University.

——. (1992). The history of art education as criticism. In P. Amburgy, D. Soucy, M. Stankiewicz, B. Wilson, & M. Wilson (Eds.), *The history of art education: Proceedings from the Second Penn State Conference, 1989* (pp. 1-11). Reston, VA: NAEA.

Eisner, E. (1965a). American education and the future of art education. In W. R. Hastie (Ed.), *Art education: The sixty-fourth yearbook of the National Society for the Study of Education* (pp. 299-325). Chicago: University of Chicago Press.

——. (1965b). Curriculum ideas in a time of crisis. *Art Education, 18* (17), 7-12.

——. (1965c). Graduate study and the preparation of scholars in art education. In W. R. Hastie (Ed.), *Art education: The sixty-fourth yearbook of the National Society for the Study of Education, Part II* (pp. 274-298). Chicago: University of Chicago Press.

——. (1972). *Educating artistic vision.* New York: Macmillan.

——. (1974). Is the artist-in-the-school program effective? *Art Education, 27* (2), 19-23.

——. (1985). Why art in education and why art education? In *Beyond creating: The place for art in America's schools* (pp. 64-69). Los Angeles: Getty Center for Education in the Arts.

——. (1992). The efflorescence of the history of art education: Advance into the past or retreat from the present? In P. Amburgy, D. Soucy, M. Stankiewicz, B. Wilson, & M. Wilson (Eds.), *The history of art education: Proceedings from the Second Penn State Conference, 1989* (pp. 37-41). Reston, VA: NAEA.

——. (1994). Revisionism in art education: Some comments on the preceding articles. *Studies in Art Education, 35* (3), 188-191.

Eisner, E. W., & Ecker, D. W. (1970). Some historical developments in art education. In G. Pappas (Ed.), *Concepts in art and education* (pp. 12-25). New York: Macmillan.

Eisner, E. & Ecker, D. (Eds), (1966). What is art education? In *Readings in art education* (pp. 1-27). Waltham, MA: Blaisdell.

Emerson, S. (1961). Viktor Lowenfeld as a colleague. *Art Education, 14* (2), 8-9.

Eng, H. (1931). *The psychology of children's drawing.* (H. S. Hatfield, Trans.). London: Routledge & Kegan Paul.

Erickson, M. (1977). Uses of history in art education. *Studies in Art Education, 18* (3), 20-29.

——. (1979). An historical explanation of the schism between research and practice in art education. *Studies in Art Education, 20* (2), 5-13.

——. (1985). Styles of historical investigation. *Studies in Art Education, 26* (2), 121-124.

Excerpts from notes by Arthur Wesley Dow (1935). In Belle Boas (Ed.), *Art Education Today* (pp. 73-74). New York: Teachers College, Bureau of Publications.

Fabricant, N. (1931, September 21). Intolerance in Vienna. *The Nation*, pp. 442-444.

Fadrus, V. (1927). Austria. In I. L. Kandel (Ed.), *Educational Yearbook of the International Institute of Teachers College Columbia University* (pp. 3-44). New York: Macmillan.

Fiedler, C. (1949). *On judging works of visual art* (H. Schaefer-Simmern & F. Mood, Trans.). Berkeley: University of California.

Fishman, S. (1976). *The struggle for German youth: The search for educational reform in imperial Germany.* New York: Revisionist Press.

Flexner, J. (1969). *First flowers of our wilderness: American painting, the colonial period.* New York: Dover.

Franciscono, M. (1971). *Walter Gropius and the creation of the Bauhaus in Weimar.* Urbana: University of Illinois Press.

Freedman, K. (1987). Art education and changing political agendas: An analysis of curriculum concerns of the 1940s and 1950s. *Studies in Art Education, 29* (1), 17-29.

Freud, M. (1970). Who was Freud? In J. Fraenkel (Ed.), *The Jews of Austria* (pp. 197-211). London: Valentine, Mitchell.

Freyberger, R. (1985). Integration: Friend or foe of art education? *Art Education, 38* (6), 6-9.

Froebel, F. (1826). *The education of man* (W. Hailman, Trans.). New York: D. Appleton & Co.

Fröhlich, F. (1968). Aesthetic paradoxes of abstract expressionism and pop art. In L. Jacobus (Ed.), *Aesthetics and the arts,* (pp. 236-244). New York: McGraw-Hill.

Gaitskell, C. (1958). *Children and their art.* New York: Harcourt, Brace & world.

Gardner, H. (1980). *Artful scribbles.* New York: Basic Books.

Getty Center for Education in the Arts. (1984). *Beyond creating: The place for art in America's schools.* Los Angeles, CA: Author.

——. (1992). *Discipline-based art education and cultural diversity.* Los Angeles, CA: Author.

Glimpses of Professor Cizek's School in Vienna. (1930, December). *School Arts*, pp. 220-223.

Gombrich, E. (1961). *Art and illusion.* New York: Pantheon Books.

——. (1963). *Meditations on a hobby horse.* Chicago: University of Chicago.

——. (1972). *The story of art* (12th ed.). London: Phaidon Books.

——. (1976). *The heritage of Apelles*. Ithaca, NY: Cornell University.

——. (1979). *Ideals and idols: Essays on values in history and art*. Oxford: Phaidon.

——. (1979). *The sense of order*. Ithaca, NY: Cornell University Press.

Goodman, N. (1978). *Ways of world-making*. Indianapolis, IN: Hackett Publishing.

Götze, K. (1898). *Das kind als künstler*. Hamburg: Lehrervereinigung für die Pflege der Künstlerischen Bildung.

Gould, J. (1961). *The Chautauqua movement: An episode in the continuing American revolution*. New York: University Publishers.

Graves, M. (1951). *The art of color and design*. New York: McGraw-Hill

Green, H. B. (1948). *The introduction of art as a general education subject in American schools*. Unpublished doctoral dissertation, Stanford University, Palo Alto, CA.

Greene, M. (1965). *The public school and the private vision*. New York: Random House.

Greer, C. (1972). *The great school legend*. New York: Viking Press.

Gregory, A. (1982, January). People make traditions: An interview with Marion Quin Dix. *Art Education, 35* (1), 16-21.

Gutteridge, M. V. (1958, October). The classes of Franz Cizek. *School Arts*, pp. 21-22.

Haag, J. (1976). Blood on the Ringstrasse: Vienna's students, 1918-33. *Wiener Library Bulletin, 24* (39), 29- 34.

Hagarty, L. D. (1907, January). Picture enjoyment. *School Arts Book*, pp. 385-389.

Hamblen, K. (1985). Historical research in art education: A process of selection and interpretation. In H. Hoffa and B. Wilson (Eds.), *The history of art education: Proceedings from the Penn State Conference* (pp. 1-10). Reston, VA: NAEA.

——. (1987). An examination of discipline-based art education issues. *Studies in Art Education, 28* (2), 68-78.

Hanawalt, L. L. (1968). *A place of light: A history of Wayne State University, a centennial publication*. Detroit, MI: Wayne State University Press.

Haney, J. P. (1908). *Art education in the public schools of the United States: A symposium prepared under the auspices of the American Committee of the Third International Congress for the Development of Drawing and Art Teaching, London 1908*. New York: American Art Annual.

Hansot, E., & Tyack, D. (1982). A usable past: Using history in educational policy. In A. Liebman & M. McLaughlin (Eds.), Policy making in education. *Eighty-first yearbook of the National Society for the Study of Education* (pp. 1-22). Chicago: University of Chicago.

——. (1988). Silence and policy talk: Historical puzzles about gender and education. *Educational Researcher, 17* (3), 33-41.

Harris, D. (1963). *Children's drawings as measures of intellectual maturity*. New

York: Harcourt, Brace & World.

Hartman, G., & Shumaker, A. (1932). *Creative expression*. New York: Regral & Hitchcock.

Hausman, J. (1987). Another view of discipline-based art education. *Art Education, 40* (1), 56-59.

Hearnden, A. (1976). *Education, culture, and politics in West Germany*. Oxford: Pergamon Press.

Hempel, C. (1941). The function of general laws in history. *Journal of Philosophy, 38*, 35-48.

Hendrickson, G., & Waymack, E. (1932). Children's reactions as a basis for teaching picture appreciation. *Elementary School Journal, 33* (4), 268-276.

Herrington, B. (1971). Foreword. In J. B. Welling, *They were here too* (vol. 3). Greenwich, NY: Washington County Historical Society.

Hexter, J. H. (1971). *Doing history*. Bloomington: Indiana University Press.

Highet, G. (1954). Sailing to Byzantium. In C. Canby & N. E. Gross (Eds.), *The world of history* (pp. 9-14). New York: Mentor Books.

Historisches Museum der Stadt Wien. (1985). *Franz Cizek, Pioneer der kunsterziehung (1865-1946)*. Vienna: Author.

Hollingsworth, C. (1988). *Viktor Lowenfeld and the racial landscape of Hampton Institute during his tenure from 1939 to 1946*. Unpublished doctoral dissertation, Pennsylvania State University, University Park.

Hollister, A. B. (1926, July-August-September). Franz Cizek's contribution to the teaching of art. *Progressive Education*, pp. 263-265.

Howat, J. (1983). *The Hudson River and its painters*. New York: American Legacy.

Hurwitz, A., & Madeja, S. (1977). *The joyous vision*. Englewood Cliffs, NJ: Prentice-Hall.

Jackson, P. (1990). The functions of educational research. *Educational Researcher, 19* (7), 3-9.

Janik, A. & Toulmin, S. (1973). *Wittgenstein's Vienna*. New York: Simon & Schuster.

Jaszi, O. (1929). *The dissolution of the Habsburg monarchy*. Chicago: University of Chicago Press.

Johnston, W. (1972). *The Austrian mind: An intellectual and social history, 1848-1938*. Berkeley: University of California Press.

Jones, R. (1968). *Feeling and fantasy in education*. New York: New York University Press.

Kallir, J. (1986). *Viennese design and the Wiener Werkstätte*. New York: Galerie St. Etienne/George Braziller.

Katz, M. (1971). *Class, bureaucracy, and schools: The illusion of educational change in America*. New York: Praeger.

Keel, J. (1960). *The writings of Sir Herbert Read and their curriculum implications--The aesthetic education of man*. Unpublished doctoral dissertation, University of Wisconsin, Madison.

Kent, D. (1953). *The refugee intellectual*. New York: Columbia University Press.

Kern, E. (1987). Antecedents of discipline-based art education: State departments of education curriculum documents. *Journal of Aesthetic Education, 21* (2), 35-56.

Kerschensteiner, G. (1905). *Die entwicklung der zeicherischen begabung*. Munich: Druck and Verlag von Carl Gerber.

Kindler, A. (1994). Children and the culture of a multicultural society. *Art Education, 47* (4), 54-60.

Kleinbauer, W. (1971). *Modern perspectives in Western art history*. New York: Holt, Rinehart & Winston.

Kniazzeh, C. R. (1978, October). Book reviews. *American Journal of Art Therapy, 18* (1), 31-33.

Korzenik, D. (1985a). Doing historical research. *Studies in Art Education, 26* (Winter): 125-128.

——. (1985b). *Drawn to art: A nineteenth century American dream*. Hanover, NH: University Press of New England.

——. (1987). Why government cared. In *Art education here*, pp. 59-74. Boston: Art Education Department, Massachusetts College of Art.

Kraus, B. (1968). *History of German art education and contemporary trends*. Unpublished doctoral dissertation, Pennsylvania State University, University Park.

Krüsi, H. (1872). *Krüsi's drawing. Manual for teachers: Inventive course-synthetic series*. New York: D. Appleton & Co.

Kuhn, T. (1962). *The structure of scientific revolutions*. Chicago: University of Chicago Press.

Kunkel, J. (1972). *Aesthetic education program: Initial survey of selected implementation sites, 1971-72*. St. Louis: CEMREL, Inc. (Eric Document Reproduction Service No. ED. 164 385).

Kuspit, D. (1986, November). Strategies of shamelessness. *Art in America*, pp. 118-128.

Langbehn, J. (1891). *Rembrant als Erzieher* (33rd. ed.). Leipzig: Hirschfeld.

Lanier, V. (1963). Schismogenesis in contemporary art education. *Studies in Art Education, 5* (1), 10-19.

——. (1975). Objectives of art education: The impact of time. *Peabody Journal of Education, 52*, 182-186.

——. (1977). The five faces of art education. *Studies in Art Education, 18* (3), 7-21.

Lark-Horovitz, B., Lewis, H., & Luca, M. (1967). *Understanding children's art for better teaching*. Columbus, Ohio: Charles E. Merrill.

Lehmann-Haupt, H. (1954). *Art under a dictatorship*. New York: Oxford University Press.

Lemos, J. T. (1925, November). Correlated pictures: Shoeing the Mare. *School Arts*, pp. 186-191.

Levi, A., & Smith, R. (1991). *Art education: A critical necessity.* Urbana: University of Illinois Press.

Lewin, K. (1973). Some social-psychological differences between the United States and Germany. In G. W. Lewin (Ed.), *Resolving social conflicts* (pp. 3-33). London: Souvenir Press.

Lilge, F. (1948) *The abuse of learning.* New York: Macmillan.

Logan, F. (1955). *The Growth of art in American schools.* New York: Harper & Brothers.

London, P. (1987). *Lowenfeld vs. Getty.* Paper presented at the Annual Conference of the National Art Education Association, Boston, MA.

Lovano-Kerr, J., Semler, V., & Zimmerman, E. (1977). A profile of art educators in higher education: male/female comparative data. *Studies in Art Education, 18* (2), 21-37.

Lowenfeld, V. (1939). The nature of creative activity (Second ed., 1952). (O. Oesner, Trans.). London: Routledge & Kegan Paul.

——. (1944, September). New Negro art in America. *Design*, pp. 20-21, 29.

——. (1945 January). Negro art expression in America. *Madison Quarterly, 5* (11), 26-31.

——. (1947). *Creative and mental growth.* New York: Macmillan.

——. (1951). Psycho-aesthetic implications of the art of the blind. *Journal of Aesthetics and Art Criticism, 10* (1), 109.

——. (1952). *Creative and mental growth.* (2nd ed.). New York: Macmillan.

——. (1954). *Your child and his art.* New York: Macmillan.

——. (1957). *Creative and mental growth.* (3rd ed.). New York: Macmillan.

——. (1958). Autobiography: Viktor Lowenfeld's lectures at the Pennsylvania State University, University Park, PA. Unpublished tape transcript. (Available from Jerry W. Morris, Center for the Study of the History of Art Education, 105 Van Voorhis Hall, Miami University, Oxford, OH 45056).

Ludwig, W. (1966). *Graven images: New England stonecarving and its symbols, 1650-1815.* Middletown, CT: Wesleyan University Press.

MacDonald, R. (1941). *Art as education.* New York: Henry Holt.

MacDonald, S. (1970). *History and philosophy of art education.* New York: American Elsevier.

MacDougall, A. (1926, January). Developing artists through imagination. *Arts and Decoration*, pp. 46-47.

Manfredi, J. (1982). *The social limits of art.* Amherst: University of Massachusetts Press.

Mangravite, P. (1926). The artist and the child. *Progressive Education, 3* (2), 124.

Mann, H. (1844, April 15). Seventh annual report to the Board of Education of the Commonwealth of Massachusetts. *Common School Journal.*

Manzella, A. (1963). *Educationists and the evisceration of the visual arts.* Scranton, PA: International Textbooks.

Mathias, M. (1924). *Beginnings of art in the public schools.* New York: Charles

Scribner's Sons.

——. (1929). *Art in the elementary school*. New York: Charles Scribner's Sons.

——. (1932). *The teaching of art*. New York: Charles Scribner's Sons.

Matson, N. H. (1923, September). In the strange brave world of children. *The Survey*, pp. 576-582.

Mattil, E. (1982). Yes, I remember Viktor. *Art Education, 35* (16), 8-11.

McFee, J. (1961). *Preparation for art*. Belmont, CA: Wadsworth.

——. (1987, May). *Art and society*. Paper presented at the invitational seminar, Discipline-based Art Education: Strengthening the Stance, Extending the Horizons, Cincinnati, OH.

——. (1991). Art education progress: A field of dichotomies as a network of mutual support. *Studies in Art Education, 32* (2), 70-82.

McGrath, W. (1974). *Dionysian art and populist politics in Austria*. New Haven, CT: Yale University Press.

McMury, R. N. (1935). Student freedom in Germanic universities: Panacea or illusion? *School and Society, 14* (1), 8-14.

McWhinnie, H. (1972). Viktor Lowenfeld: Art education for the 1970s. *Studies in Art Education, 14* (1), 8-14.

Mearns, H. (1929). *Creative power*. New York: Doubleday, Doran & Company.

Meyer, A. (1934). *Modern European educators and their work*. New York: Prentice-Hall.

Michael, J. (1981). Viktor Lowenfeld: Pioneer in art education therapy. *Studies in Art Education, 22* (2), 7-19.

——. (Ed.). (1982). *The Lowenfeld lectures*. University Park, PA: Penn State Press.

——. (1983a). *Development of a center for historical research in art education*. Presentation at National Art Education Conference, Detroit, MI, March 24-29.

——. (1983b). *Art and adolescence: Teaching art at the secondary level*. New York: Teachers College Press.

Michael, J. & Morris, J. (1985). European influences on the theory and philosophy of Viktor Lowenfeld. *Studies in Art Education, 26* (2), 103-110.

——. (1986). A sequel: Selected European influences on the theory and philosophy of Viktor Lowenfeld. *Studies in Art Education, 27* (3), 131-139.

Mills, C. (1939). Language, logic, and culture. *American Sociological Review, 4* (5), 670-680.

Mitchell, D. J. (1980). "Living document": Oral history and biography. *Biography, 3* (4), 283-296.

Monroe, P. (Ed.) (1911). *A cyclopedia of education* (Vol. 1). New York: Macmillan.

Monroe, W. (1899). Book notes. *Pedagogical Seminary, 6* (2), 264.

Morrison, J. G. (1935). *Children's preferences for pictures*. Chicago: University of Chicago Press.

Mosse, G. (1947). The influence of the *volkisch* idea on German Jewry. *Studies of the Leo Beack Institute*. New York: Frederick Ungar.

Muller, H. J. (1954). *The uses of the past*. New York: Mentor Books.

Munro, T. (1929a). The Dow method and public school art. In J. Dewey (Ed.), *Art and education* (pp. 329-337), Merion, PA: Barnes Foundation Press.

——. (1929b). Franz Cizek and the free-expressive method. In J. Dewey (Ed.), *Art and education* (pp. 311-316). Merion, PA: Barnes Foundation Press.

——. (1956). *Art education, its philosophy and psychology*. New York: Liberal Arts Press.

Munson, R. (1971). The Gustaf Britsch theory of the visual arts. *Studies in Art Education, 12* (2), 4-17.

Münz, L., & Lowenfeld, V. (1934). *Plastische Arbeiten Blinder*. Brun: R. M. Rohrer.

National Commission on Excellence in Education (1983). *A nation at risk: The imperative for educational reform*. Washington, DC: U.S. Government Printing Office.

Naumburg, M. (1973a). The Children's School. In C. B. Winsor, (Ed.), *Experimental schools revisited* (pp. 43-45). New York: Agathon Press.

——. (1973b). *An introduction to art therapy: Studies of the "free" art expression of behavior problem children and adolescents as a means of diagnosis and therapy* (Rev. ed., 1st edition published as *Studies of the "free" art expression of behavior problem children and adolescents as a means of diagnosis and therapy*, 1947). New York: Teachers College Press, Columbia University.

Neale, O. W. (1927). *Picture study in the grades*. Stevens Point, WI: Author.

——. (1933). *World-famous pictures*. Chicago, IL: Lyons & Carnahan.

Neale retires from faculty after 29 years. (1944, July 22). *Stevens Point [WI] Daily Journal*, pp. 1, 6.

Novotny, F. (1961). Foreword. In L. Münz, *Bruegel, the drawings* (L. Hermann, Trans.). Greenwich, CT: Phaidon.

Pächt, O. (1963). Art historians and art critics-vi: Alois Riegl. *Burlington Magazine, 105* (722), 188-193.

Pauley, B. (1981). *Hitler and the forgotten Nazis: A history of Austrian National Socialism*. Chapel Hill: University of North Carolina Press.

Pepper, S. (1942). *World hypotheses*. Berkely, CA: University of California Press.

——. (1945). *The basis of criticism in the arts*. Cambridge, MA: Harvard University Press.

Picture study, a symposium. (1907, February). *School Arts Book*, pp. 482-499.

Plummer, G. (1985). Collage: People, places and problems in our historic continuum. In H. Hoffa and B. Wilson (Eds.), *The history of art education: Proceedings from the Penn State Conference* (pp. 213-218). Reston, VA: NAEA.

Proust, M. (1934). *The Guermantes way: Vol. 1. Remembrance of things past* (C.K.S. Moncrieff, Trans.). New York: Random House.

Rafferty, M. (1963). *What they are doing to your children?* New York: New American Library.

Rath, R. J. (1943). *Training for citizenship,* "authoritarian" Austrian style. *Journal of Central European Affairs,* 3 (2), 121-146.

Read, H. (1943). *Education through art.* London: Faber & Faber.

——. (1957). *Modern art.* New York: Meridian Books.

Reynolds, C. (1933). Child art in the Franz Cizek School in Vienna. *Childhood Education, 10* (3), 121-126, 152.

Rhoads, E. E. (1935, April). Old crafts for the new schools. *Progressive Education, 12* (4), 262-264.

Ricci, C. (1887). *L'arte dei bambini.* Bologna: Publisher unlisted.

Riedl, J. (1985). *The Jewish heritage: Vienna, diaspora and the art of survival.* Paper presented at the Williams College Symposium on Vienna, Williamstown, MA, October 5.

Robinson, A. (1923). The passing of the city supervisor of art. *Educational Review, 66,* 99-102.

Rochowanski, L. (1922). *Der Formwille der Zeit in der Angewandten Kunst.* Vienna: Burg.

——. (1930). *Ein Fuhrer durch das Osterreichische kunstgewerbe.* Vienna: Verlag Heinz.

——. (1946) *Die Wiener jugendkunst.* Vienna: Wilhelm Frick Verlag.

Rugg, H., & Shumaker, A. (1928). *The child-centered school: An appraisal of the new education.* Yonkers, NY: World Book.

Saunders, R. (1994, April). Book review [*A history of African-American artists: From 1972 to the present*]. *USSEA Newsletter, 17* (3), p. 3.

——. (1961). *The contributions of Horace Mann, Mary Peabody Mann, and Elizabeth Peabody to art education in the United States.* Unpublished doctoral dissertation, Pennsylvania State University, University Park.

——. (1964). The search for Mrs. Minot: An essay on the caprices of historical research. *Studies in Art Education, 6* (1), 1-7.

——. (1966). A history of teaching art appreciation in the public schools. In D. W. Ecker (Ed.), *Improving the teaching of art appreciation* (pp. 1-47). Columbus: School of Art, Ohio State University.

——. (1970). Selections from historical writings on art education. In G. Pappas (Ed.), *Concepts in art and education: An anthology of current issues* (pp. 4-11). New York: Macmillan.

——. (1960). The contributions of Viktor Lowenfeld to art education: Part I: Early influences on his thought. *Studies in Art Education, 2* (1), 6-15.

Schaefer-Simmern, H. (1948). *The unfolding of artistic activity.* Berkeley: University of California Press.

——. (1953). The 1952 meeting of the League of German Art Educators. *Art Education, 6* (2), 2-4.

Schapiro, M. (1953). Style. In A. Kroeber (Ed.), *Anthropology today* (pp. 287-312). Chicago: University of Chicago Press.

Schleiffer, J. (1960, June). Kokoschka, pioneer in art education. *School Arts,* pp. 29-32.

Schnitzler, H. (1954). "Gay Vienna"--myth and reality. *Journal of the History of Ideas, 15* (1), 94-117.

Schorske, C. (1980). *Fin-de-siècle Vienna*. New York: Alfred A. Knopf.

Schwartz, J. (1993, December 8). Scientific truths and true science. *Chronicle of Higher Education*, pp. B1-2.

Sculpture by the blind. (1939). In B. Boas (Ed.), *Art Education Today* (pp. 88-89). New York: Teachers College, Bureau of Publications.

Scully V. (1960). *Frank Lloyd Wright*. New York: George Braziller.

Shedel, J. (1981). *Art and society: The new art movement in Vienna, 1897-1914*. Palo Alto, CA: Society for the Advancement of Science and Scholarship.

Silke, L. S., (1909, May). The work of normal schools. *School Arts Book*, pp. 874-887.

Simons, A. P. (1968). *Viktor Lowenfeld: Biography of ideas*. Unpublished doctoral dissertation, Pennsylvania State University, University Park.

Simons, D. (1966). *Georg Kerschensteiner: His thought and its relevance today*. London: Methuen.

Smith N. (1983). Drawing conclusions: Do children draw what they see? *Art Education, 36* (5), 22-25

Smith, P. J. (1982a). Germanic foundations: A look at what we are standing on. *Studies in Art Education, 23* (3), 23-30.

——. (1982b). Lowenfeld in a Germanic perspective. *Art Education, 35* (6), 25-27.

——. (1982c, April). *Before Lowenfeld: Five women of power in art education*. Paper presented at the annual conference of the National Art Education Association, New York City.

——. (1983). *An analysis of the writings and teachings of Viktor Lowenfeld: Art educator in America*. Unpublished doctoral dissertation, Arizona State University, Tempe.

——. (1984). Natalie Robinson Cole: The American Cizek? *Art Education, 37* (1), 36-39.

——. (1985a). Franz Cizek: The patriarch. *Art Education, 38* (2), 28-31.

——. (1985b). The Lowenfeld motivation revisited. *Canadian Review of Art Education Research, 12*, 11-18.

——. (1986). The ecology of picture study. *Art Education, 39* (5), 48-54.

——. (1987). Lowenfeld teaching art: A European theory and American experience at Hampton Institute. *Studies in Art Education, 29* (1), 30-36.

——. (1988). The role of gender in the history of art education: Questioning some explanations. *Studies in Art Education, 29* (4), 232-241.

——. (1989). Lowenfeld in a Viennese Perspective: Formative influences for the American art educator. *Studies in Art Education, 30* (2), 104-114.

——. (1991). The case of the artist-in-the-classroom with special reference to the teaching career of Oskar Kokoschka. *Studies in Art Education, 32* (4), 239-247.

——. (1991). Working with art education history: Natalie Robinson Cole as a

"living document." *Art Education, 44* (4), 6-15.

——. (1992). Multiculturalism and the education of artists: Loveboat or Titanic? *Art & Academe, 5* (1), 12-21.

——. (1993). Multiculturalism's therapeutic imperative. *Visual Arts Research, 19* (2), 55-60.

Smith, P., & Pusch, J. (1990). A cautionary tale: The stalling of DBAE. *Visual Arts Research, 16* (2), 43-50.

Smith, R. (1964). Art education criticism: A reply to David Manzella's *Educationists and Evisceration of the Visual Arts. Art Education, 17* (2), 4- 8.

——. (1987). The changing image of art education: Theoretical antecedents of discipline-based art education. *Journal of Aesthetic Education, 21* (2), 2-34.

Stankiewicz, M. A. (1982). Woman, artist, art educator: Professional image among women art educators. In M. A. Stankiewicz & E. Zimmerman (Eds.), *Women art educators* (pp. 30-48). Bloomington: Indiana University Press.

——. (1983, March). *The printed image and art education*. Paper presented at the NAEA Conference, Detroit, MI.

——. (1984). Self-expression or teacher influence: The Shaw system of finger painting. *Art Education, 37* (2), 20-24.

——. (1985). A picture age: Reproductions in picture study. *Studies in Art Education, 26* (2), 86-92.

——. (1987). A generation of art educators. In H. Hoffa & B. Wilson (Eds.), *The history of art education: Proceedings of the Penn State Conference* (pp. 205-212). Reston, VA: NAEA.

Stankiewicz, M .A., & Zimmerman, E. (1984). Women's achievements in art education. In G. Collins & R. Sandell, *Women, art, and education* (pp. 113-140). Reston, VA: NAEA.

Stark, G. (1985). Oswego Normal's and art education's forgotten man. *Art Education, 37* (1), 40-44.

Steiner, K. (1972). *Politics in Austria*. Boston: Little, Brown & Company.

Stern, F. (1961). *The politics of cultural despair*. Berkeley: University of California Press.

Stevens Point Normal School. (1918). *Normal Bulletin*. Stevens Point, WI: Author.

Stinespring, J. (1992). Discipline-based art education and art criticism. *Journal of Aesthetic Education, 26* (3), 104-112.

Stinespring, J., & Kennedy, L. (1988). Discipline-based art education neglects learning theory: An affirmation of studio art. *Design for Arts in Education, 90* (2), 33-40.

Swift, J. (1991). The use of art and design archives in critical studies. In D. Thistlewood (Ed.), *Critical studies in art and design education* (pp. 158-170), Portsmouth, NH: Heineman.

Tadd, J. L. (1899). *New methods in art education: Art, real manual training, nature study*. Springfield, MA: Orange Judd.

Todd, J. (1933, April). My impressions of a visit to the Cizek school. *School Arts*, pp. 484-488.

Todd, J. G. (1991). The ethical and aesthetic education of artists in the 1990s. *Art & Academe, 3* (2), 1-13.

Tolstoy, L. (1930). *What is art?* (Trans., A. Maude). London: Oxford University Press. (Original work published 1898).

Tomlinson, R. (1934). *Picture making by children*. London: Studio Limited.

Ubbelohde, R. (1977). A neo-conservative approach to curriculum. In A. Molnar and J. Zahonik (Eds.) *Curriculum Theory* (pp. 22-34). Washington, DC: Association for Supervision and Curriculum Development.

Un-American System, An. (1881, February 24). *Boston Evening Transcript* (p. 4).

Vergo, P. (1981). *Art in Vienna, 1898-1918*. Ithaca, NY: Cornell University Press.

Viola, W. (1944). *Child art*. Peoria, IL: Charles A. Bennett.

——. (1936). *Child Art and Franz Cizek*. Vienna: Austrian Junior Red Cross.

Von Hagen, V. (1958). *The Aztec: Man and tribe*. New York: Mentor Books.

Wagner, R. (1911). Das Judentum in der musik. In Julius Kapp (Ed.), *Gesammelte Schriften* (Vol. 13), (pp. 11-50). Leipzig: Hesse &Becker.

Walsh, W. (1960). *Philosophy of history*. New York: Harper & Row.

Wasson, R., Stuhr, P., & Petrovich-Mwaniki, L. (1990). Teaching art in the multicultural classroom: Six position statements. *Studies in Art Education, 31* (4), 234-246.

Wayne, J. (1974). The male artist as stereotypical female. *Arts in Society, 11* (1), 107-113.

Weber, C. (1960). *Basic philosophies of education*. New York: Holt, Rinehart & Winston.

Weitz, M. (1956). The role of theory in aesthetics. *Journal of Aesthetics and Art Criticism, 15*, pp. 27-35.

Welling, J. B. (1923, October). Suggestions in art education for elementary schools. *Industrial Education Circular No. 21*. Washington, DC: Department of the Interior, Bureau of Education.

——. (1924, November). Art education and the N.E.A. *School Arts*, pp. 180-182.

——. (1927). *More color for you: Color study development by the experimental method*. Chicago: Abbott.

——. (1930, May). Creative. *School Arts*, p. 514.

——. (1931, November). Illustrated books for the four-to-eight year old. *Childhood Education*, pp. 132-138.

——. (1932, November). Integration of elementary art. *Ohio Schools*, pp. 288, 299.

——. (1935a, October). Socialized art education. *Design*, pp. 24-25.

——. (1935b, November). Design grows from the community. *Design*, pp. 26-29.

——. (1935c, December). Art workshops for children where they create real toys. *Design*, pp. 44-45.

——. (1937a). Visualizing health education through art. *Progressive Education, 14* (1), 47-49.

——. (1937b). Integration of art in the elementary school curriculum. *Virginia Journal of Education, 30* (7), 297-298.

——. (1937c, April). Modern furniture for the small apartment. *Design*, pp. 8-9.

——. (1938, March). Much can be done with paper. *Design*, p. 22.

——. (1939a, February). Art education offers a way of working. *School Arts*, p. 183.

——. (1939b). The place of the arts in the progressive school program. *Progressive Education, 16* (5) 308-313.

——. (1942). *The art workshop: '166 and all that, a study of education in democracy*. Unpublished doctoral dissertation, Teachers College, Columbia University, New York.

——. (1943a, May). Art education a wartime resource. *Design*, p. 3.

——. (1943b, March). A Pan-American fiesta in Detroit uses scrap, salvage and substitutes. *Design*, pp. 14-15.

——. (1945). Any one can cartoon. *Design*, pp. 18-19.

——. (1949a, March). Children make art. *Childhood Education*, pp. 299-301.

——. (1949b, April). Where is art education going today? *Design*, pp. 7-8.

——. (1953). Save that string! *Design*, p. 208.

——. (n. d.). *The art of it all*. Manuscript.

Welling, J. B. & Calkins, C. M. (1923). *Social and industrial studies for the elementary grades*. Chicago: J. B. Lippincott.

Welling, J. B., & Pelikan, A. (1939). *Creative arts* (vols. 1-3). Chicago: Mentzer-Bush.

Whiteside, A. (1975). *The socialism of fools*. Berkeley: University of California Press.

Whyte, J. (1943). *American ways and works: Especially for German Americans*. New York: Viking Press.

Wilson, B., & Wilson, M. (1982). *Teaching children to draw*. Englewood Cliffs, NJ: Prentice Hall.

Wilson, B., Hurwitz, A., & Wilson, M. (1987). *Teaching drawing from art*. Worcester, MA: Davis.

Wilson, F. M. (1921a). *The child as artist*. London: The Children's Exhibition Fund.

——. (1921b). *A class at Professor Cizek's*. London: Children's Exhibition Fund.

——. (1921c). *A lecture by Professor Cizek*. London: Children's Exhibition Fund.

——. (1924, March). The Cizek exhibition at the Metropolitan, New York. *Industrial Arts Magazine*, pp. 112-113.

——. (1945). *In the margins of chaos: Recollections of relief work in and between*

three wars. New York: Macmillan.

Wistrich, R. (1979). Dilemmas of assimilation in fin de siècle Vienna. *Weiner Library Bulletin, 32* (49/50), 15-28.

Wygant, F. (1983). *Art in American schools in the nineteenth century.* Cincinnati, OH: Interwood Press.

——. (1993). *School art in American culture: 1820-1970.* Cincinnati, OH: Interwood Press.

Young Negro art impresses New York. (1943, October 15). *Art Digest*, pp. 25-26.

Young Negro Artists. (1943, November). *Design*, p. 7.

Ziegfeld, E., & Faulkner, R. (1941). *Art today.* New York: Holt, Rhinehart & Winston.

Zimmerman, E. (1982). Belle Boas: Her kindly spirit touched all. In M. Stankiewicz & E. Zimmerman (Eds.), *Women art educators* (pp. 49-58). Bloomington: Indiana University Press.

Zweig, S. (1943). *The world of yesterday, an autobiography.* New York: Viking Press.

Zweybruck, N. (1953, October). Cizek as father of art education. *School Arts*, pp. 11-14.

Index

About the Author

PETER SMITH is Coodinator of Art Education/Art Therapy at the University of New Mexico. He has exhibited his art work in many parts of the United States and is a familiar name in art education journal literature, with more than thirty major articles. His twenty-five-year background in public school teaching serves him well as a spokesman of institutional art education.

ISBN 0-313-29870-X

EAN

90000>

HARDCOVER BAR CODE